The Palace Museum's Essential Collections

PAINTINGS

of

THE JIN, TANG, SONG, AND YUAN DYNASTIES

The Commercial Press

Paintings of the Jin, Tang, Song, and Yuan Dynasties

Chief Editor	Yu Hui
Deputy Chief Editor	Li Shi, Zeng Jun
Editorial Board	Jin Weidong, Fu Dongguang, Nie Chongzheng, Yuan Jie, Yang Lili
Photographers	Hu Chui, Liu Zhigang, Zhao Shan, Feng Hui
Translator	Chan Sin-wai
Assistant Translator	Florence Li
Editorial Consultant	Hang Kan
Project Editors	Xu Xinyu, Fu Mei
Cover Design	Zhang Yi
Published by	The Commercial Press (Hong Kong) Ltd. 8/F., Eastern Central Plaza, 3 Yiu Hing Rd, Shau Kei Wan, Hong Kong http://www.commercialpress.com.hk
Printed by	C & C Offset Printing Co., Ltd. C & C Building, 36 Ting Lai Road, Tai Po, N.T., Hong Kong
Edition	First Edition in October 2015

ISBN 978 962 07 5659 7

Printed in Hong Kong

Introducing the Palace Museum to the World

SHAN JIXIANG

Built in 1925, the Palace Museum is a comprehensive collection of treasures from the Ming and Qing Dynasties and the world's largest treasury of ancient Chinese art. To illustrate ancient Chinese art for people home and abroad, the Palace Museum and The Commercial Press (Hong Kong) Ltd. jointly published *The Complete Collection of Treasures of the Palace Museum*. The series contains 60 books, covering the rarest treasures of the Museum's collection. Having taken 14 years to complete, the series has been under the limelight among Sinologists. It has also been cherished by museum and art experts.

After publishing *The Complete Collection of Treasures of the Palace Museum*, it is understood that westerners, when learning about Chinese traditional art and culture, are particularly fond of calligraphy, paintings, ceramics, bronze wares, jade wares, furniture, and handicrafts. That is why The Commercial Press (Hong Kong) Ltd. has discussed with the Palace Museum to further co-operate and publish a new series, *The Palace Museum's Essential Collections*, in English, hoping to overcome language barriers and help more readers to know about traditional Chinese culture. Both parties regard the publishing of the series as an indispensable mission for Chinese history with significance in the following aspects:

First, with more than 3,000 pictures, the series has become the largest picture books ever in the publishing industry in China. The explanations show the very best knowledge from four generations of scholars spanning 90 years since the construction of the Museum.

Second, the English version helps overcome language and cultural barriers between the east and the west, facilitating the general public's knowledge of Chinese culture. By doing so, traditional Chinese art will be given a fresher image, becoming more approachable among international art circles.

Third, the series is going to further people's knowledge about the Palace Museum. According to the latest statistics, the Palace Museum holds more than 1.8 million pieces of artifacts (among which 228,771 pieces have been donated by the general public and purchased or transferred by the government since 1949). The series selects nearly 3,000 pieces of the rare treasures, together with more than 12,000 pieces from *The Complete Collection of Treasures of the Palace Museum*. It is believed that the series will give readers a more comprehensive view of the Palace Museum.

Just as *The Palace Museum's Essential Collections* is going to be published, I cannot help but think of Professor Qi Gong from Beijing Normal University; famous scholars and researchers of the Palace Museum Mr. Xu Bangda, Mr. Zhu Jiajin, and Mr. Liu Jiu'an; and well-known intellectuals Mr. Wu Kong (Deputy Director of Central Research Institute of Culture and History), and Mr. Xu Qixian (Director of Research Office of the Palace Museum). Their knowledge and relentless efforts are much appreciated for showing the treasures of the Palace Museum to the world.

Looking at History through Art

YANG XIN

The Palace Museum is a comprehensive collection of the treasures of the Ming and Qing Dynasties. It is also the largest museum of traditional art and culture in China. Located in the urban centre of Beijing, this treasury of ancient Chinese culture covers 720,000 square metres and holds nearly 2 million pieces of artifacts.

In the fourth year of the reign of Yongle (1406 A.D.), Emperor Chengzu of Ming, named Zhu Di, ordered to upgrade the city of Beiping to Beijing. His move led to the relocation of the capital of the country. In the following year, a grand, new palace started to be built at the site of the old palace in Dadu of the Yuan Dynasty. In the 18th year of Yongle (1420 A.D.), the palace was complete and named as the Forbidden City. Since then the capital of the Ming Dynasty moved from Nanjing to Beijing. In 1644 A.D., the Qing Dynasty superceded the Ming empire and continued using Beijing as the capital and the Forbidden City as the palace.

In accordance with the traditional ritual system, the Forbidden City is divided into the front part and the rear part. The front consists of three main halls, namely Hall of Supreme Harmony, Hall of Central Harmony, and Hall of Preserving Harmony, with two auxiliary halls, Hall of Literary Flourishing and Hall of Martial Valour. The rear part comprises three main halls, namely Hall of Heavenly Purity, Hall of Union, Hall of Earthly Tranquillity, and a cluster of six halls divided into the Eastern and Western Palaces, collectively called the Inner Court. From Emperor Chengzu of Ming to Emperor Puyi, the last emperor of Qing, 24 emperors together with their queens and concubines, lived in the palace. The Xinhai Revolution in 1911 overthrew the Qing Dynasty and more than 2,000 years of feudal governance came to an end. However, members of the court such as Emperor Puyi were allowed to stay in the rear part of the Forbidden City. In 1914, Beiyang government of the Republic of China transferred some of the objects from the Imperial Palace in Shenyang and the Summer Palace in Chengde to form the Institute for Exhibiting Antiquities, located in the front part of the Forbidden City. In 1924, Puyi was expelled from the Inner Court. In 1925, the rear part of the Forbidden City was transformed into the Palace Museum.

Emperors across dynasties called themselves "sons of heaven," thinking that "all under the heaven are the emperor's land; all within the border of the seashore are the emperor's servants"("Decade of Northern Hills, Minor Elegance," Book of Poetry). From an emperor's point of view, he owns all people and land within the empire. Therefore, delicate creations of historic and artistic value and bizarre treasures were offered to the palace from all over the country. The palace also gathered the best artists and craftsmen to create novel art pieces exclusively for the court. Although changing of rulers and years of wars caused damage to the country and unimaginable loss of the court collection, art objects to the palace were soon gathered again, thanks to the vastness and long history of the country, and the innovativeness of the people. During the reign of Emperor Qianlong of the Qing Dynasty (1736–1796), the scale of court collection reached its peak. In the final years of the Qing Dynasty, however, the invasion of Anglo-French Alliance and the Eight-Nation Alliance into Beijing led to the loss and damage of many art objects. When Puyi abdicated from his

throne, he took away plenty of the objects from the palace under the name of giving them out as presents or entitling them to others. His servants followed suit. Up till 1923, the keepers of treasures of Palace of Established Happinesss in the Inner Court who actually stole the objects, set fire on them and caused serious damage to the Qing Court collection. Numerous art objects were lost within a little more than 60 years. In spite of all these losses, there was still a handsome amount of collection in the Qing Court. During the preparation of construction of the Palace Museum, the "Qing Rehabilitation Committee" checked that there were around 1.17 million items and the Committee published the results in the Palace Items Auditing Report, comprising 28 volumes in 6 editions.

During the Sino-Japanese War, there were 13,427 boxes and 64 packages of treasures, including calligraphy and paintings, picture books, and files, were transferred to Shanghai and Nanjing in five batches in fear of damages and loot. Some of them were scattered to other provinces such as Sichuan and Guizhou. The art objects were returned to Nanjing after the Sino-Japanese War. Owing to the changing political situation, 2,972 pieces of treasures temporarily stored in Nanjing were transferred to Taiwan from 1948 to 1949. In the 1950s, most of the antiques were returned to Beijing, leaving only 2,211 boxes of them still in the storage room in Nanjing built by the Palace of Museum.

Since the establishment of the People's Republic of China, the organization of the Palace Museum has been changed. In line with the requirement of the top management, part of the Qing Court books were transferred to the National Library of China in Beijing. As to files and essays in the Palace Museum, they were gathered and preserved in another unit called "The First Historical Archives of China."

In the 1950s and 1960s, the Palace Museum made a new inventory list for objects kept in the museum in Beijing. Under the new categorization system, objects which were previously labelled as "vessels", such as calligraphy and paintings, were grouped under the name of "Gu treasures." Among them, 711,388 pieces which belonged to old Qing collection and were labelled as "Old", of which more than 1,200 pieces were discovered from artifacts labelled as "objects" which were not registered before. As China's largest national museum, the Palace Museum has taken the responsibility of protecting and collecting scattered treasures in the society. Since 1949, the Museum has been enriching its collection through such methods as purchase, transfer, and acceptance of donation. New objects were given the label "New." At the end of 1994, there were 222,920 pieces of new items. After 2000, the Museum re-organized its collection. This time ancient books were also included in the category of calligraphy. In August 2014, there were a total of 1,823,981 pieces of objects in the museum collection. Among them, 890,729 pieces were "old," 228,771 pieces were "new," 563,990 were "books," and 140,491 pieces were ordinary objects and specimens.

The collection of nearly two million pieces of objects were important historical resources of traditional Chinese art, spanning 5,000 years of history from the primeval period to the dynasties of Shang, Zhou, Qin, Han, Wei, and Jin, Northern and Southern Dynasties, dynasties of Sui, Tang, Northern Song, Southern Song, Yuan, Ming, Qing, and the contemporary period. The best art wares of each of the periods were included in the collection without disconnection. The collection covers a comprehensive set categories, including bronze wares, jade wares, ceramics, inscribed tablets and sculptures, calligraphy and famous paintings, seals, lacquer wares, enamel wares, embroidery, carvings on bamboo, wood, ivory and horn, golden and silvery vessels, tools of the study, clocks and watches, pearl and jadeite jewellery, and furniture among others. Each of these categories has developed into its own system. It can be said that the collection itself is a huge treasury of oriental art and culture. It illustrates the development path of Chinese culture, strengthens the spirit of the Chinese people as a whole, and forms an indispensable part of human civilization.

The Palace Museum's Essential Collections Series features around 3,000 pieces of the most anticipated artifacts with nearly 4,000 pictures covering eight categories, namely ceramics, jade wares, bronze wares, furniture, embroidery, calligraphy, and rare treasures. The Commercial Press (Hong Kong) Ltd. has invited the most qualified translators and

academics to translate the Series, striving for the ultimate goal of achieving faithfulness, expressiveness, and elegance in the translation.

We hope that our efforts can help the development of the culture industry in China, the spread of the sparkling culture of the Chinese people, and the facilitation of the cultural interchange between China and the world.

Again, we are grateful to The Commercial Press (Hong Kong) Ltd. for the sincerity and faithfulness in their cooperation. We appreciate everyone who have given us support and encouragement within the culture industry. Thanks also go to all Chinese culture lovers home and abroad.

Yang Xin former Deputy Director of the Palace Museum, Research Fellow of the Palace Museum, Connoisseur of ancient calligraphy and paintings.

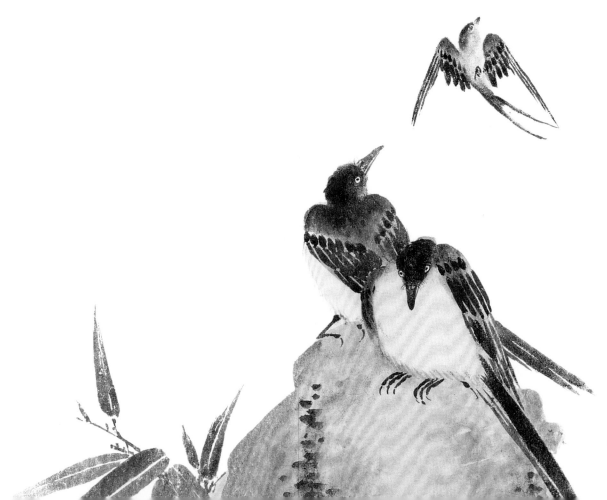

Contents

List of Paintings

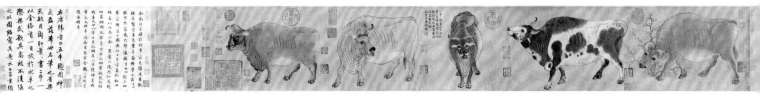

PAINTINGS OF THE LIAO, JIN, AND YUAN DYNASTIES

An Introduction to the Painting Collection of the Early Period in the Palace Museum

YU HUI

In the cultural heritage and museum circles in China, "painting of the early period" is a general expression referring to the works of the Western and Eastern Jin (265–420), Southern and Northern Dynasties (420–589), Sui Dynasty (581–618), Tang Dynasty (618–907), Five Dynasties (907–960), Song Dynasty (960–1279), and Yuan Dynasty (1271–1368). The Palace Museum in Beijing has a collection of more than 50,000 paintings from various dynasties, over 410 of which are works of the early period. These works substantially constitute the basic development of China's painting history of the early

period and has garnered attention from academic circles and the general public alike.

In this volume, the most representative ninety-nine pieces of this collection of early paintings are presented to general readers. They are often used in exhibitions, research, and publications, and nearly each has its own unusual history. With reference to the treasure selected for this volume, this article gives a brief general introduction of the Palace Museum painting collection of the early period in terms of their origin, special features, and their cultural and artistic value.

ORIGIN OF THE PAINTING COLLECTION OF THE EARLY PERIOD OF THE PALACE MUSEUM IN BEIJING

Like other collections in museums, the painting collection of the Palace Museum comes from government acquisitions, transfers from other museums, and donations from the public. What is different is that the Palace Museum in Beijing, being a palace of the Qing Dynasty, hosts the imperial collection of the Qing court, which includes works recorded in two bibliographies of painting and calligraphy: *The Shiqu Imperial Catalogue of Paintings and Calligraphy* and *Catalogue of Buddhist and Daoist Works in the Qianlong Imperial Collection*. The former has a catalogue of 5,610 pieces of calligraphy and painting from various periods, and the latter comprises 1,228 Buddhist-themed pieces. Together, they cover all the imperial works of calligraphy and painting collected from the Qing court.

Imperial Collection just before and after the Fall of the Qing Dynasty

After abdicating in February 1912, Puyi, the last emperor of the Qing Dynasty, still lived in the Inner Court of the Forbidden City, and the works of calligraphy, painting, and other artworks collected by the Qing court continued to be under his custody. Taking advantage of this, he was able to transfer these works out of the palace intentionally and systematically, under the pretext of granting rewards to his brother Pujie, but probably to gather funds for future restoration. He also privately gave these works as gifts to his subordinates, warlords, and Japanese diplomats in order to build up his social connections. To cover up his actions and for the convenience of hiding these works, he smuggled over one thousand pieces of the small but valu-

able hand scrolls and albums of calligraphy and painting of the early period. The eunuchs, who saw what Puyi did, secretly followed suit, making the streets around the Houmen Bridge a busy transaction area. Puyi was irate when the eunuchs' behaviour was exposed, and he ordered an audit of the inventory. As a result, on the evening of 27 June 1923, the eunuchs burnt down Jianfu Palace where the inventory and the works of calligraphy and painting were stored, destroying 1,157 pieces. After the fire, cultural artefacts continued to be stolen until the morning of 5 November 1924, when Beijing Garrison Commander Lu Zhonglin, by order of Feng Yuxiang, forced Puyi, along with his family and servants, to leave the Inner Court immediately, bringing the thefts to an end.

Puyi's looting led to a serious loss of ancient Chinese works of calligraphy and painting. In 1949, these works still had not been returned to the government and some had even been taken abroad. These works were those that could not be taken in the 1933 southward evacuation of antiquities from Beijing, and consisted of hand scrolls and albums of calligraphy and painting of the early period that the National Palace Museum in Taipei did not possess.

The Beiyang government established the Exhibition Office of Ancient Artefacts in 1914, then the Palace Museum in 1925 (the former was merged into the latter in 1946), signaling that the private collection of the imperial court then became public property. After the 918 Incident in 1931, the Japanese wanted to occupy northern China. In spring 1933, the Nationalist Government implemented its southward evacuation plan to transfer a large quantity of antiquities to southwest China, in order to prevent the cultural artefacts in the Exhibition Office of Ancient Artefacts and the Palace Museum from falling into Japanese hands. Restricted by the transportation conditions at that time, large paintings by court artists of the Ming and Qing dynasties were left in the Palace Museum. Also due to time constraint, some works of the early period were left out, such as "Secluded Stream and Cold Pines" by Ni Zan of the Yuan Dynasty (Figure 73), which was packed with ceramics in a box that was left behind and was found only after 1949. Furthermore, limited by the appraisal standard of the time, some paintings of the Song Dynasty were mistakenly assessed and registered as counterfeits, and were left behind in Beiping. For instance, "Listening to the *Qin*"

(Figure 26) of the Song Emperor Huizong, and "Dancing and Singing" (Figure 38) of Ma Yuan of the Southern Song period were wrongly appraised as works by artists of the Ming Dynasty. In addition, some paintings of the Song and Yuan dynasties, which had been hidden by the eunuchs, were recovered after 1949. An example of this is the "Six Reverends" of the Song Dynasty, which was accidentally discovered in a mattress in the Xunyan Study Room located in the northeast corner of the Palace Museum in the early 1950s. The painting had probably been stolen by a Qing eunuch and temporarily concealed there to prevent it from being taken out of the palace. It had become seriously moldy and damaged before it saw the light of day again. These hundred-odd works of calligraphy and painting of the early period and some 90,000 pieces of the Qing court collection of cultural artefacts that were left behind after the southward evacuation constitute the first collections in the Palace Museum in Beijing after 1949.

Collection of Paintings through State Acquisition and Social Donation

The imperial collection of the Qing court and the ancient paintings that were lost from the Qing palace but later returned, comprise about two thirds of the Palace Museum's paintings of the early period. The former constitutes the Palace Museum's first collection of calligraphy and painting of the early period, and the latter encompass important works acquired from the public by the government.

State Acquisition

More than 3,700 pieces of calligraphy and painting of various dynasties have been acquired from the public since 1950 under the State Administration of Cultural Heritage. Among these, there are paintings of the early period such as "The Riverside Scene at the Qingming Festival" (Figure 23) by Zhang Zeduan of the Northern Song period, "Fishing Village after Snow" (Figure 20) by Wang Shen of the Northern Song period, and "Palace in the Pines" (Figure 31) by Zhao Bosu of the Southern Song period.

Nearly every cultural artefact collected by the Palace Museum has an unusual history. For instance, in 1952 the Chinese Government bought "Five Oxen" (Figure 5) by Han Huang of the Tang Dynasty in Hong Kong. In 1953

Zheng Zhenduo, through his social connections in Hong Kong, purchased a batch of valuable cultural artefacts from Zhang Daqian at a low price, including "The Night Banquet of Han Xizai" (Figure 11) by Gu Hongzhong of the Five Dynasties, and "The Rivers of Xiao and Xiang" (Figure 8) by Dong Yuan of the Five Dynasties. "Rest Stop for the Khan" (Figure 53), which was previously said to be painted by Hu Gui of the Five Dynasties, is also a painting with a special background. After it was transferred out of the puppet emperor's palace, the picture became the private property of Zheng Dongguo, commander of the First Army of the Kuomintang. However, after his revolt in Changchun, he surrendered this scroll, which was then handed over to the Palace Museum in 1954.

Donations from the Public

Donations constitute one of the most important ways of acquiring paintings from the public. Some well-known cultural figures and collectors such as Zhang Boju, Xu Zonghao, Shen Zhongzhang, and Ding Xieyou have generously donated their paintings and enormously enriched the Palace Museum's collection. The following works, which are included in this volume, have been donated by them: "Spring Excursion" (Figure 3) by Zhan Ziqian, "Dwelling in the Mountains" (Figure 56) by Qian Xuan, "Tranquil Bamboo and Elegant Rock" (Figure 83) by Gu An, and "Stone Cliffs and Heavenly Lake" (Figure 68) by Huang Gongwang.

FEATURES OF THE PAINTING COLLECTION OF THE PALACE MUSEUM

The Palace Museum's collection of ancient Chinese paintings can be considered as the best in the world, in terms of both quantity and quality. It is important for a museum to have a considerable amount of cultural artefacts, but it is even more important to let people know what it owns. If a museum wants to have a complete record of how painting developed in ancient times, its painting collection must be comprehensive, systematic, and classic.

The Palace Museum has a comprehensive collection of paintings, which is demonstrated in its excellent storage of masterpieces of different periods and areas, and in its balanced distribution in the number of paintings collected. This collection represents the artistic achievement of ancient Chinese painting in various periods of history, cultural regions, schools of painting, and types of painters' status. For instance, dozens of paintings of the Jin and Tang dynasties and their copies reproduced in the Song Dynasty are generally recognized by scholars of fine arts history as authentic works handed down from ancient times, and are regarded as unique treasures of Chinese painting of the early period. Other examples include masterpieces of Dong Yuan of the Jiangnan School of landscape ink painting of the Five Dynasties and works of the Northern School of landscape painting, such as those by Guo Xi and Wang Shen, landscape paintings depicting the petty scenes of Jiangnan of the Northern Song period, and works of the "Four Masters of the Southern Song Period." Also collected in the Palace Museum are extant works by Wei Xian and Ruan Gao of the Five Dynasties, Zhao Shilei, Li Gonglin, Zhang Zeduan, and Wang Ximeng of the Northern Song period, and Ma Yunqing and Zhao Lin of the Jin Dynasty (Jurchen, 1115–1234). The collection of paintings of the period from the Yuan to the Qing dynasties includes works by most of the painters of that time. It even has works by excellent artists with superb techniques but whose names have not come down in history, such as those by Li Dong of the Southern Song period, Zhao Lin of the Jin Dynasty, and Chen Jizhi and Xue Jieweng of the Yuan Dynasty. With such an extensive coverage, the collection is complete and comprehensive. The Palace Museum's holdings can be acclaimed as an encyclopedia of achievements in painting in various periods of the Chinese history.

The Palace Museum's painting collection is systematic as it contains works of various genres and techniques. There is a large number

of paintings of both primary genres, including landscape, flower-and-bird, and figure, and secondary genres such as tower, pavilion, grass-and-insect, and portrait. As to painting techniques, the collection has representative works at different development stages of these techniques, such as outline drawing, blue-and-green, ruled-line painting, elaborate painting, and small and large freehand styles. The collection in the Palace Museum can be easily classified into dozens of such thorough and systematic painting series. Its scale of storage can be considered as an encyclopedia of the history of Chinese painting.

The painting collection of the Palace Museum is classic in view of its incorporation of great works by masters of various dynasties and periods, showing the inheritance and development of Chinese painting. The masterpieces produced by dozens of great artists in the history of ancient Chinese painting have been collected in the Palace Museum. These works are the shining points of the Chinese painting history. Joined into a development route of art based on artists' observation and presentation experience, they practically constitute the better part of the history of ancient Chinese painting. The Palace Museum's collection can also be acclaimed as an encyclopedia of classic paintings by masters of different dynasties.

The Palace Museum's painting collection is comprehensive, systematic, and classic. Together, these qualities embody its "hard power." However, in order to bring this "hard power" into full play, it relies on its "soft power" – the standard of interpretation. When looking at the ancient paintings, scholars of different expertise will have different opinions due to their different viewpoints. Historians are mostly concerned about the rise and fall of the dynasties; aesthetes appreciate the beauty of the works; artists attend to the artistic skills and techniques, and appraisers establish the authenticity of individual paintings. However, what would the largest audience – the general public – observe? In fact, the public would be interested in knowing the opinions on all the aspects mentioned above. To achieve this, the views of the appraisers, aesthetes, artists, and historians need to be integrated and passed on to the public in a way that is easy to understand. Perhaps this may be one of our original intentions to compile this series.

ARTISTIC CONNOTATIONS OF THE PALACE MUSEUM'S PAINTING COLLECTION OF THE EARLY PERIOD

Generally speaking, Chinese painting began in the Spring and Autumn and the Warring States periods. Jin and Tang was a stage of gradual maturity; Song and Yuan was a period of deepening and transformation; and Ming and Qing was a period during which ideas flourished, works abounded, and schools were formed. Artists of various dynasties inherited the traditional culture and dedicated themselves to it persistently, absorbing at the same time the cultural essence of different nationalities. Such cultural inheritance and development have been passed down to the present. With the help of the works selected for this volume, we will briefly describe below the artistic connotations of the Chinese paintings of the Jin, Tang, Song, and Yuan dynasties.

The Charm of the Paintings of the Period from the Jin to the Tang Dynasties

The Jin and Tang paintings were at an important stage where paintings of ancient China were moving towards maturity. The paintings of that period needed to find a way that they could become an instrument for the rulers and how they could achieve their entertainment function. With respect to composition, what they needed to solve was how to use lines, how to express time and space, and how to use simple colours to represent objects. In the Eastern Jin period, painting shifted from being the art of the craftsmen to the art of the officials. Painters conscientiously appreciated nature and art, and this period also marks the

maturity of rolled paintings, which became artworks to be appreciated and collected by the upper class of the society.

Gu Kaizhi is representative of the official-painters of that time. His extant works "Ode to the Goddess of the Luo River" (Figure 1) and "Exemplary Women" (Figure 2) display the stylistic features of the Wei-Jin paintings. The characters in these two paintings have basically the same expression and spirit, manifesting the so-called "demeanour of the Wei and Jin dynasties," which focuses on a person's spiritual ease and freedom. In the "Ode to the Goddess of the Luo River," cavalier perspective is employed to represent the background space. The disproportion of "a figure being larger than a mountain" that exists in the painting illustrates one more feature of Wei-Jin painting. It is specially worth noting that blue and green are the predominant colours in "Ode to the Goddess of the Luo River," marking the beginning of the blue-and-green landscape painting of the early period.

In turn, "Spring Excursion" (Figure 3) by Zhan Ziqian of the Sui Dynasty keeps on the one hand certain stylistic features of the Wei-Jin painting, whereas on the other it puts an end to the awkward way of landscape painting in which "water does not overflow even when it is higher than its banks and a figure is larger than a mountain," and enters into the age where "the charm of a thousand miles is manifested in a foot." This can be inferred from the progress that has been made in the representation of space in the landscape painting of the early period.

Besides their artistic quality, Tang paintings also stressed the political functions they played. The most representative work is "Emperor Taizong Receiving the Tibetan Envoy" (Figure 4) by Yan Liben. This work truly presents the real state of early-Tang painting. It uses iron-wire strokes and simple colours to record the scene in which the Tibetan King Songtsen Gampo sent mGar Stong Rtsan Yul Zung (Lu Dongzan) to travel thousands of miles to the Tang capital Chang'an to seek a marriage alliance with Li Shimin, Emperor Taizong of the Tang Dynasty. The artist paints nothing but an eunuch in white clothes, which clearly indicates that the event has taken place at the rear palaces. The artistic feature of "intuition" in Chinese painting is on full display here.

The "Five Oxen" (Figure 5) by Han Huang, a minister during the reign of Emperor Dezong of the Tang Dynasty, paints five oxen in a row, indicating the gradual maturity in the technique of horizontal distribution of objects in hand scrolls. The plain and simple style of this artwork represents the aesthetic concept of pursuing simplicity in the agricultural society in the mid-Tang period, and this concept has influenced the painting of the elite of society.

Southern and Northern Song Dynasties — Ways of the World

With the social, economic, and cultural developments of the Southern and Northern Song period and the active participation of the royal family in artistic activities, painting entered into a time of unprecedented growth. Various rules on traditional Chinese painting were established, the imperial institution for painting management, Imperial Painting Academy, was further enhanced, and different types of aesthetic concepts of the imperial court, scholars, and the common people matured in this period. More importantly, artists were more strongly inclined to use painting to reflect reality of society more deeply and accurately, and express their thoughts and feelings more strongly and profoundly.

Five Dynasties — The Prelude

The development of painting in the Five Dynasties and Ten Kingdoms period (907–979) in many aspects paved the way for this art to prosper in the Song Dynasty. In this period, the Southern Tang (937–975) was the region where painting was most developed.

"Noble Scholar" (Figure 7) by Wei Xian, a court artist of the Southern Tang, tells the story of Liang Hong and his wife Meng Guang of the Han Dynasty who respected each other as if the other were a guest and held the tray level with the eye. The artist in fact emphasizes more on the living environment of a hermit rather than the couple in the painting, reflecting the mental state of the scholars in the Five Dynasties who aspired to live in reclusion in the time of turbulence. "Playing Go in Front of a Double Screen" (Figure 10) by Zhou Wenju, also a court artist of the South-

ern Tang, employs a shaking brushstroke which the artist is good at to depict the folds and texture of the characters' clothes, and uses the conceptions of "painting within a painting" and "screen within a screen" to open up a new vista. It is worth noting that this work also contains a political message which is quite unusual. In the picture, Li Jing, the second ruler of the Southern Tang, sits with his younger brothers to play a game of go. This actually serves as a political message from the ruler: he will pass the throne to his younger brother in order to avoid fighting among brothers. Another work of art that is concerned with court politics is "The Night Banquet of Han Xizai" (Figure 11) by Gu Hongzhong. This painting is a work that was commissioned by Li Yu, the third and last ruler of the Southern Tang, who ordered the artist to secretly enter Han's house at night to watch Han's activities, and then record his debauchery in a painting, which Li Yu could then use to admonish Han to mend his ways. In the area of landscape painting, "The Rivers of Xiao and Xiang" (Figure 8) by Dong Yuan, a landscape painter of the Southern Tang, may be said to be the seminal ink-wash landscape painting of the Jiangnan style. The picture simply uses ink dots to touch up the Jiangnan misty hills, which has a far-reaching influence on later generations. Furthermore, "Fairies of the Celestial Realm" (Figure 12) by Ruan Gao, a painter of the Kingdom of Wuyue, is utterly a masterpiece made for aesthetic purposes. The richly endowed and slim figure of a lady shows the transition of modelling from the Tang Dynasty to the Song Dynasty.

Northern Song Period — A Great Change

Painting entered into a stage of artistic maturity in the Northern Song period. New changes continuously arose in various painting genres. On the basis of expressing the ways of the world, artists were increasingly prone to express their thoughts and ideas through their works.

There was a significant artistic transformation in the way of presentation in Northern Song painting. From macroscopic display of the whole scene to microscopic depiction of details, dramatic development and changes occurred. For instance, in both "Grazing and the Landscape" (Figure 18) by Qi Xu and "Winter Sparrows" (Figure 16) by Cui Bai, animals are put in the specific seasons, and the echoes and connections among them are described in a touching manner.

In the middle and late period of Northern Song, the neat and realistic academy style of painting was further enhanced. Painter had a better observation of the nature, and the creative idea of expressing feelings and thoughts advocated in the literati painting gradually gained wider acceptance. Landscape painting made considerable progress in depicting the subtle changes in different seasons. For instance, "Rocks in the Distance" (Figure 17) by Guo Xi uses the technique of level distance to describe the scenery of early autumn. The composition is not complicated but the realm is vast and magnificent. The "three distances" principle (high distance, deep distance, and level distance) in the composition of landscape painting was first put forward by Guo Xi, which had a far-reaching impact on the development of this genre in later generations. "Fine Snow on Reedy Sandbanks" (Figure 19) by Liang Shimin and "Fishing Village after Snow" (Figure 20) by Wang Shen are both refined and delicate works illustrating scenes of poetic bearing. The artists composed these winter landscape paintings under the influence of the ideas of Su Shi and Mi Fu in literati painting. "The Riverside Scene at the Qingming Festival" (Figure 23), a masterpiece of this period, is a representative ancient genre painting of the highest artistic achievement and showing the most in-depth understanding of society. By depicting the flourishing business scenes of Northern Song's capital Bian Liang (present-day Kaifeng) at the Qingming Festival, the artist reveals the corrupt situations of society at that time in order to alert Emperor Huizong of the reality. "Painting after Wei Yan's Pasturing Horses" (Figure 21) is the only generally recognized authentic work by Li Gonglin. It is a great work of art integrating ancient painting techniques with his personal style of natural ease and grace. Song Emperor Huizong was an outstanding artist who was good at both calligraphy and painting. His aesthetic taste and artistic pursuits had a significant impact on the painting development of the time, or even court painting of Southern Song. "Auspicious Dragon Rock" (Figure

24) reflects his conception of praying for a prosperous country through drawing an auspicious symbol. His other works, including the "Golden Pheasant and Cotton Rose Flowers" (Figure 25) and "Listening to the *Qin*" (Figure 26), are neat and realistic, representing the artistic climax of the Academy style of painting. "A Thousand Miles of Rivers and Mountains" (Figure 27) by Wang Ximeng of the late Northern Song period and "Rivers and Mountains in Autumn Colours" (Figure 28) by an anonymous painter are not only classic masterpieces of the Northern School that adopt panoramic compositions to present the magnificent and grandiose mountains and rivers, but also the most successful blue-and-green landscape paintings of the Northern Song. In the early period of Southern Song, a descendant of the imperial family Zhao Bosu tuned the elegance and gentleness of literati painting to the blue-and-green style, creating a new impressive mode of the art.

Southern Song Period — A New Trend

No rulers in Southern Song was as good at the art of painting as the Northern Song Emperor Huizong. It is for this reason that the development of painting in this period was freer and more profuse without the arbitrary personal influence of a ruler.

Li Tang was one of the last artists of the Northern Song court painting as well as a pioneer of the academy style of Southern Song. The seminal work of his Southern Song painting "Gathering Wild Herbs" (Figure 34) is about the allusion of Bo Yi and Shu Qi, noblemen of the Shang Dynasty, who were determined not to eat any crop planted in the territory of the Zhou Dynasty after the fall of the Shang Dynasty. The picture serves to encourage the painter himself for his will to be loyal to the Song Dynasty. Such patriotism and concerns about current politics became the soul of figure painting of this period. For instance, "A Mass of the Blind under the Willow Shade" (Figure 51) by an anonymous painter, which portrays several blind people fighting, actually satirizes the Southern Song court which is engaged in meaningless internal strife in the face of fierce foreign enemies.

In Southern Song, with the upholding of Confucianism as the orthodox ideology by Neo-Confu-cian scholars such as Zhu Xi, paintings expounding the moral concepts of Confucianism and Daoism emerged, giving birth to a series of figure paintings that praise the Confucian moral concepts, such as "The Ladies' Classic of Filial Piety" (Figure 49) and "Confucius' Disciples" (Figure 50).

The composition of landscape painting of the Southern and Northern Song dynasties shifted from a macroscopic panoramic view to a microscopic partial view, concluding the evolutionary aesthetic process of moving from the magnificent north to the elegant south. To a certain extent, this is related to the political, cultural, and geographical changes arising from the move to the south of the Song court after the Jinkang Incident, and the court had to be content to exercise sovereignty over a part of the country in Jiangnan. This turning point in painting also started from "Gathering Wild Herbs" by Li Tang: the painter switched from a panoramic composition with huge mountains and great rivers to a composition of a sectioned scenery, which means that landscape painters in Southern Song started to pay attention to the observation of the natural objects from the best part. In brushing and wrinkling, Li Tang used thick brush, heavy ink, and slant rubbing to do the great axe-cut wrinkles, which changed the reserved painting method of small axe-cut wrinkles. Li Tang, Liu Songnian, Ma Yuan, and Xia Gui are collectively known as the "Four Great Masters of the Southern Song Dynasty." They are the propagators and inheritors of this approach of painting. The "Landscape of the Four Seasons" (Figure 35) by Liu Songnian is dedicated to the scenic spots around the area of the West Lake, whereas the "Dancing and Singing" (Figure 38) by Ma Yuan focuses on a green belt of Jiangnan after the spring rain. These are typical creative works that pay attention to partial scenes and objects.

Small round paintings and rectangular albums in Southern Song were mostly produced by well-known painters, leaving important marks on the history of Chinese painting. For instance, the "Plum Tree, Rock, Stream, and Mallards" (Figure 39) by Ma Yuan showed the artistic trend of integrating flowers, birds, and landscape that was popular in Southern Song. However, the half-side beautiful scene in the "Remote Mountains in

the Mist and Clouds" (Figure 41) and the misty view in snow in the "Friends Chatting in a Snowy Weather" (Figure 42), both by Xia Gui, and the birds startling at the moon in the "Autumn Willow and Double Crows" (Figure 46) by Liang Kai, all revealed that the aesthetic trend of landscape painting in the middle and late Southern Song period focused on the charm and spirit of coldness and solitude. At the same time, the "Ripe Fruits and Bird" (Figure 36) by Lin Chun and "Lotus Flower Breaking the Surface" (Figure 45) by an anonymous painter were not confined to the skills of depicting the realistic scenes and objects, they also brought the aesthetic feelings of fine-brush flower-and-bird paintings to the sublime level.

The brushing and spirit of literati paintings are embodied in a more striking and personalized way in "Four Views of the Flowering Plum" (Figure 30) by Yang Wujiu and "The Spectacular Views of the Rivers of Xiao and Xiang" (Figure 29) by Mi Youren. The aesthetic concept of pursuing serenity and freedom in ink brushing in literati painting was getting more mature at the turn of the two periods of Song Dynasty and was increasingly influential until the last years of Southern Song when it flew into Zhao Mengjian's "Orchids in Ink" (Figure 48).

In sum, the painting style in the Song Dynasty was closely related to the blood relationships of a family and the common origins of a school of painting, which formed three major types of painting, namely court painting, literati painting, and non-official artisan painting. They strengthened the power of distribution of the traditional paintings and exerted their influence on painters of many generations.

Yuan Dynasty — Diversity

The Yuan Dynasty unified China and put an end to its some 400 years of separation since the late Tang period. At the same time, it also further opened up China's door to the world. Cultures of different nationalities flowed into all levels of Yuan society, co-existing and integrating with each other. Yuan emperors, such as Emperor Renzong (1312–1321), were enthusiastic about painting, and the imperial court did not restrict official or non-official artists to any specific aesthetic ideology, making it possible for painting to be diversified in contents, form, and style, and for different genres of painting to have an equal opportunity for development.

Pioneers — Qian Xuan and Zhao Mengfu

Qian Xuan and Zhao Mengfu were pioneers of Yuan literati painting. Both were natives of Huzhou (present-day Zhejiang). Qian led a life of seclusion after the fall of the Song Dynasty. Zhao Mengfu, being a descendant of the Song imperial family, sometimes served as an official of the Yuan Dynasty or lived as a hermit, enjoying esteem within and without the imperial court. In Jiangnan, these two artists advocated the ideology of incorporating "clerical script," "spirit," and "classic elegance" into painting. Their paintings were executed in the elaborate and delicate brushwork style of the Jin and Tang dynasties, infused with the literary charm of leisure and elegance. Zhao Mengfu further enhanced the trend of literati freehand painting of the Northern Song, exerting a great influence on the painting art of his family and the "Four Masters of the Yuan Dynasty."

Qian Xuan's superb painting technique demonstrates what ability and accomplishments a literati painter must have when doing realistic painting. Employing the techniques of the Tang artists to paint his landscape masterpiece "Dwelling in the Mountains" (Figure 56), he used double outlines filled with blue and green without the loss of elegance. In his representative flower-and-bird work "Eight Flowers" (Figure 57), he portrayed the actual flowers in detail and used light pale colours to fill the painting with grace and delicacy.

Zhao Mengfu not only enhanced the artistic strength of literati painting in Jiangnan, but also brought this art to the imperial court. The Palace Museum has collected more than 10 masterpieces of Zhao Mengfu, giving a real account of his artistic achievements at different times and in different genres. In the "Bathing Horses" (Figure 59), one of his most characteristic paintings on men and horses, Zhao Mengfu meticulously portrays the horses' psychological change before and after their entering the pond. At the same time, he skilfully integrates rich colour favoured by the Mongolian nobility with the

refined elegance of scholars. His "Water Village" (Figure 60) depicts a long range of flat hills being encircled by a stretch of clouds and water, producing a sense of vastness, quietness, and coldness. It establishes his artistic style of using dry brush and light ink to represent landscapes, and it becomes the work that Zhao Mengfu made the greatest impact on later generations. His wife Guan Daosheng and his son Zhao Yong were also good at painting. Their knowledge and skills could be seen from the "Three Bamboo Paintings of the Zhao Family" (Figure 62) and "Hunting on a Horse" (Figure 63) in this volume.

Superb Techniques of the Four Masters

The Four Masters were Huang Gongwang, Ni Zan, Wang Meng, and Wu Zhen. Being famous literati painters of the Yuan Dynasty, they did not use Zhao Mengfu's refined and delicate brushwork of the pro-Tang style. Instead, they were directly or indirectly influenced by his freehand painting. In the latter period of the Yuan Dynasty they became the core figures of the literati painting circle in Jiangnan. However, their painting style varied when examined in detail.

Huang Gongwang was especially good at landscape painting. He was skilled in employing dry brushwork and light ink to portray the Jiangnan landscape. His works give the feeling of boldness, elegance, and freedom, and exude an air of being gentle, carefree and unrestrained. As a core artist of the Four Masters of the Yuan Dynasty, Huang Gongwang can be seen as the originator of many schools of literati painting of the Ming and Qing dynasties. His great works, such as "Stone Cliffs and Heavenly Lake" (Figure 68) establish the basic features of light purple red landscape and long hemp-fibre wrinkles. Trees and tall pines in this work are vividly drawn with unrestrained and delicate strokes, creating a scene with rich contents and a painting done by simple brushstrokes. The painter also shades and dyes with faint umber and flowery green, making the painting freer, more natural, spacious, and elegant. Huang Gongwang's snowy landscape painting is unique in style. The "Nine Peaks after Snow" (Figure 69) depicts the nine famous Daoist mountains in Songjiang (present-day Shanghai). Light ink is used to set off the snowy sky,

leaving the peaks blank to show that they are covered by snow. The strokes used for painting the mountain rocks and trees are precise and fluid, showing that the artist is a devout believer of the Quanzhen School of Daoism.

Ni Zan's painting has a simple, quiet, and solitary tone. He at first modelled on Dong Yuan and Ju Ran of the Five Dynasties and Mi Fu of the Northern Song. Later he succeeded Huang Gongwang, and most of his paintings depicted the gentle slopes, flat rocks, scattered trees, and distant mountains of the Taihu Basin. Ni Zan created the bent-ribbon wrinkles. The tracks of his brush are like folded belts, representing the lines on the rocks scored out by the lake water of Taihu. In addition, his paintings never depict decorative figures, revealing his determination to keep himself away from mundane matters. "Secluded Stream and Cold Pines" (Figure 73) is a masterpiece of Ni Zan's later years. He does not use "one river and two banks" pattern, but employs an eyelevel view to present different distances clearly. The whole picture uses very simple brushwork imparting a pale and sombre tone, from which the beauty of grace and elegance is revealed through its clean, tranquil, and delicate atmosphere. It is one of the best works of its kind. Ni Zan also liked to draw bamboos in ink to encourage himself to keep to the principles and moral integrity of a scholar. For instance, "Parasol Tree, Bamboo, and Elegant Rocks" (Figure 72) depicts a Chinese parasol tree and two thin bamboo trees among some rocks. The bamboo leaves are drawn by simple strokes, so that they merge well with the Chinese parasol tree into one single entity.

Wu Zhen's brushwork is simple and moist with the sombre and majestic effects. He did not imitate the style of his predecessors, but evolved his own unique artistic way of expression. The theme of his landscape painting was mainly about daily life and the activities of fishermen, such as their drifting a boat on the river and fishing. His works were usually in ink and rarely in colour. He excelled at painting water to achieve a moist and natural effect. His works generally consist of three types: (1) one river and two banks; (2) rivers, lakes, and flat slopes; and (3) rough or towering cliffs. Take the "Seclusion amid Mountains and

Streams" (Figure 70) as an example. Its composition is dense but uncluttered. The artist uses long hemps to wrinkle out the towering mountains and not a single gap is left on the slopes. The work not only represents the geologic characteristics of the earthen mountains in Jiangnan, but also expresses the painter's wish to lead a simple and easy life. Wu Zhen was also fond of drawing bamboos in the wild and bamboos in the wind. He drew the branches carefully and the leaves neatly with down-strokes. Sometimes his brushwork of bamboo leaves appears like cursive script, and it is as if one can hear the rustling of the leaves; his painting "Withered Wood, Bamboo, and Rock" (Figure 71) is a typical example.

Wang Meng's painting has a lush and profound tone with the charm of vastness and delicacy. Wang, a maternal grandson of Zhao Mengfu, inherited the soft and restrained style of the family. His wrinkling is resourceful, combining the techniques of Dong Yuan and Ju Ran of the Five Dynasties and Li Cheng and Guo Xi of Northern Song. He specialized in using the soft, loose, and smooth-hanging cattle-hair wrinkles and unravelled-rope wrinkles to draw the range upon range of earthen mountains in Jiangnan. In his creative painting, Wang Meng often presents the abstract with the real. His composition is meticulous and full, dense but cluttered, depicting vividly the wet weather and the vitality of the luxuriant grass and trees of Jiangnan in summer. For instance, "Lofty and Secluded Mountains in Summer" (Figure 74) is painted with meticulous strokes. It is compact and sombre, and there is verdant vegetation throughout as the mountains are covered with green plants in midsummer. "Ge Zhichuan Relocating" (Figure 75) is a rare work in colour by Wang Meng. It depicts the story of Ge Hong, a scholar of Eastern Jin, who moved with his family to Luo Fu Mountain in Guangdong to make pills of immortality and to practise Daoism. The artist uses dry ink and thirsty brush to draw cattle-hair wrinkles and unravelled-rope wrinkles, and dye the painting with light ink and green umber, showing moist in thirst.

Major successors of the Four Masters of the Yuan Dynasty were Ma Wan, a disciple of Huang Gongwang, and Zhao Yuan, whose brushwork was influenced by Wang Meng. Zhao Yuan had the greatest impact on painting circles and was held in high regard by his contemporaries. Looking at his "Trees and Rocks" (Figure 77), you can see that his reputation was well deserved.

Successors of Ink Play of Cloudy Mountains

"Ink play of cloudy mountains," also known as the "Cloudy Mountains of the Mi Family," was introduced by the Mi family (Mi Fu and his son Mi Youren) of the Song Dynasty. It was common in the Jin Dynasty and became even more popular in the Yuan Dynasty.

Gao Kegong, whose ancestors were from Uihur in the Western Regions (present-day Xinjiang Uygur Autonomous Region), was a famous minority painter in the Yuan Dynasty who mainly followed the Mi Fu style of landscape painting. "Spring Clouds and Morning Mist" (Figure 78) in this volume is a work in Mi style, in which Gao uses the Mi technique of dotting rainy mountains to represent the high peaks and large mountains of the north. Fang Congyi (1302–1393), a Daoist of Jiangxi who enjoyed equal fame with Gao Kegong, interpreted the Mi-style cloudy mountains from a Daoist's point of view and applied Mi's painting skills in a more natural and unrestrained way. For instance, his "Rowing by Mount Wuyi" (Figure 86) is full of wildness and lofty spirit. He adopts the "chaotic firewood wrinkles" to paint wrinkles on the mountaintop, which has in many respects gone far beyond the bounds of the Mi style of landscape painting.

Successors of the Li Cheng-Guo Xi and the Style Inherited from Southern Song

The landscape paintings of Li Cheng and Guo Xi of the Northern Song emerged in Jiangnan alongside the rise of the literati painting style of the Yuan Dynasty. Many of their works reveal the ideal life and scholarly sentiment of the hermits in Jiangnan.

Representative painters who inherited the style of Li Cheng and Guo Xi included Zhu Derun and Cao Zhibai. They were rich and prominent people in Jiangnan and also had close contacts with wealthy and influential families like those of Ni Zan and Gu Ying, forming a rather stable painter group, and the

theme of their works often described their literary activities. The "Pavilion of Elegant Plain" (Figure 79) was a late masterpiece of Zhu Derun, employing bold and unrestrained brushstrokes to present a free, delicate, and sophisticated spirit. The landscape painting of Cao Zhibai is, on the other hand, clear, graceful, and elegant. For instance, his "Sparse Pines and Secluded Cliffs" (Figure 80) focuses on the shape and structure of a mountain, omits the details, and leaves much space blank, showing in full the sparse, simple, green, and elegant appearance of the mountain.

Besides Zhu and Cao, successors of Li Cheng and Guo Xi also included Yao Tingmei, Zhang Guan, and Wu Zhizhong, and rare editions of their works are also collected in the Palace Museum. Due to limited space, details of their works will not be discussed here.

The scholars in Jiangnan used brushes and ink to express their feelings and understanding of life and nature. Under the influence of a number of factors, such as their common interest in art, their common living area, and close aesthetic values, the successors of Li Cheng and Guo Xi and those of the Four Masters of the Yuan Dynasty jointly developed the Wu School of painting which enjoyed great popularity in the Ming Dynasty. It could also be said that the Wu School, as a representative of painting circles in the Ming Dynasty, to a greater extent inherited the brushwork of the Yuan artists.

Elegance of Plum and Bamboo Painting

Artists in the Yuan Dynasty painted bamboos in two ways. The first was to paint double outlines that would be filled with colours and in a neat and realistic manner. Two of the painters who followed this technique were Li Kan and his son. For instance, in "Bamboo in the Rain" (Figure 81) Li Kan employs the method of double outlines to be filled with green to give a vivid portrait of the raindrops that seemed to be on the slightly slanting bamboo culms and drooping leaves. The second way consisted in freehand ink painting, as in the "Bamboo Painted at Qingmi Chamber" (Figure 82) by Ke Jiusi of the late Yuan Dynasty. He imitates the style of Wen Tong of the Northern Song by drawing the background in light ink and the surface in dark ink, and runs his brush very dexterously. Another artist, Gu An, also "switched" from his scripts for calligraphy to brushstrokes for ink bamboos. His ink bamboos were much more natural and vivid than those of Ke Jiusi. He regularly drew newly-grown bamboos which were always full of vigour.

Wang Mian, who excelled in painting plum blossoms, imitated the style of the Monk Huaguang and Yang Wujiu of the Song Dynasty. He pioneered "the use of rouge in boneless painting" and also in "the dense style of plum painting." His "Plum Blossoms" (Figure 84) does not have dense flowers or branches, but just a twig of dark ink plum stretching across the paper. The branch is stiff and forceful, only with dots of petals representing the plum blossoms. The dark ink dominates the whole picture, giving the painting a sense of extreme coldness, revealing the strong artistic character of the painter.

Meticulous — Style of Ink Wash Flower-and-Bird Painting

A new language of ink wash realism emerged in flower-and-bird painting circles in the Yuan Dynasty. The artists modelled their paintings on the splendid and refined artistic style of Huang Quan and his son of the Kingdom of Western Shu of the Five Dynasties, and used creative and meticulous brushstrokes and light colour washes. What marks the difference is that the Yuan artists employed multiple levels of thick and thin ink to represent the colourful world of flowers and birds. This includes the aesthetic preference of scholars for elegance, delicacy, and refined beauty. This method could be called "ink wash fine brush." An outstanding representative of this school was Wang Yuan, who was excellent at using both meticulous and freehand styles in light ink for wrinkling and dyeing flowers, bamboos, and birds. For instance, "Peach, Bamboo, and Golden Pheasants" (Figure 85) in this volume uses neat and orderly double outlined lines and ink wash wrinkling. Various levels of ink with both bold and fine brushstrokes are applied to achieve a free style out of steady brushstrokes.

Outline Painting, Ruled-line Painting, and Court Painting

The key technique for figure painting and ruled-line painting (boundary drawing) in the Yuan Dynasty involved using simple clear lines in a single colour to draw the shapes. Some figure and ruled-line paintings were filled with bright colours, which play an important role in the court paintings of the time.

Ren Renfa, a water conservation specialist and painter, had the scientific thinking of pursuing the truth in a serious manner, and this was of enormous help to bring his talent of painting to full play in a realistic way. Ren Renfa served the court for a long time, so he knew officialdom thoroughly. His "Two Horses" (Figure 65) shows a fat horse and a thin horse, and the intention is to satirize the corrupt officials "who fatten themselves but impoverish many people" and praised clean honest officials "who impoverish themselves but fatten the whole country." His son Ren Xianzuo painted "Man and Horse" (Figure 66), successfully showing the same spirit of his father with even freer brushstrokes.

Wang Zhenpeng was a representative court artist of the Yuan Dynasty. His foremost work is "Boya Plays the *Qin*" (Figure 87), where he depicts in detail the shape and movements of Boya so as to reflect his own inner world. The artist does not paint high mountains or flowing water in the background, so the painting leaves more room for the imagination. Wang Zhenpeng's painting activities in Jiangnan in his early years influenced masters in ruled-line painting, such as Xia Yong and Zhu Yu, to name but a few. For instance, Xia Yong in "Yueyang Tower" (Figure 89) uses precise shapes and rhythmic lines to infuse the towers and pavilions with creative life.

Other court painters made their achievements in their own ways. Shang Qi in his "Spring Mountains" (Figure 90) depicts the rocky peaks of Mount Taiheng and its extension in the north by blending ink and wash with some green-and-blue to bring out the refined and elegant aura of intellectuals. Zhou Lang painted "Lady Du Qiu" (Figure 91), a female character in the *Poem of Lady Du Qiu* by the Tang poet Du Mu, and this painting is an extension of "Zhou's version" of the Tang Dynasty. Influenced by the style of line painting of Li Gonglin of Northern Song, Zhou Lang's brushstrokes pause or transition forcefully, and are smooth, and moist.

Outline painting was a unique modelling language of the commoner figure painters. In "A Meeting to Form an Alliance at Bianqiao" (Figure 92), Chen Jizhi of the North depicts the story of a meeting between Li Shimin, Emperor Taizong of Tang, and Jiali Khan of Turkey at Bianqiao to form an alliance. Chen's outline painting is vivid, lively, fluid, and free. Wang Yi, a Jiangnan artist, wrote the *Key to Portrait Painting* in which he detailed his painting experience and techniques. His most illustrative figure painting was "Portrait of Yang Zhuxi" (Figure 93), in which Yang's face is painted with slight light wrinkling and rubbing, and touched up with dissolved ink, showing evocatively the expression and lofty spirit of the character.

Works of Artisans

The folk artisans and literati painters who were scattered about in Jiangnan had artistic connections and they showed their abilities in different areas. One example is "Boating around Spring Mountains" (Figure 64), the only extant work of Hu Tinghui, a renowned expert in repairing and mounting paintings in Jiangnan. The work first outlines with wire strokes, fills them with colour, and maintains many ancient techniques of the blue-and-green landscape painting of the Tang Dynasty, which has great significance for the verification of the landscape painting of the early period. The realistic skills in the painting "Hawk and Juniper" (Figure 94) by Xue Jieweng and Zhang Shunzi surpass those of the Song painters. The work is neat but not too elaborate and fine but not vulgar, which shows the standard of realistic painting in the fine-brush flower-and-bird painting of the Yuan Dynasty. Another artisan was Sheng Mao, who enjoyed great reputation at that time and whose works were much sought after by the common people. Sheng Mao's reputation fell behind that of Wu Zhen because Dong Qichang of the Ming Dynasty highly praised the latter. As seen from "Waiting for the Ferry on the Autumn River" (Figure 95) in this volume, Sheng Mao had good painting skills and shone at the use of colour. What he lacked was the aura of a scholar.

Rich and Vivid Religious Paintings

The Yuan Dynasty adopted a policy of placing equal emphasis on various religions, making it possible for the independent development of paintings on Chinese Buddhism, Tibetan Buddhism, and Daoism.

Yan Hui's "The Immortal Li Tieguai" (Figure 96) presents a Daoist theme. Under his bold brushstrokes, Tieguai Li (an alias of the Immortal Li) has a pair of threatening and thought-provoking eyes that detest the world and its ways. Many Buddhist-themed paintings by anonymous artists, such as "Lifting the Overturned Alms Bowl" (Figure 99) and "Guanyin with a Fish Basket" (Figure 97), to name just a few, represent the artistic styles of two different types of religious scroll painting of the Yuan Dynasty. The former is particularly delicate and refined with details, belonging to the style of murals in temples. The latter is simple and pleasing, being typical of the Zen painting of the Yuan Dynasty. The brushwork of "Seven Buddhas Preaching Buddhism" (Figure 98), a mural in the Xinghua temple in Jishan, Shanxi, is most meticulous, elegant, and delicate, representing the highest artistic achievement in the graceful and dignified murals of the Shanxi region of the Yuan Dynasty.

Overall, freehand literati painting was a new artistic trend of the Yuan Dynasty, and both fine freehand and rough freehand styles existed in literati painting. Artists of the Yuan Dynasty surpassed their predecessors in many techniques for realistic painting, such as elaborate strokes with rich colours, detailed strokes in water and ink, and outline painting. At that time dozens of treatises and illustrated books on painting and painting techniques emerged to explore ways to represent objects elaborately and precisely. These features of Yuan painting are closely related to the rapid advances of science in a generally open environment and the better overall knowledge of the material world compared to that of the previous dynasty.

CONCLUSION

In recent years, there are people who are keen on comparing the collections of the Palace Museum in Beijing with those of the National Palace Museum in Taiwan, and they come up different conclusions, which are usually far from thorough and often inaccurate and biased. We can certainly say that as far as the painting of the early period is concerned, these two museums are comparable and each has its own characteristics. The Beijing Museum, for example, has more hand scrolls from the Five Dynasties and the Southern and Northern Song periods, whereas the Taipei Museum has more hanging scrolls. The Beijing Museum has collected more than 130 paintings of the Yuan Dynasty, representing the artistic achievements of almost all genres and schools of Yuan painting. Among these, as many as 23 paintings are authentic works of the Four Masters of the Yuan Dynasty, ranking first in the world in terms of quantity and quality.

Painting is a product of spiritual activity and artistic creation. Different genres of painting show different spiritual concerns which are an important component of the spiritual home of the Chinese people and a part of the cultural home of the world. Religious paintings, for example, are illustrations of the thoughts of Buddhism, Confucianism, and Daoism. Historical paintings and portraits pass moral judgments on people and events in history. Landscape paintings express a spiritual quest for the natural life. Certain flower-and-bird paintings also have symbolic moral connotations. Perhaps we could put it in this way: Chinese painting is Chinese learning in pictures and images, and these pictures and images illustrate Chinese learning. Turning the ideas in Chinese learning into art has the greatest power to affect people.

Chinese painting is an art form with many national as well as global characteristics. Only with such a spiritual home could the Eastern and Western cultures start to have various forms of exchange activities, and the Chinese people maintain their cultural genes in today's process of economic globalization.

PAINTINGS OF THE JIN, TANG, AND THE FIVE DYNASTIES

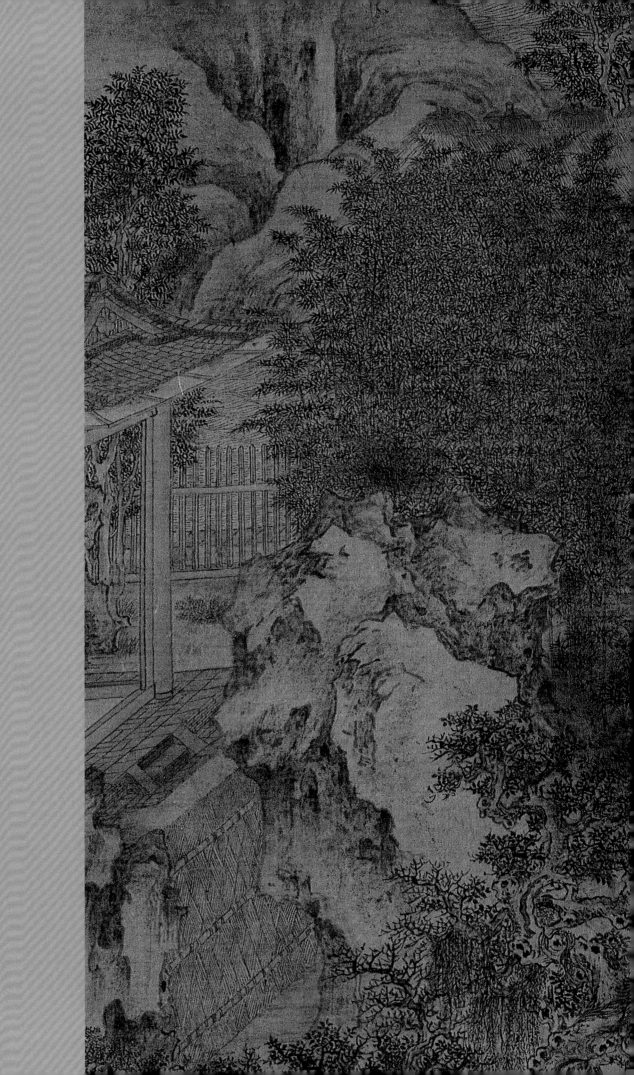

1

Ode to the Goddess of the Luo River

—— by ——
Gu Kaizhi
—— of ——
Eastern Jin
Hand Scroll
(Copied in Song)

Ink and colour on silk

Height 27.1 cm Width 527.8 cm
Qing court collection

This work was produced by a painter of the Song Dynasty who faithfully modelled on the simple and elegant figure painting style of Gu Kaizhi of the Eastern Jin. It is also a typical work of Chinese figure painting of the early period. Gu Kaizhi (345–406), otherwise known as Changkang and Hutou, was a native of Wuxi, Jinling (present-day Wuxi in Jiangsu). He was born into a family of officials and served as Senior Recorder for Comprehensive Duty. He excelled in painting; his brushstrokes are like spring silkworms spinning silk, successfully depicting both the form and the spirit of the object.

The *Ode to the Goddess of the Luo River* is a famous literary piece written by Cao Zhi, a poet of the Three Kingdoms period. It depicts Cao Zhi seeing the Goddess of the Luo River in a dream that he had when he was resting at the riverbank on his way from Luoyang, capital of the State of Wei, back to his manor estate. He could not help falling in love with her. The lines he wrote were full of lingering affections, sincere and touching. This painting is a long scroll of the serial that was made according to the ode, in which the following parts are shown: Cao Zhi and his party discharge their horses and rest along the bank of the Luo River; he faintly sees the Goddess of the Luo River as a swimming dragon, a startled swan, and the rising sun; but as romance between a man and a goddess is impossible, the Goddess of the Luo River and other goddesses just fly around; the Goddess of the Luo River reluctantly leaves in a cloud carriage; Cao Zhi intends to row a boat to meet her again; the following day, Cao Zhi mounts his chariot to continue his journey. The details of the story are narrated side by side, the backgrounds are connected, and the figures

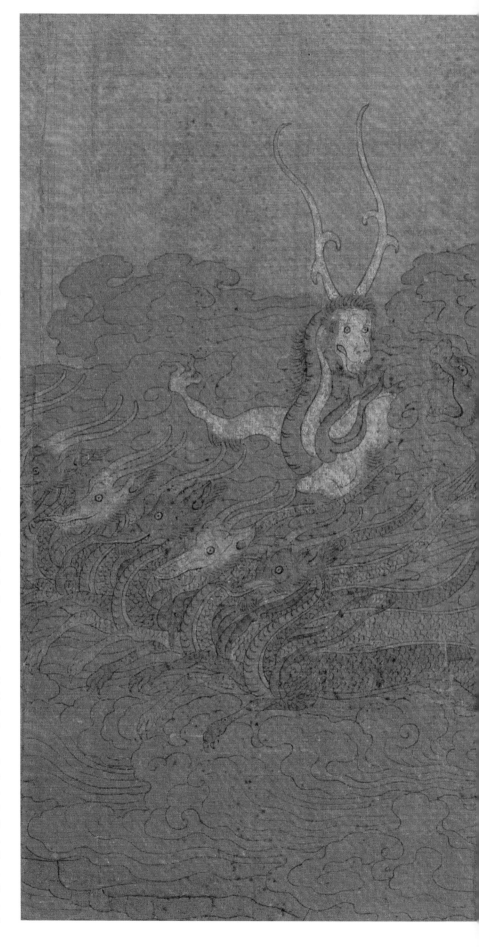

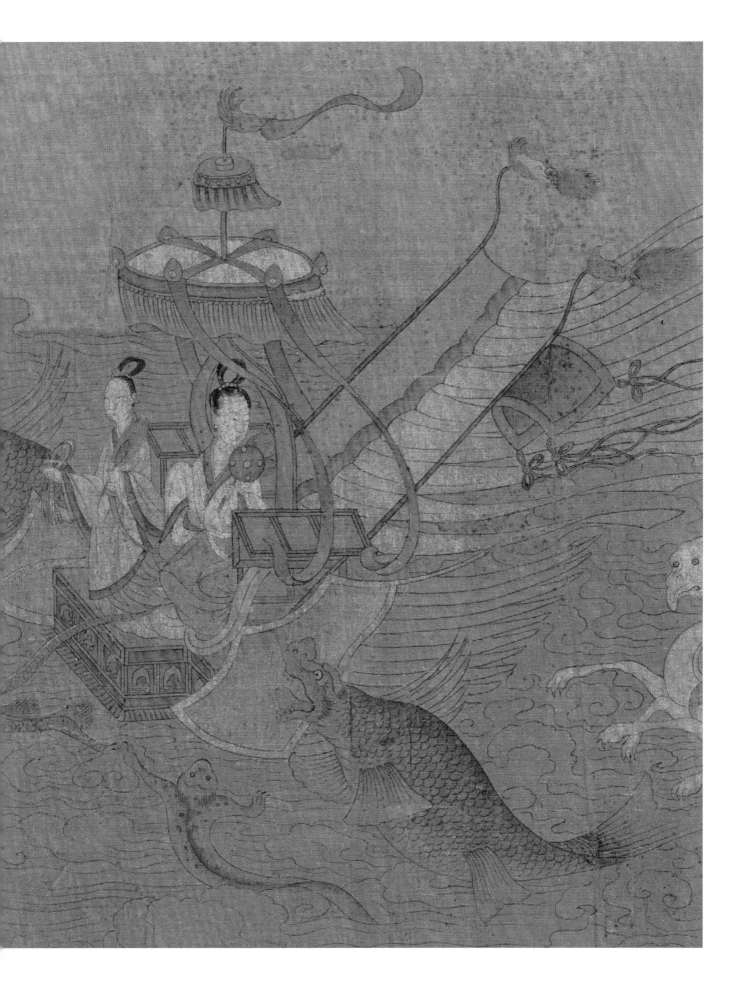

appear repeatedly, manifesting the features of narrative painting of the early period. The clothes and ornaments are brightly coloured, the scarves and ribbons flutter, and the landscape background shows the characteristic "figures are larger than mountains, and water does not overflow even when it is higher than the banks," which is the typical painting style of the Wei and Jin dynasties.

This work bears an inscription of Qing Emperor Qianlong, which reads: "The best

scroll of the Ode to the Goddess of the Luo River," and his seal reads: "Treasure of the Seventy-year-old Emperor" (red relief). The frontispiece has an inscription of the Emperor Qianlong: "Marvellous to the Tip of the Brush," and his seal reads: "Inscribed by Qianlong" (red relief). The rear separate piece has three articles inscribed by Emperor Qianlong. The end paper has *Ode to the Goddess of the Luo River* written by Zhao Mengfu of Yuan (reproduction), and inscriptions by seven calligraphers, including Li Kan (fake) and Yu Ji (fake) of the Yuan Dynasty, Shen Du (fake) and Wu Kuan (fake) of the Ming Dynasty, and He Shen, Liang Guozhi, and Dong Gao of the Qing Dynasty. There are more than forty collector seals on the painting, including "Seventy-year-old Emperor," "Appreciated by Emperor Qianlong," "Treasure Perused by Emperor Jiaqing," and "Treasure Perused by Emperor Xuantong" of the Qing Palace Treasury. This painting is recorded in *The Shiqu Imperial Catalogue of Paintings and Calligraphy* and *Notes on the Shiqu Imperial Catalogue of Paintings and Calligraphy*.

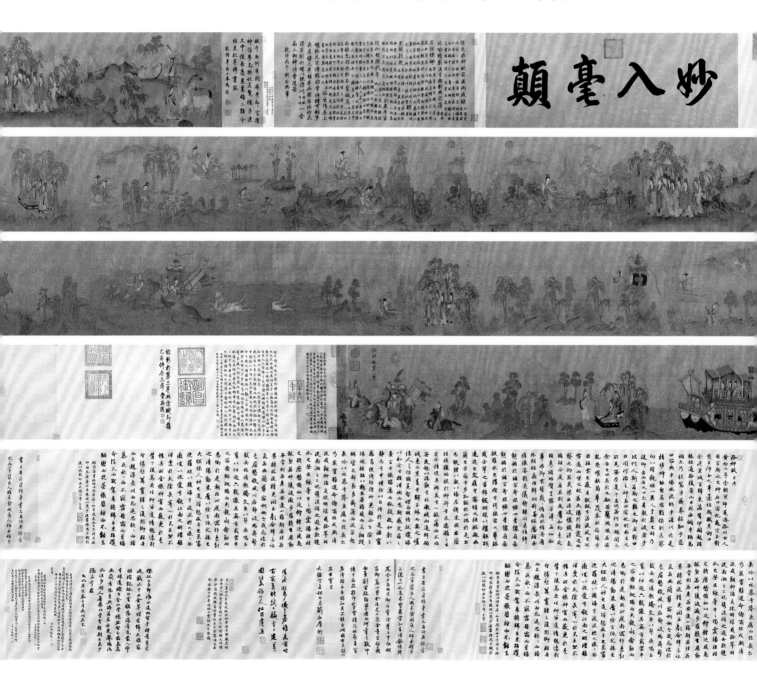

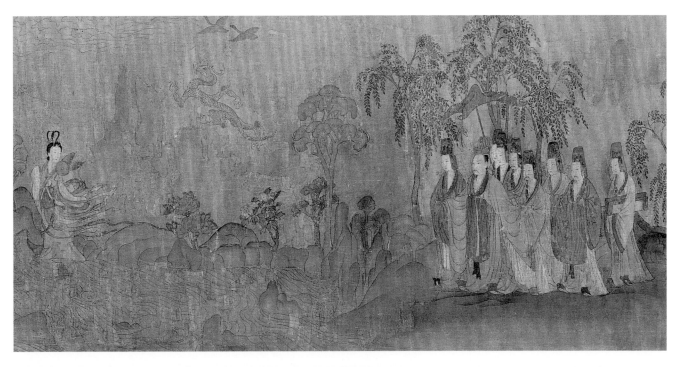

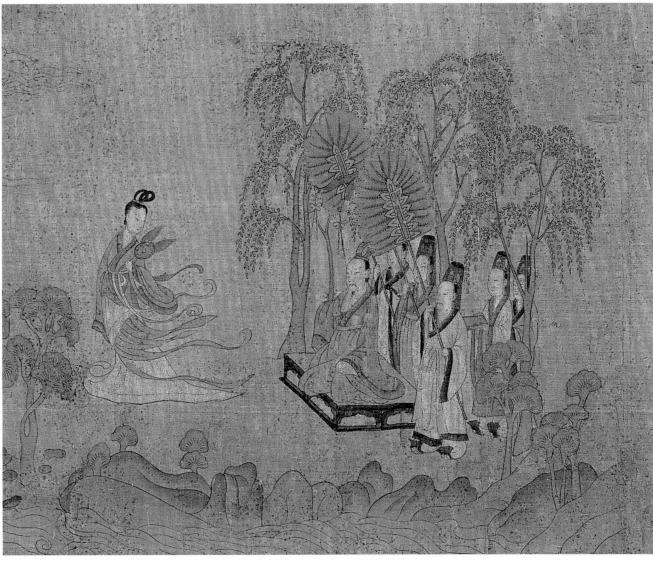

2

Exemplary Women

— by —

Gu Kaizhi

— of —

Eastern Jin

Hand Scroll

(Copied in Song)

Ink and colour on silk

Height 25.8 cm Width 470.3 cm
Qing court collection

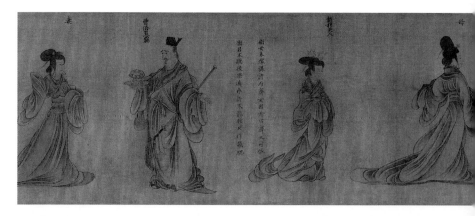

Also titled *Wise and Benevolent Women*, this painting is the earliest extant work created by imagination from historical allusions. It depicts the outstanding women described in the *Biographies of Exemplary Women*, which was written by Liu Xiang of the Western Han period to praise how they cared for their states, as well as their foresight and sagacity. The whole scroll is divided into ten sections, each of them with a title and an extract from the *Biographies of Exemplary Women*. The artist deploys the ink brush to shade the dark sides of the wrinkles in the clothes and to create a feeling of realism. The composition of the painting and postures of the figures are relatively simple and unsophisticated.

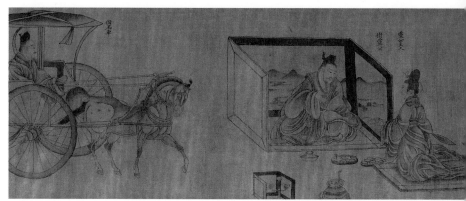

(1) The story of "Deng Man." Deng Man was the wife of King Wu of the State of Chu. The King wanted to attack the State of Sui, and Deng persuaded him that he had to understand the principle that things reverse their course when they go to the extreme and decline when they reach the peak of their prosperity, and that nothing should be achieved with force. But the King did not listen to her advice, and he later died suddenly on his expedition. In the painting, the warlike king is holding his sword, about to leave to the battle. His swaying sleeves are a reflection of his restless mind.

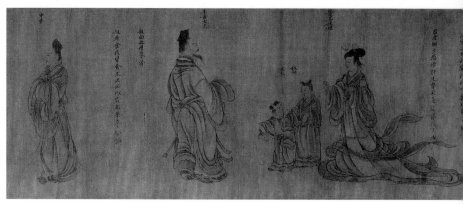

(2) The story of "Lady Xu Mu." Lady Xu Mu was the younger sister of Duke Yi of the State of Wei. She was married to Duke Mu of the State of Xu and, therefore, named Lady Xu Mu. At first, the two states of Xu and Qi sent their envoys to Wei at the same time to seek a marriage alliance. Duke Yi of Wei refused to follow Lady Xu Mu's and her mother's advice to accept the marriage alliance with the powerful state of Qi, and insisted on marrying her to the small and weak state of Xu. Later

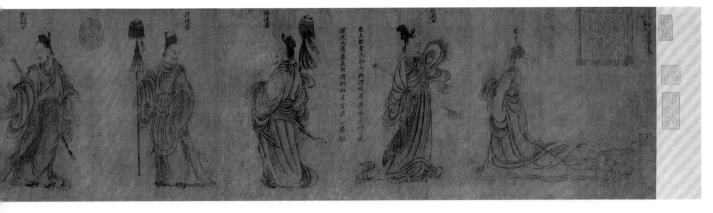

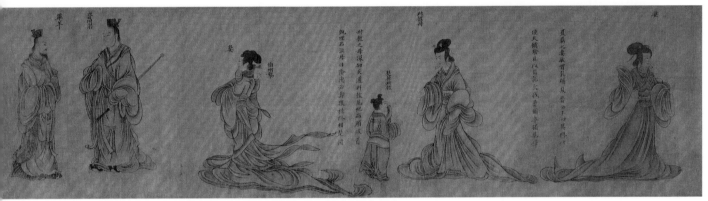

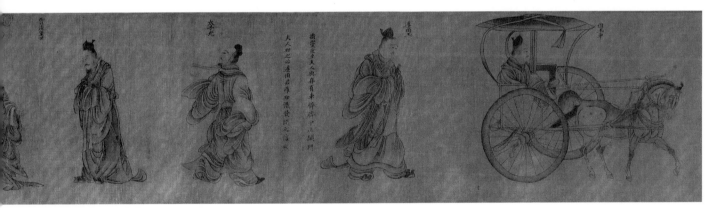

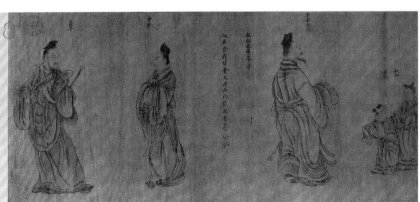

on, when Wei was invaded by Di, Duke Yi lost the battle and was killed. Lady Xu Mu ran to seek help from Duke Huan of Qi, and Wei was then able to be restored as a state. Lady Xu Mu was also a famous poetess, whose extant three works were all included in the *Classic of Poetry* and have been handed down to the present day.

(3) The story of the "Wife of Xi Fuji of the State of Cao." Xi Fuji was a grand master of Cao. Chong'er, a prince of the State of Jin, was in exile due to the unrest in his state. He wandered to Cao, where he was despised and treated rudely by Duke Gong. Xi Fuji, however, followed his wife's advice to treat Chong'er kindly and offered him a plate of food and a piece of jade. Later on, Chong'er returned to his homeland, became the Duke Wen of Jin and one of the hegemons at that time. He launched a massive invasion of Cao for revenge, but ordered his troops not to attack the residence and family of Xi Fuji to show his respect to him and return the favour.

(4) The story of the "Mother of Sun Shu'ao." Sun Shu'ao was a minister of the State of Chu. As a teenager, he heard that people who saw double-headed snakes would soon die. Therefore, when he saw one, he killed and buried it for fear that other people would suffer the same misfortune. The painting depicts Sun going home after killing the snake to say goodbye to his mother and tell her in tears what had happened. His mother praises him and says he will not only stay alive, but also become a pillar of the state in the future as he is considerate of other people.

(5) The story of the "Wife of Bo Zong." Bo Zong was the son of Sun Bojiu, a grand master of the State of Jin. He was impetuous and outspoken, and for this his wife had admonished him repeatedly in vain. In the painting, his wife is holding their youngest son Bo Zhouli in her arms, worrying inwardly. Bi Yang is entrusted by Bo Zong's wife to admonish Bo Zong to mend his ways. Young and impetuous, Bo Zong is holding his sword with his chin up, showing no trace of scruple. His image of being upright by nature is clearly seen. In the end, Bo Zong was killed for offending the rich and powerful.

(6) The story of the "Wife of Duke Ling of Wei Knowing the Virtuous People." One late night, Duke Ling of the State of Wei heard the sound of a chariot from afar outside the palace. It briefly stopped and then started again. The wife of the Duke firmly believed that it was Qu Boyu passing by the palace. She said Boyu was a virtuous official as he was the only person who conscientiously observed the ritual system when travelling in the evening. He would get off the chariot and walk slowly and quietly when his chariot went past the palace. Duke Ling went out to check and found that it was really Boyu. In the painting, Duke Ling of Wei sits in a screened area asking questions, with his wife sitting opposite him and answering them. In the part outside the palace, Boyu is sitting in the chariot and then starts to walk, showing in sequence how Boyu walks before and after he passes by the palace.

(7) The story of "Zhongzi of Duke Ling of Qi." This section is incomplete and only one figure remains. Zhongzi was the wife of Duke Ling of the State of Qi. At first, Duke Ling married Shengji who gave birth to a son called Guang, designated as the crown prince. Later, Duke Ling married Zhongzi who gave birth to a son called Ya. The Duke wanted to depose Guang and designate Ya as the crown prince, but Zhongzi strongly persuaded him not to do so. Unfortunately, the Duke did not listen to her and insisted on going on with his plan, leading to a civil war. The painting portrays the scene where Prince Guang runs quickly away waving his hands, and turning back his head to take one last glance.

(8) The story of the "Woman from Qishi in Lu." This section is damaged and only two figures remain. A woman from Qishi County in the State of Lu was still single when she was above the average age for marriage. She looked sad all the time and her neighbours thought she felt sorrow at her misfortune. But she was actually worried that since Duke Mu of Lu was old and the prince was young and innocent, this would cause a disaster and then people would suffer. Three years later, her fears actually came true. There was a civil war, Lu was invaded by Qi and Chu, and the people lost their homes. The painting depicts the woman from Qishi telling a man about her apprehension and the man showing great respect for her.

(9) The story of "Yang Shuji of the State of Jin." The painting depicts Yang Shuji teaching the young Shuxiang (Yangshe Xi) and Shuyu (Yangshe Fu) to serve the state with comity, and stay away from greed and lust. Once they grew up, Shuxiang, who was learned and talented, served the state with courtesy, enforcing the law impartially; whereas Shuyu became a grand master of Jin and took charge of the judiciary, but was later killed due to his greed and lust.

(10) The story of the "Mother of the Fan Family of the State of Jin." This section is damaged and only two figures remain, i.e. the eldest and elder sons. The image of the mother of the Fan family was damaged before the Qing Dynasty. The painting originally portrays the mother admonishing her sons.

The inscription on the head of the painting was blurred and only the character *kai* (triumph) is legible. The end paper has four annotations by Wang Zhu, Ye Longli, Wang Duo, and others. There are dozens of collector seals on the painting, including "Treasure Perused by Emperor Qianlong," "Treasure of the Seventy-year-old Emperor with Five Types of Fortune and Five Generations Living Together," "Appreciated by Emperor Xuantong," and "Imperial Seal of the Wuyi Imperial Study" of the Qing Palace Treasury, "Jiaolin Bookhouse" and "Fisherman Fishing in a Stream" by Liang Qingbiao of Qing. The painting is recorded in *The Shiqu Imperial Catalogue of Paintings and Calligraphy, Volume 1* and *Records of Paintings and Calligraphy in the Summer of the Year of Genzi*.

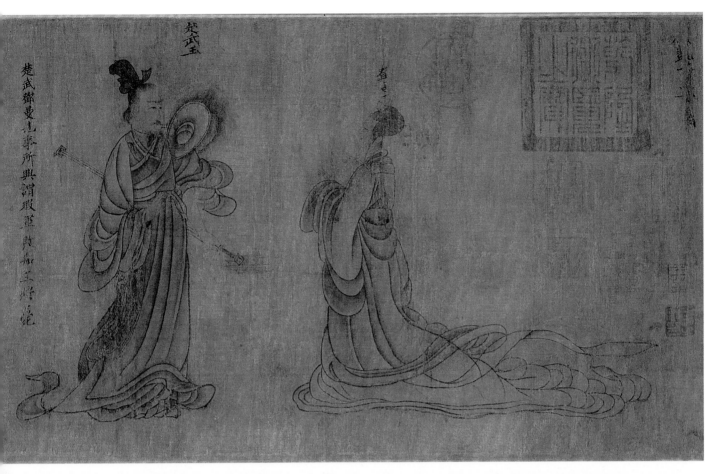

楚武鄧曼並坐事所典謂取莒阿和王好范

楚武王

者

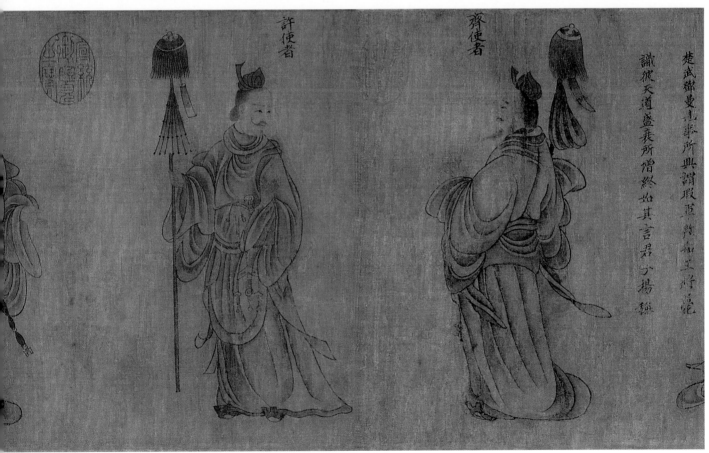

許使者

齊使者

楚武鄧曼並坐事所典謂取莒阿和王好范

識狄天道盈衰所謂終始其言君為揚謀

23

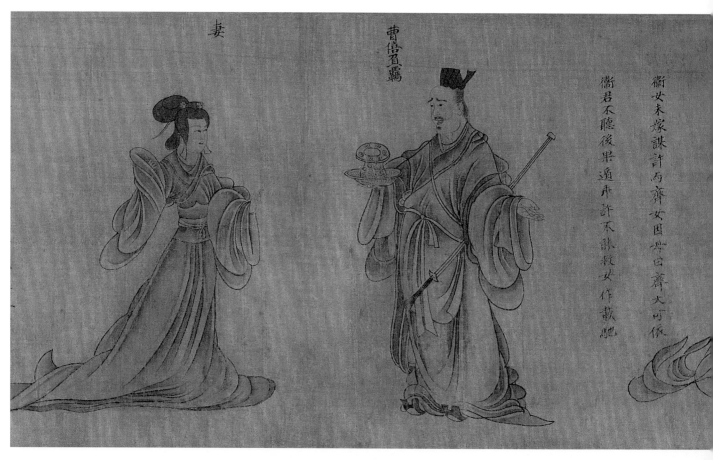

妻　　　　　　　　　　曹僖負羈　　　衛女不聽後果通乎許不許殺女作載馳
衛女未嫁謀許為齊女因告白齊大可依

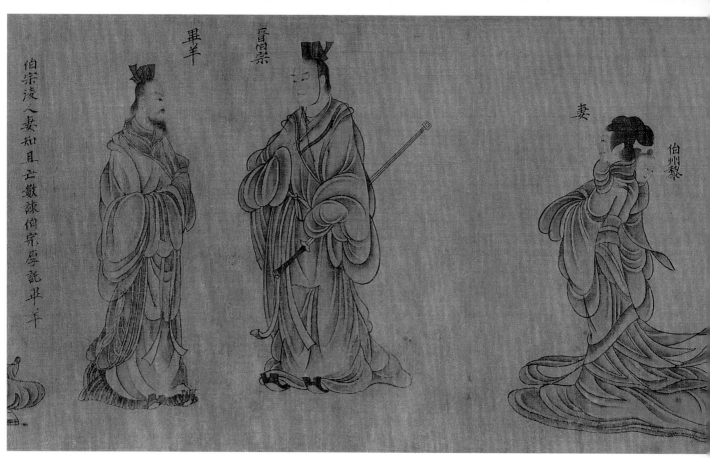

畢羊　　　晉伯宗　　　　　　　　　　妻
伯宗凌人妻知且士譏諫伯宗學說畢羊　　　　伯州犁

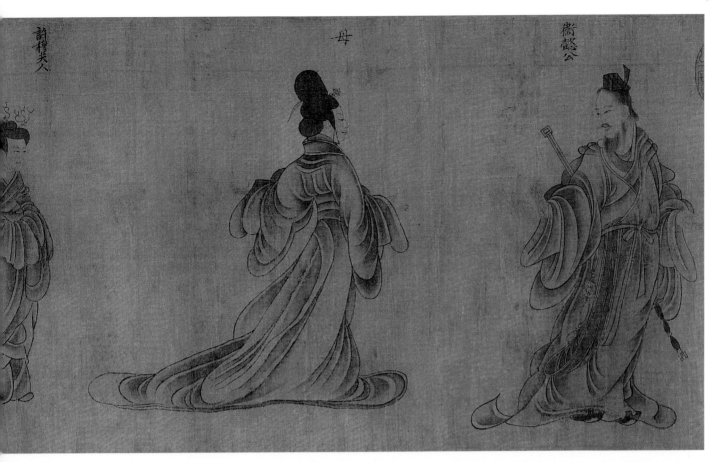

許穆夫人　　　　母　　　　　衛懿公

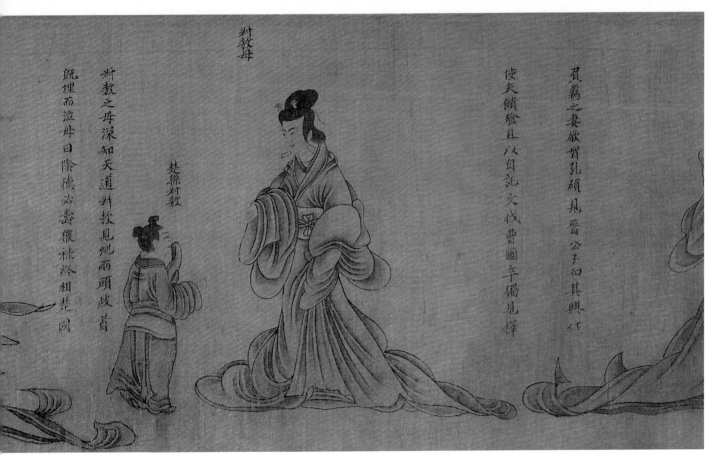

料敎母

楚彼料敎

料敎之母深知天道料敎見蜩兩頭故首
既埋而泣母曰陰德必壽䋲排拎相楚國

覓羈之妻嚴賢孔碩見晉公子和其與作
使夫儈殘且以自託文伐曹國辛獨見擇

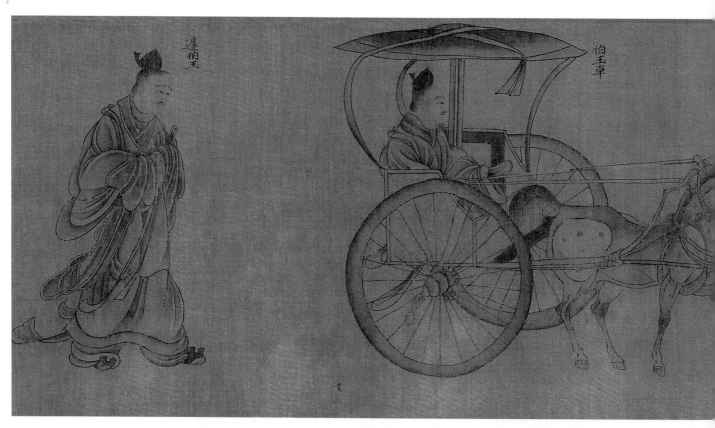

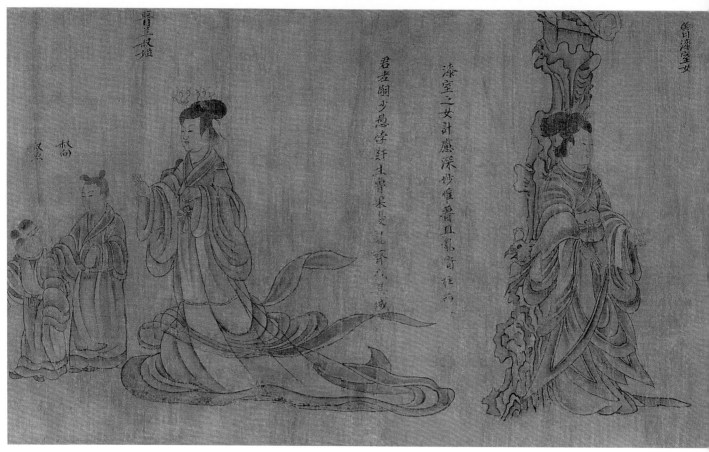

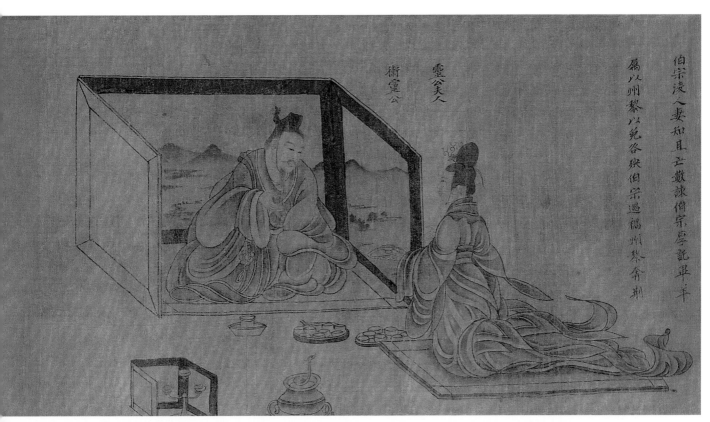

伯宗凌人妻知且立敢諫伯宗畏讒平平
屬以州黎以畝各陝伯宗過禍州黎奔荊

靈夫人
衛靈公

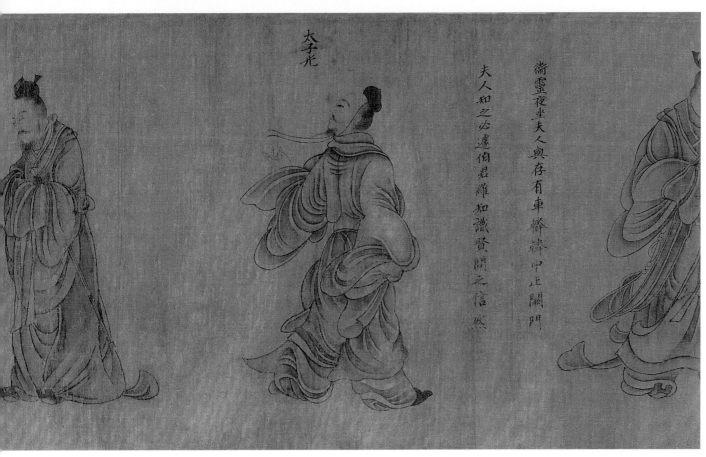

太子光

夫人知之必邊伯君雖知識賢問之信然

衛靈夜坐夫人與存有車鑾轢中止關門

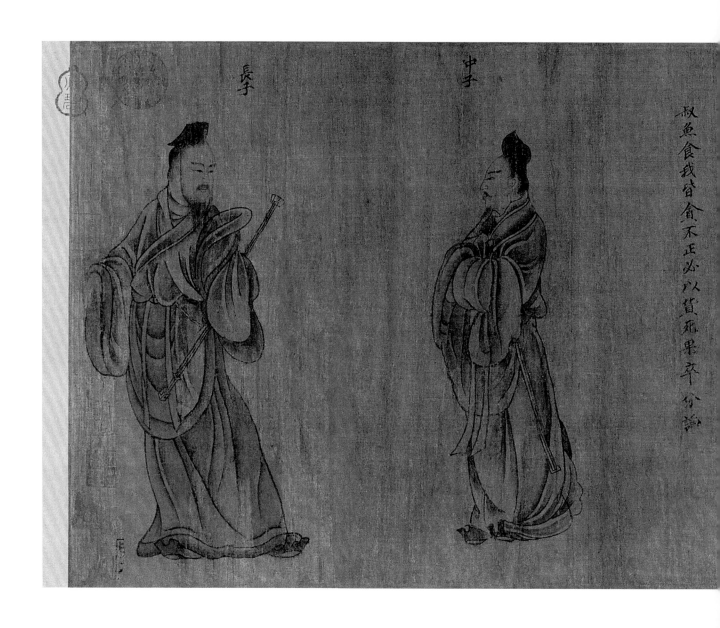

長子　中子

叔魚食我皆貪不正必以貨死果卒分論

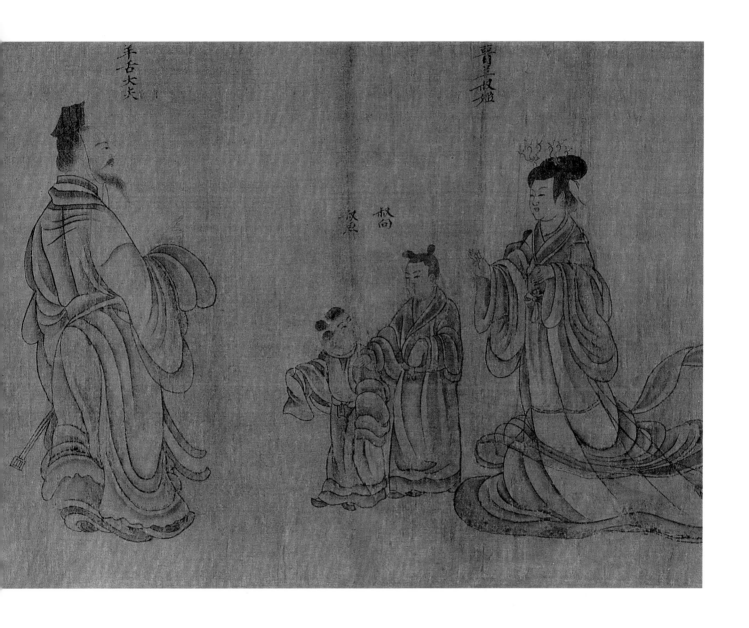

3

Spring Excursion

by

Zhan Ziqian

of

the Sui Dynasty

Hand Scroll

Ink and colour on silk

Height 43 cm Width 85 cm
Qing court collection

This work is the earliest landscape painting and has great significance in the history of Chinese painting. Zhan Ziqian, whose years of birth and death are unknown, was a native of Bohai (present-day Yangxin in Shandong). He lived through the three dynasties of Northern Qi, Northern Zhou, and Sui. During the Sui Dynasty, he served as Grand Master for the Closing Court and Commander-in-chief of the Escort Brigade. He excelled in painting Buddhist and Daoist themes, figures, saddled horses, towers, pavilions, and landscapes. He was also good at murals and made paintings for temples and monasteries in places such as Chang'an (present-day Xi'an in Shaanxi) and Luoyang (present-day Luoyang in Henan). His style of painting inherited the tradition of the Six Dynasties and heralded the new style of the Tang Dynasty. Zhan, Gu Kaizhi of Eastern Jin, and Lu Tanwei and Zhang Sengyao of the Southern Dynasties are known as master painters with the surnames of "Gu, Lu, Zhang, and Zhan." Zhan has an important position in the history of painting.

The scene depicts people going for a walk in the countryside in spring. The breeze seems gentle and the day is fine. There are all kinds of flowers on the trees. Water in the lake extends far into the distance while white clouds curl up from the mountain. The old temples are quiet and secluded. People ride on horsebacks, stroll, sail on a boat, or enjoy the natural beauty of lakes and mountains on the outing. The composition of the painting adopts the technique of level distance; the vision is wide, and the gradation of far and close is clear. The outline is finely drawn and coloured with mineral blue and mineral green, which form the main colours. They are interlaced with red, white, and umber colours, making the painting bright and full of variations, setting out the liveliness of spring.

This work does not bear the name or signature of the painter. The front of the scroll has the inscription of the Song Emperor Huizong, which reads: "Spring Excursion by Zhan Ziqian." It was therefore established that the work was painted by Zhan Ziqian. The scroll also includes a poem inscription by Qing Emperor Qianlong. The separate piece at the back of scroll has a poem inscription, which reads: "In the first month of the tenth year of the reign of Hongwu in the Ming Dynasty." The rear separate piece has another poem inscribed by Qing Emperor Qianlong, which reads: "In the First Month of the Year of Bingshen." The end paper has annotations, including "Inscription of a Poem by Feng Zizhen, formerly the Edict Attendant of Scholarly Worthies, by the Order of Princess Supreme, the Paternal Aunt of the Emperor," the inscription of a poem by Zhao Yan, the inscription of a poem by "Zhang Gui, Secretarial Manager of Governmental Affair," and an annotation by Dong Qichang. There are dozens of collector seals on the painting, including "Xuanhe," "Zhenghe," and "Library of Palace Treasury" of the Song Palace Treasury, "The Shiqu Imperial Catalogue of Paintings and Calligraphy," "Treasure Perused by Emperor Qianlong," "Treasure Perused by Emperor Jiaqing" of the Qing Palace Treasury, "Seal of An Qi," "Koreans," and "Liang Qingbiao's Seal." The painting is recorded in *Critical and Descriptive Notes on Paintings and Calligraphy*, *Postscripts on Famous Calligraphy and Paintings by Wang Keyu*, *Notes on the Calligraphy and Paintings of the Qianshan Hall*, *The Boat of Calligraphy and Paintings on the Qing River*, *Classified Records of Calligraphy and Paintings in the Shigu Hall*, *Dream Journey in the Records of Wonderful Sights*, *Random Notes on Works in Ink*, and *The Shiqu Imperial Catalogue of Paintings and Calligraphy*.

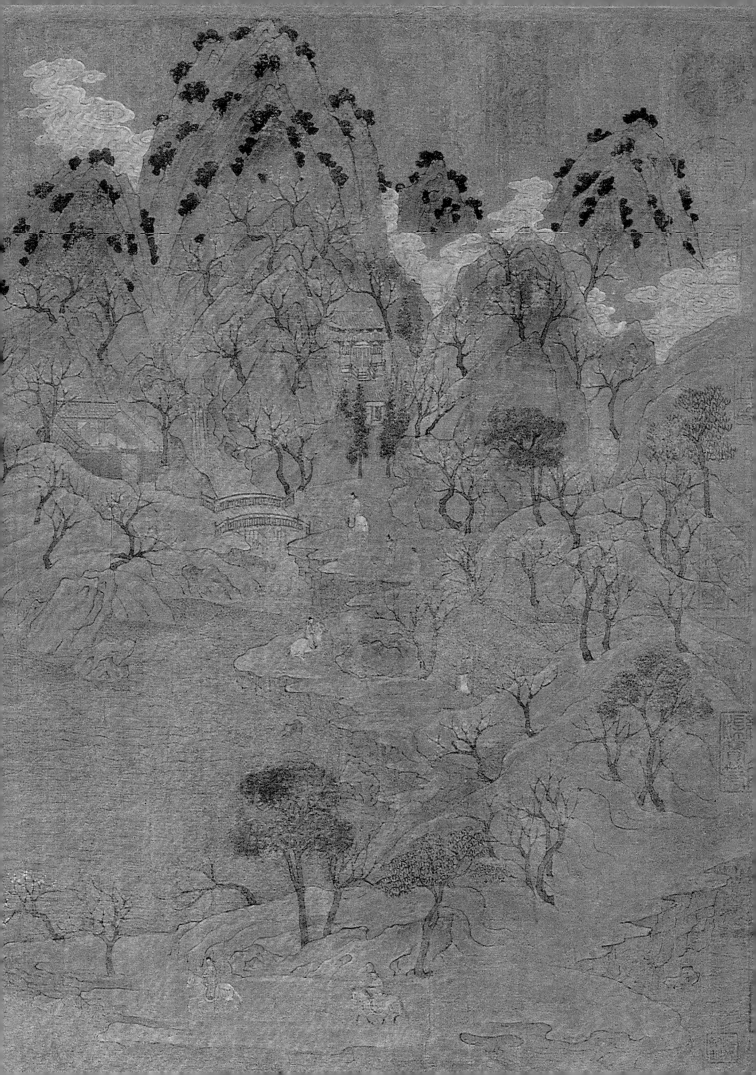

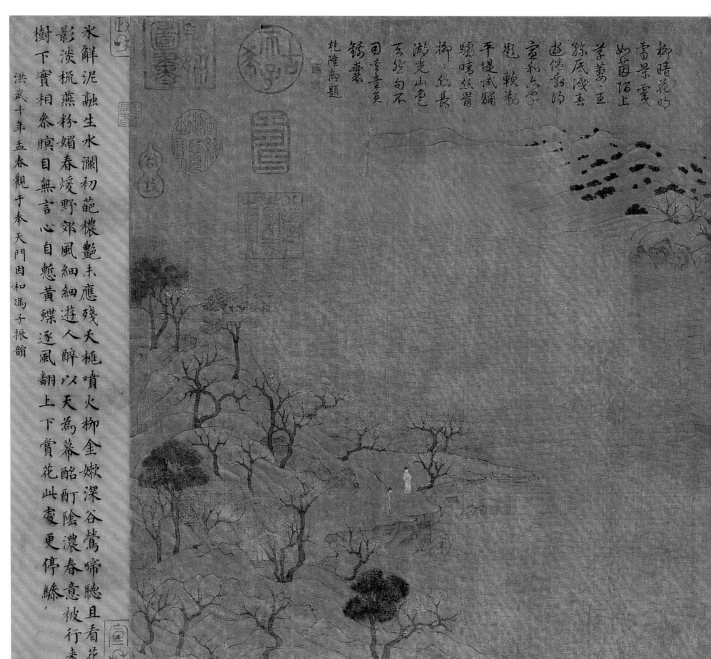

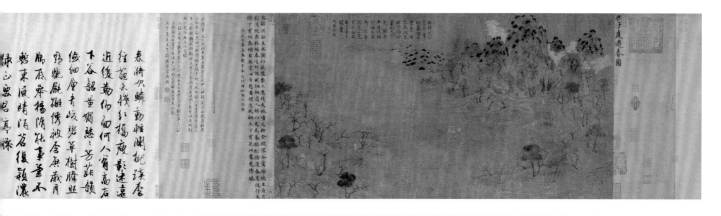

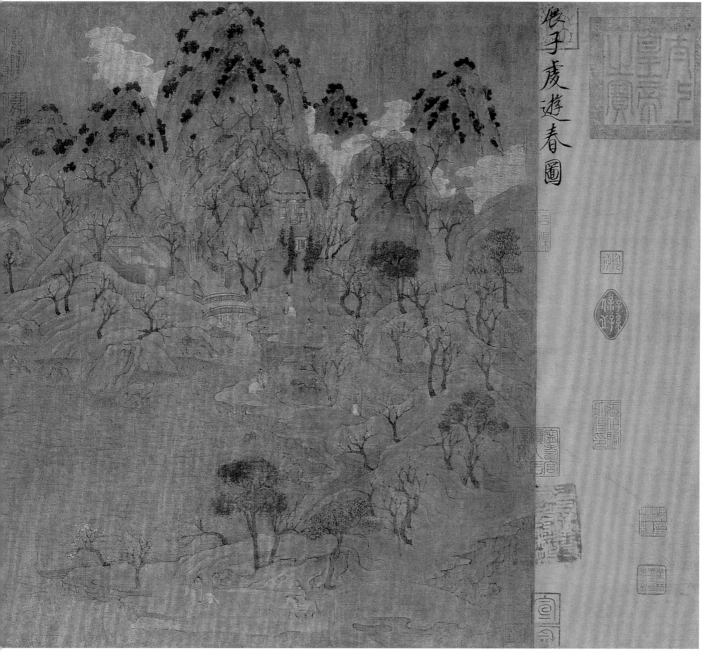

4

Emperor Taizong
Receiving the Tibetan Envoy

by

Yan Liben

of

the Tang Dynasty

Hand Scroll

Ink and colour on silk

Height 38.5 cm Width 129.6 cm
Qing court collection

This work is a historical painting that shows the relationship between the Tang Dynasty and its tribes, which can be verified in the records of historical books. There is evidence that proves that this is an authentic work of the Tang Dynasty, but some believe that it is a copy made during Northern Song. Yan Liben (?–673), was a native of Wannian in Jingzhao (present-day Xi'an in Shaanxi). Yan Pi, his father, was a Sui Dynasty painter. Yan Liben served as Minister of Works on the behalf of his elder brother Lide and the highest position he held was Chancellor. In painting circles, he succeeded the painting style of Zhang Sengyao of the Southern Dynasty. He excelled in the painting of figures, and was especially good at narrating history through painting, and he became "known for his paintings."

This work depicts an incident in which the Tibetan King Songtsen Gampo sent his envoy Lu Dongzan to China in the fifteenth year of the reign of Zhenguan (641) to pay a visit to the Tang Emperor Taizong to discuss the matter of escorting Princess Wencheng back to Tibet for a wedding as a way of achieving peace by a marriage arrangement. Emperor Taizong sits straight on his imperial carriage. The imperial maids lift up the carriage, hold up the fans, and open the umbrellas. At the front, dressed in red and holding a tablet, is the Official Interpreter of the Imperial Palace. Behind him, the Tibetan envoy can be observed clad in a Tibetan court dress and giving his salutations to the emperor. On his heel, with a white shirt, there is an imperial servant of the Tang palace, showing that this event occurs at the Inner Court. The spirit and disposition of the figures in the painting are drawn in a way that fits the scene. Emperor Taizong, whose eyes flash with light, still looks sincere and kind. Lu Dongzan, who is thin but energetic, is rather capable and experienced, and he has an expression of urgency and expectation on his face. The iron-line strokes are strong, tough, and solid, whereas the colours are thick, heavy, simple, and concise. The painting is harmonious and natural and keeps the style of figure painting of the early Tang period.

This painting is inscribed with the title "Emperor Taizong Receiving the Tibetan Envoy." At the back of the painting is a piece written in seal script by Zhang Boyi of the Northern Song, describing in detail the allusion of the painting and pointing out that "It was painted by Tang Grand Councillor Yan Liben." The end paper has twenty-two inscriptions, including those of Mi Fu, Zhang Zhiquan, and Huang Gongqi of Northern Song, Lin Ding and Xu Shansheng of Yuan, and Guo Qujie of Ming. There are one hundred collector seals on the painting, including, "Imperial Library" by Emperor Zhangzong of the Jin Dynasty, "The Shiqu Imperial Catalogue of Paintings and Calligraphy," "Treasure Perused by Emperor Qianlong," and "Treasure Perused by Emperor Jiaqing" of the Qing Palace Treasury; "Seal of Appreciatim by Guo Shi Hengfu" by Guo Qujie of the Ming Dynasty, "Seal of Treasure Collected by Wu Xinyu" by Wu Xinyu, "Rare Treasure of Jiaolin" by Liang Qingbiao of the Qing Dynasty, and "Chengde Rongjun" by Nalanchengde. This painting is recorded in the *Catalogue of Imperial Paintings in the Xuanhe Era*, *The Shiqu Imperial Catalogue of Paintings and Calligraphy, Volume 1*, and *Catalogue of Paintings and Calligraphy in the Peiwen Studio*.

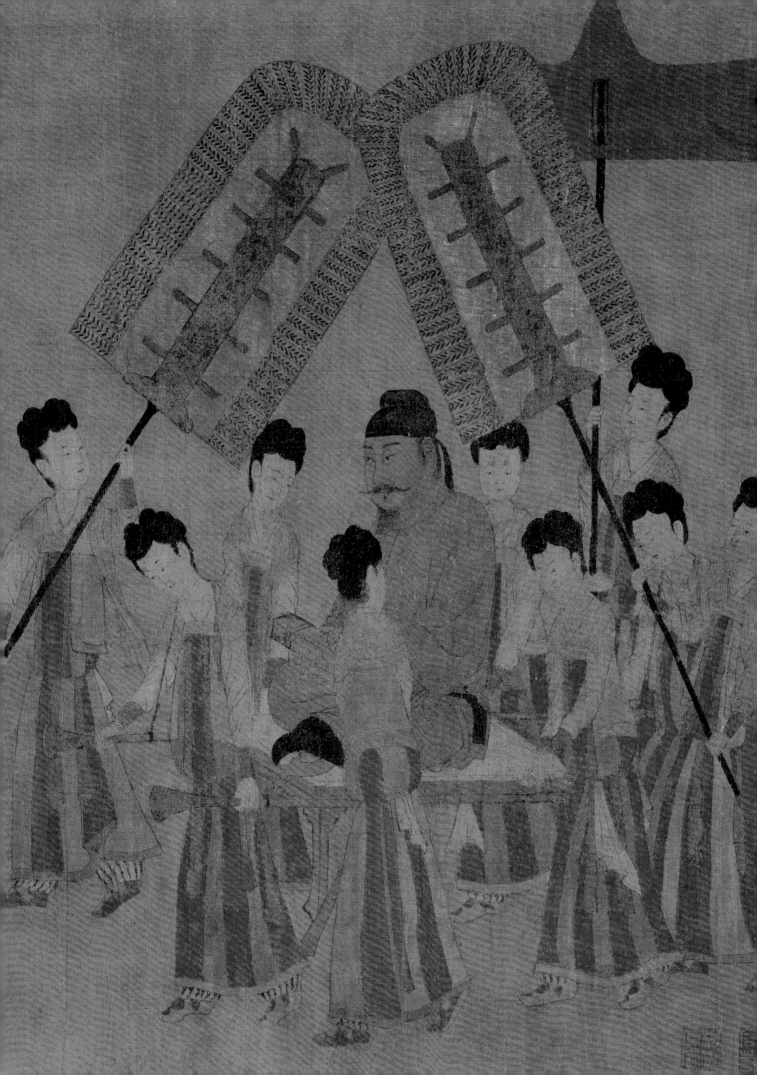

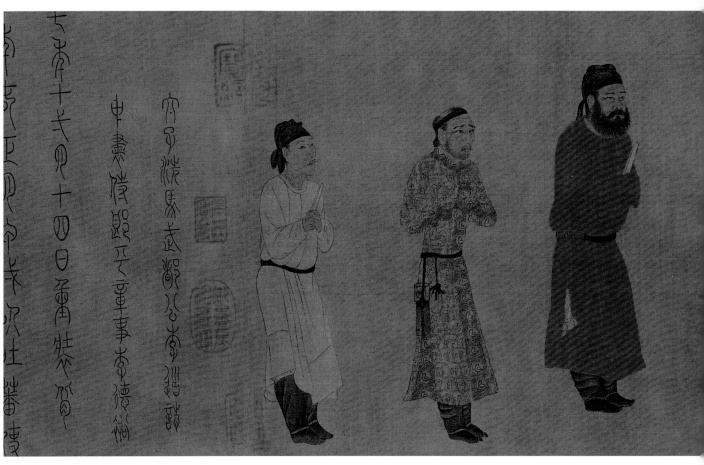

濟陽朱某□

元豐三年六月廿八日長沙靜□齋□觀

元豐七年四月十二日長沙學舍□觀
閩相國之本章伯益之篆皆當時
精妙閱文之會甲子孟春中禊日□澤
依尚書托於長沙之郭祭軒

元豐七年二月三日觀步輦圖
章伯益篆誠汪筆也
長沙劉次莊

延平曹時美以
其月十日觀

元豐甲子六月廿六日長沙驛倉中
蔡挍閱文之會指爲宗題閱訖
丙寅孟夏十有七日
尋陽陶巽咨堂觀

右相馳譽丹青光於此本宣
爲加意秦李丞相妙拾篆籀
乃刪改史籀大篆而爲小篆
其銘題開鍾施拾苻壐楷
隸之祖爲不爲之範今見伯
益之筆僅得其妙而附之閣公
人物之僅爲雙絕吳元豐己丑
上巳河南劉忱題

甲山奇寅爾亐辭日蕭奉權
見此畫今十三季觀書間幾
跋辰庚禄丙寅宋巳十个
日記雪拳蕭案議題其緯云

天地弥綸除筆戌指字
中今朝畫圖裏每見虹
須脊
元祐丙寅歲閏月長沙

李唐威信章遠方王姬萬里嬌戎先
上方筆積腰膝端簡朝清光
毅勤爲主近驚柴周旋不屏使指持
瑯瑯外孫依桐房語小妻贊恩非常
贊拜稽首不敢當有妻忍遺糗糧
主禮未畫先省要荒人心天理無存已
閩公粉本真輝煌建安筆色香
何年八公寶繪堂顏與鍾周同珍藏
當讀坡前題閩立本職貢圖猶以
未見墨妙爲恨句可從宗庶技
目步輦之筆妙於是倣坡體化數語
八繫卷末大德丁未永嘉許氏膝

古步輦圖法度高古真人筆事伯益
篆先佳米南宮篆之當之爲篆十有三
平春仲之望郡衡陽李前存頫

正肇己丑五桂子十邦瀨墨支曾
郡中室密禮識

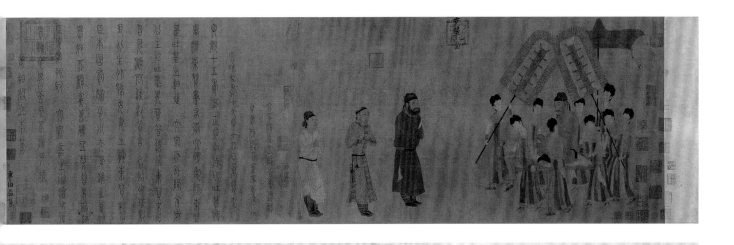

見此畫今十三年觀畫間矣
跋尾元祐丙寅央巳壬十个
日紅尋章蕭癸講題其緯云

天地彌綸隊華戎指掌
中今朝畫圖裏再見虹
須眉
元祐丙寅歲閏月長沙
觀幽張帝民題

丙寅三月同孔武仲觀於
南楚門舟中鄧慥崖題
縣齊滇川張　崔诠題

元祐丙寅夏望日觀於　長沙
元豐乙巳七月十三日玫麹
林菩所　子山攜酒於湘
西二真身輝利祐劉因
閣畫墓奇華太之珍
順鹼卅元祐元年
三月十五日汝陰張知閣題

靜力居士所蓄名畫法書悉皆佳絕
而唐相閻公所作太宗步輦圖尤為著
本故後世傳之以為寶玩建安章伯益
復以小篆戴其事於後伯益用華圖
建名閣于時帝二李之亞峽元祐元年

桃易長徽以遂義月經○當縣

十六日也

田偃杜綱上官壽同觀時元祐丙寅五月

至治三年夏六月三日集賢倓伍同觀于登瀛堂書
林定正仲書

步輦勵後墓進所畫於廷
絕藝信有之也而好之者少
好者有之而藏之者少藏者
有之而識之之少
公好而藏之而又且識其妙
不亦今之傳古者乎濟南
城為主官恭墓大其別文
慶華聞其知遠劉寵藝献清
成公主恭吐蕃贊晉大甚別文
之唐書貞觀十五季唐降文

5

Five Oxen
by
Han Huang
of
the Tang Dynasty
Hand Scroll

Ink and colour on hemp paper

Height 20.8 cm　Width 139.8 cm
Qing court collection

This painting is the only extant work of Han Huang. It is also the most valuable early piece of painting done on paper. Han Huang (723–787), styled Taichong, was a native of Chang'an (present-day Xi'an in Shaanxi) and son of Han Xiu, Minister of State of the Tang Dynasty. During the early years of the reign of Zhenyuan, he served as the Acting Left Vice-Director and Joint Manager of Affairs with the Secretariat-Chancellery, and he was given the title of Duke of the State of Jin. He was versed in music, skilled at playing drums and qin, and fond of calligraphy and painting. The style of his calligraphy and painting is noble and free. His calligraphy followed the style of Zhang Xu of the Tang Dynasty, Lu Tanwei of the Southern Dynasty in painting, and was skilled in the painting of figures, beasts, animals, and the customs and mores of the rural people.

This horizontal piece of work depicts five oxen, each with its own posture, forming a long scroll. One ox is scratching its itches with its head inclined. A second ox is strolling with a raised head. The third is standing in a front view. Another is turning its head to stick out its tongue. And the last ox has a yoke on its head. This painting uses five oxen to make an analogy with people. When a civilian is not in office, he will be idle and unrestricted, whereas when that person is in office, he will be restrained and prudent. This painting is a typical work of expressing one's feelings through objects. The outlining of the body of the ox is varied, and the depiction is accurate, deep, and solid. The head, tail, brows, and eyes of the ox are painted with a fine brush. It is lively and captures the spirit of the animals. The

brushstrokes are fine and excellent, and the line sketches are beautiful. The five oxen are independent, yet they are related to each other, making the painting harmonious and unified.

This work has the character "Ci (here)" by Xiang Yuanbian as a serial number and a poem inscribed by Qing Emperor Qianlong. The head of the scroll has an inscription by Qianlong, which reads: "Prosperity Depends on the Farming in Spring." The front separate piece has another poem inscribed by Emperor Qianlong. The end paper has annotations by Zhao Mengfu, Kong Kebiao of Yuan, Xiang Yuanbian of Ming, Emperor Qianlong, Wang Xiyu, and Jin Nong of Qing, and those by other people, and poems in reply to other poems by Qing Jiangpo, Wang Youdun, Qiu Yuexiu, Guan Bao, Dong Bangda, Qian Weicheng, Jin Deying, Qian Rucheng, and others. There are close to one hundred collector seals on the painting, including "*Shao*" (Succession), "*Xing*" (Prosperity), and "East Hall of Wise Thoughts" of the Song Palace Treasury, "Appreciated by Emperor Qianlong," "Imperial Seal of the Hall of Three Treasures," "Blessings to Children and Grandchildren," "Seventy-

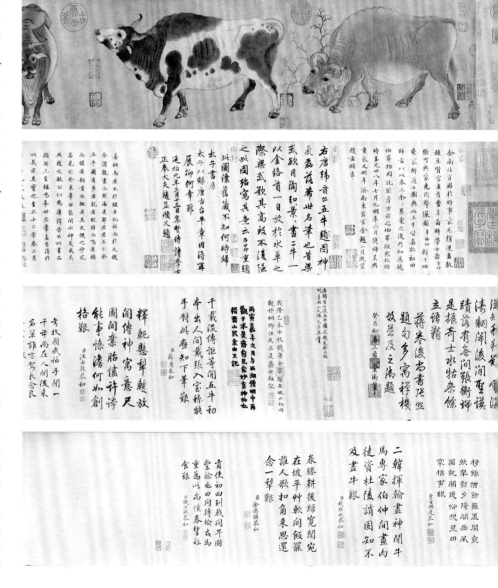

year-old Emperor," "Treasure Perused by Emperor Qianlong" of the Qing Palace Treasury, "Hermit of Ink Circles," "Rare Family Collection of Xiang Zijing," and "Zijing" of Ming, and "Works Verified by Song Luo of Shang Qiu as Authentic" of Qing. This painting is recorded in *The Boat of Calligraphy and Paintings on the Qing River, A Collection of Miscellaneous Notes Compiled by Ming Scholar Li Rihua, Postscripts on Famous Calligraphy and Paintings by Wang Keyu,* and *The Shiqu Imperial Catalogue of Paintings and Calligraphy.*

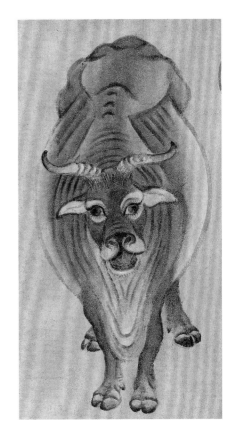

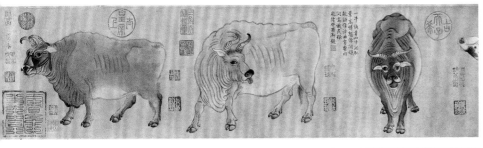

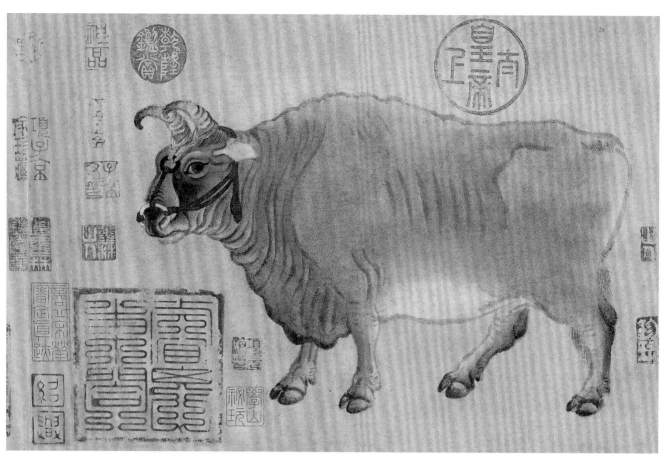

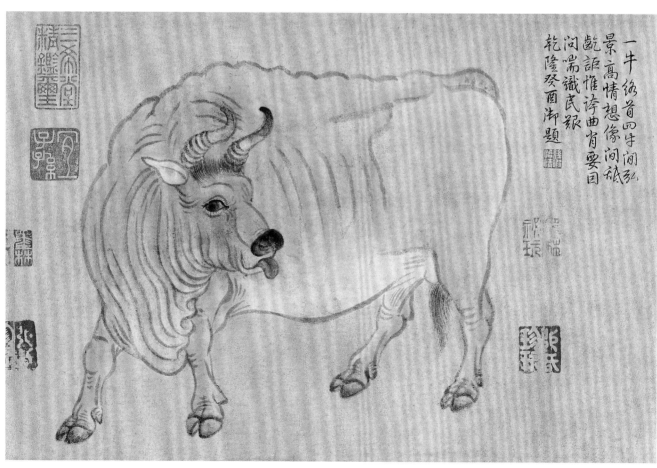

一牛納首四牛間弘
景高情想像間紙
虔訏惟詩曲肖要目
間喘端識民艱
乾隆癸酉御題

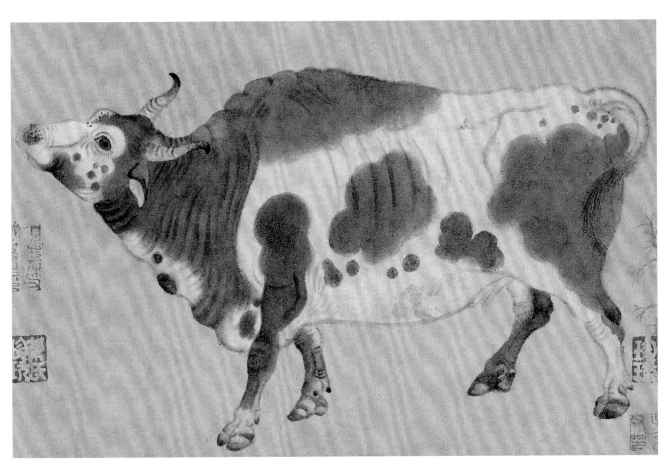

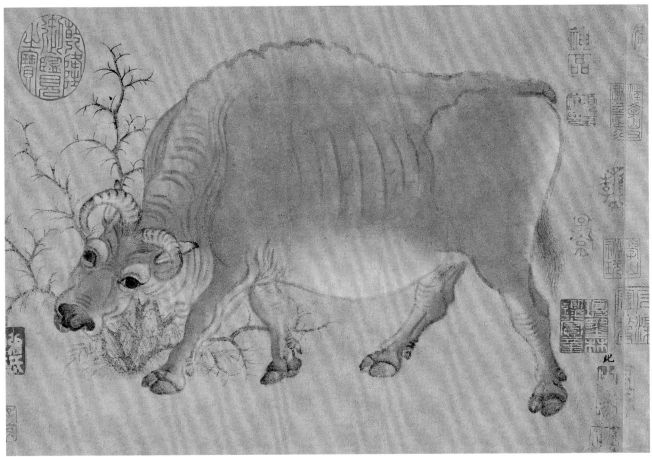

6

Fanning Ladies

ascribed to

Zhou Fang

of

the Tang Dynasty

Hand Scroll

Ink and colour on silk

Height 33.7 cm Width 204.8 cm

Qing court collection

This painting shows in a most vivid and realistic manner the life of the courtesans inside the inner chambers of the imperial palace in the Tang Dynasty. Zhou Fang, whose years of birth and death are unknown, was active in the ninth century. He was known as Zhonglang (or Jingxuan) and was a native of Jingzhao (present-day Xi'an in Shaanxi). He was born into a family of officials, and the highest positions he held were Yuezhou Administrator and Administrative Aide of Xuanzhou. His painting of ladies and Buddhist statues are respectfully called the "Zhou's Version." His painting of beauties, in particular, represents the dominant style of mid-Tang, and he was praised by his contemporaries as "the best painter of beauties of all ages."

This work depicts the ladies of the Tang palace. They are all plump with round faces. Their brows are thin and their eyes are long. Their lips are like cherries. Their clothes are beautiful and their postures are varied: some hold fans or utensils, embrace

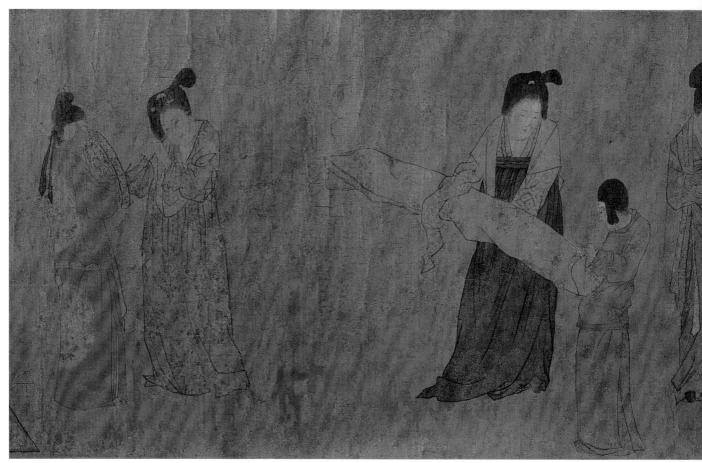

the *qin*, face the mirror, do embroidery, sit alone, or lean against a tree. Their expression is that of loneliness. They are leisurely but idle, showing the growing restless and boredom of living in the palace with the passage of time. The lines are small but vigorous, with slight turns and pauses. The wrinkles in their clothes are slightly square and hard. Owing to the age of the painting, its strip is seriously damaged and only the vermilion mineral colour on the surface is still as fresh and bright as new.

The title label of this work has an inscription of the Qing Emperor Qianlong, which reads: "The Painting of Fanning Ladies by a Tang Artist is in the Collection of the Palace Treasury." The frontispiece has another inscription by Emperor Qianlong, which reads: "Noble painting of Qing." There are dozens of collector seals on the painting, including "Authenticated by the Imperial Catalogue," "Treasure Perused by Emperor Qianlong," and "Treasure of the Emperor's Father" of the Qing Palace Treasury, "Seal of a Zongbo Scholar" by Han Shineng, and "Jiaolin Bookhouse" and "Taking a Grand View" by Liang Qingbiao. This painting is recorded in *The Boat of Calligraphy and Paintings on the Qing River*, *Sequel to the Shiqu Imperial Catalogue of Paintings and Calligraphy*, and *Notes on the Shiqu Imperial Catalogue of Paintings and Calligraphy*.

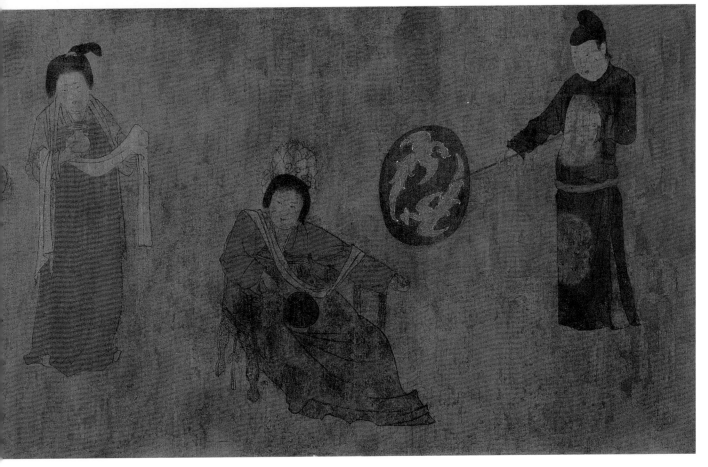

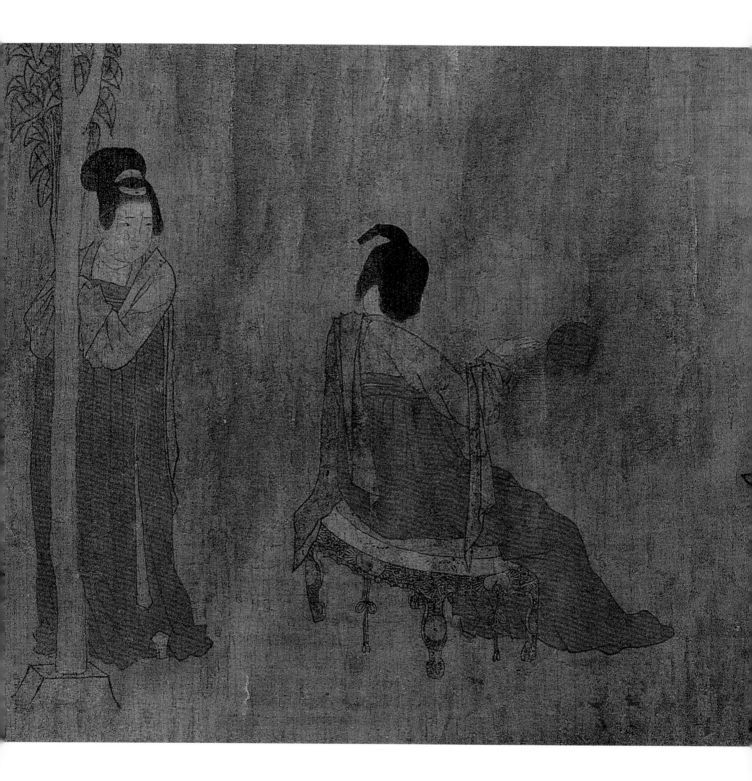

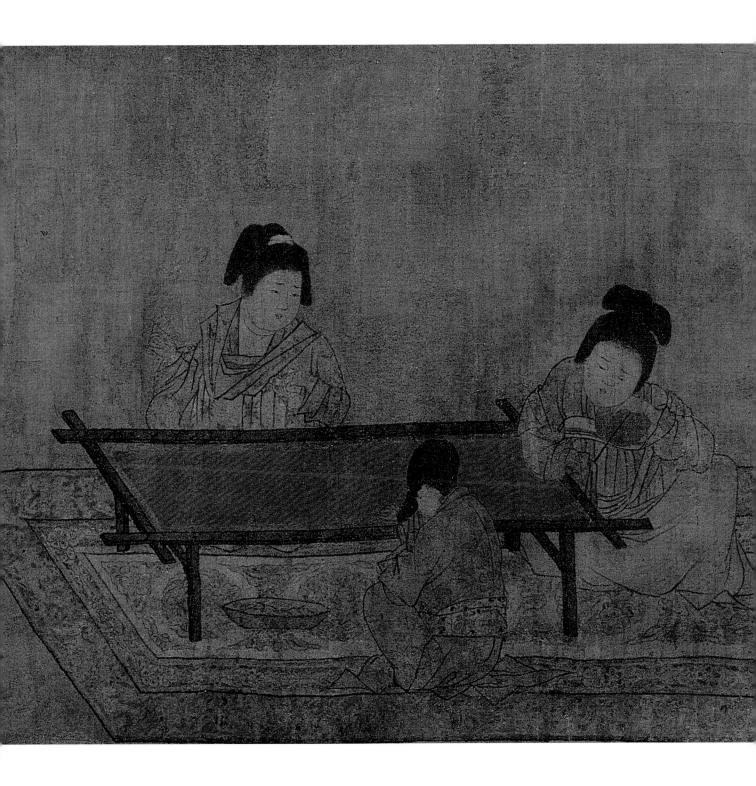

7

Noble Scholar

— by —

Wei Xian

— of —

the Five Dynasties

Hand Scroll

Light ink and colour on silk

Height 134.5 cm Width 52.5 cm
Qing court collection

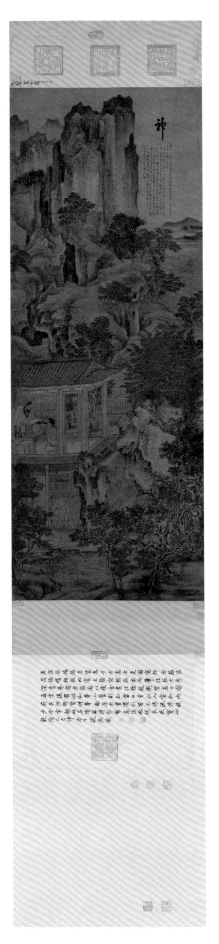

This painting is the only remaining authentic work of Wei Xian and it is also one of the typical landscape paintings of the Five Dynasties period. Wei Xian, native of Jingzhao (present-day Xi'an in Shaanxi), was active in the tenth century, yet the exact dates of his birth and death are unknown. He was Palace Attendant during the Southern Tang period. He followed the style of the Tang painter Yin Jizhao and was particularly skilled in painting figures, towers, and pavilions. He was also a well-known master in boundary drawing.

This painting depicts the story of the hermit Liang Hong and his wife Meng Guang of the Han Dynasty in which "They respected each other as if the other were a guest and Meng held the tray level with her eyebrow." On the valley of a mountain is a brick house with a tiled roof. Inside the house, Liang Hong sits straight on the couch, and an open book is placed across the desk. Meng Guang is on her knees, holding a food tray high to the level of her eyebrows. The garden is surrounded with strangely shaped rocks, set off by trees. In the distance, the mountains are lofty. At the foot of the mountain, the rivers flow meanderingly without any waves. The painter brings out emphatically the environment in which the hermit resides to reflect the mentality of the intellectuals of the Five Dynasties who, faced with the turbulent world, think highly of leading a life of seclusion. The mountain rocks are mostly wrinkled and rubbed with a dry brush, and heavy ink is used to sketch the outlines. The painting is full of the feeling of gradation.

This painting was originally mounted vertically, but the Song Emperor Huizong remounted it horizontally during the reign of Xuanhe. It has the character "shen" and a seven-character poem inscribed by Qing Emperor Qianlong. The separate front piece has an inscription by the Song Emperor Huizong, which reads: "Noble Scholar by Wen Xian, Liang Boluan." The end paper includes one more inscription by Qing Emperor Qianlong. More than ten collector seals are present on the painting, including "Xuanhe," "Zhenghe," and "Seal for the Paintings and Calligraphy of the Library of the Palace Treasury" of the Song Palace Treasury, "Seventy-year-old Emperor," "Inscribed by Qianlong," and "Treasure of the Emperor's Father" of the Qing Palace Treasury, "Siyuan Hall" and "Ink Circles" of An Qi, and "Cangyanzi" of Liang Qingbiao, both of Qing. This painting is recorded in *Sequel to the Shiqu Imperial Catalogue of Paintings and Calligraphy*, *The Boat of Calligraphy and Paintings on the Qing River*, *Du Mu's Critical and Descriptive Notes on Paintings and Calligraphy*, *Records of Paintings and Calligraphy in the Summer of the Year of Gengzi*, *Notes on the Shiqu Imperial Catalogue of Paintings and Calligraphy*, *Collections of Professional Paintings*, and *Random Notes on Works in Ink*.

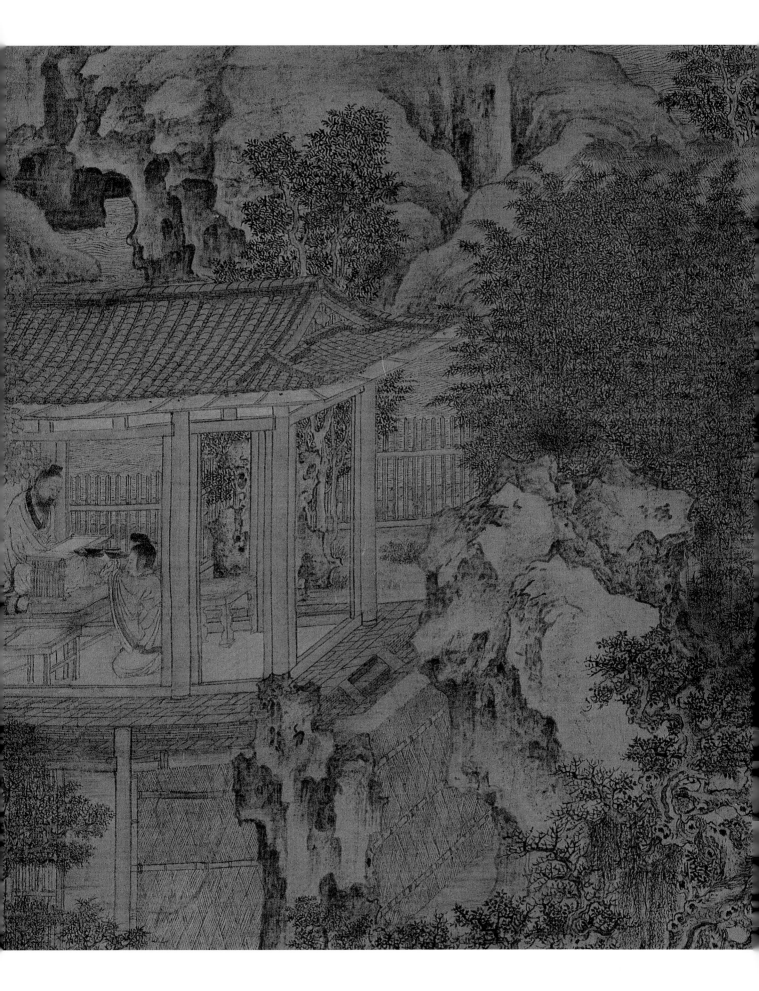

8

The Rivers of Xiao and Xiang

by

Dong Yuan

of

the Five Dynasties

Hand Scroll

Ink and colour on silk

Height 50 cm Width 141.4 cm
Qing court collection

This is a gem of landscape painting by Dong Yuan. Dong Yuan (?–962), styled Shuda, was a native of Zhongling (present-day Jinxian in Jiangxi). He was Vice-Commissioner of the Northern (Rear) Garden during the Southern Tang Dynasty, and he was known as "Dong of the Northern Garden." He excelled in landscape painting and was skilled at painting figures, and beasts. He usually painted real mountains and scenes of Jiangnan. He and his disciple Ju Ran are known together as "Dong and Ju," and they were honoured by the posterity as "the orthodox Southern School." His style of painting had a huge impact on later generations. Zhao Mengfu and Wang Gongwang of the Yuan Dynasty and Shen Zhou and Dong Qichang of the Ming Dynasty, were under his influence.

The painting depicts the scenery of River Xiang. Over the water are green earless reeds with a few small boats. There are also noble people travelling in delight and fishermen raising their nets with their catches. These are painted one by one in fine brush showing a superb skill. On the other side of the river are undulating mountain ranges, planted with luxuriant trees. The inscription of this painting says: "It allows people to visit River Xiang without having to move their feet." The composition adopts the technique of level distance, but with a wide perspective. The method of painting mountains consists in adding, on top of the hemp wrinkles, rain wrinkles in wet ink according to the topography of the mountains, making them green, moist, natural, and simple. The leaves of the trees are also dotted with ink, the thick interlacing with the light, making them free and varied in postures.

The frontispiece of this painting has an inscription by Dong Qichang, its rear separate piece has an annotation by Wang Duo, and the end paper has three annotations by Dong Qichang and one annotation by Yuan Shu. More than ten collector seals can be found on this painting, including "The Shiqu Imperial Catalogue of Paintings and Calligraphy," and "Treasure Perused by Emperor Jiaqing" of the Qing Palace Treasury, "Seal of Yuan Shu" by Yuan Shu, "Shigu Hall" by Bian Yongyu, and "Rare Family Collection of An Yizhou" by An Qi. This painting is recorded in *Random Notes on the Principles of Painting and Calligraphy by Dong Qichang, Soft Painting Catalogue, Records of the Paintings and Calligraphy in the Family Collection of the Antiquity Hall, Classified Records of Calligraphy and Paintings in the Shigu Hall, The Boat of Calligraphy and Paintings on the Qing River, Dream Journey in the Records of Wonderful Sights, Random Notes on Works in Ink*, and *The Shiqu Imperial Catalogue of Paintings and Calligraphy, Volume 3.*

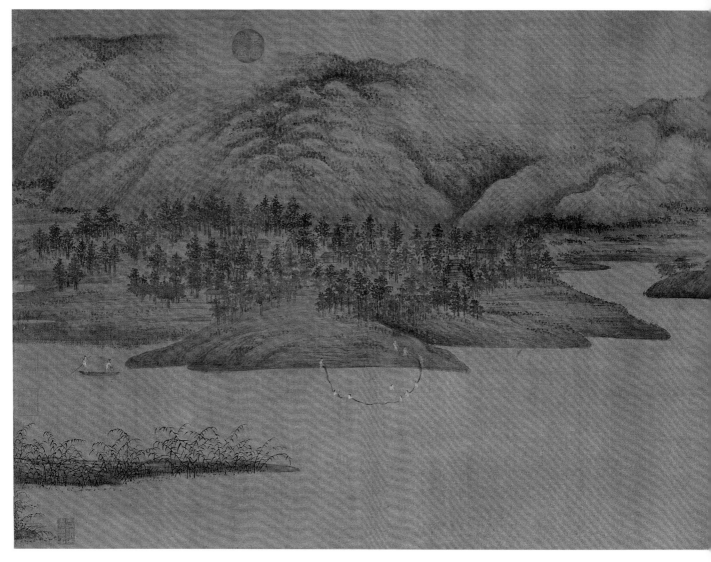

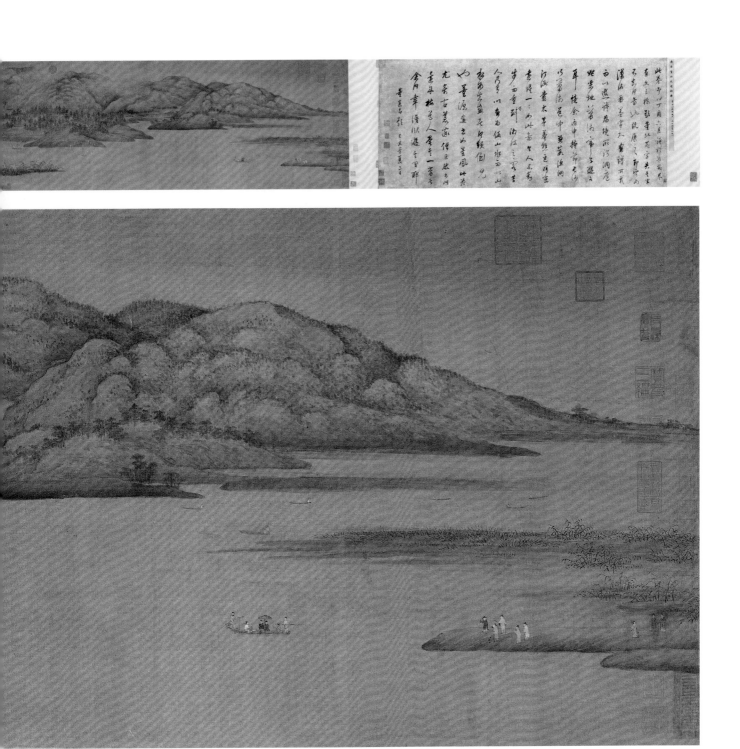

9

Literary Garden

— by —

Zhou Wenju

— of —

the Five Dynasties

Hand Scroll
(Copied in Song)

Ink and colour on silk

Height 37.4 cm Width 58.5 cm
Qing court collection

Zhou Wenju, whose years of birth and death are unknown, was a native of Jurong (belonging to present-day Jiangsu). He was a painter of the Southern Tang Painting Academy and held the position of Academician Awaiting Orders. According to the records in *The Precious Mirror of Paintings*: "His brushstrokes are thin, hard, shaking, and dragging, following the painting method of his master Li Chongguang. As for portraits of beauties, he does not apply the shaking method. His method is close to Zhou Fang, but he surpasses him in fineness and beauty."

This painting depicts a scene in which the Tang poet Wang Changling (698–756), then the Vice Magistrate of Jiangning (present-day Nanjing in Jiangsu), built the Liuli Hall next to his official residence to meet his friends and write poems. The guests included some of his poet friends: the brothers Cen Shen and Cen Kuang, and Liu Shenxu. This painting reproduces the gathering of intellectuals in the Tang Dynasty.

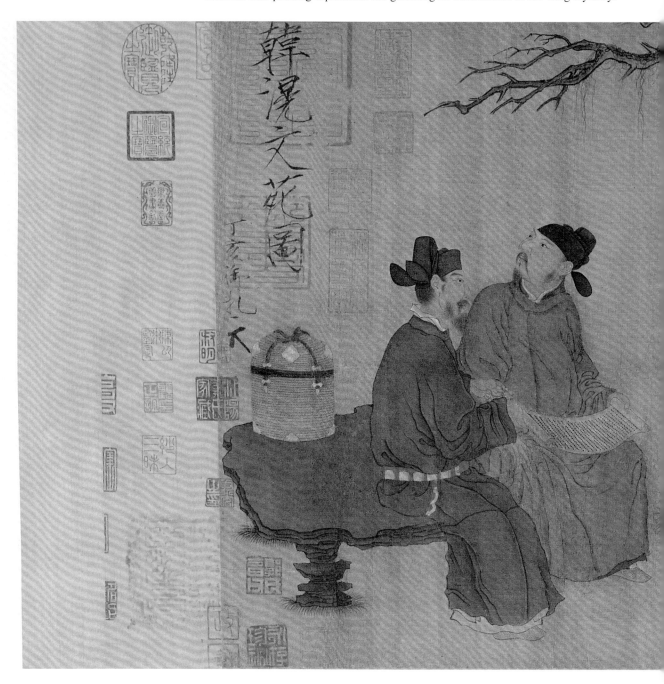

Wrinkles in the characters' clothes are outlined in a thin, strong, shaking, and dragging way. The lines curve and bend, pause and turn, and are full of motion, illustrating the shaking stroke that Zhou Wenju excelled at, i.e. wielding the brush in a slightly shaking way to show the texture of the clothes.

This work bears no name or seal of the painter. It has an inscription of the Song Emperor Huizong, which reads: "Literary Garden by Han Huang, Inscribed by the Emperor in the Year of Dinghai. The Man under Heaven." As a result, it was believed for a long time that this was a painting of Han Huang of the Tang Dynasty. After examination, however, it was confirmed that this painting is the latter part of the hand scroll "Poets at the Liuli Hall" (Copied in the Song Dynasty) by Zhou Wenju. There are dozens of collector seals on the painting, including "Imperial Seal of the Academy of Scholarly Worthies," by Li Yu, last ruler of Southern Tang, "Xuanhe," "Zhenghe," and "Written by the Emperor" of the Song Palace Treasury, "Treasure of the Chonghua Palace," "The Shiqu Imperial Catalogue of Paintings and Calligraphy," and "Treasure Perused by Emperor Qianlong" of the Qing Palace Treasury, "Seal of Appreciation by Guo Hengfu" by Guo Qujie and "Seal of Gu Zhengyi" by Gu Zhengyi, both of Ming, and "Wang Chang'an Fu" by Wang Chang'an in Qing. This painting is recorded in *The Shiqu Imperial Catalogue of Paintings and Calligraphy, Volume 1.*

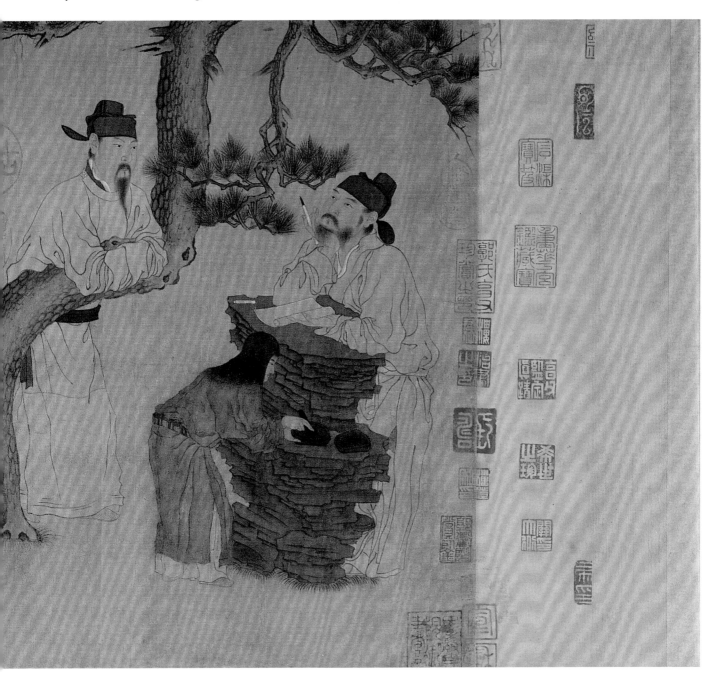

10

Playing Go in Front of a Double Screen

by

Zhou Wenju

of

the Five Dynasties

Hand Scroll
(Copied in Song)

Ink and colour on silk

Height 40.3 cm Width 70.5 cm
Qing court collection

This is an elaborate and realistic style of figure painting that built on the achievement of the portrait painting of the Tang Dynasty, with the characteristics of the "Entertainment in the Palace" of the earlier period. According to records in *Volume 2 of A History of Southern Tang* by Ma Ling of the Southern Song Dynasty, Li Jing (r. 943–961), the second ruler of Southern Tang, made a public announcement that he would pass his throne to his brothers instead of his son in order to prevent his brothers from revolting against him. This painting praises and shows the character of Li Jing, who was considerate in treating his brothers. It portrays Li Jing and his younger brother Jingsui watching how Jingda and Jingtang play go, and the four of them are painted sitting on two couches, shoulder to shoulder. Placed on the couches are utensils for chess competition, such as the pitch pot. Behind the couches is a screen, on which the poetic *Occasional Naps* by Bai Juyi of the Tang Dynasty is painted to express

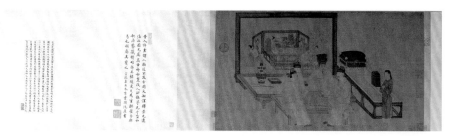

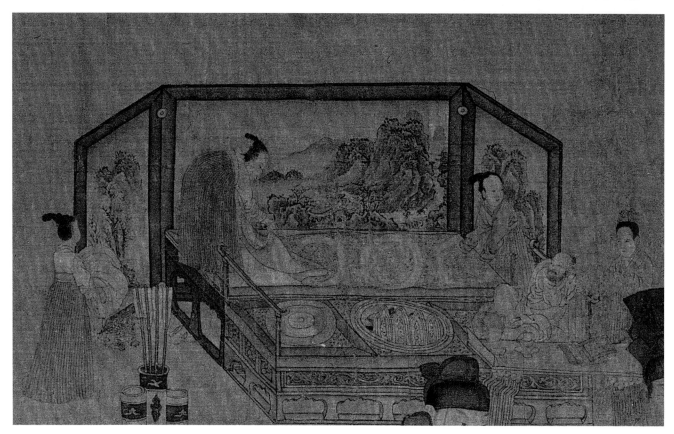

his pursuit of a simple and leisurely life. An additional landscape screen is drawn within the illustration; hence, the painting is called "double screen." The servants in the painting are of short stature so as to make the master of the scene stand out more clearly. The shaking method is used to paint wrinkles in the clothes, which are curved and full of vibrations. The furniture is painted in an elaborate and detailed way, giving a certain feeling of space.

This work bears no name or signature of the painter. In the past, it was ascribed to Zhou Wenju of the Five Dynasties and believed to be his authentic work. After closer examination, it was verified that the painting was a reproduction of Zhou Wenju's work by a Northern Song painter, yet the work was close to the original. The end paper has three annotations, including those by Ming calligraphers such as Shen Du and Wen Zhengming. There are more than ten collector seals on the painting, including "Xuanhe" of the Song Palace Treasury, "Treasure Perused by Emperor Jiaqing," "Imperial Catalogue of Paintings and Calligraphy, Volume 3," "Appreciated by Emperor Xuantong" of the Qing Palace Treasury, and "Rare Family Collection of An Yizhou" by An Qi of Qing. This painting is recorded in *The Shiqu Imperial Catalogue of Paintings and Calligraphy*.

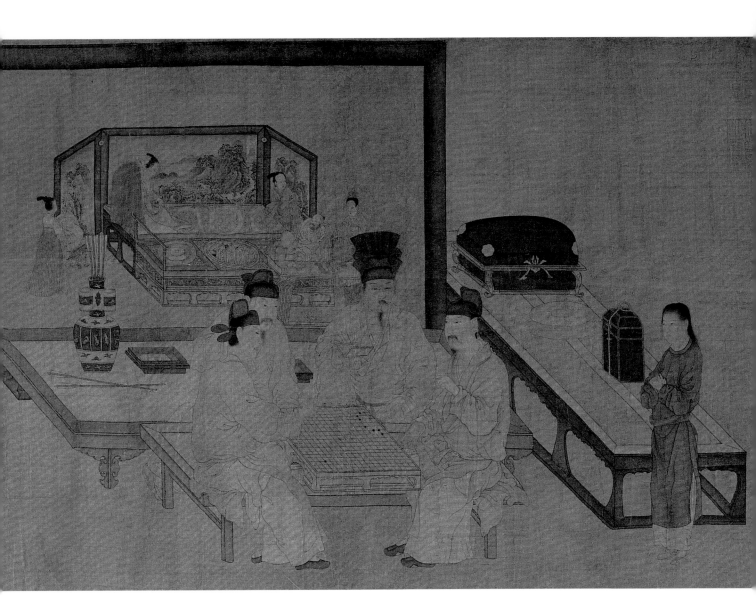

11

The Night Banquet of Han Xizai

——— ascribed to ———

Gu Hongzhong

——— of ———

the Five Dynasties

Hand Scroll

Ink and colour on silk

Height 28.7 cm Width 335.5 cm
Qing court collection

This painting, the earliest extant story figure painting with a sequential plot, is a gem of figure painting of the early Chinese period. In the past, it was thought that this was an original painting by Gu Hongzhong. Now, it is ascertained that this is a copy made in later ages, apparently by someone in the Song Dynasty. Gu Hongzhong, whose years of birth and death are unknown, was active in the tenth century, serving as Expectant Official of the Southern Tang Painting Academy. He received a decree from the emperor to sneak into the residence of Han Xizai to look into the debauched events going on there. He painted this scroll based on his memory.

In the painting, the South Tang Secretariat Drafter Han Xizai (902–970) was depicted as a lustful person who loves to indulge himself in wild night life. He was actually full of worries and used his behaviour as an excuse to avoid being in the service of Li Yu, the last emperor of Southern Tang. The painting is divided into five scenes, with Han Xizai listening to music, watching dances, having a rest, playing the flutes, and seeing off the guests. The layout is the separation of each section with furniture, with figures appearing repeatedly, making up an undulating entity. The furniture is black, and the colour of the figures is interlaced with white, red, and black colours, making the painting full of strong colours without being too staid. The images of all the major figures are consistent, and it can be seen that the painter has a deep foundation in drawing.

The frontispiece of this painting has "The Night Banquet" in seal script by Cheng Nanyun of Ming. The front separate piece has a biographical sketch of Han Xizai by Qing Emperor Qianlong and an inscription by someone in Southern Song. The end paper has annotations by an anonymous author and Ban Weizhi of the Yuan Dynasty, Wang Duo of the Ming Dynasty, Nian Gengyao of the Qing Dynasty, Ye Gongchuo and Pang Yuanji of the modern period. There are around fifty collector seals on the painting, including "Treasure of the Imperial Study," "The Shiqu Imperial Catalogue of Paintings and Calligraphy," "Treasure Perused by Emperor Qianlong" of the Qing Palace Treasury, "Jiaoxun" by Shi Miyuan of Southern Song, "Jiaolin Bookhouse" and by Liang Qingbiao, "Works Verified by Song Luo of Shang Qiu as Authentic" by Song Luo, both of Qing, "Parting is Easy" by Zhang Daqian of the modern period. This painting is recorded in *Records of Paintings and Calligraphy in the Summer of the Year of Genzi* and *The Shiqu Imperial Catalogue of Paintings and Calligraphy, Volume 1*.

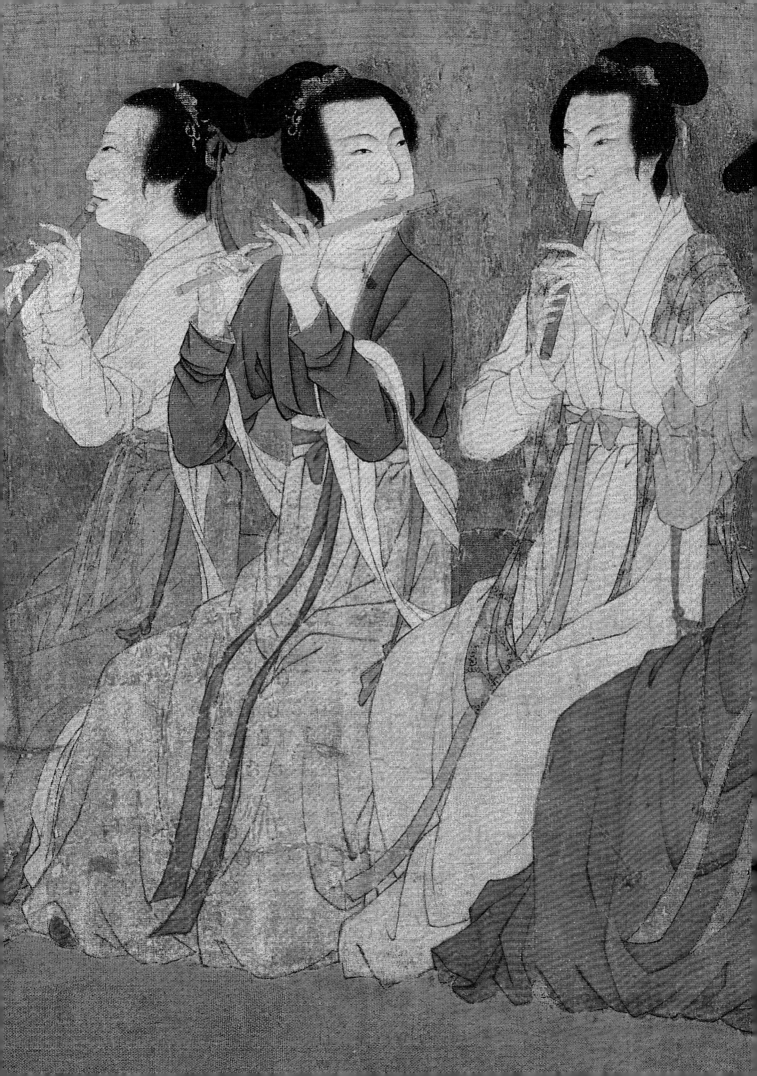

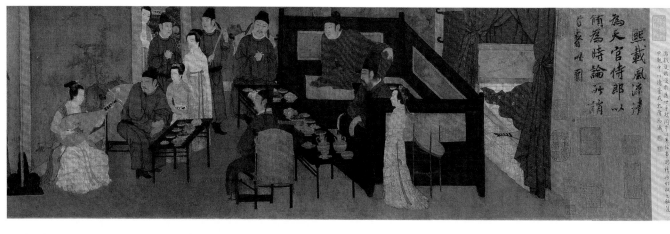

夜寢圖

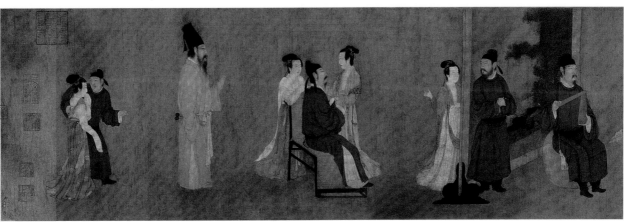

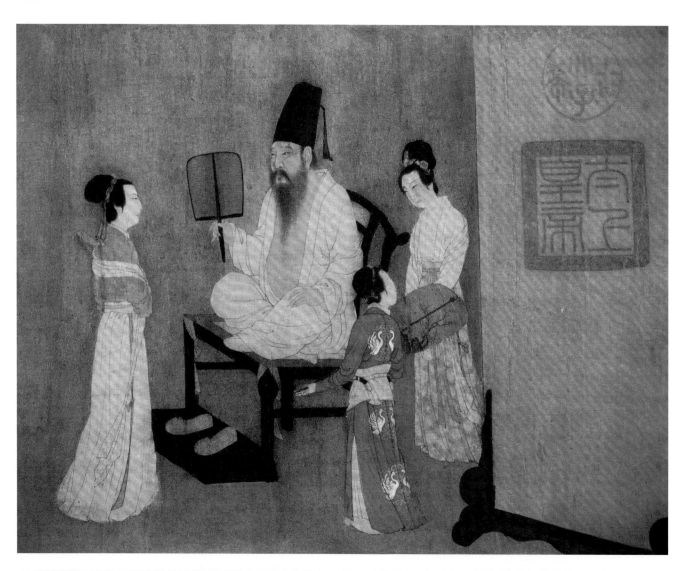

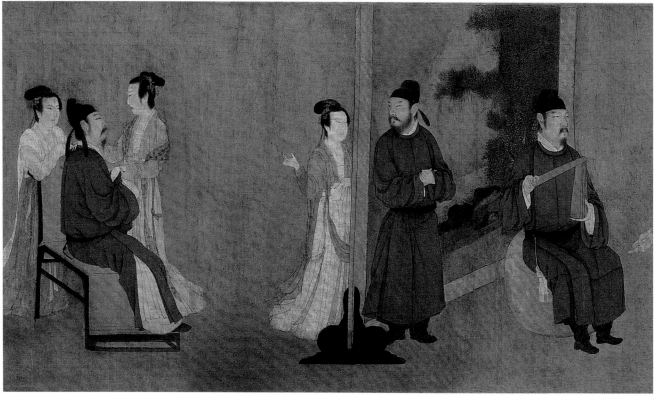

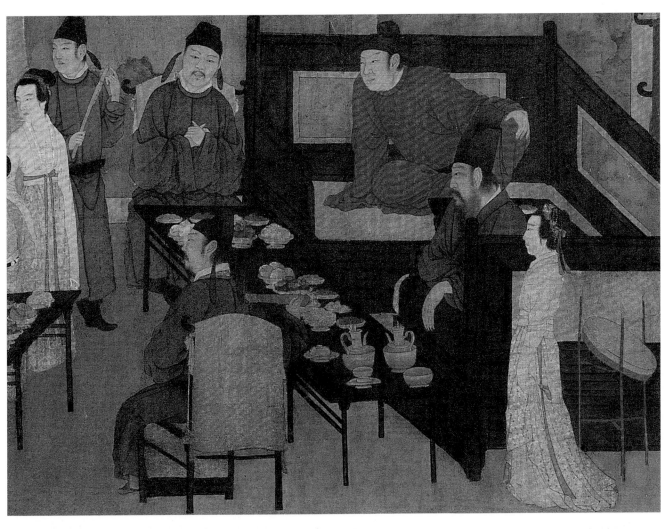

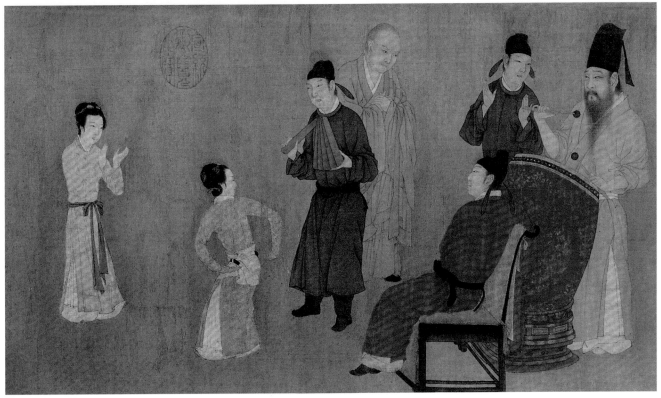

12

Fairies of the Celestial Realm

by

Ruan Gao

of

the Five Dynasties,

Hand Scroll

Ink and colour on silk

Height 42.7 cm Width 177.2 cm

Qing court collection

This painting is the only work of Ruan Gao that has been handed down and it is a masterpiece of the painting of beautiful women that was drawn when he was young. It is uncertain when he was born or when he died. However, it is known that he was a painter of the States of Wu and Yue who was active in the tenth century. It is said in a book on painting history that He "joined officialdom as Court Gentleman for Fasting in the Imperial Ancestral Temple" and that "He captured with his brush all the delicate and beautiful movements of ladies and his Fairies of the Celestial Realm has the atmosphere of jade pools and phantom gardens."

As mentioned above, the painting has jade pools, phantom gardens, as well as green pines, and bamboos. Fairies, surrounded by serving maids, hold brushes in hands with the intention of writing, have books opened as if they were going to be read, or pluck the strings of musical instruments. All sides of the realm are surrounded by seawater and a misty cloudy vapour. There are fairies riding on mythical birds, dragons, clouds, waves, and coming from the surface of the sea with slow paces, from the gaps of mountains, and from the sky, echoing with the numerous fairies who gather together. The figures are structurally complicated and the style of painting is exquisite and refined. The background water patterns are elaborate, and the mountain rocks are sketched with black lines. The background is filled in blue and green.

This work has a poem inscribed by Qing Emperor Qianlong. The end paper has an annotation by Gao Shiqi of Qing, and annotations by Shang Ting and Deng Yu of Ming are counterfeits. There are dozens of collector seals on the painting, including "Treasure Perused by Emperor Qianlong," "The Shiqu Imperial Catalogue of Paintings and Calligraphy," and "Treasure of the Emperor at Eighty" of the Qing Palace Treasury, and "Seal of Gao Shiqi" by Gao Shiqi of Qing. This painting is recorded in *Catalogue of Imperial Paintings in the Xuanhe Era*, *Record of Paintings and Calligraphy Seen by Gao Shiqi*, *Painting and Calligraphy Catalogue of Gao Shiqi*, *Classified Records of Calligraphy and Paintings in the Shigu Hall*, *Dream Journey in the Record of Wonderful Sights*, and *The Shiqu Imperial Catalogue of Paintings and Calligraphy, Volume 1*.

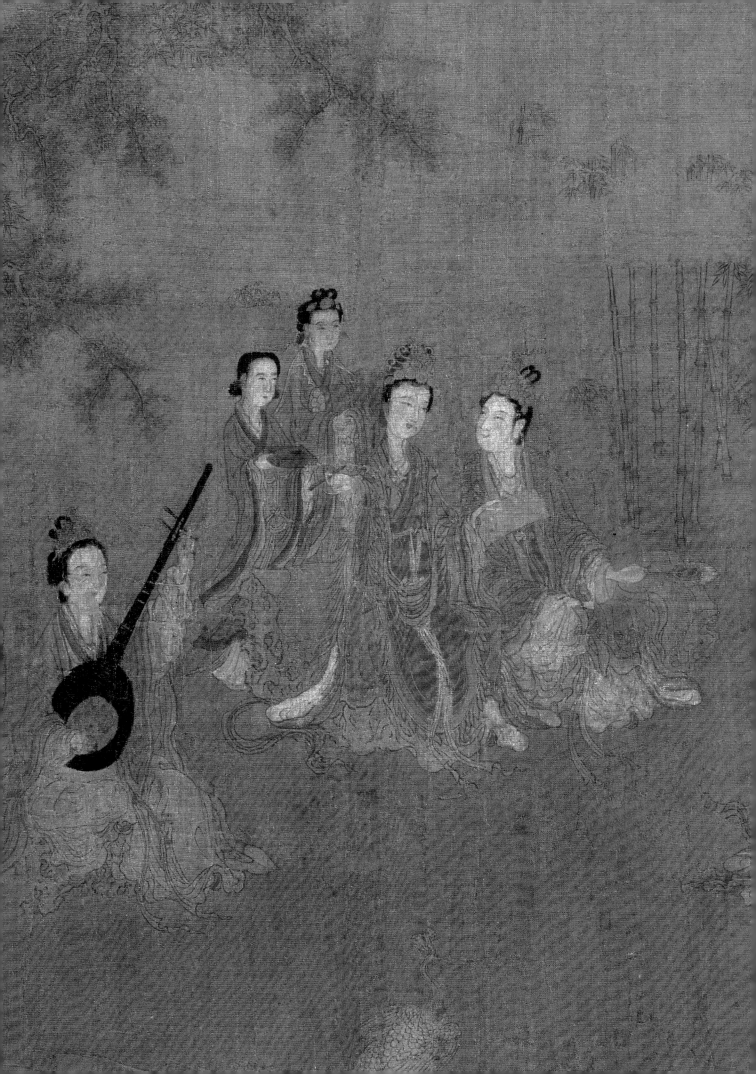

控鶴葉我荒荒墨海
山佳靈勝遊阿逍隨
經是行雲紹鄉十三
壺與小橋靄御鳳
裙襟體婚休言五杵
結屋徐上清氣奇塵
諭諦字法人間漫學
仙周家時奠王家
脏洋速狷餘五代人
不星宣和许什葉初
道岳霜玉崇真
百民春陶延

13

Live Sketches of Rare Fowls

by

Huang Quan

of

the Five Dynasties

Hand Scroll

Ink and colour on silk

Height 41.5 cm Width 70 cm

Qing court collection

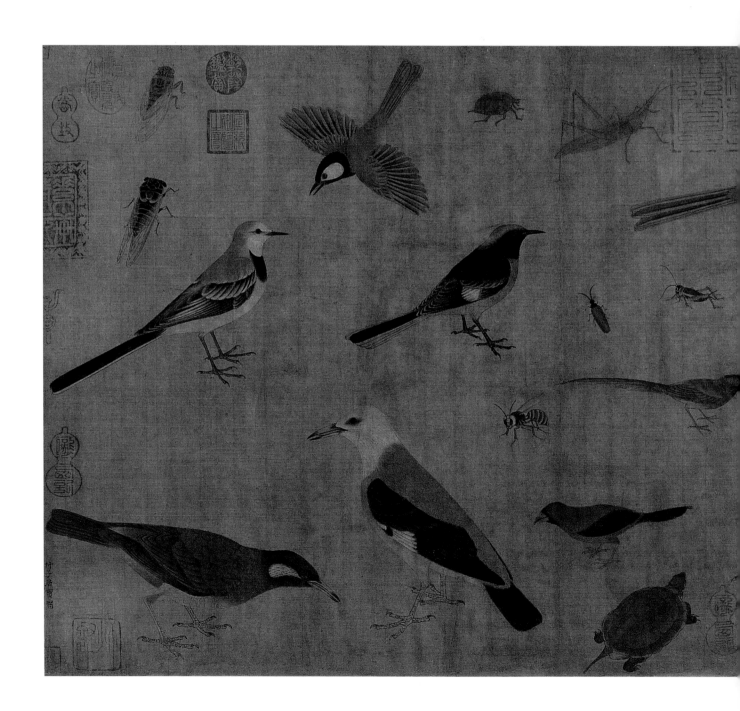

This painting is the only reliable surviving work of Huang Quan. Huang Quan (903–965), styled Yaoshu, was a native of Chengdu in Sichuan. He was a painter of the West Sichuan Painting Academy and served in both Former Shu and Later Shu. With the advent of the Song Dynasty, he served as Left Grand Master Admonisher of the Heir Apparent. He was a disciple of Diao Guangyin. Huang Quan was skilled in painting flowers and birds, and his painting methods were elaborate, exquisite, and beautiful. He used pale ink and light sketches, then coloured them with gold, and this was described as "filling sketches with colour to make them bright and beautiful." That is why his paintings are known for their "Richness of the Huang Family." This style of painting is typical of the painting academies of the Song Dynasty, and affected the painting of flowers and birds of the painting circle of the Northern Song Dynasty for more than a hundred years. Shen Kuo of the Song Dynasty said that "Huang was skilled in the use of colours in painting flowers. His subtle and delicate use of the brush makes it impossible to see any trace of ink, and his paintings consist of five colours. This is what we call live sketches."

In the painting, such as fowls, birds, turtles, and insects, Huang interlaces large creatures with small ones, giving them lively postures, and focusing on depicting the reality. He uses variations in lines to give the sense of texture, such as the flexibility and lightness of birds' feathers, the hardness of turtles' shells, and the transparency of cicadas' wings. His brushstrokes are delicate and his focus is on colours. He used delicate brushwork and light ink to sketch out the framework for his compositions, and later applies colours that cover the ink traces. From this, we can understand Huang's style which is known for its richness of colour and its delicate brushstrokes. As described by Wen Zhengming of the Ming Dynasty, "From the ancient time, no live sketchers can surpass Huang Quan who could draw the spirit and understand the feelings."

This work was entitled by the painter as "To Ju Bao for Practising Painting." It is known that this is a model work that Huang Quan gave to his second son Ju Bao for practising painting. The margin of the mounting has an inscription by Liang Qingbiao of Qing, which reads: "This is *Live Sketches of Rare Fowls* by Huang Quan. The painting was remounted at Jiaolin Bookhouse in the year of Dingsi in the reign of Kangxi." There are dozens of collector seals on the painting, including "East Hall of Wise Thoughts" of the Song Palace Treasury, "Treasure Perused by Emperor Qianlong," "The Shiqu Imperial Catalogue of Paintings and Calligraphy," "Treasure of the Imperial Study" of the Qing Palace Treasury, "Qiuhuo" and "Yuesheng" by Jia Sidao of Song, "Rare Treasure of Jiaolin" and "Taking a Grand View" by Liang Qingbiao of Qing. This painting is recorded in *The Shiqu Imperial Catalogue of Paintings and Calligraphy*.

14

Guanyin in a White Robe

— by —

an Anonymous Painter

— of —

the Five Dynasties

(Painting from Dunhuang)

Ink and colour on silk

Height 52 cm Width 55.2 cm

Dunhuang murals are paper and silk paintings that have survived through the ages and were unearthed from scripture storage caves at Mogaoku of Dunhuang in the early twentieth century. Guanyin in a white robe is rarely seen in Dunhuang murals. This painting, discovered in a stone room at Dunhuang, is the best extant work of this kind in China.

Guanyin in a white robe is one of the numerous images of Guanyin bodhisattva. In the painting, she is sitting cross-legged on a stand. She is wearing a jewelled crown, a Sankacchā inside and a kasaya outside, and her head is covered with white silk. She is holding a willow twig in her right hand and a clean bottle in her left hand, while her feet rest on lotus petals. In front of her stand, there is a glass alms bowl filled with peony. An offerer is kneeling on a square mat, holding a censer from which smoke is released. In the upper corner, appearing on the auspicious clouds, we can observe a vajra pestle and a boy who soars into the sky while scattering down flowers. The lines are mainly iron wires, strong, and powerful. The main colours are blue, red, and white. Parts of the head decorations and floating belts are gilded with rich, strong, and beautiful colour tones.

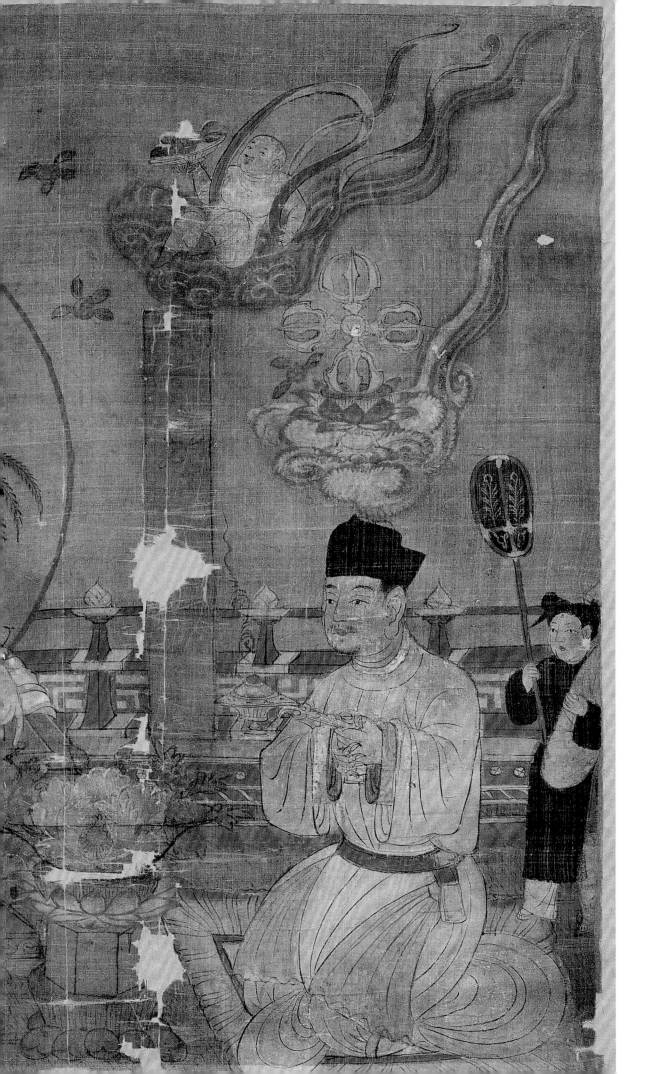

PAINTINGS OF THE NORTHERN AND SOUTHERN SONG DYNASTIES

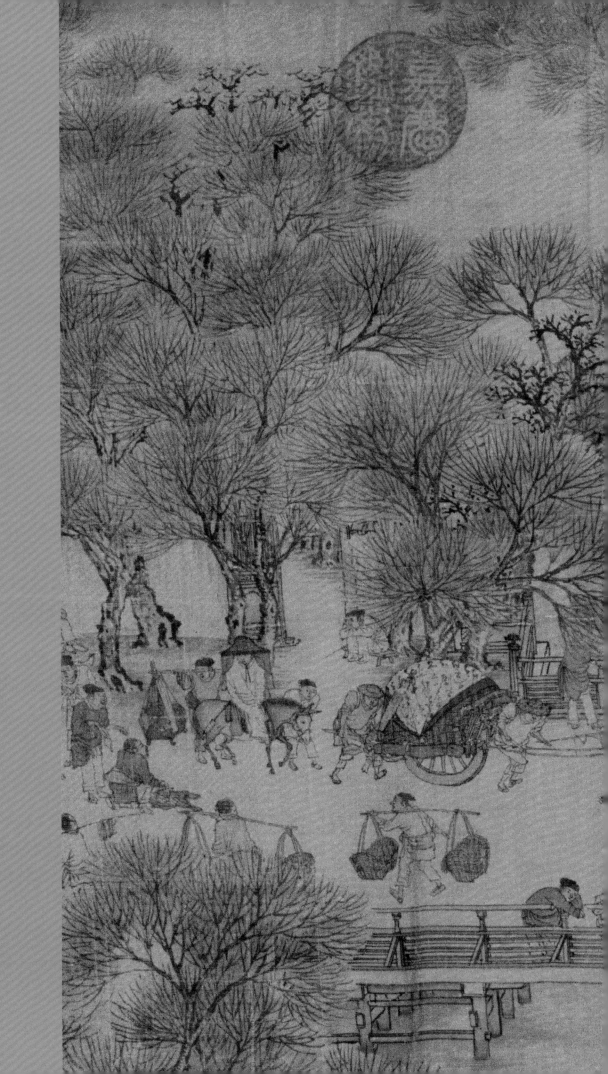

15

Live Sketches of Butterflies

— ascribed to —

Zhao Chang

— of —

Northern Song

Hand Scroll

Ink and colour on paper

Height 27.7 cm Width 91 cm
Qing court collection

The unique brushstrokes of this painting grant it a privileged position among the flowers and birds paintings of the Song Dynasty. However, as pointed out by specialists, the style of this painting is different from the records in the literature which describe Zhao Chang as an artist who was skilled in applying thick and beautiful colours rather than sketching with lines. It was thus concluded that the painting was not produced by him. Zhao Chang, whose years of birth and death are unknown, alias Changzhi, was a native of Jiannan (present-day Chengdu in Sichuan) and was active in the eleventh century. He was a painter of the Northern Song Dynasty who specialized in drawing flowers, grass, and insects. In his early years, he learned painting from Teng Changyou, and called himself Xiesheng Zhao Chang. His contemporaries thought highly of him as his works were recognized by their vividness and richness in colour. Zhao Chang, however, seldom gave his works to others, and as a result, his paintings have rarely found their way down to the present age.

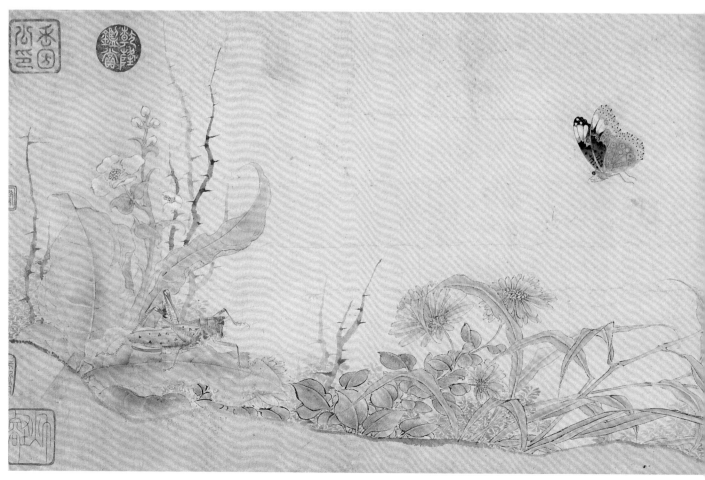

In this painting, we can observe flying butterflies. On the lower part there are red leaves, chrysanthemums, surrounded by growing autumn grass. Hidden under the flowers are some grasshoppers. It is a picture of rustic enjoyment. The red butterflies are drawn in a delicate and elaborate manner, whereas the flowers and the grass are sketched with ink lines. The brushstrokes are skilfully applied, and the colours do not hide the ink. All these features are seldom seen in the flower paintings of the Song Dynasty.

This work has a poem inscribed by Emperor Qianlong. The end paper has an annotation by Feng Zizhen under the orders of Princess Supreme, two annotations by Zhao Yan of Yuan, and Dong Qichang of Ming respectively. Collector seals are also present on the painting, including "Imperial Seal of the Hall of Three Treasures," "The Shiqu Imperial Catalogue of Paintings and Calligraphy," "Treasure of the Imperial Study" of the Qing Palace Treasury, "Qiuhuo" by Jia Sidao of Southern Song, "Official Seal of Jia Sidao" of his official residence in Southern Song, "Paintings and Calligraphy of the Elder Sister of the Emperor" by Princess Supreme of Yuan, "Layman Jiaolin" and "Authenticated by Jiaolin" by Liang Qingbiao of Qing. This painting is recorded in *The Shiqu Imperial Catalogue of Paintings and Calligraphy, Volume 1.*

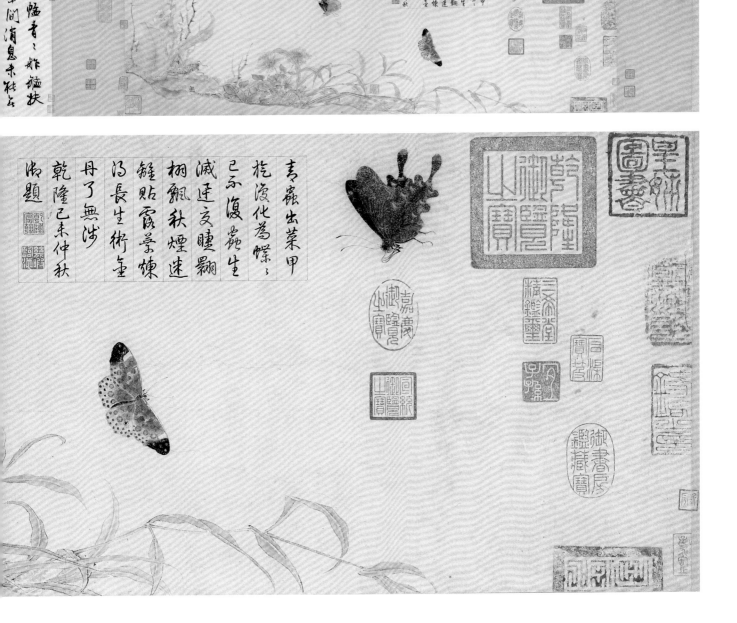

16

Winter Sparrows

by

Cui Bai

of

Northern Song

Hand scroll

Ink and colour on silk

Height 30 cm Width 69.5 cm
Qing court collection

This painting is one of the most representative flowers and birds paintings of the Northern Song Dynasty. Cui Bai, whose dates of birth and death are unknown and whose alias was Zixi, was a native of Haoliang (in present-day Anhui) and active in the eleventh century. He enrolled the Painting Academy in the early years of the reign of Xining of Emperor Shenzong of the Song Dynasty (1068–1077), and proved to be dexterous in painting figures, Daoist and Buddhist ghosts and gods, flowers, birds, and beasts. He painted with realism. His concepts of vividness and simplicity were in contrast with the elaborate style of painting of the Huangquan School which was popular in the Painting Academy of early Song.

In the painting we can see a withered tree with its branches lying horizontally. There are nine sparrows playing around the heads of the branches. Some birds are flying, others, resting or chirping. Their postures are different and lively. The dry and cold environment contrasts sharply with the energetic sparrows, representing vividly an actual scene of the natural world.

The frontispiece of This work has an inscription by Emperor Qianlong which reads: "Picturesque." This work bears the signature of the painter, which reads: "Cui Bai." It also has a poem inscribed by Emperor Qianlong. The end paper has an inscription by Wen Peng of Ming. There are forty-six collector seals on the painting, including "Imperial Seal of the Hall of Three Treasures," "Blessings to Children and Grandchildren," "Treasure in the Collection of the Hall of Happiness and Longevity," "The Shiqu Imperial Catalogue of Paintings and Calligraphy," "Revised Imperial Catalogue of Paintings and Calligraphy," "Sequel to the Shiqu Imperial Collection of Paintings and Calligraphy at the Palace of Serenity and Longevity" of the Qing Palace Treasury, "Paintings and Calligraphy of the Elder Sister of the Emperor" by Princess Supreme of Yuan, "Seal for Calligraphy and Paintings Authenticated by Geng Huihou," and "Geng Jiazuo's Seal for Paintings and Calligraphy" by Geng Jiazuo of Qing. This painting is recorded in *The Shiqu Imperial Catalogue of Paintings and Calligraphy*.

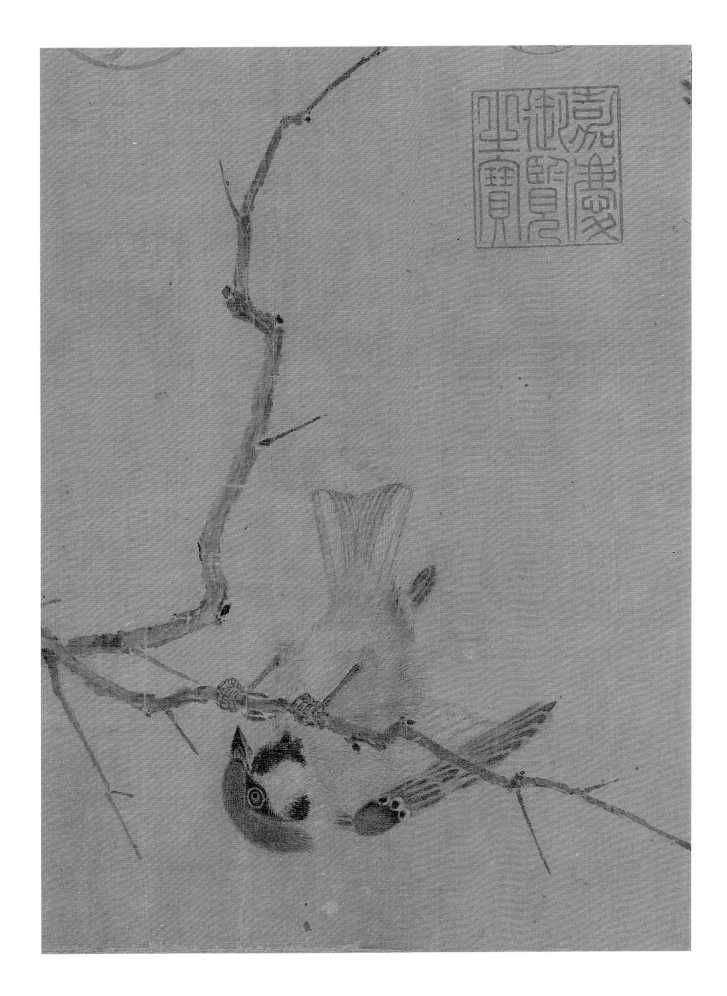

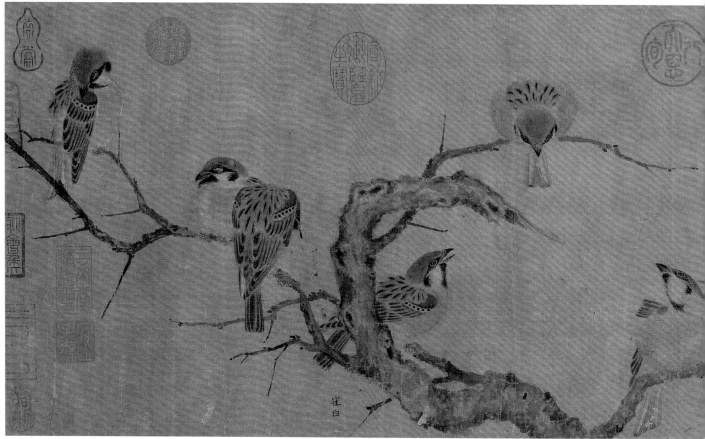

崔白

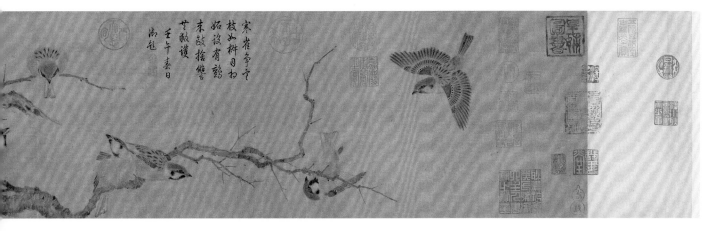

寒雀爭空
枝如棘目拘
始設有鷂
末蔟搖僭
芟敕譏
壬午春日
御題

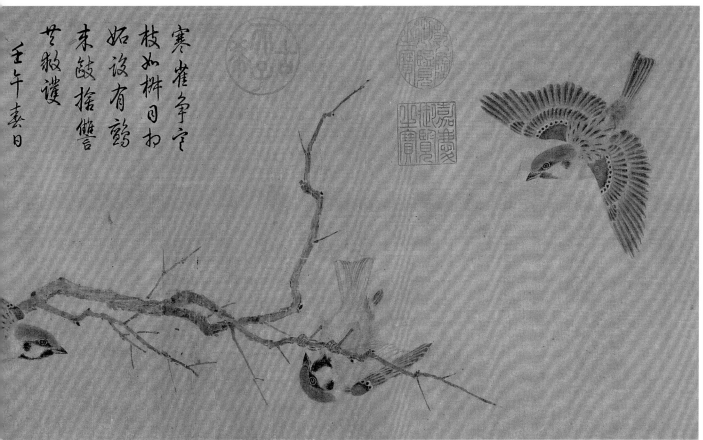

寒雀爭空
枝如棘目拘
始設有鷂
末蔟搖僭
芟敕譏
壬午春日

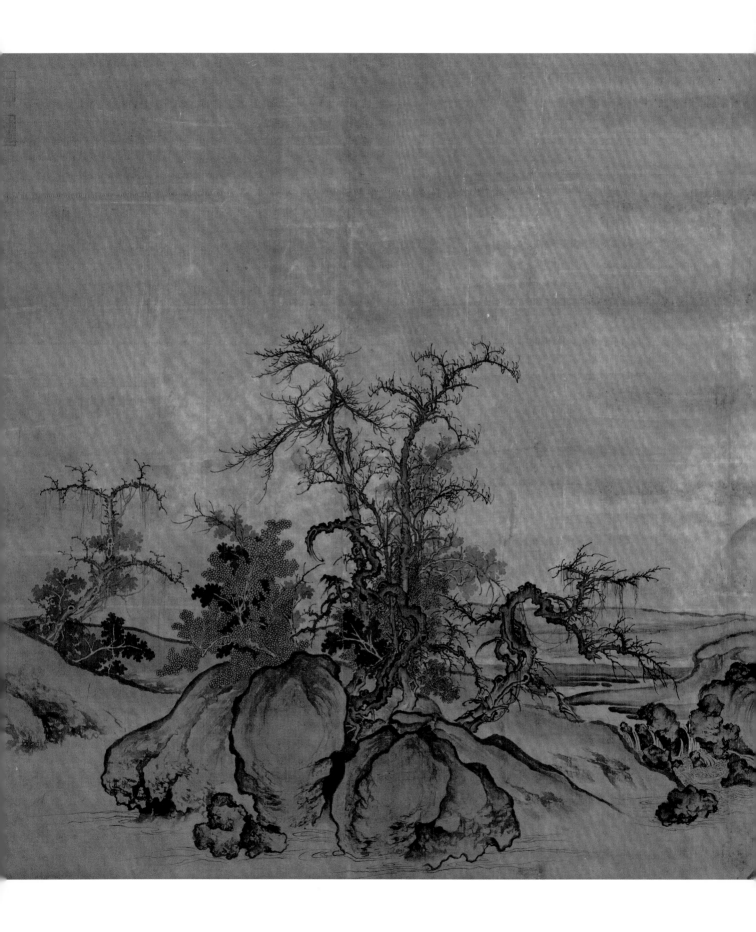

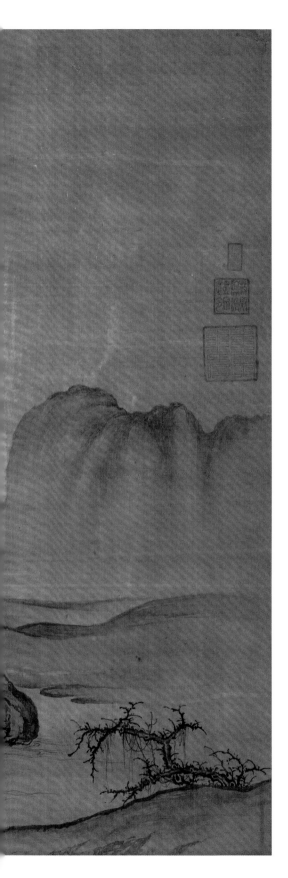

17

Rocks in the Distance

by

Guo Xi

of

Northern Song

Hanging Scroll

Ink and colour on silk

Height 120.8 cm Width 167.7 cm
Qing court collection

This painting is Guo Xi's masterpiece in his late years. Guoxi, whose years of birth and death are unknown, was active in the eleventh century. Guo, also known as Chunfu, was a native of Wenxian in Heyang (present-day Mengxian, Henan). He was called to serve at the Painting Academy during the reign of Emperor Shenzong of the Song Dynasty, holding the position of Chief Academician Awaiting Orders. He was skilled in landscape painting, but only six or seven works have been confirmed as being painted by him. He wrote a book entitled *Linquan Gaozhi*, which had a great impact on the development of landscape painting in later ages.

This painting depicts the wild rural area of northern China in autumn. In the foreground there is a clear and shallow brook with bare rocks along its banks. On the rocks there is a clump of trees with winding branches. Some of these trees have lost all their leaves, while others have retained their old, which are painted with pale ink. In the distance, the chilly mist is dark green, and we can see the vast wilderness and the mountains that lie horizontally like a screen, framed with a vast and clear sky. Guo used the technique of level distance in the layout. The distant scene is seen through the middle scene from the front scene. It is clear layer by layer, showing the distance between the vertical and the horizontal and spaciousness and width. The mountain rocks are drawn with rolling clouds wrinkles. The brush and ink are brisk and neat, full of expression.

The work bears the signature of the painter, which reads: "Rocks in the Distance is painted by Guo Xi, in the year of Wuwu in the reign of Yuanfeng." His seal reads: "Seal of Guo Xi" (red relief). There are more than ten collector seals on the painting, including "Seal of the Directorate of Ceremonial" of the Ming Palace Treasury, "Seal of the Literature of the State of Jin" and "Seal of the Paintings and Calligraphy in the Jin Palace" by Zhu Tong, "Jiaolin," "Taking a Grand View," and "Jiaolin" by Liang Qingbiao.

18

Grazing and the Landscape

by

Qi Xu

of

Northern Song

Hand Scroll

Ink and colour on silk

Height 47.3 cm Width 115.6 cm
Qing court collection

This painting is the only extant work of Qi Xu that has been handed down from his time. Qi Xu, whose dates of birth and death are unknown, was a native of Jiangnan and active in the eleventh century. He excelled at painting flowers, bamboo, beasts, and birds. He was also skilled in painting buffaloes and cow fighting. He was creative in thinking and delicate in his composition. It is said that he inherited the style of Dai Song. His works are lively and full of rural interest, and were praised in *Catalogue of Imperial Paintings in the Xuanhe Era* as "unparalleled in recent ages."

The painting depicts a spring scene in the waterside village in Jiangnan. The rivers are shallow and meandering, the trees green and luxuriant, all enclosed in an atmosphere of spaciousness and remoteness. On the green slope and islet are idling and leisurely buffaloes. Some boys are driving the buffaloes and playing the flute, others are flying kites, and still others are playing the game of grass guessing, exhibiting an atmosphere of peace and tranquility. Dry and thin short lines are used to delineate the buffalo hairs in a technique that involves a delicate way of realism and shows the painter's keen observation and exquisite skill in expression.

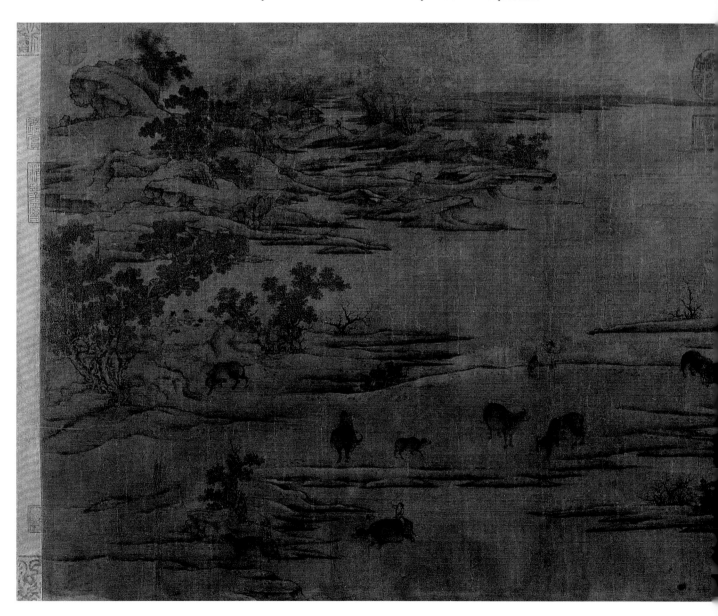

This work has a poem inscribed by Qing Emperor Qianlong. The rear seal is inscribed with "qian" and "long" (red relief, linked). The front separate piece has an inscription of the title by Emperor Zhangzong of Jin, which reads: "Grazing and the Landscape by Qi Xu." Dozens of collector seals can be found on the painting, including "Ming Chang," "Treasure in the Imperial Collection," "Treasure Paintings in the Palace Collection," and "Palace Collection" of the Jin Palace Treasury, "Blessings for Children and Grandchildren," "The Shiqu Imperial Catalogue of Paintings and Calligraphy," and "Treasure Perused by Emperor Qianlong" of the Qing Palace Treasury, "Seal of Geng Zhaozhong's Collection," and "Authentic Collection of Geng Zhaozhong" by Geng Zhaozhong of Qing, "Taking a Grand View" and "Jiaolin" by Liang Qingbiao. This painting is included in *The Shiqu Imperial Catalogue of Paintings and Calligraphy, Volume 1*.

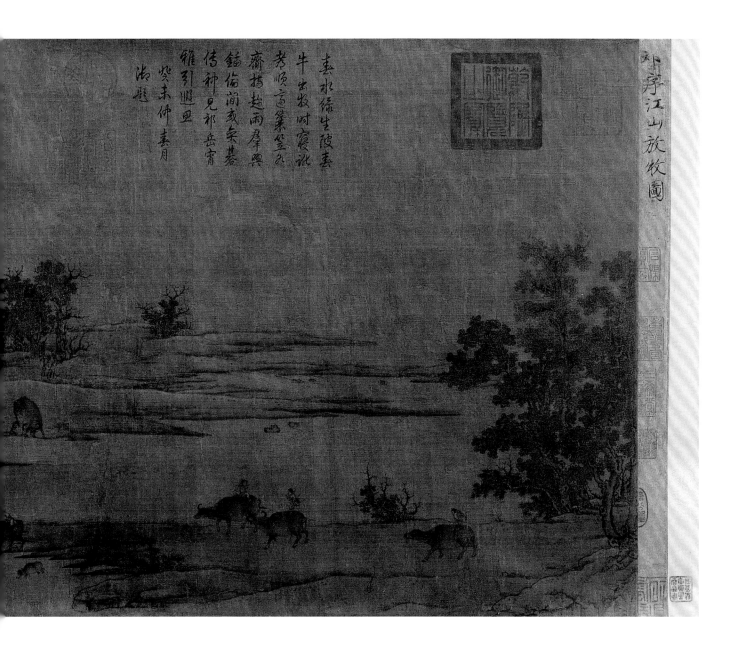

19

Fine Snow on Reedy Sandbanks

— by —

Liang Shimin

— of —

Northern Song

Hand Scroll

Ink and colour on silk

Height 26.5 cm Width 145.6 cm
Qing court collection

This artwork is a painting scroll that Liang Shimin presented to the royal family of Northern Song. Warmth and poetic feelings are perceived in the painter's realistic brushwork and ink. Liang Shimin, known as Xunde and whose years of birth and death are unknown, was a native of Bianliang (present-day Kaifeng in Henan) and active in the eleventh century. He served as Commissioner for Palace Audience Gate of the East and Regional Inspector of Zhongzhou. He was skilled in poetry, calligraphy, as well as painting flowers, birds, and scenes of lakes and villages. His paintings are delicate and elaborate, full of life and vividness.

The scene in this particular work is one of desolation and quietude. The sky is dim and gloomy. The lakes and islets are covered in snow. There are two waterbirds perching besides the aloe plants on the islet, and a pair of mandarin ducks play in the chilly water. The implication of the painting is analogous to the imperial poem inscribed by Qing Emperor Qianlong: "One's loyalty will not be changed by severe coldness." The brushstrokes and ink are serious and elaborate, and the colour is pale, beautiful, and light, which is a paradigm of the style of the Painting Academy of Northern Song.

The work exhibits the signature of the painter, which reads: "Fine Snow on Reedy Sandbanks by Official Liang Shimin." It has a poem inscribed by Emperor Qianlong, The characters on the seal read: "Qian" and "Long" (red relief, linked). The front separate piece has an inscription by Emperor Huizong of Song, which reads: "Liang Shimin, Fine Snow on Reedy Sandbanks." The end paper has a poem inscribed by Zhao Yan of Yuan and an annotation of Zhu Biao of Ming. There are dozens of collector seals on the painting, including "Written by the Emperor," "Seal of Double-dragon Patterns," "Xuanhe," and "Zhenghe" of the Song Palace Treasury, "Treasure Perused by Emperor Qianlong" and "The Shiqu Imperial Catalogue of Paintings and Calligraphy" of the Qing Palace Treasury, "Paintings and Calligraphy of the Elder Sister of the Emperor," by Princess Supreme of Yuan, and "Fisherman Fishing in a Stream" and "Seal of the Paintings and Calligraphy of Liang Shi Jiaolin" by Liang Qingbiao of Qing. This painting is recorded in *Catalogue of Imperial Paintings in the Xuanhe Era*, *The Shiqu Imperial Catalogue of Paintings and Calligraphy, Volume 1*, and *Collections of Professional Paintings*.

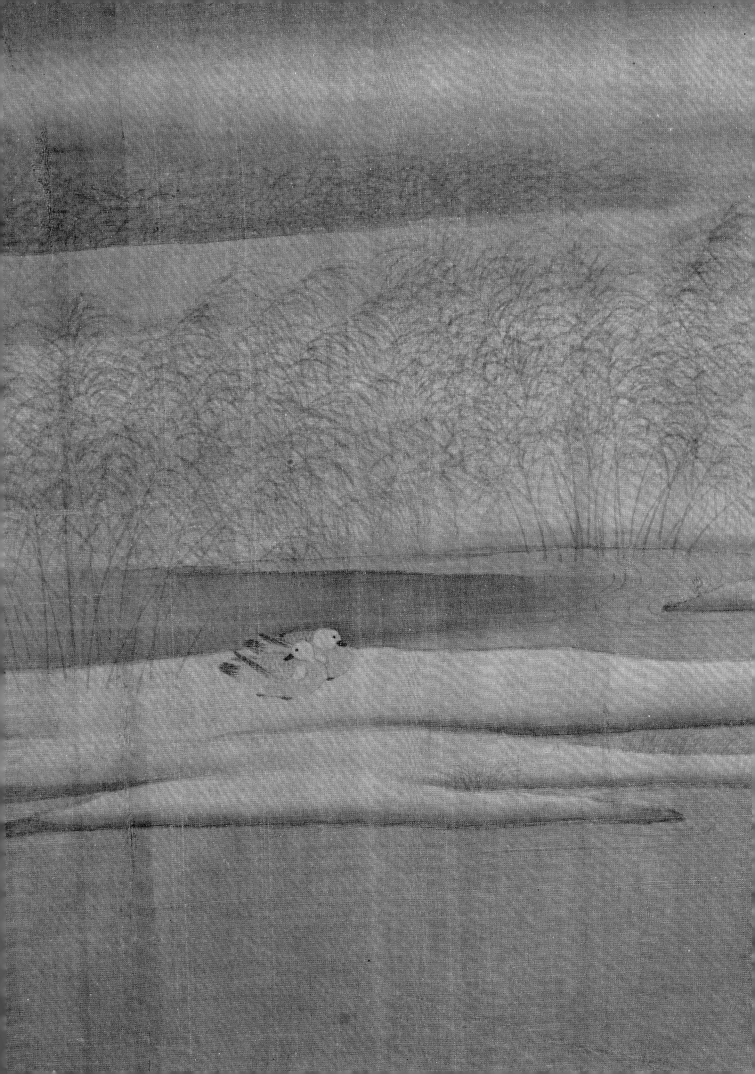

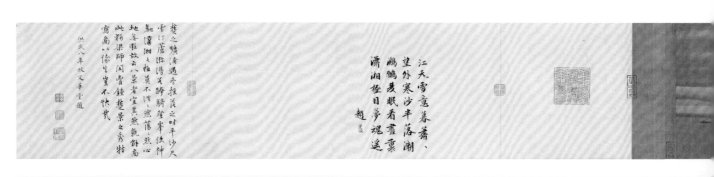

江天雪意蒼蕭、
望外寒沙半落潮
鴻鵠麦眠看畫裏
瀟湘極目夢魂遙

趙巖

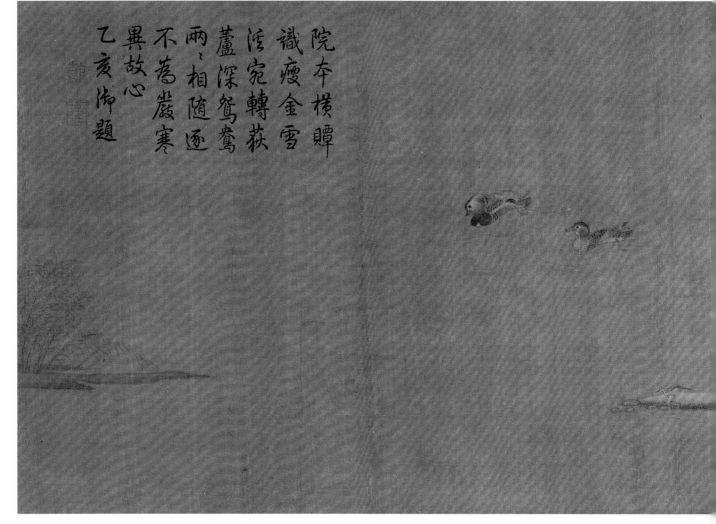

院本橫贉
識瘦金雪
清宛轉荻
蘆深鴛鴦
兩〜相随逐
不為嚴寒
異故心
乙亥御題

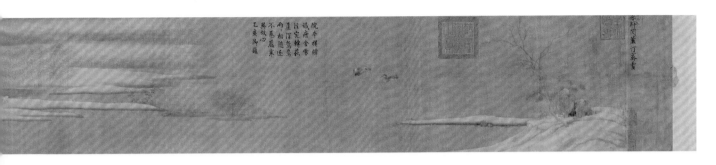

院本棋
諳應金雪
涯宛輪荻
蓷深駕烏
兩相遁連
不為虞其
崴收心
乙亥陽題

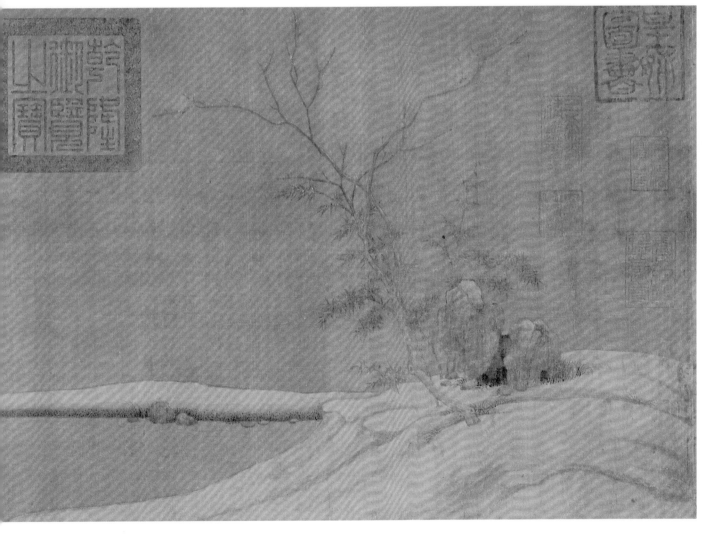

20

Fishing Village after Snow

——— by ———
Wang Shen
——— of ———
Northern Song
Hand Scroll

Ink and colour on silk

Height 44.4 cm Width 219.7 cm
Qing court collection

This painting was made after the banishment of Wang Shen, which reflects the painter's aspiration of leading a secluded and simple life. Wang Shen (1036–cir 1093), styled Jinqing, was a native of Taiyuan in Shanxi. His wife was the eldest daughter of Emperor Yingzong of the Song Dynasty and was titled Princess Supreme of the State of Wei. He, on the other hand, was Commandant-escort and served as Surveillance Commissioner of Dingzhou. He befriended Su Shi and Mi Fu. He was versed in assessing artworks and his studio Baohui Tang had an extensive art collection. He was also skilled in both calligraphy and painting. In painting, he was inspired by the works of Li Sixun and Li Cheng of the Tang Dynasty, but created a new style, becoming a painter in his own right.

This painting depicts the scene of a riverside village after a light snow when the sky starts to clear up. Green pines, like legendary small dragons with horns, cover the towering peaks and deep valleys. The slopes and islets are in severe cold. The elderly people visit friends with their musical instruments. Fishermen either cast their nets or go fishing, wading into water to do their work. Taverns hoist their flags high, and water birds cluster over the mist-covered waters. The painter uses hemp wrinkles to show the mountains and hills and the bitter green to colour the sky and streams. He also borrows the Northern Song painter Guo Xi's method of crab claws to paint trees, gilding the tree branches and dead reeds and powdering the treetops and boat awnings, which reproduces in a lively way a scene in which the sky is vaguely about to be cleared up and the myriad things glow in bleakness amidst a haze. The brushstrokes are precise and terse and the aura is noble, beautiful, luxuriant, and smooth.

Both the front of the painting and the area where it joins with its rear separate piece have an inscription by Emperor Qianlong. The front separate piece also includes an inscription by the Song Emperor Huizong, which reads: "Fishing Village after Snow by Wang Shen." The end paper has annotations by Nian Gengyao and Song Luo of Qing. There are also annotations by Jiang Pu, Liu Tongxun, Wang Youdun, Qiu Yuexiu, Liu Lun, Guan Bao, Peng Qifeng, Yu Minzhong, Dong Bangda, Jin Deying, Wang Jihua, and Qian Rucheng, all of the Qing Dynasty. An inscription of a poem by Emperor Qianlong in the years of Gonghe is also present. There are dozens of collector seals on the painting, including "Xuanhe" and "Zhenghe" of the Song Palace Treasury, "Treasure Perused by Emperor Qianlong," "The Shiqu Imperial Catalogue of Paintings and Calligraphy," and "Treasure of the Seventy-year-old Emperor with Five Types of Fortune and Five Generations Living Together" of the Qing Palace Treasury, and "Jin Bosheng" by Jin Bosheng of the modern period. This painting is recorded in *Catalogue of Imperial Paintings in the Xuanhe Era*, *The Shiqu Imperial Catalogue of Paintings and Calligraphy, Volume 1*, *Dream Journey in the Records of Wonderful Sights*, and in *Collections of Professional Paintings*.

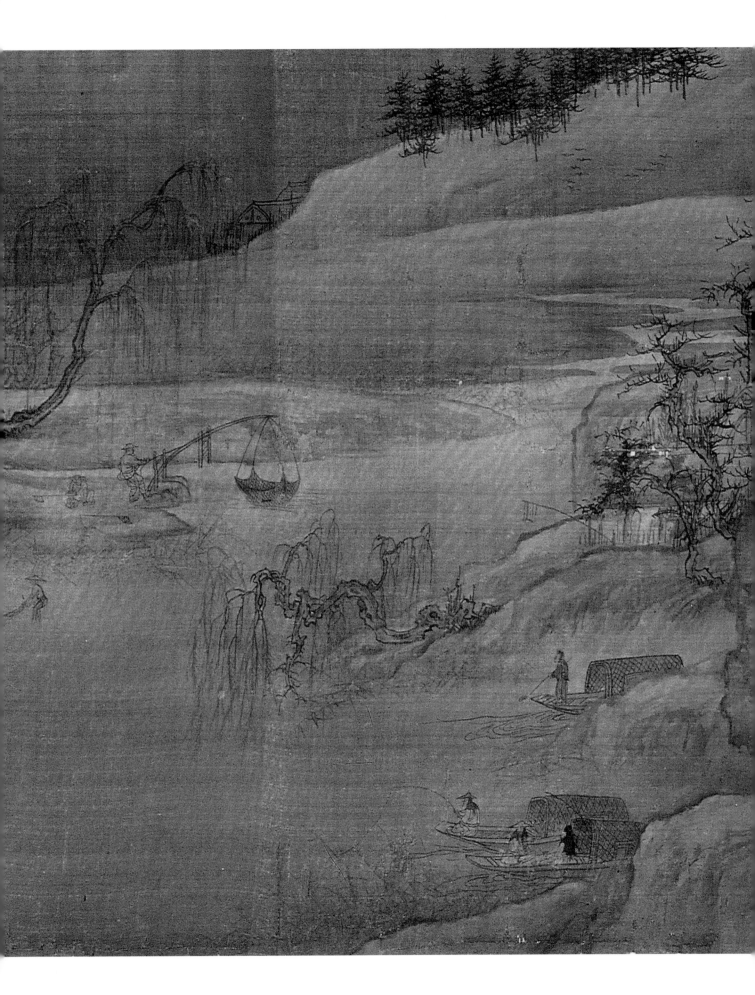

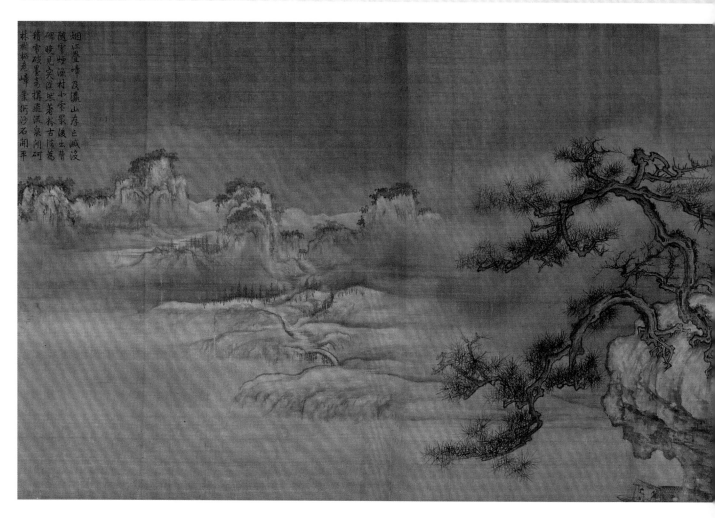

烟江疊嶂及瀟山存已藏没
隨雲煙漁村小室最後出曾
碑映見突徑延著柘古陵蒿
積雪破量高撑飛流泉閃砢
林楠栖老嶂生術沙石澗平

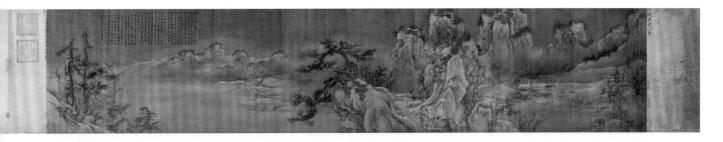

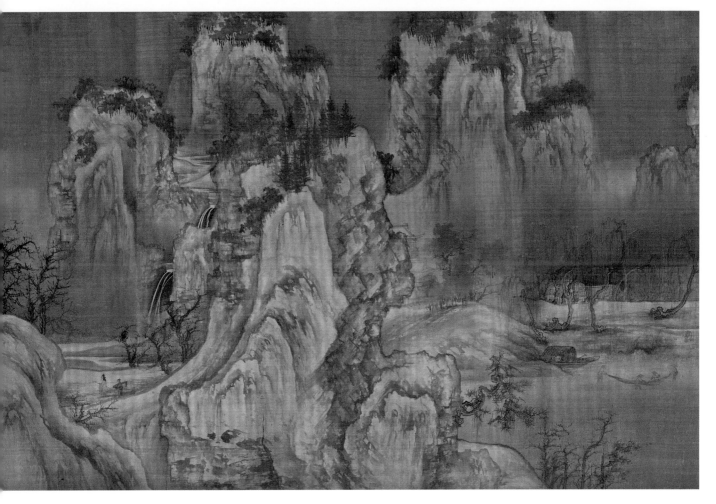

21

Painting after Wei Yan's Pasturing Horses

by

Li Gonglin

of

Northern Song
Hand Scroll

Ink and colour on silk

Height 46.2 cm Width 429.8 cm
Qing court collection

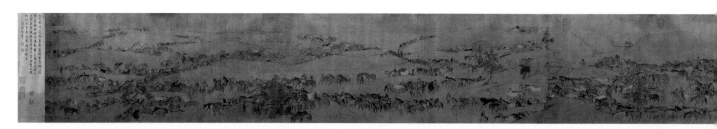

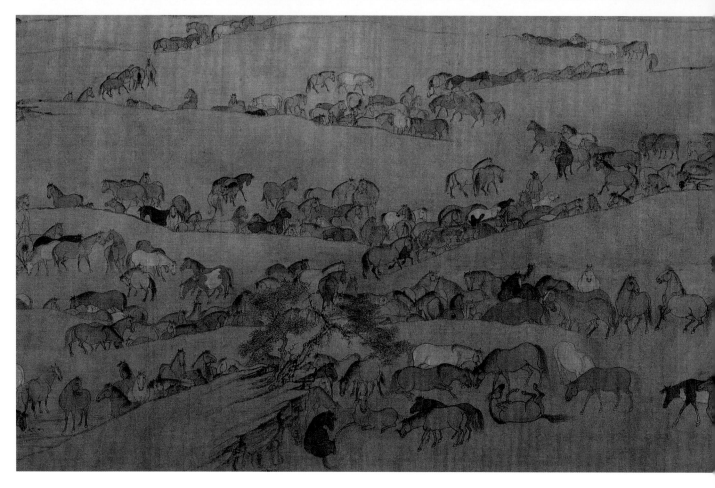

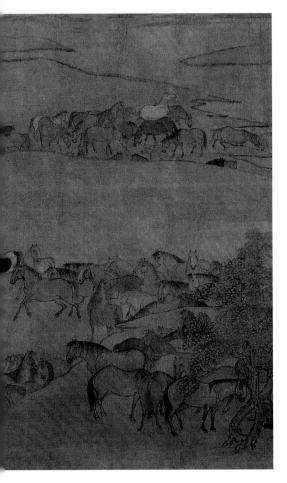

This painting is a large work in which Li Gonglin combines the ancient painting methods with his own painting style. Li Gonglin (1049–1106), styled Boshi and Longmianjushi, was a native of Shucheng (belonging to the present-day Anhui). He passed the imperial examination and obtained the degree of *jinshi* (metropolitan graduate) in 1070, or the third year of the reign of Xining in Northern Song. The highest official position he held was Censor and Legal Researcher. Later, he retired to Mount Longmian to live in seclusion and started calling himself Hermit Longmian. He was knowledgeable and talented in art. He also excelled in poetry and calligraphy, and was skilled in the appreciation and verification of artwork. He was good at sketching. He is said to have learned from Wu Daozi in the so-called "sweeping away of the powder and pigments to paint with light brush and slight ink," which exerted a huge impact on subsequent painters. He was on good terms with Su Shi and Wang Anshi, who held him in high regard.

Wei Yan was a well-known painter of horses in mid-Tang. Though this is a painting by Li Gonglin who copied the work of Wei Yan, judged by the brushwork, it is clear that it has the style of the Song painters. There are more than twelve hundred horses in the painting with more than one hundred and forty herdsmen, making the scene a spectacular one. The layout of the horses on the painting is dense at the front and sparse at the rear. The images of figures and horses are based on line sketching in ink with the use of light colours. The lines are strong, and the colours are classic and simple.

This work bears the painter's signature, which reads: "Painting after Wei Yan's Pasturing Horses by Li Gonglin of Northern Song by Order of the Emperor." The front of the painting and the rear separate piece has a poem inscribed by Qing Emperor Qianlong. The end paper has an annotation by Zhu Yuanzhang, the first emperor of Ming, and a line of inscription by Emperor Qianlong. There are more than fifty collector seals on the painting, including "Xuanhe," "Zhenghe," "Shao," "Xing," "Imperial Literature Library in the Xuanhe Period," of Song, "Seal of the Reign of Wanli" and "Paintings and Calligraphy of the Emperor" of the Ming Palace Treasury, "Treasure Perused by Emperor Qianlong" and "Sequel to the Shiqu Imperial Catalogue of Paintings and Calligraphy at the Palace of Serenity and Longevity" of the Qing Palace Treasury, "Xu Shi Rengsun of Jiangnan, Doctorate of Calligraphy in the Reign of Xuanhe" of the Song Palace Treasury, "Seal of Sun Chengze" of Ming, and "Seal of Liang Qingbiao" of Qing. This painting is recorded in *Sequel to the Shiqu Imperial Catalogue of Paintings and Calligraphy*, *Notes on the Shiqu Imperial Catalogue of Paintings and Calligraphy*, and in *Records of Paintings and Calligraphy in the Summer of the Year of Gengzi*.

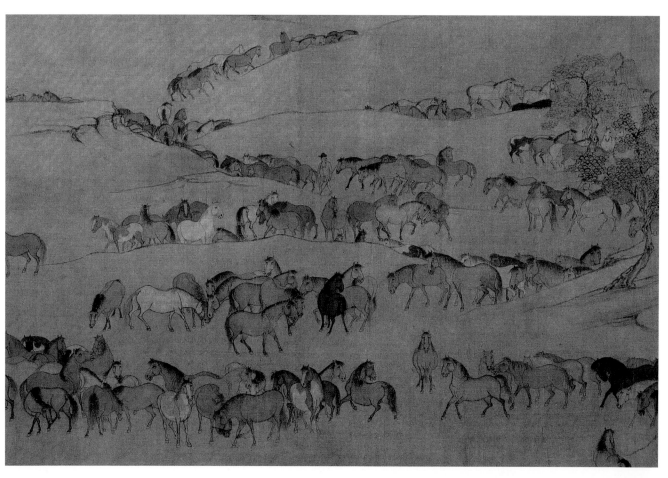

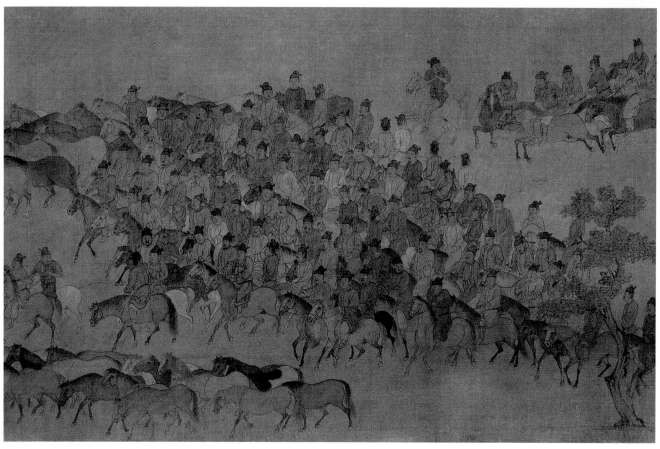

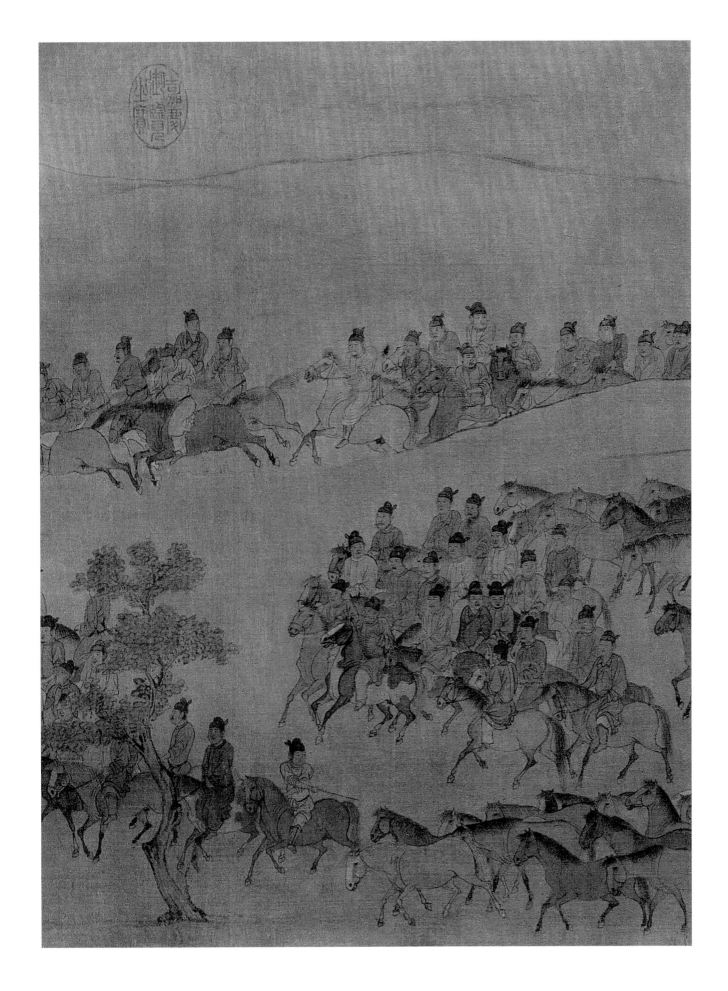

22

Vimalakirti Preaching Buddhism

———— ascribed to ————

Li Gonglin

—— of ——

Northern Song

Hand Scroll

Ink and brush sketches on paper

Height 34.6 cm Width 207.5 cm
Qing court collection

This painting shows the high artistic skills of the artist in using lines to form shapes. Since this painting bears no signature or seal of the painter, there is still controversy as to its authorship. Dong Qichang and Wang Zhideng said in their postscripts that it was a work by Li Gonglin, but there are others who believed that it was a painting by Ma Yunqing of Jin (Jurchen) or by an anonymous painter of the Song Dynasty.

This painting depicts Manjusri visiting Vimalakirti to enquire about his illness. Vimalakirti was a lay practitioner of Buddhism who lived in Vaisali in ancient India and was proficient in debating. He feigned an illness and stayed at home, waiting for visitors to come and debate Buddhism with him. Manjusri followed the instructions of Sakyamuni and went to enquire about Vimalakirti's illness. In the painting, Manjusri is sitting on a waisted throne, with his feet resting on lotus petals. The lion legions lie on his side. Behind the throne are bodhisattvas, mendicant monks, and elders. Further back is the King of Khan in warrior attire. Vimalakirti sits on the couch. His face is emaciated. His right hand points ahead and his left hand holds a deer-tailed fan. Behind the couch, there are monks sitting on their knees, a maid holding an alms bowl, with Vaisravana standing further behind. In between, the Buddha's Todoroki and the goddess generated from Vimalakirti stand facing each other. The goddess holds flowers and, at the same time, intends to release them, a metaphor of debating Buddhist scriptures. Placed between them on the incense table is a lion-shaped censor, with fragrant vapour coming out from its mouth. The entire scroll is painted by plain sketching with ink and brush. The shape of the figures is elegant and detailed. The models of the furniture are lifelike and exquisite.

As mentioned above, the work bears no signature or seal of the painter. The end paper has an annotation and a text of the *Heart Sutra* written by Shen Du of Ming, two annotations by Dong Qichang, and another annotation by Wang Zhideng. There are dozens of collector seals on the painting, including "Treasure Perused by Emperor Xuantong," "Imperial Seal of the Wuyi Imperial Studio" of the Qing Palace Treasury, "Seal of Ke Jingzhong" by Ke Jiusi of Yuan, and "Seal of Paintings and Calligraphy in the Collection of the Songgotu Family in Changbai" by Songgotu of Qing. This painting is recorded in *Catalogue of Buddhist and Daoist Works in the Qianlong Imperial Collection, Volume 1*.

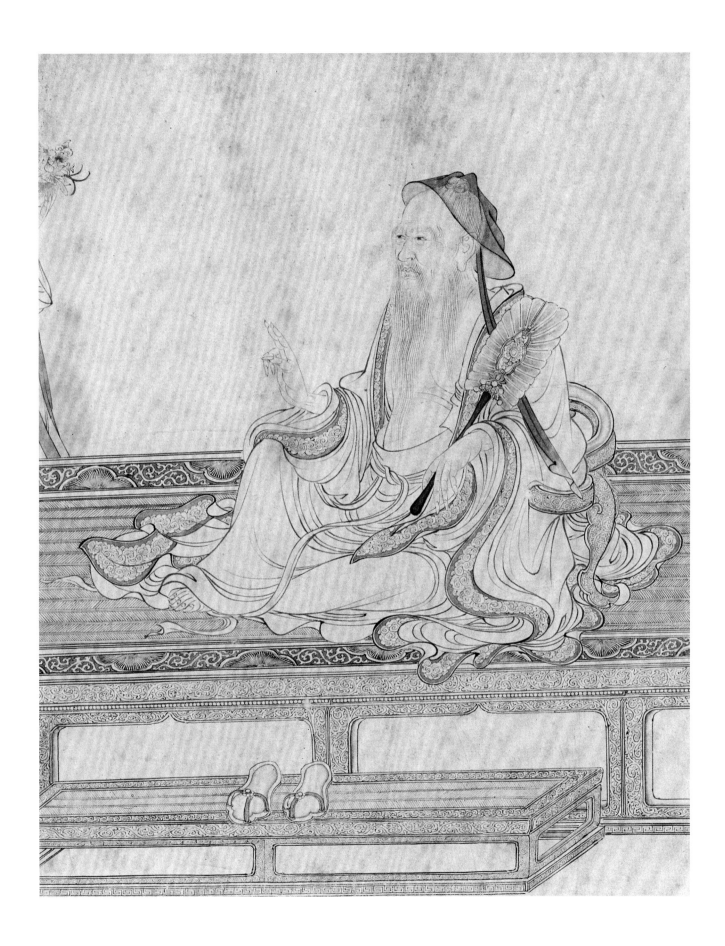

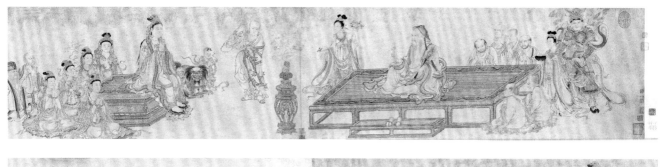

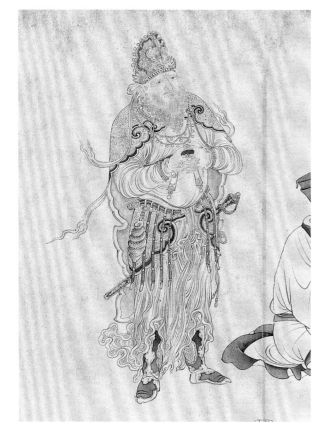

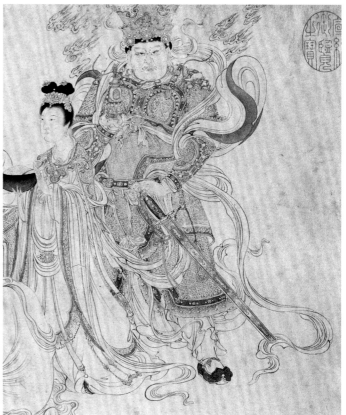

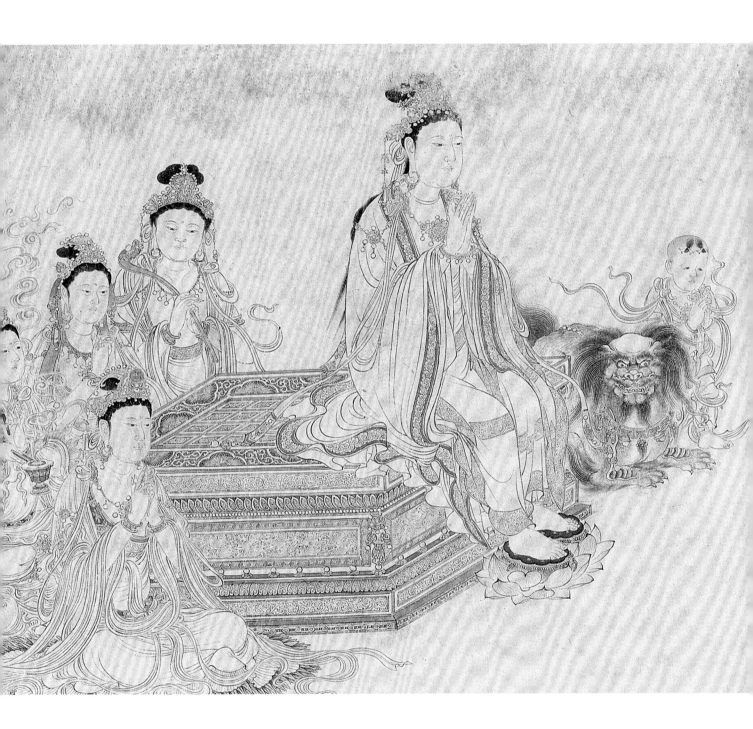

23

The Riverside Scene at the Qingming Festival

— by —

Zhang Zeduan

— of —

Northern Song

Hand Scroll

Ink and colour on silk

Height 24.8 cm Width 528.7 cm
Qing court collection

This painting is the only work handed down by Zhang Zeduan and has the reputation of being "the top spiritual work in China." Zhang Zeduan, whose years of birth and death are unknown, was active in the twelfth century. He was known as Zhengdao and came from Dongwu (present-day Zhucheng in Shandong). When he was young, he went to Bianliang to study, but later he concentrated on learning painting. He served as Expectant Official of the Imperial Painting Academy during the reign of Xuanhe in Northern Song (1119–1125). He excelled in boundary drawing. All the boats, carts, town bridges, and city lanes that he painted could "indirectly show their miens to the full," in a style that was uniquely his own.

This painting depicts the scene of Bianliang (present-day Kaifeng in Henan), capital of Northern Song, at the time of the Qingming Festival. The composition is in the form of a horizontal scroll. It can be divided into three sections, treating the complicated scene in a systematic manner. The first section describes a scene in the outskirts of Bianliang. There are willow trees, thatched huts, ridges between fields, vegetable plots, and hinnies carrying goods. The middle section shows the Bian River, which threads through the town. On the riverbanks are all sorts of shops, guesthouses, and godowns. The bustling pedestrians from all walks of life are conversing among themselves, and their movements are lively. When the boat sails through the arched bridge, the people on the boat, the bridge, and on the riverbanks greet each other. The

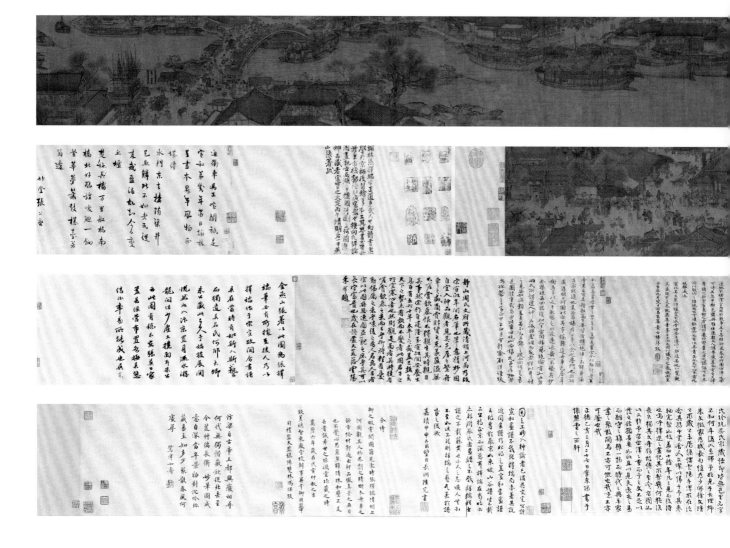

last section shows a scene inside and outside the town gate. The city walls are overgrown with trees and the camel caravans pass through the town. Inside the town, crowds of people show their prosperity.

This painting reproduces faithfully the life of the ordinary people in the capital of Northern Song. In fact, many of the scenes in the painting have been verified by historical books such as the *Reminiscences of the Eastern Capital*. The entire painting is drawn mainly by line sketching; some lines are by ruled strokes or straight rulers, and others are by freehand strokes. The use of brush is flexible, every stroke is sharp and detailed, and the colour is pale, simple, and elegant. The towers and beams are clearly shown, the houses are individually depicted, the boats and clinch pins are shown

clearly, and the structures of bridges and beams are accurate. These features carry important information for studying the architecture, transportation vehicles, clothing, and ornaments of the Song Dynasty, and especially, for the study of painting skills.

The end paper of this painting has thirteen annotations by the following persons: Zhang Zhu, Zhang Gongyao, Li Quan, Wang Jian, Zhang Shiji, Yang Zhun, Liu Han, Li Qi, Wu Kuan, Li Dongyang, Lu Wan, Feng Bao, and Ru Shou. No less than one hundred collector seals can be found on the painting, including "Treasure Perused by Emperor Jiaqing," "The Shiqu Imperial Catalogue of Paintings and Calligraphy," and "Appreciated by Emperor Xuantong" of the Qing Palace Treasury, "Bi Yuan," "Authenticated and Collected by Bi Yuan in Loudong," "Master of Taihua," and "Family Inheritance of Uprightness and Honesty" of Qing. This painting is recorded in *Critical and Descriptive Notes on Paintings and Calligraphy*, *Notes on the Calligraphy and Paintings of the Qianshan Hall*, *The Shiqu Imperial Catalogue of Paintings and Calligraphy*, *The Boat of Calligraphy and Paintings on the Qing River*, *Postscripts on Famous Calligraphy and Paintings by Wang Keyu*, *Records of Paintings and Calligraphy in the Summer of the Year of Gengzi*, *Classified Records of Calligraphy and Paintings in the Shigu Hall*, and in *Catalogue of the Year of Paintings and Calligraphy in the Peiwen Studio*.

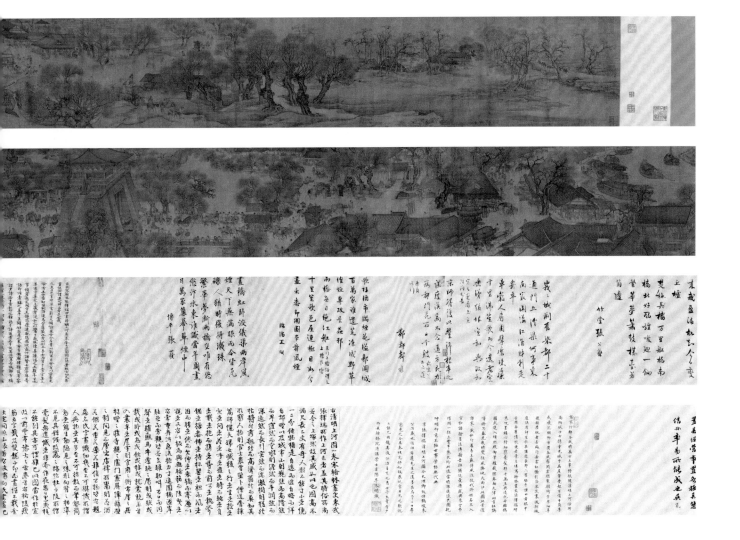

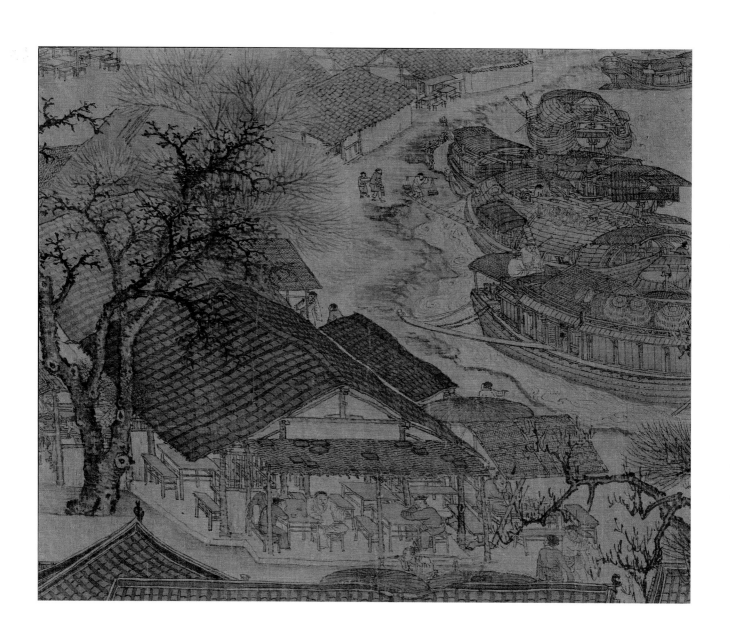

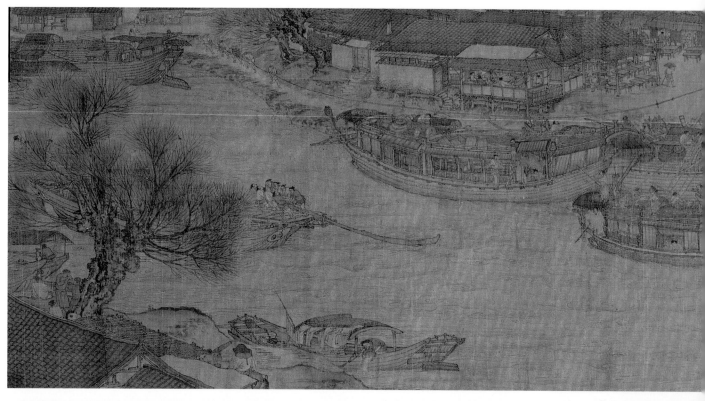

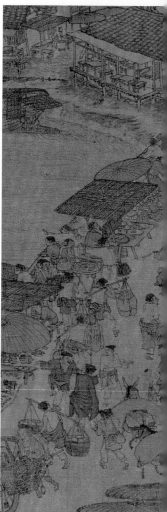

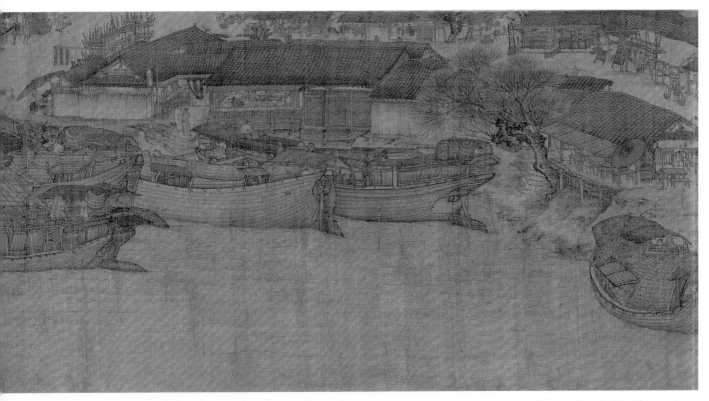

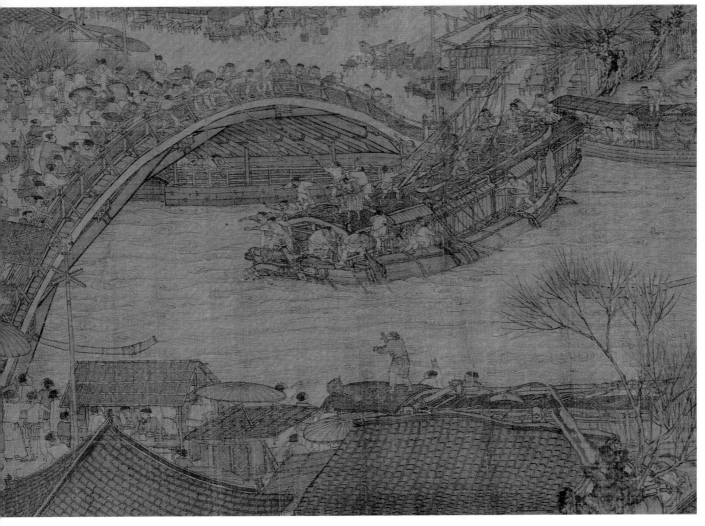

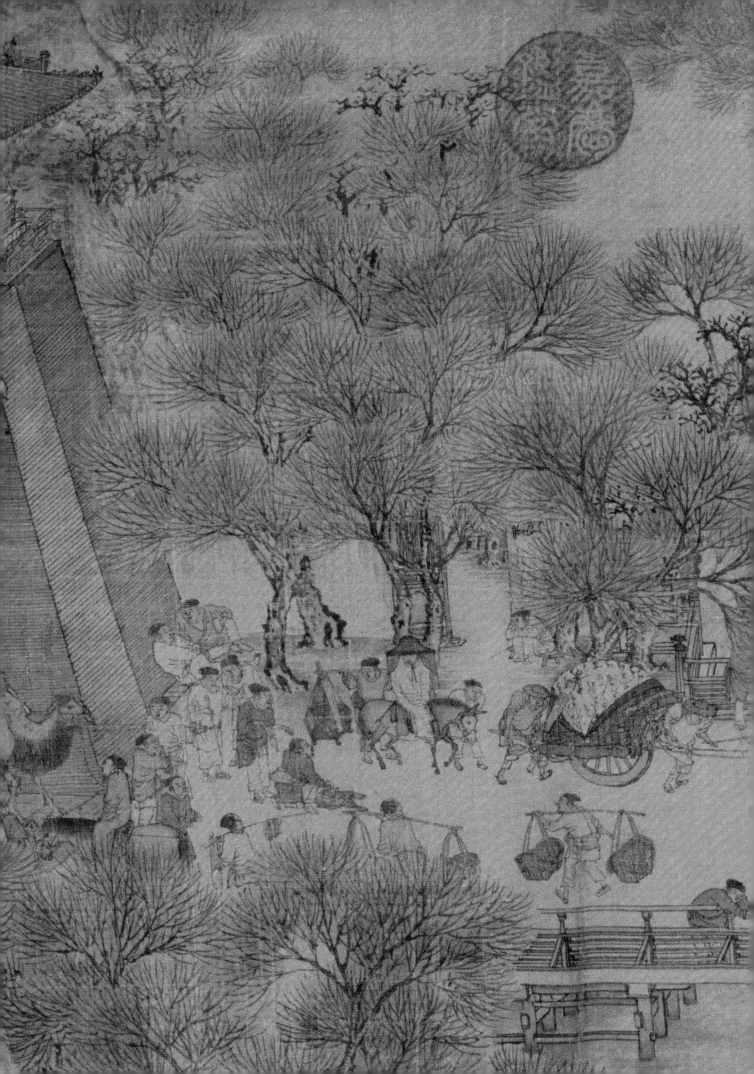

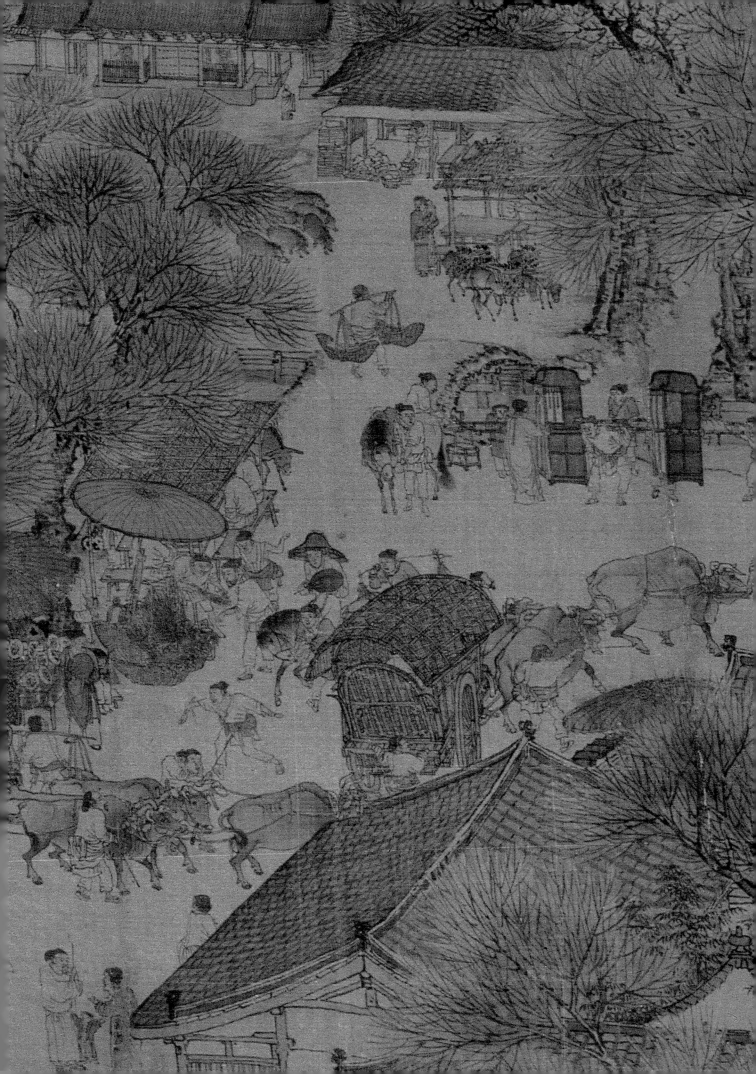

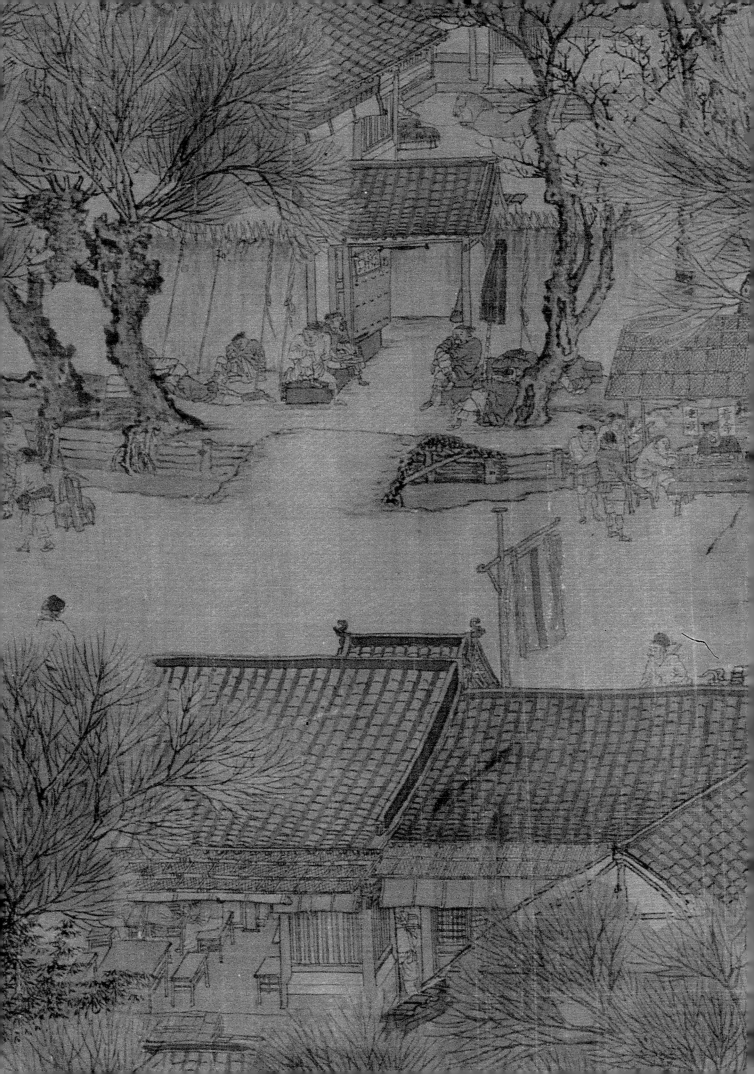

24

Auspicious Dragon Rock

— by —
Zhao Ji
— of —
Northern Song
Hand Scroll

Ink and colour on silk

Height 53.9 cm Width 127.8 cm

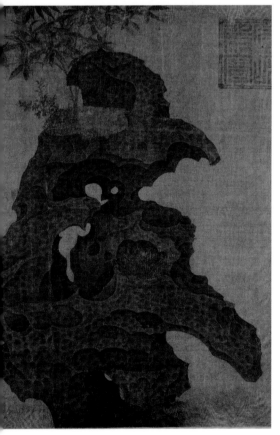

The painting style of this work corresponds to that of the Painting Academy in Northern Song, which emphasized rules and sough realism. It is a masterpiece of lake-rock painting by Zhao Ji. Zhao Ji (1082–1135), Emperor Huizong (reigned 1100–1126) of the Song Dynasty. He was also a painter and calligrapher and produced both fine and coarse painting. The fine paintings are neat and beautiful, whereas the coarse ones are simple and elegant. Nevertheless, they are all realistic. His calligraphy was under the influence of people such as Xue Ji of the Tang Dynasty, yet he created his own unique "thin-gold style." During his reign, he compiled and edited the Catalogue of Imperial Calligraphy in the Xuanhe Era and Catalogue of Imperial Paintings in the Xuanhe Era, among other books.

This particular painting depicts a rock rolling up and down like a dragon. It fulfils the five aesthetic conditions that a grotesque rock should possess: thin, leaky, wrinkled, transparent, and ugly. This rock must have been selected by Emperor Huizong from "Flowery Rocks," and he gave it the name of "Auspicious Dragon" as its appearance resembled a dragon intending to rise. The painter uses multiple layers of light ink to colour the eyes of the lake rock. There is somewhat overlapping of the big and the small, the dark and the light. Dark ink is used for the deep parts of the eyes to avoid light. It shows the thickness of the rock and makes the scene three-dimensional. On the rock several strange grasses grow. Emperor Huizong regarded the emergence of this type of grotesque rock and strange grasses as auspicious omens for the national fate of the Song empire, and praised it as "distinguishingly auspicious." His painting of this auspicious omen was the best way to pray for national fortune and raise the morale of his countrymen.

This work has a long inscription by the painter Emperor Huizong. His signature reads: "Made, painted, and written by the Emperor." It also has: "The Man under Heaven." Imperial seals on the painting with the words "Written by the Emperor" and "Treasure of the Xuanhe Hall" are counterfeits. In the early years of the Southern Song Dynasty, Emperor Gaozong appointed incapable officials such as Cao Xun and Song Kuang to be in charge of matters relating to the mounting of paintings and calligraphy works in the palace. They cut away Emperor Huizong's seals, which forced people in later generations to put in fake seals on the genuine paintings. The towed end paper has annotations by Chen Rentao and Wu Rongguang of the Republican period. There are more than twenty collector seals on the painting, including "Treasure of the Reign of Tianli," "Seal of the Literature of the State of Jin," "Seal of the Paintings and Calligraphy in the Jin Palace," and "Records of Paintings and Calligraphy at the Jingde Hall."

25

Golden Pheasant and Cotton Rose Flowers

ascribed to

Zhao Ji

of

Northern Song

Hanging Scroll

Ink and colour on silk

Height 81.5 cm Width 53.6 cm

Qing court collection

This painting is a representative work of the neat and realistic style of painting promoted by Emperor Huizong of Song. Based on the signature of Zhao Ji, scholars of various dynasties firmly believed that it had been painted by him. In recent years, however, there are experts who hold that this work was ghost-painted by a master-hand in the Painting Academy.

This painting features a golden pheasant flying on the cotton rose flowers. It turns back to gaze at two butterflies flying towards it, which carries the meaning of "beautiful clothes and wealth." Certainly that the entire painting is drawn in ink, and the colouring is simple, but the appearance of the golden pheasant, the manner of the coloured butterflies, and the radiance of the cotton rose flowers are expressed to the full. Lines are drawn with the tip of the brush, flowers and leaves are dotted by the brush, the twigs and leaves are painted upward, downward, and sideways, each with its own posture, and each is magnificent in its own way.

This work has a poem inscribed by the painter Zhao Ji himself, who signed with the words: "Made and written by the Emperor at the Xuanhe Hall," and the seal reads: "The Man under Heaven." There are more than ten collector seals on the painting, including "Written by the Emperor" of the Song Palace Treasury, "Treasure of the Reign of Tianli," and "Treasure of the Hall of Literature" of the Yuan Palace Treasury, "Treasure Perused by Emperor Qianlong," and "Treasure Perused by Emperor Jiaqing" of the Qing Palace Treasury.

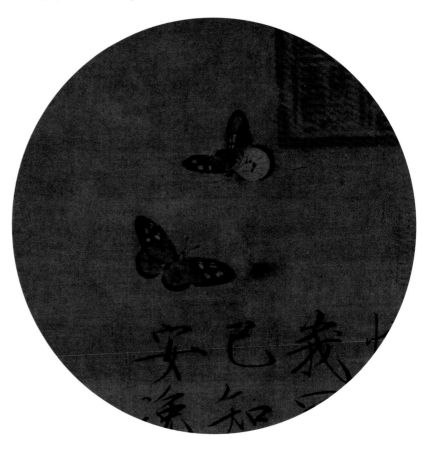

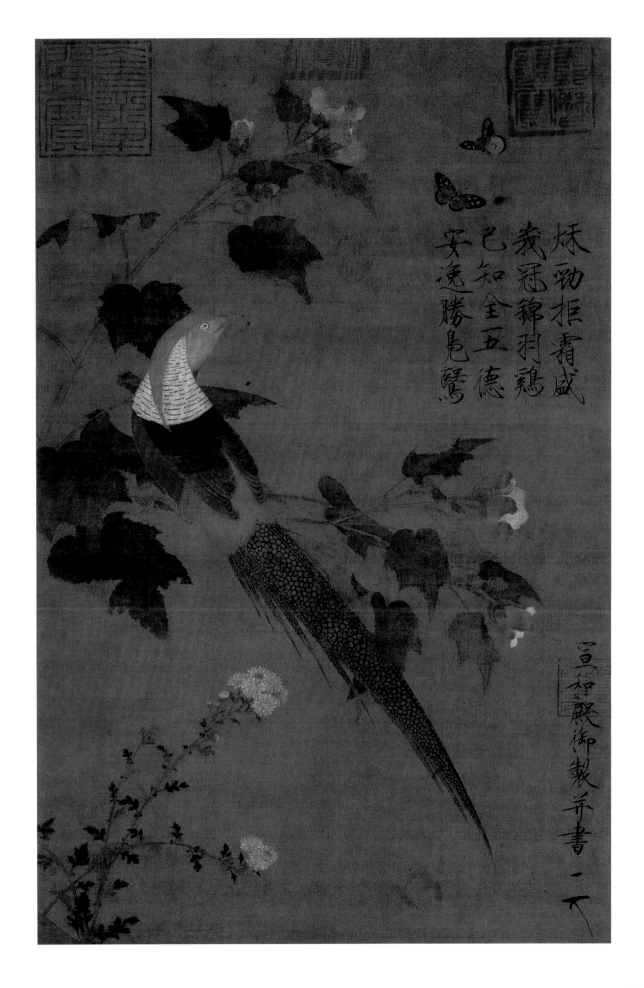

烁动拒霜盛
羲冠錦羽鶏
已知全五德
安逸勝鳧鷖

宣和殿御製并書 一

26

Listening to the *Qin*

— ascribed to —

Zhao Ji

of

Northern Song

Hanging Scroll

Ink and colour on silk

Height 147.6 cm Width 51.3 cm
Qing court collection

This painting depicts a scene of listening to the *qin* in the inner hall of the Song court. It is a typical figure painting in the style of the Painting Academy of Northern Song. The player is said to be Emperor Huizong himself. The two listeners seem totally immersed in the music and appear lost in it. Wrinkles in clothes are painted with shaking strokes and iron lines. The facial expression and the movements of the hands and fingers are painted in minute detail. The painting of the trees and rocks is neat, fine, and regulated, and everything is enclosed in a quiet and serene atmosphere.

This work has an inscription by Zhao Ji, Emperor Huizong of Song, which reads: "Listening to the *Qin*." The stamp reads: "The Man under Heaven;" and the imperial seal reads: "Written by the Emperor" (red relief). There is also an inscription of a poem written by Cai Jing, the Imperial Tutor. There are collector seals on the painting, which include, among others, "The Shiqu Imperial Catalogue of Paintings and Calligraphy," "Appreciated by Emperor Qianlong," "Imperial Seal of the Three Treasures Hall," "For the permanent keeping of the children and grandchildren," and "Treasure Perused by Emperor Jiaqing." This painting is recorded in *The Shiqu Imperial Catalogue of Paintings and Calligraphy, Volume 3* and *Records of Paintings and Calligraphy in the Qing Dynasty*.

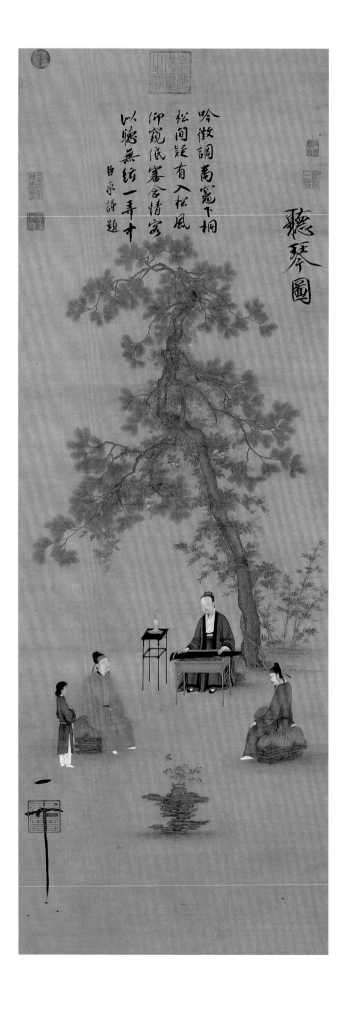

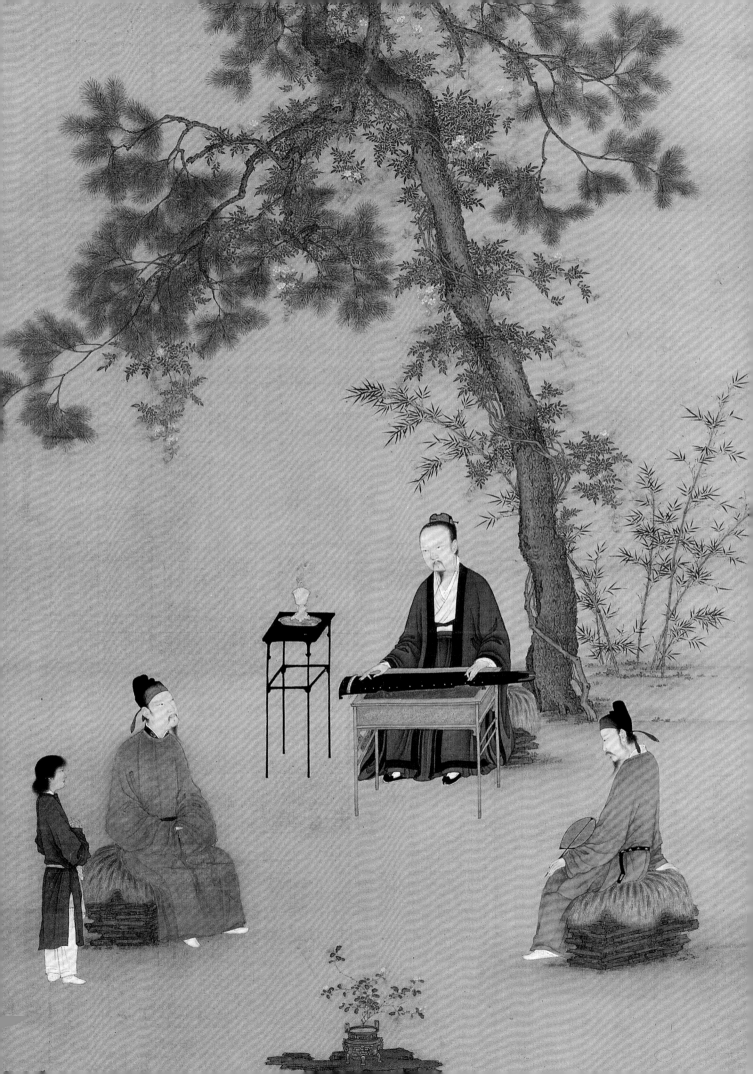

27

A Thousand Miles of Rivers and Mountains

— by —

Wang Ximeng

— of —

Northern Song

Hand Scroll

Ink and colour on silk

Height 51.5 cm Width 1191.5 cm
Qing court collection

This is the only extant work of Wang Ximeng that has been handed down to the posterity. It is also an excellent example of the blue-and-green landscape painting of Northern Song. Wang Ximeng (1096–?) was a court painter of Northern Song. He was a student at the Painting Academy, and under the tutelage of Emperor Huizong, he greatly advanced in the art of painting.

This artwork depicts the magnificent scenery of a land of enchanting rivers and mountains that stretch a thousand miles far into the distance. The green peaks and ranges are overlaying and continue without end. The water in the rivers flows with great strength and vigour, and it is flat and endless. We can see villages and houses in the mountains, and the plank roads, the pavilions, and bridges that are vaguely connected. There is a boat in the middle of the river, which echoes with the fishing nets. The composition adopts the technique of level distance. The mountain rocks are coloured with the method of "blue-and-green" inherited from the Tang Dynasty, which is very thick and beautiful. At the same time, umber is used to smear the foot of the mountain and the colour of the sky, further setting out the brightness of the blue and green. The outlining of the ink brush is delicate and fine. The wave patterns of the water and the branches and leaves of the trees are visible, whereas the figures and animals are small but vivid.

No signature or seal of the painter can be found on this work, but it has a poem inscribed by Qing Emperor Qianlong. The rear separate piece has an annotation by Cai Jing, which reads: "This painting was given by the Emperor on the first day of the fourth intercalary month in the third year of the reign of Zhenghe. When Ximeng was eighteen, he was a student at the Painting Academy, and he was summoned to the imperial court to serve at the Literature Publication Office. He presented several of his paintings to the Emperor, but they were far from exquisite. The Emperor knew that he was teachable, so he decided to teach him the skills of painting personally. In less than six months, he presented the Emperor with this painting. The Emperor praised him and gave this painting to Cai Jing, saying that it was an illustration by a talented painter." This reveals that This work was painted by Wang Ximeng. The end paper has an annotation by Pu Guang, Grand Academician of the Institute for the Glorification of Literature of the Yuan Dynasty. There are over ten collector seals on the painting, including "Treasure of the Emperor's Father," "Treasure Perused by Emperor Qianlong," and "The Shiqu Imperial Catalogue of Paintings and Calligraphy" of the Qing Palace Treasury, "Authenticated by Jiaolin," "Cangyanzi," and "Seal of Liang Qingbiao" by Liang Qingbiao of Qing. This painting is recorded in *The Shiqu Imperial Catalogue of Paintings and Calligraphy*.

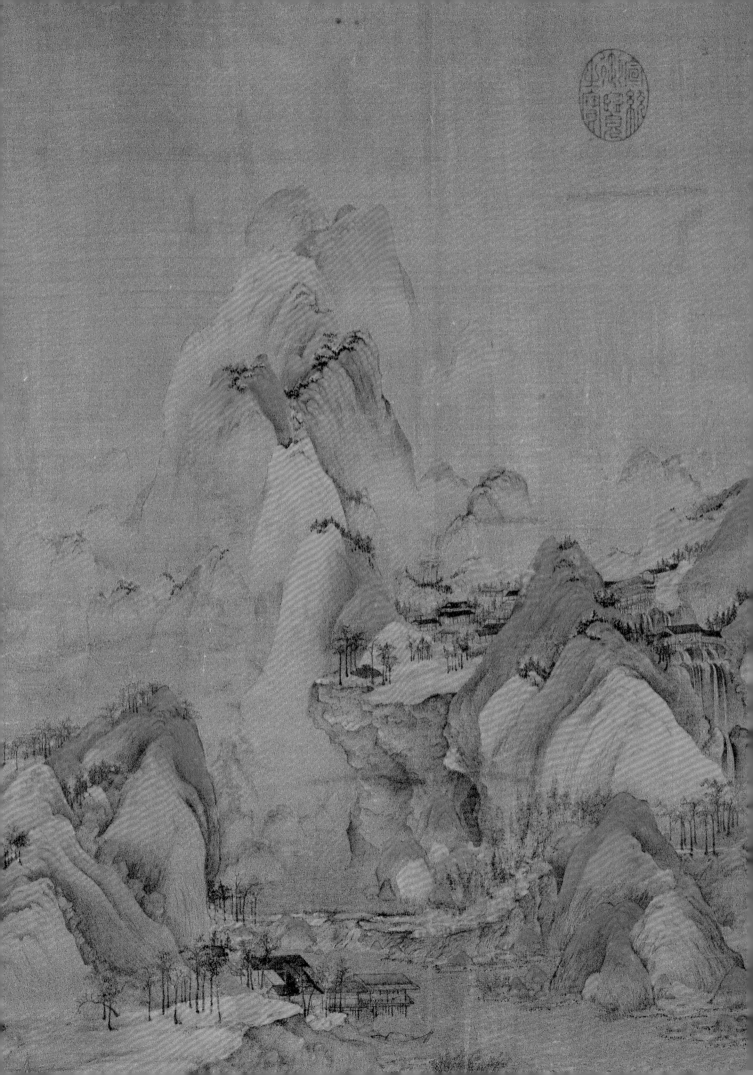

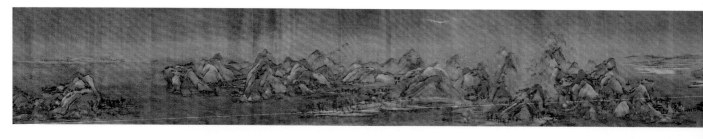

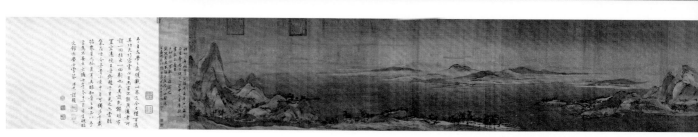

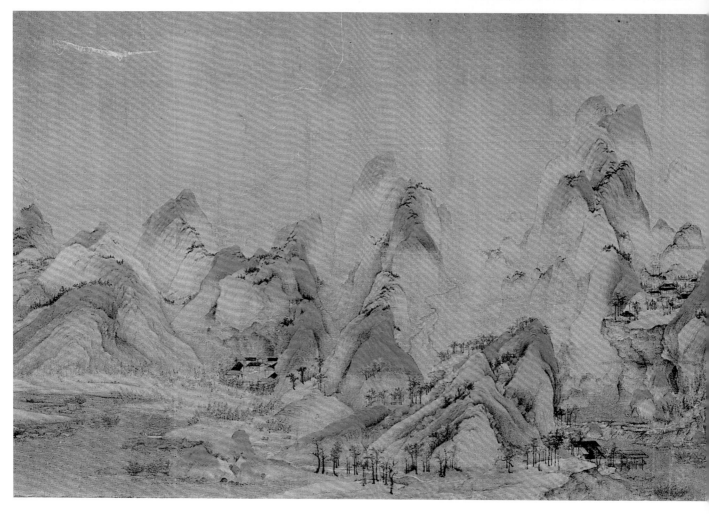

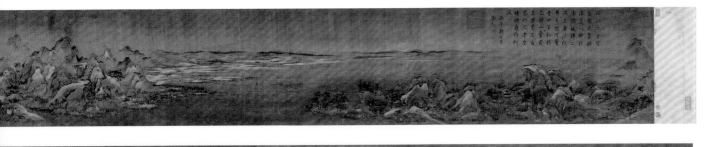

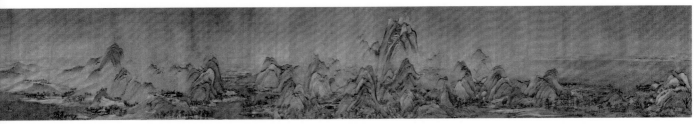

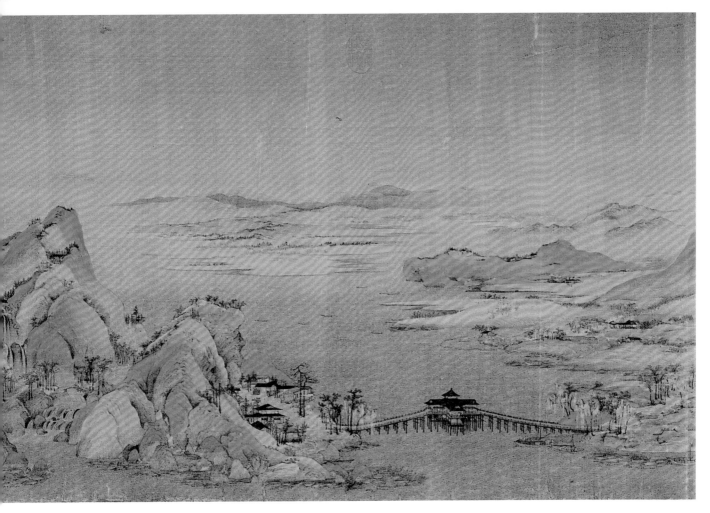

28

Rivers and Mountains in Autumn Colours

— by —

an Anonymous Painter

— of —

Northern Song

Hand Scroll

Ink and colour on silk

Height 55.6 cm Width 323.2 cm
Qing court collection

This work is an excellent blue-and-green landscape painted by a skilled hand in the Painting Academy of Northern Song. The old title of the work given in Ming times was: "Painted by Zhao Boju, a painter of the imperial clan of the Song Dynasty."

The painting depicts green pines with dots of red leaves that tower in the blue mountains surrounded by green water. The temples and the villages have plank roads that are connected to some bridges. The mountaineers and the pilgrims drive the animals and carts through the forest. The movement of the steps to change the scene is thought-provoking. The small axe-cut wrinkling is used in painting the mountains. The colours are mainly blue and green, with ink and other colours, making it rich and harmonious. The exquisite layout is broad and majestic, the colours are thick, beautiful, and yet elegant. It shows a type of "literati style" which is different from that of the Painting Academy of Northern Song.

This work bears no signature or seal of the painter. The end paper has an annotation of Zhu Biao of Ming. There are collector seals on the painting, including "Treasure Perused by Emperor Qianlong" and "The Shiqu Imperial Catalogue of Paintings and Calligraphy" of the Qing Palace Treasury, "Taking a Grand View" and "Authenticated by Jiaolin" by Liang Qingbiao of Qing. This painting is recorded in *The Shiqu Imperial Catalogue of Paintings and Calligraphy*.

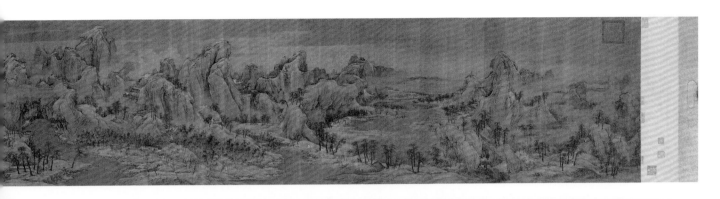

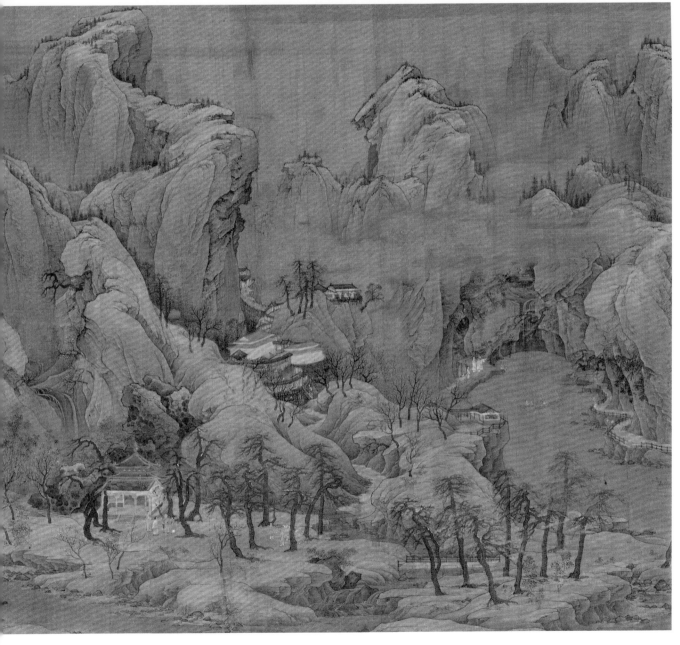

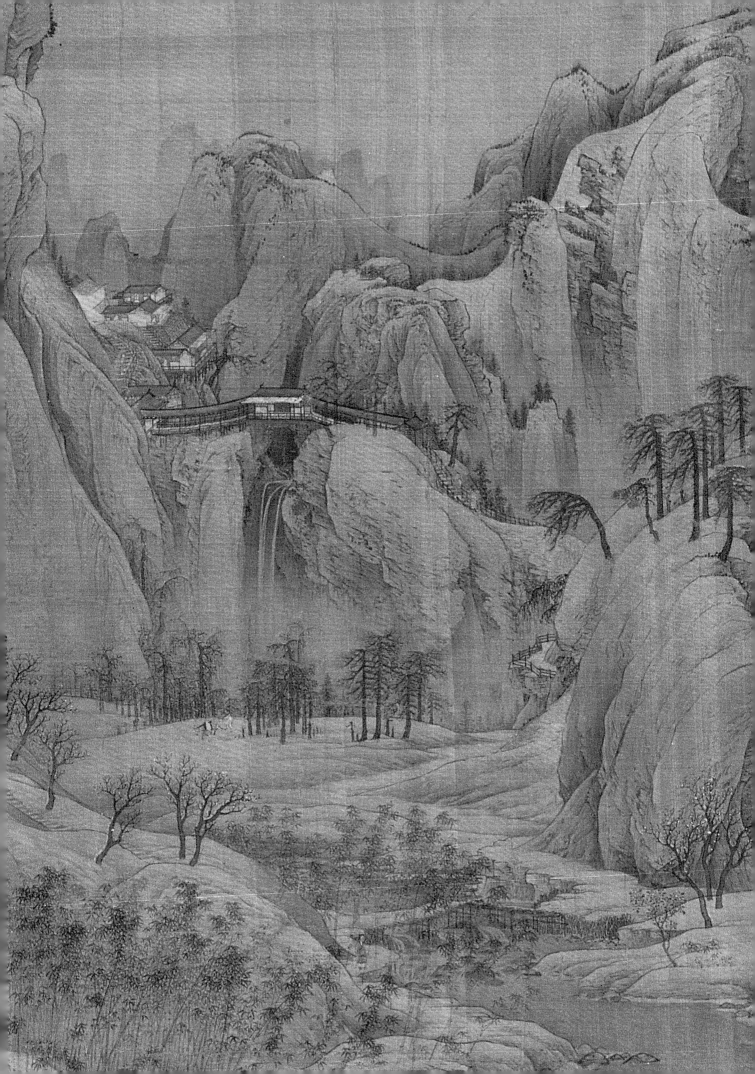

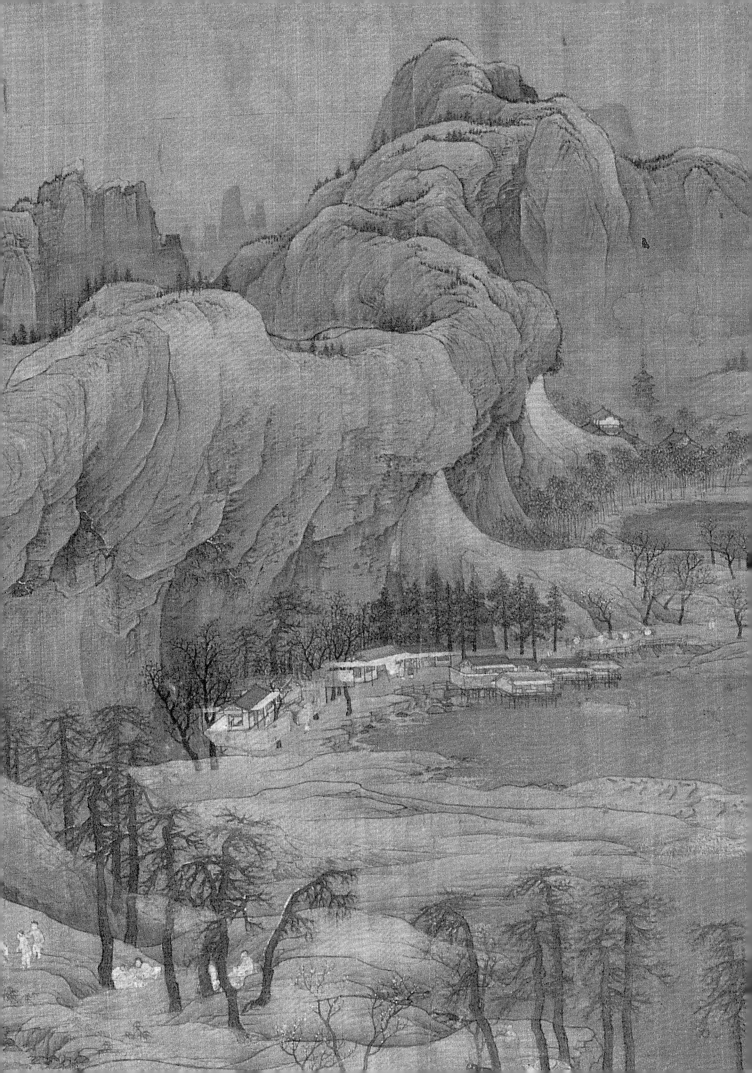

29

The Spectacular Views of the Rivers of Xiao and Xiang

— by —
Mi Youren
— of —
Southern Song
Hand Scroll

Ink and brush on paper

Height 19.7 cm Width 285.7 cm

This scroll is an important legacy of Mi Youren. Mi Youren (1074–1153), whose alternative name was Yinren, was later styled Yuanhui, and in his old age, he started calling himself Nenzhuolaoren. He was a native of Taiyuan and the eldest son of the Northern Song painter and calligrapher Mi Fu. For this reason, he was also called "Little Mi." In 1122, or the fourth year of the reign of Xuanhe of Song, he was selected to be in charge of the calligraphy studies. After the dynasty moved to the south, he served as Vice-Minister of War and Auxiliary Academician of the Hall for the Diffusion of Literature. He also verified works of calligraphy for Emperor Gaozong. His landscape paintings inherited Mi Fu's "dotting method," yet he conferred them more maturity.

The opening part of this painting consists of a thick rolling cloud and the shape of the mountains that is patchily shown through the cloud. Due to the clustering and scattering of clouds, the peaks of the mountains are intermittently visible, giving the work a sense of movement. The hills undulate, the rivers meander, and the trees in the forest flank the shores. All these reflect the typical features of the area. This work brings out the theme of seclusion by concluding with a thatched hut on the bank of a river in the forest. The ink in the entire scroll is pale and moist. The tops of the mountains have "dot wrinkles," in which the painter transforms the "thick ink and big dots" method of his father Mi Fu into his method of "light ink and small dots." In turn, the misty air switches from "coloured but not sketched" to "sketching with light ink," which is more elegant.

No signature or seal of the painter can be distinguished on this piece of artwork but the end paper has a long sentence inscribed by the painter, which reads: "Inscribed by Youren. The goat brush is used to write characters, just like the paper is used to do painting." There is a red seal on one side, but the characters are illegible. The end paper also has some annotations, including those by Xue Xi, Ge Yuanzhe, Gong Shitai, Liu Zhongshou, Deng Yuzhi, Wu Hushuo, Zeng Huan, Zhu Xiwen, Bian Mengsheng of Yuan, Dong Qichang of Ming, and Ye Gongchuo and Zhang Yuan of the modern period. There are altogether more than one hundred and fifty collector seals on the painting, such as "Seal of the Calligraphy and Paintings of Wu Zhen of Jiaxing," "Works Verified by Song Luo of Shangqiu as Authentic," "Feng Gongdu's Collection," and "Seal of Cheng Zhenyi," to mention but a few. The painting is recorded in *Postscripts on Famous Calligraphy and Paintings by Wang Keyu, Classified Records of Calligraphy and Painting in the Shigu Hall, Dream Journey in the Records of Wonderful Sights, Paintings and Calligraphy Collections by Yang Enshou*, and *Records of Paintings and Calligraphy by Gu Wenbin*.

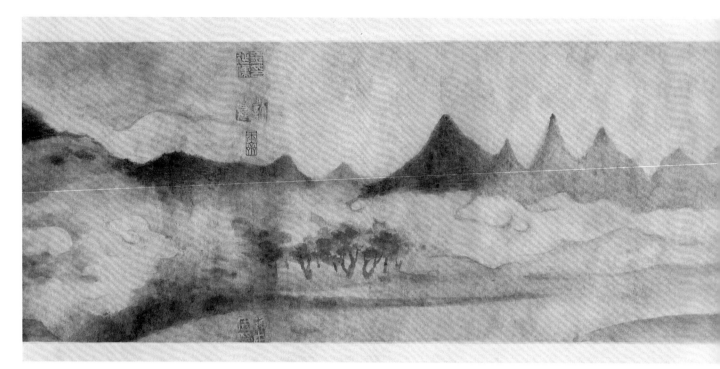

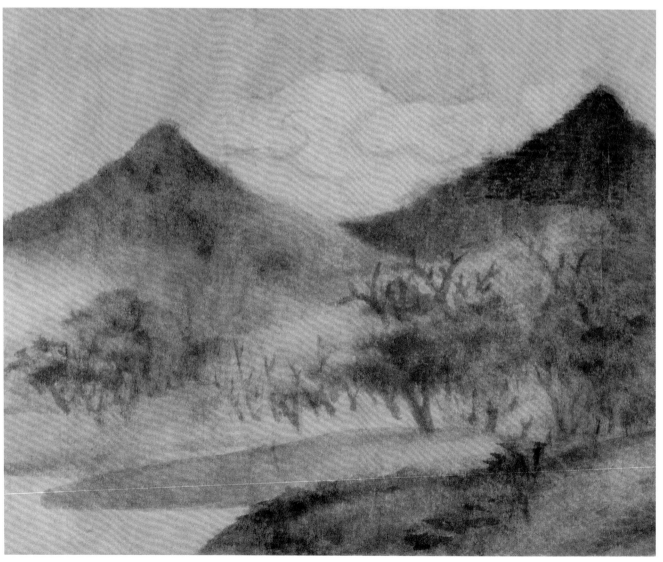

30

Four Views of the
Flowering Plum

by

Yang Wujiu

of

Southern Song

Hand Scroll

Ink and brush on paper

Height 37 cm Width 358.8 cm

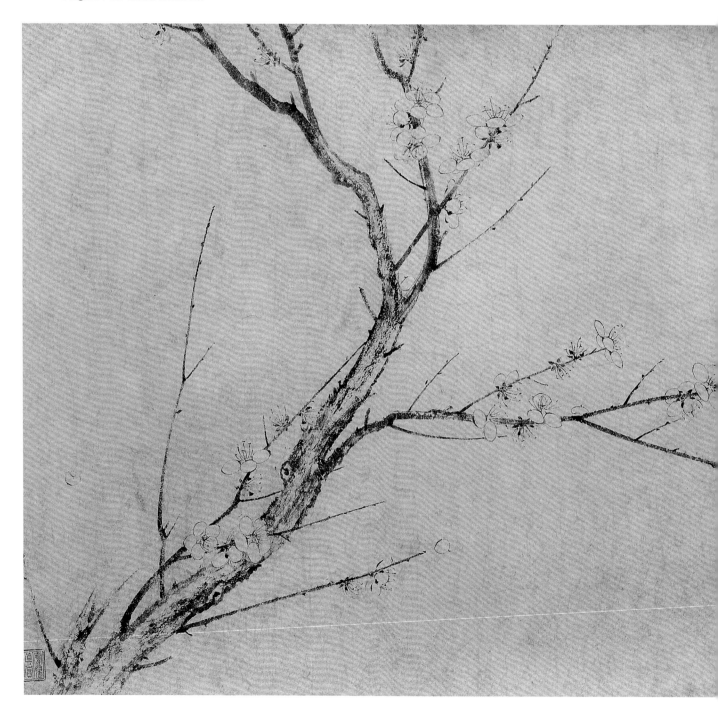

This is a painstaking work performed by Yang Wujiu in his later years that displays his ingenious craftsmanship in painting plums. Yang Wujiu (1097–1171), also known as Buzhi, Taochanlaoren, and Xiaoyizhangzhe, was a native of Qingjiang (present-day Qingjiang in Jiangxi). When Emperor Gaozong was on the throne, he was unhappy with the dictatorial administration of Qin Hui. He did not, therefore, take up any office even after repeated summons, yet he enjoyed the reputation of being a noble person. He was well versed in poetry and *ci*-poetry and skilled in calligraphy and painting, following the style of Ouyang Xun in calligraphy and that of Zhongren of the Huaguang Temple in painting. He was inspired by Hua's method of painting plums in ink, and the plums in this painting are mostly located in the mountains or along the riverbanks. The plum trees are sparsely branched and the pistils are cold. They are pure, chilly, wild, and free, which is totally different from the style of "palatial plums" of the Painting Academy. In fact, the plum trees that he painted were jokingly called "rustic plums," and originated a new school of painting plums in ink, which had a huge impact on his peers and subsequent painters.

It is known from the artist's inscription that this work was painted at the request of his friend Fan Duanbo. Through variations in the twigs and flowering, the reserved manner of the plums "yet to blossom," the charm of the plums "about to blossom," the radiance of the plums "in full blossom," and the disconsolation of the plums "about to wither" are all shown in full. The trunks and twigs of plums are rarely outlined, but usually painted directly with ink. The texture of an old trunk is shown by leaving blank spaces, and the hierarchy of the twigs is expressed through the application of ink of different thickness and wetness. The brushing is forceful, full of liveliness and resilience. The petals are circled out with fine brushes, and various types of ink-dotting are used to show calyxes, stamens, and small buds. There is spiritual resemblance in the painting, showing the painter's meticulous observation of the various stages of growth of a plum blossom, while his painting technique had reached the highest level.

This work has four poems written by the painter, and his inscription reads: "Fan Duanbo asked me to paint four twigs of plum blossoms according to blossoming: 'yet to blossom,' 'about to blossom,' 'in full blossom,' and 'about to wither,' and write a poem for each twig. … At midnight just one day before the seventh day of the seventh month in the first year of Qiandao, Yang Wujiu (Buzhi), who was born in the year of Dingchou, wrote the poems at a monastery at Wuning in Yuzhang." His seal reads: "Descendant of Yang Xiong" (red relief), "Escape from Chan Buddhism" (red relief), and "Seal of Yang Wujiu" (red relief). The front of this painting has an inscription by Liang Tongshu. The end paper has annotations by Ke Jiusi, Da Zhongguang, Fei Nianci, Han Chong, and Huang Shoufeng. There are more than three hundred collector seals on the painting, such as those of Ke Jiusi and Wu Zhen of Yuan, Shen Zhou, Wen Zhengming, Wen Peng and Xiang Yuanbian of Ming, and Cheng Zhenyi, Wu Hanchen, Wu Hanjie, Jiang Zao, Fei Nianci, Wu Yun, and Zhang Yanrong of Qing. This painting is recorded in *Critical and Descriptive Notes on Paintings and Calligraphy*, *The Boat of Calligraphy and Paintings on the Qing River*, *Postscripts on Famous Calligraphy and Paintings by Wang Keyu*, *Classified Records of Calligraphy and Paintings in the Shigu Hall*, *Dream Journey in the Record of Wonderful Sights*, and *Records of Paintings and Calligraphy by Gu Wenbin*.

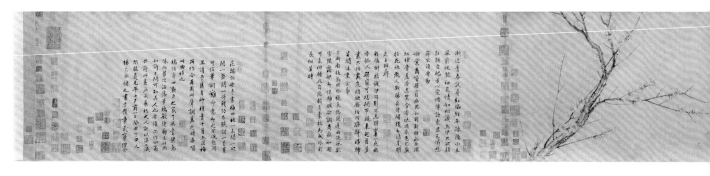

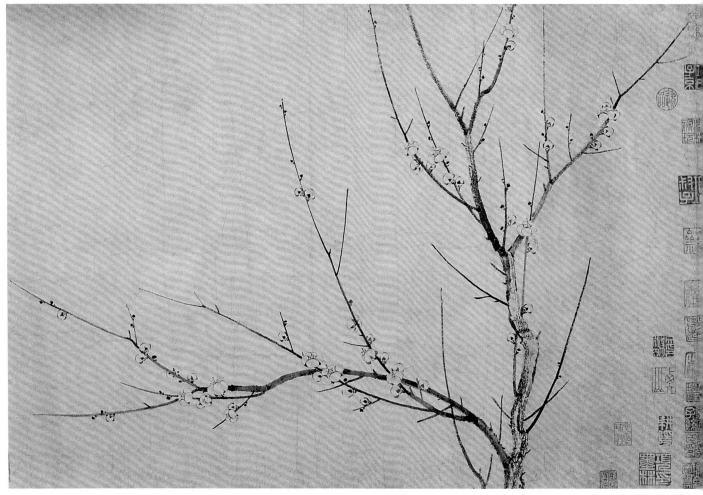

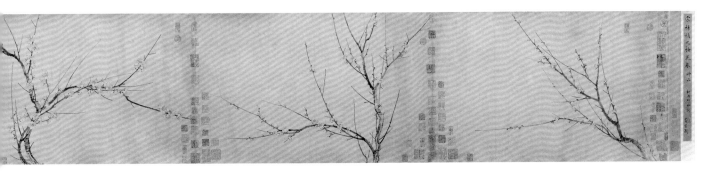

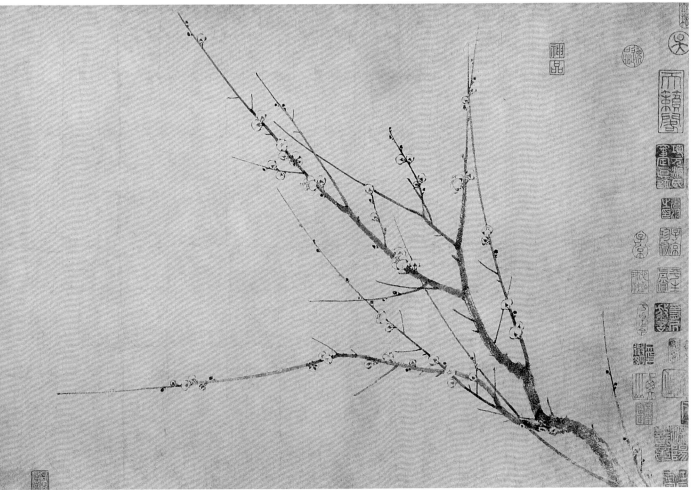

31

Palace in the Pines

— by —

Zhao Bosu

— of —

Southern Song

Hand Scroll

Ink and colour on silk

Height 27.7 cm Width 135.2 cm
Qing court collection

This painting is a masterpiece of blue-and-green landscape of the Song Dynasty. Zhao Bosu (1124–1182), styled Xiyuan, was a member of the imperial clan. He was a native of Bianliang (present-day Kaifeng in Henan), but since the dynasty moved south, he resided in Lin'an (present-day Hangzhou in Zhejiang). The highest official position he held was Defense Commissioner of Hezhou. He read widely on the history of calligraphy, and was skilled in painting. *The Precious Mirror of Paintings* says the following about him: "He excelled in the painting of landscapes and figures, and he was especially skilled in flowers and fowls. His colouring was light and full of life."

This piece of art depicts the scene of the area of Mount Phoenix outside the palaces of Lin'an, capital of Southern Song. The red sun rises over a vast expanse of blue water. The ranges are green, dotted with gold tiled roofs, and surrounded by clouds and mist. White cranes fly and dance over the pine forest, while mountain magpies fly towards the red bridge over the stream. The painter uses mineral green to dot and colour the bushes, both vertically and horizontally, all over the mountain and he employs the dark brush to outline the rocks on the slopes and fill them with mineral green. This combination of sketching and colouring makes the brush and ink rich and moist in its structure, and adds fineness to the coarseness. The colour tone is beautiful and elegant; the artistic conception is rich, serene, and full of intellectual spirit.

Neither the signature nor the seal of the painter is present on this work. The end paper has annotations by Zhao Mengfu, Ni Zan, and Zhang Shen of Yuan. There are more than ten collector seals on the painting, including "Treasure Perused by Emperor Qianlong," "The Shiqu Imperial Catalogue of Paintings and Calligraphy," and "Treasure Perused by Emperor Jiaqing" of the Qing Palace Treasury, "Seal of An Qi" by An Qi of Ming, and "Jiaolin" and "Taking a Grand View" by Liang Qingbiao of Qing. This painting is listed in *Random Notes on Works in Ink* and *Dream Journey in the Records of Wonderful Sights*.

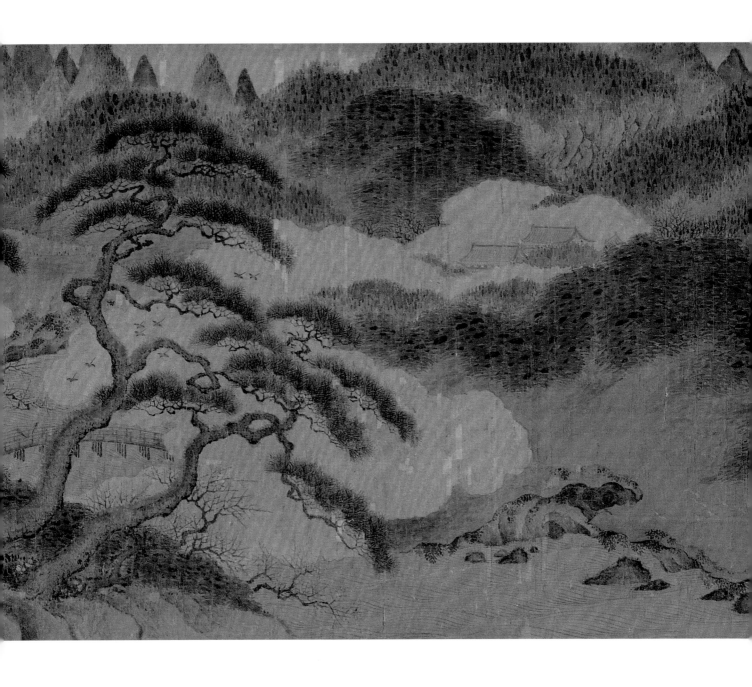

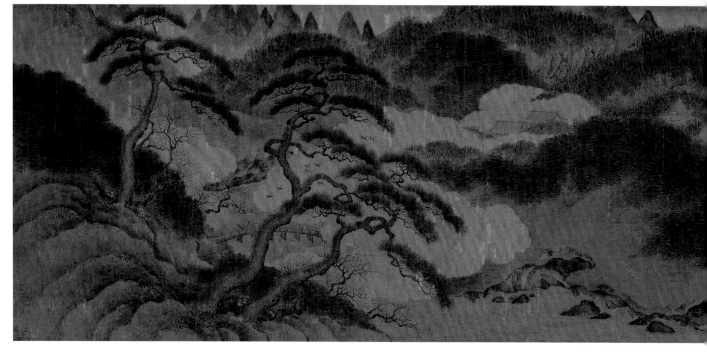

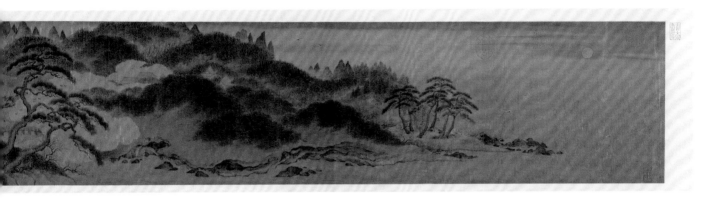

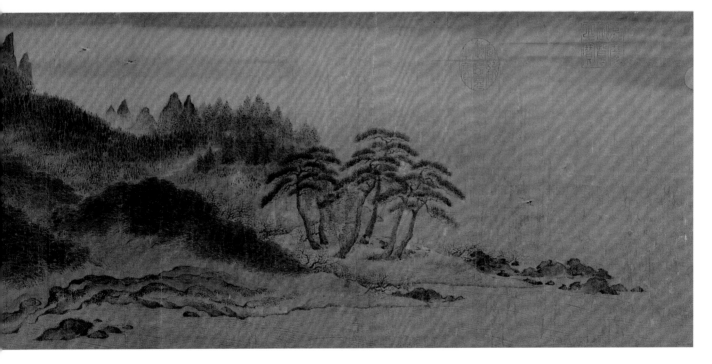

32

Second Ode to
the Red Cliff

— by —

Ma Hezhi

— of —

Southern Song

Hand Scroll

Ink and colour on silk

Height 25.9 cm Width 143 cm
Qing court collection

This painting by Ma Hezhi is based on the message comprised in Su Shi's essay *Second Ode to the Red Cliff*. It is a classic masterpiece that vividly reproduces the contents of the essay in the form of a painting. Ma Hezhi, whose years of birth and death are unknown, was active in the twelfth century and a native of Qiantang (present-day Hangzhou in Zhejiang). He obtained the degree of *jinshi* (metropolitan graduate) during the years of the reign of Shaoxing in Southern Song (1131–1162), and the highest official position he held was Vice-Minister of Works. He excelled in the painting of figures, Buddhist and Daoist themes as well as landscapes. He created the "orchid-leaf stroke" that involved a natural and elegant brushwork, creating a style of his own. His exquisite craftsmanship was highly regarded by Song emperors Gaozong and Xiaozong, and had many followers down the ages.

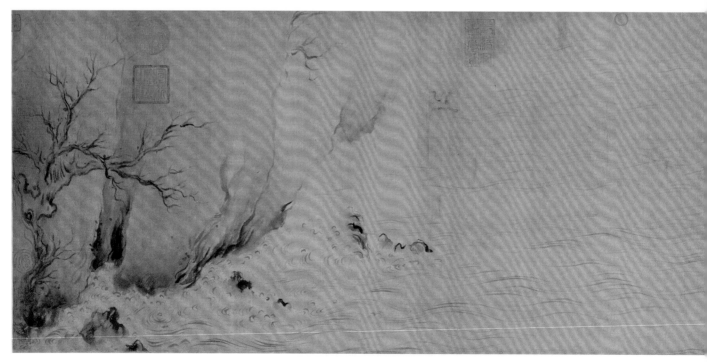

A famous literary figure in Northern Song, Su Shi was arrested and put into prison in the third year of the reign of Yuanfeng (1079) because of the "Wutai Poem Case." He was later banished to Huangzhou (located in Hubei), where he served as Vice Military Training Commissioner. To drive away his inner depression, he often brought wine and went boating with his friends to the Red Cliff. Legend has it that the Red Cliff was the ancient battlefield where the allied army of Sun Quan and Liu Bei defeated the army of Cao Cao during the period of the Three Kingdoms, and it was in this place that Su Shi wrote his famous works *Ode to the Red Cliff*, *Cherishing the Past at the Red Cliff: To the Tune of Niannujiao*, and *Second Ode to the Red Cliff*. The scene depicts Su Shi and his friends sailing a boat to the Red Cliff at night. The water in the river extends into the distance, and the leaves of the trees are swaying and falling. Under the moonlight is a fairy crane flapping his wings and flying away. On the boat, people raise their heads to gaze into the distance. This corresponds to the part of the poem that says: "It was midnight. We saw nothing but the solitude that was all around. At that time, a solitary crane crossed the river and came here from the east." This work was painted during the reign of Emperor Xiaozong (1163–1189). Its composition is far and wide in perspective. The unique "orchid-leaf stroke" is used to show objects in the scene, the sketches and lines are smooth, and the style of the painting is elegant, easy, and free.

The work bears no signature or seal of the painter. The end paper has the full text of *Second Ode to the Red Cliff* written by the Song Emperor Gaozong in cursive script and the same text written by an anonymous calligrapher in seal script. There are more than forty collector seals on the painting, including "Treasure Perused by Emperor Qianlong," "Treasure Perused by Emperor Jiaqing," and "The Shiqu Imperial Catalogue of Paintings and Calligraphy" of the Qing Palace Treasury, "Seal of An Qi" by An Qi, "Rare Treasure of Jiaolin" by Liang Qingbiao, and "Ruo Ai" by Zhang Ruoai of Qing. This painting is recorded in *Sequel to the Shiqu Imperial Catalogue of Painting and Calligraphy*, *Dream Journey in the Records of Wonderful Sights*, *Random Notes on Works in Ink, Second Series*, and *Records of Southern Song Academy Painters*.

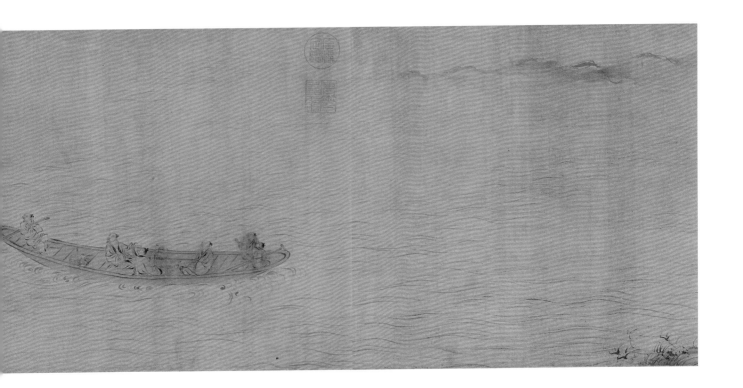

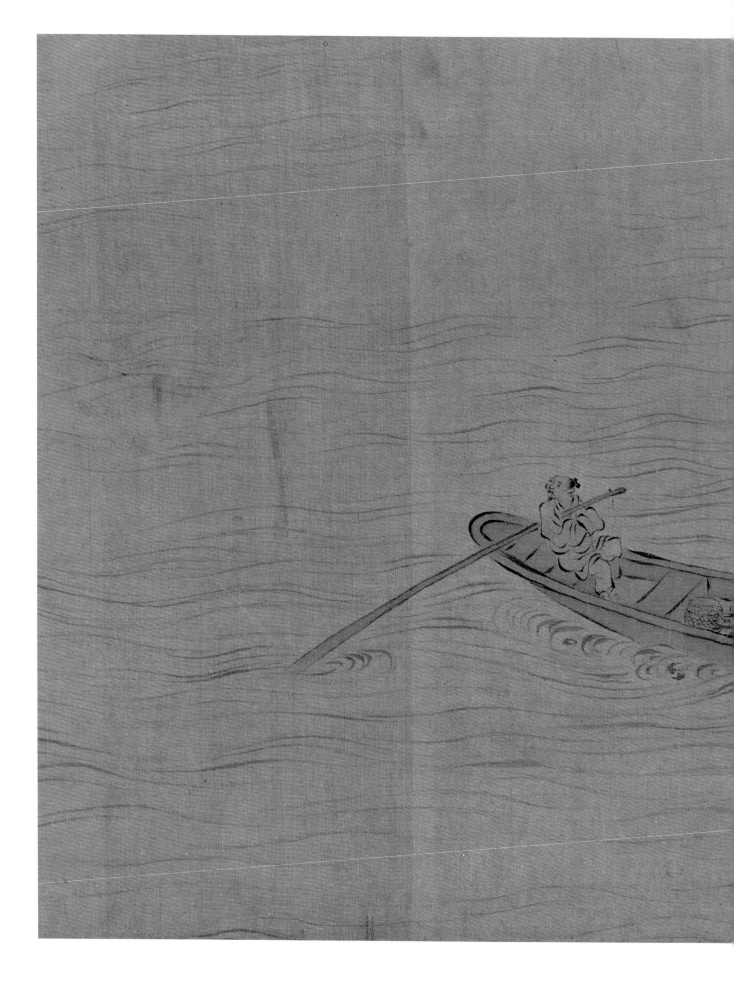

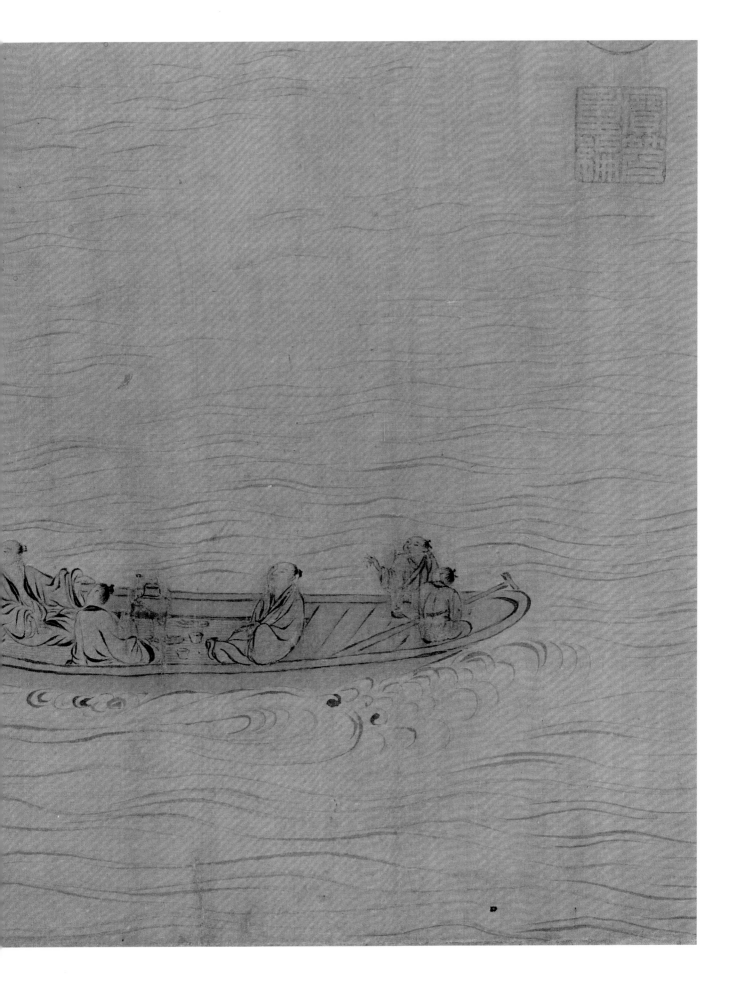

137

33

A Landscape of Rivers and Mountains

— by —
Zhao Fu
— of —
Southern Song
Hand Scroll

Ink and brush on paper

Height 45.1 cm Width 992.5 cm
Qing court collection

This scroll is the only extant painting of Zhao Fu that has been passed on to the present. Zhao Fu (also known as Zhao Fei), whose years of birth and death are unknown, was active in the twelfth century. He was a native of Jingkou (present-day Zhenjiang in Jiangsu), and resided in Beigu during the reign of Shaoxing (1131–1162). He was particularly skilled in painting landscapes, rocks, and Jin and Jiao mountains. His brush and ink are unrestrained and free, without any traces of the style of the Painting Academy. He signed his works with a single character of his name "Fu" without writing out his surname, which often misleads people into thinking that his works are the paintings of Mi Fu.

This painting depicts the magnificent Yangtze River. It starts with the ranges shrouded in clouds and mist. The mountain roads are winding, and the passage boats in the river are about to set off. The surging waves and the boats seem to compete with each other to cross the river first. There is a dangerous cliff separating the river. In front of a tile-roofed house is a guest paying a visit. Near, in a thatched hut, a student is

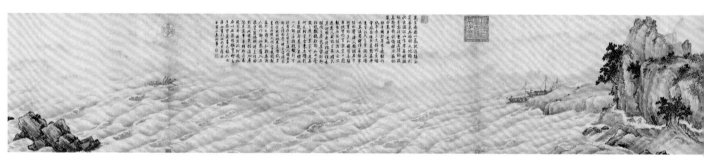

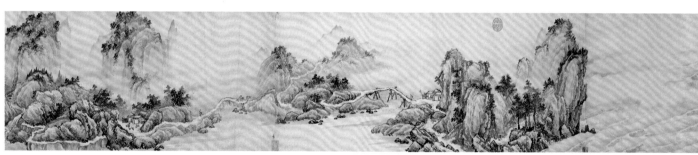

studying. On the river, a boat sails in the wind and rain, while on one side of the steep cliff, we can see a bridge. The wine shop flags are hung slantingly and the temple tower stands tall. It ends with a flowing of huge waves. The entire painting places emphasis on the natural scenes and objects and does not deliberately seek to reproduce the style of sharpness and stiffness of the landscape painting of the Song Dynasty. The painter uses water and ink only in this work. The ink colour is rich in variations. Both axe-cut wrinkles and moss dots are employed. This technique heralds the painting methods of the Yuan Dynasty.

This work bears the painter's signature: "Painted by Zhao Fu from Jingkou," together with his seal, which reads: "Fu." It also has the inscription of a poem and an annotation by Qing Emperor Qianlong. The frontispiece has an inscription by Zhang Ning, which reads: "The Yangtze River Flows Thousands of Miles." The end paper has annotations by Qian Weishan, Zhang Ning, and Lu Shusheng of Ming. There are dozens of collector seals on the painting, including "Treasure Perused by Emperor Qianlong," "Treasure of the Imperial Study" of the Qing Palace Treasury, "Scholar of the Hanlin Academy," "Lu Shusheng," "Layman Qujiang," and "Qian Sifu." This painting is recorded in *Notes on the Calligraphy and Paintings of the Qianshan Hall, The Boat of Calligraphy and Paintings on the Qing River, Postscripts on Famous Calligraphy and Paintings by Wang Keyu, The Shiqu Imperial Catalogue of Paintings and Calligraphy, Volume 1*, and in *Catalogue of Paintings and Calligraphy in the Peiwen Studio.*

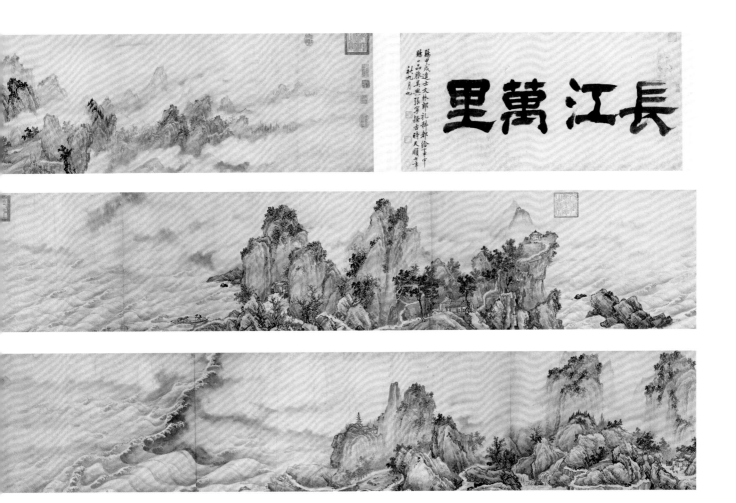

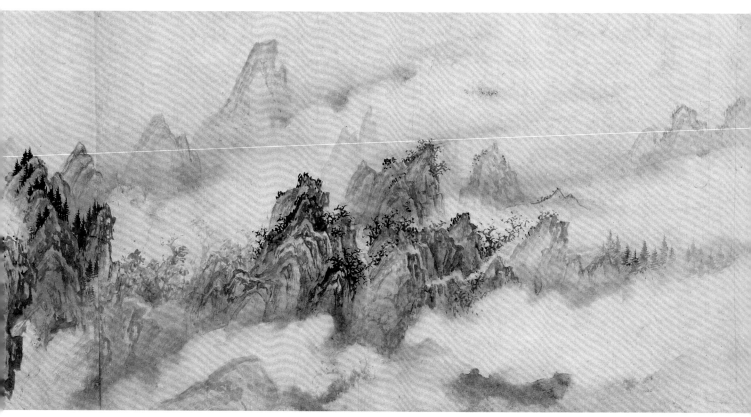

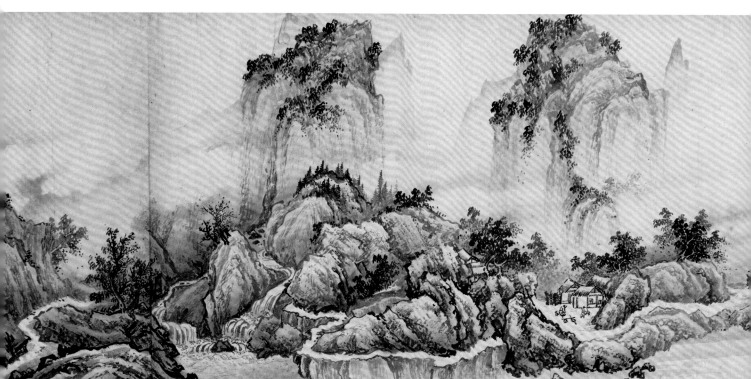

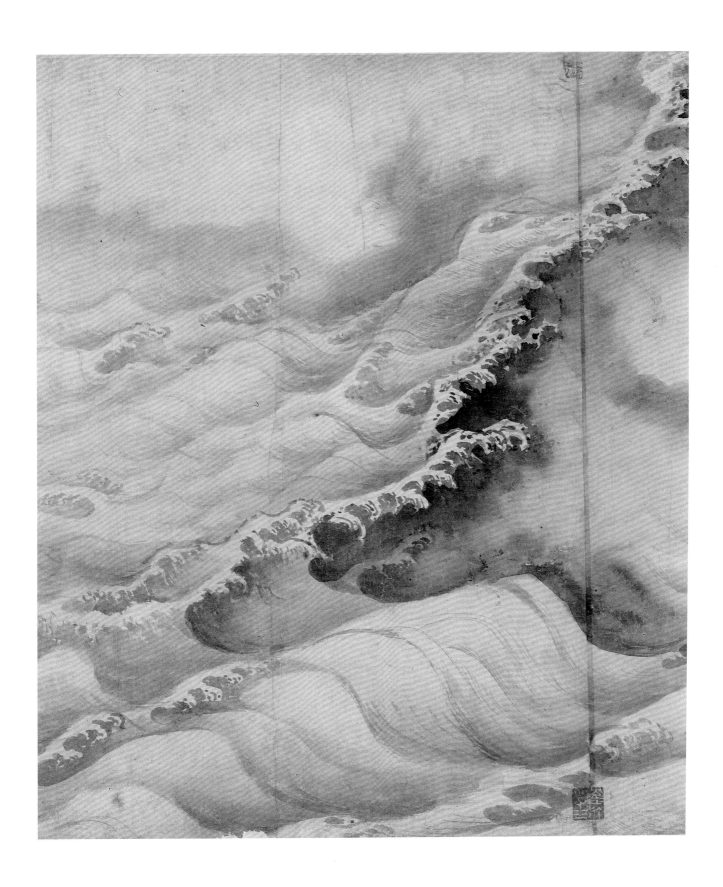

34

Gathering Wild Herbs

by

Li Tang

of

Southern Song

Hand Scroll

Ink and colour on silk

Height 27.2 cm Width 90.5 cm

This piece is a representative work of landscape and figure painting by Li Tang, which shows his excellent ability in depicting human figures, full of life and spirit. Li Tang, whose years of birth and death are unknown, was active in the twelfth century. Also known as Xigu, he was a native of Sancheng in Heyang (present-day Mengxian in Henan). He was a painter of the Painting Academy during the reign of Huizong of the Song Dynasty. Later, when the dynasty moved to the south, he was at the Southern Song Painting Academy from 1131 to 1162 in the years of the reign of Shaoxing. He found favour with Emperor Gaozong who appointed him as the Gentleman of Complete Loyalty and Expectant Official of the Painting Academy, for which he was given a gold belt. His figure painting is similar to that of Li Gonglin, and the "axe-cut wrinkles" method he created to paint landscapes had considerable influence on painters of the later successive generations. Li Tang, along with Ma Yuan, Xia Gui, and Liu Songnian, is part of the so-called "Four Master Painters of Southern Song."

The present work is based on the "Collective Biographies of Bo Yi and Shu Qi" in the *Records of the Grand Historian*. It shows the story of Bo Yi and Shu Qi, both sons of the Lord of Guzhu who, in the last years of the Shang Dynasty, were against King Wu of the Zhou Dynasty and sent an army to attack King Zhou of Shang. They fled to Mount Shouyang where they fed on wild herbs, rather than eating the staple of the Zhou Dynasty, and eventually died of hunger. The painting depicts Bo Yi sitting on a rock in a tall mountain, holding his knees. Shu Qi sits beside him and talks to him. They wear coarse clothes and grass sandals. Their hair is dishevelled, and they reflect sadness and anger on their faces. There is a sharp pickaxe and a hand basket beside them. Around them are old densely wooded forests. At the foot of the mountain we can observe meandering streams. The figures are painted by plain sketching and the wrinkles in their clothes, with bent reed strokes. The turning strokes are forceful, which shows the profound brush skill of the painter. The inscription by Song Qi of Yuan says: "The message of this painting is admonition. The praise the painter gives to Bo Yi and Shu Qi who refused to serve in the Zhou Dynasty is targeted at the officials who surrendered to Yuan when the Song Dynasty moved to the south." It can be seen that when the painter selected this motif, he expressed in a concealed way his dissatisfaction with the court of Southern Song which was content to retain sovereignty over a part of the country to drag out an ignoble existence."

This work bears the signature of the painter, which reads: "Painting of Bo Yi and Shu Qi by Li Tang of Heyang." The frontispiece has an inscription by Li Zhuogong of Ming, which reads: "Hermit in Shouyang." The inscription on the front separate piece has the words: "Bo Yi and Shu Qi Gathering Wild Herbs by Li Tang of Southern Song." The end paper has annotations by Song Qi of Yuan, Yu Yunwen, Xiang Yuanbian, and Wu Borong of Ming, and Yong Xing, Weng Fanggang, Cai Zhiding, Ruan Yuan, Lin Zexu, and Wu Rongguang of Qing. There are close to one hundred collector seals on the painting, including "Collection in the Tingfan Tower of the Pan Family," "Seal of Appraisal and Appreciation of Xiang Molin," and "Jingyuan Studio." This painting is recorded in *The Boat of Calligraphy and Paintings on the Qing River* and *Postscripts on Famous Calligraphy and Paintings by Wang Keyu.*

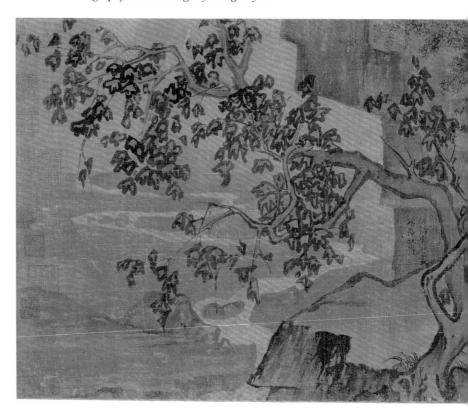

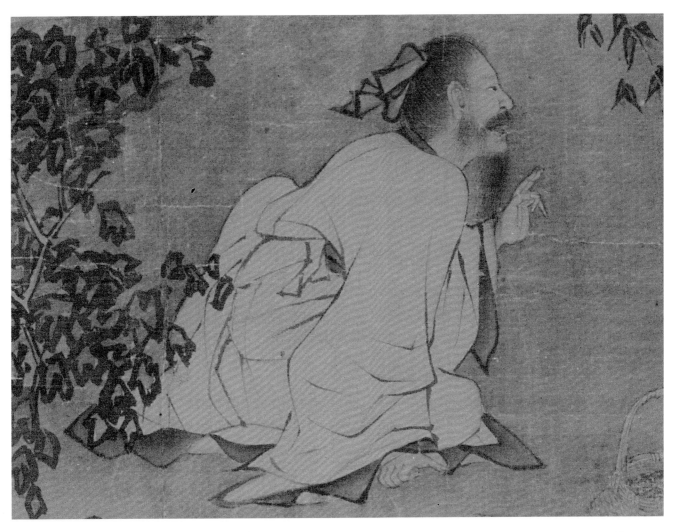

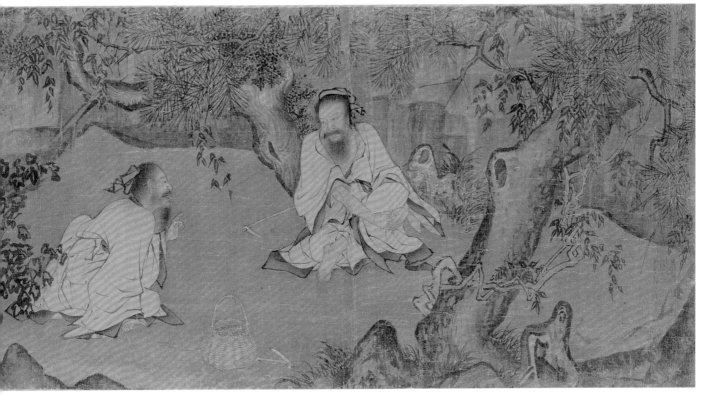

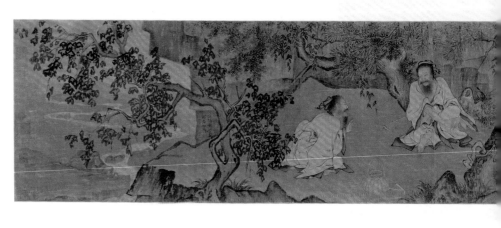

伯夷叔齊孤竹
君之二子也父欲
立叔齊及父卒
叔齊讓伯夷伯
夷曰父命也遂
逃去叔齊亦不
肯立而逃之國
人立其中子於
是伯夷叔齊
聞西伯昌善養
老盍往歸焉及
至西伯卒武王

載木主號為文
王西伯卒武王

首陽高隱

35

Landscape of the Four Seasons

by

Liu Songnian

of

Southern Song

Hand Scroll

Ink and colour on silk

Height (each painting) 41.2 cm Widths 67.9 cm, 69.2 cm, 68.9 cm, and 69.5 cm

This painting displays the solid foundation of Liu Songnian's profound expertise in landscape painting. Liu Songnian, whose years of birth and death are unknown, was active in the twelfth century. He was a native of Qiantang (present-day Hangzhou in Zhejiang), but resided at Qingbo Gate, where he was commonly called "Dark Gate Liu." He was a student at the Painting Academy in the early years of the reign of Chunxi. During 1190 and 1194, in the years of Shaoxi, he was promoted to Expectant Official of the Painting Academy. He excelled in the painting of figures and landscapes. His style followed that of the Northern Song painter Zhang Dunli, and he had the reputation of being even better than his teacher. His landscape painting is close to that of Zhao Boju. Together with Li Tang, Ma Yuan, and Xia Gui, he was part of the "Four Master Painters of Southern Song."

 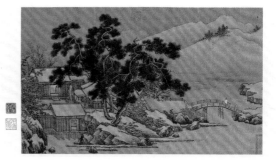

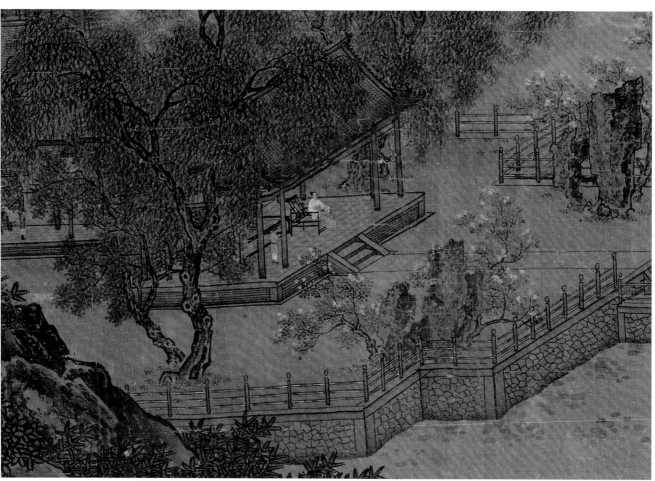

The scroll consists of four mounted paintings, depicting four garden villas in the four seasons. The painter's brush and ink are smooth, exquisite, and elegant, showing in a perfect way the beautiful, spacious, and misty scenery in the area of the West Lake in Hangzhou as well as the kind of easy, comfortable, and leisurely life led by high officials, descendants of nobles, intellectuals, scholars, and bureaucrats at that time. The composition places emphasis on variations in density and substance. The exquisite and meandering gardens, trees, and houses are placed at one side of the painting, leaving a considerable space to show the lakes, the sky, and the distant mountains. The method of painting trees and rocks reminds of the style of Li Tang, a painter of the Painting Academy. However, the axe-cut wrinkles tend to be small and broken, and the trees stall, thin, and elegant.

This work bears no signature or seal of the painter, but in the back of the painting an annotation by Li Dongyang indicates clearly that this painting is Liu's work. More than ten collector seals can be counted, including "Rare Treasures of the Lang Monsastery," "Appreciated by Ou Ting," "Collection of the Chunhe Garden," "Rearing is to Go against Heaven's Mandate," and "Seal of the Paintings and Calligraphy of Mei, Grand Defender Eunuch of the Four Territories." This painting is recorded in *Records of Paintings and Calligraphy in the Summer of the Year Gengzi.*

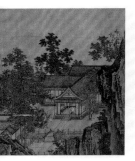
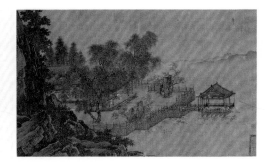
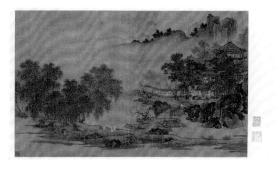

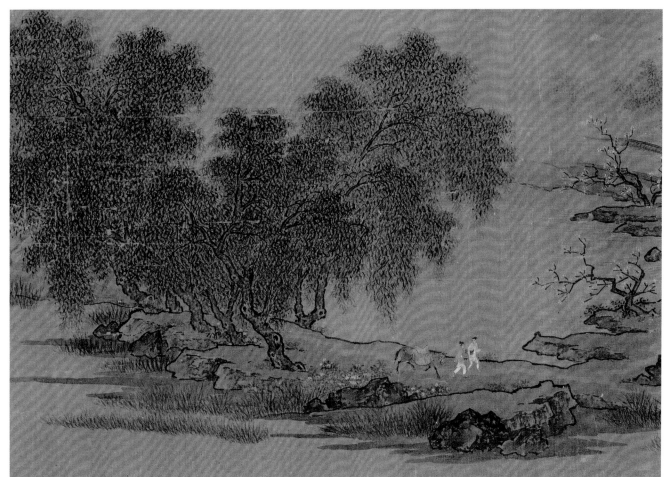

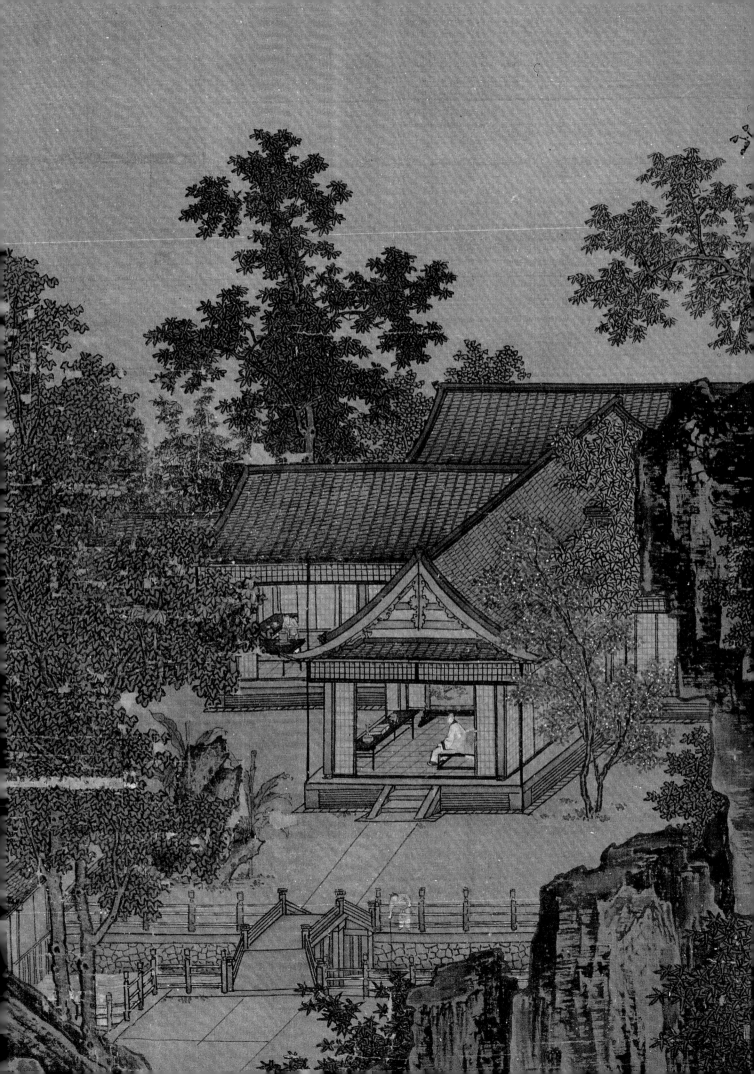

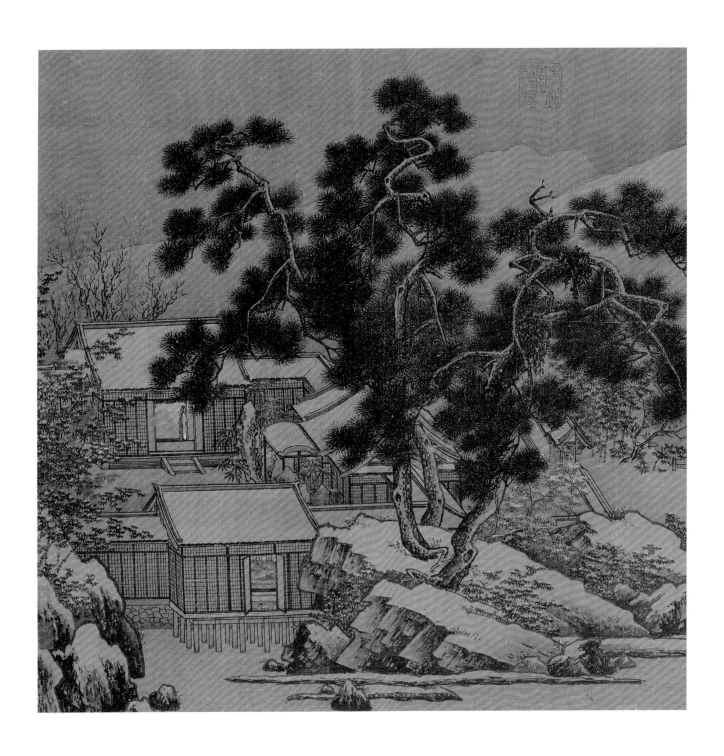

36

Ripe Fruits and Bird

by

Lin Chun

of

Southern Song

Album

Ink and colour on silk

Height 26.5 cm Width 27 cm

Qing court collection

This painting illustrates the realistic painting style of the Painting Academy of Northern Song and displays the painter's meticulous power of observation and the skills of expressing details. Lin Chun, whose years of birth and death are unknown, came from Qiantang (present-day Hangzhou in Zhejiang). He was active in the twelfth century and served as Expectant Official of the Painting Academy during the reign of Chunxi of Emperor Xiaozong in Southern Song (1174–1189). He was skilled in painting flowers, birds, grass, and insects. His paintings are mostly small sketches of blades of grass, trees, birds, and butterflies. In *The Precious Mirror for Paintings* of the Yuan Dynasty, it is said that: "His application of colour is light and pale, and he knows what is best for creation."

The painting has a crow standing with its head raised on a branch of a crabapple tree. The feathers of the crow are brush-shaded layer by layer. The colours are spread repeatedly, and there is no trace of ink, representing the soft and fluffy feathers and the soft and resilient tail fins. The tree branches are coloured with umber, while the leaves are coloured in green. Yellow and brown are used to dot the traces of moths created by insects on the leaves. The fruit is painted in pink, red, and purple, which set off the yellow and green leaves sharply.

This work bears the painter's signature, which reads: "Lin Chun." Song Luo's collector seal is on the painting: "Verified by Song Luo."

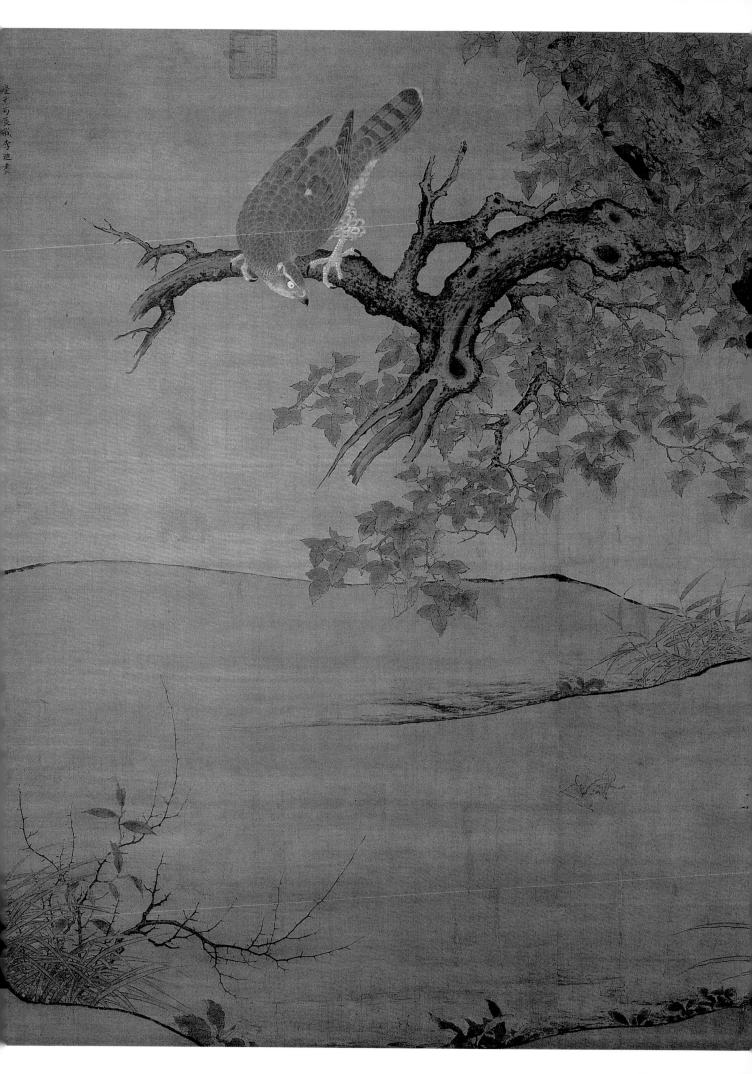

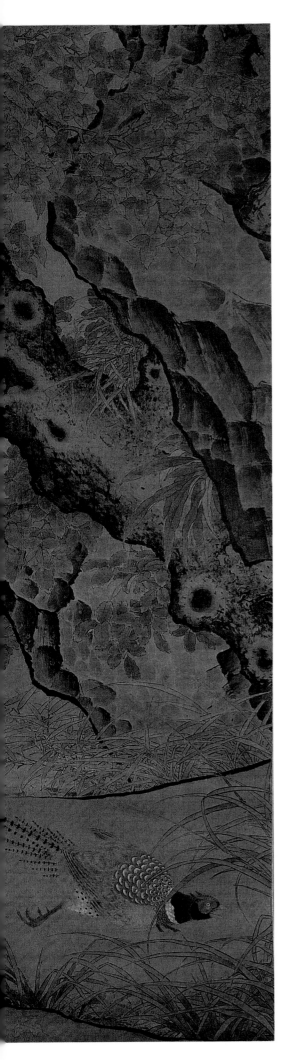

37

Maple, Eagle, and Pheasant

—— by ——
Li Di

—— of ——
Southern Song

Hanging Scroll

Ink and colour on silk

Height 189.4 cm Width 210 cm

This is a large-scale painting which is rarely seen in flower-and-bird paintings of the Painting Academy in Southern Song. In the history of Chinese painting, this work is also considered an important painting that has animal hunting as its motif. Li Di, whose years of birth and death are unknown, was active in the latter years of the twelfth century. He was born in Heyang (present-day Mengxian in Henan) and he served at the Painting Academy from 1162 to 1224 during the reigns of the emperors Xiaozong, Guangzong, and Ningzong of Southern Song. He excelled in the painting of flowers, bamboo, birds, and beasts. He inherited the tradition of the Painting Academy of Northern Song, which put emphasis on realism, and his style of painting was conscientious and careful.

The painting depicts an eagle standing majestically on a maple tree and turning its head to gaze at the pheasant that flies in the grass. A life-and-death struggle between an eagle and a pheasant takes place in the serene grass among the trees. This creates an effect of movement and also brings out a cruel atmosphere. The sharp eyes of the eagle and the fear and desperation in the eyes of the pheasant show the tyrannical air of the former, and the weakness of the latter. This is a reflection of the killings in the boundless universe. The sketching and colouring of the whole painting are neat, showing the style, marked by elaborate brushstrokes, of the Painting Academy of Southern Song.

This work bears the painter's signature, which reads: "Painted by Li Di in the Year of Bingchen in the Reign of Qingyuan." There is also a collector seal of Yun Xiang of Qing, which reads: "Treasure of the King of Yi."

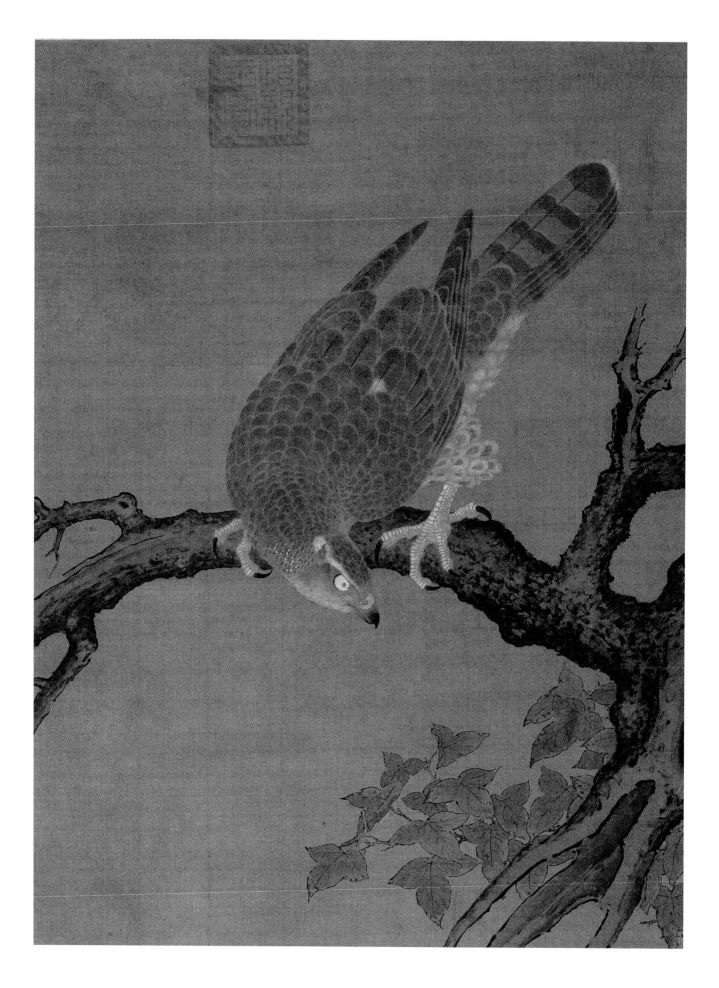

154

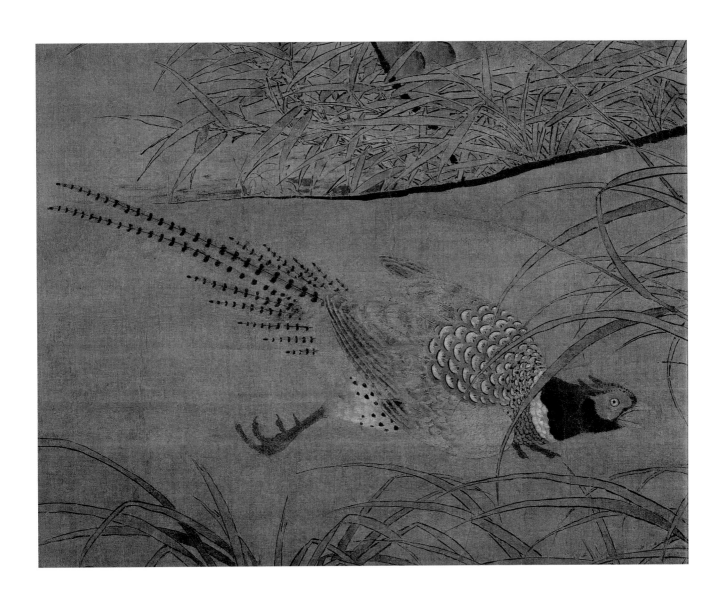

38

Dancing and Singing

by

Ma Yuan

of

Southern Song

Hanging Scroll

Ink and colour on silk

Height 192.5 cm Width 111 cm

This is a representative work of large-scale landscape painting by Ma Yuan and it is also a classic example of the method of large axe-cut wrinkles. Ma Yuan, whose years of birth and death are unknown, was active from 1190 to 1224 during the reign of the emperors Guangzong and Ningzong of Southern Song. Styled Yaofu and Qinshan, he was a native of Hezhong (present-day Yongji in Shanxi), but resided in Qiantang (present-day Hangzhou in Zhejiang). He followed in the footsteps of his great-grandfather, grandfather, elder uncle, and elder brother, and became Expectant Official of the Painting Academy. He excelled in the painting of figures, landscape, flowers, and birds. He started painting landscapes by learning from his father. He was later taught by Li Tang and came up with new ideas. The composition of his paintings adopted the form of cornering, and he began to be known as "Corner Ma." Ma, Li Tang, Liu Songnian, and Xia Gui are collectively called the "Four Master Painters of Southern Song."

This painting features a few old men returning home after drinking, waving their hands, trampling, and singing. Their funny behaviour is attracting a woman and a child who stand and look back at them. All over the painting are the luxuriant grain seedlings and bamboo, and the willow trees are green. In the distance, the mountain rocks are towering, like the cutting of a knife or the chopping of an axe. In the valleys, the pines and cypresses are dense, and the towers and pavilions set off one another. The mountain rocks are swept with the side tips of the brush, making use of the pauses in brushstrokes and the blank spaces to represent their texture and substance. Faint umber, pale blue and green are applied. The painting has a two-section composition. The upper section has the landscape as its motif, whereas the lower section has decorative figures as the main subject, which conveys the happy feelings of the people in a bumper year.

This work bears the painter's signature, which reads: "Ma Yuan," and an inscription of a poem by the Song Emperor Ningzong, which further clarifies the message of the painting. This painting is recorded in *Records of Southern Song Academy Painters*, *Dong Tu's Record of Paintings Seen*, *Paintings in the Collection of Han Shineng*, *Catalogue of Paintings and Calligraphy in the Peiwen Studio*, and *Collections of Professional Paintings*.

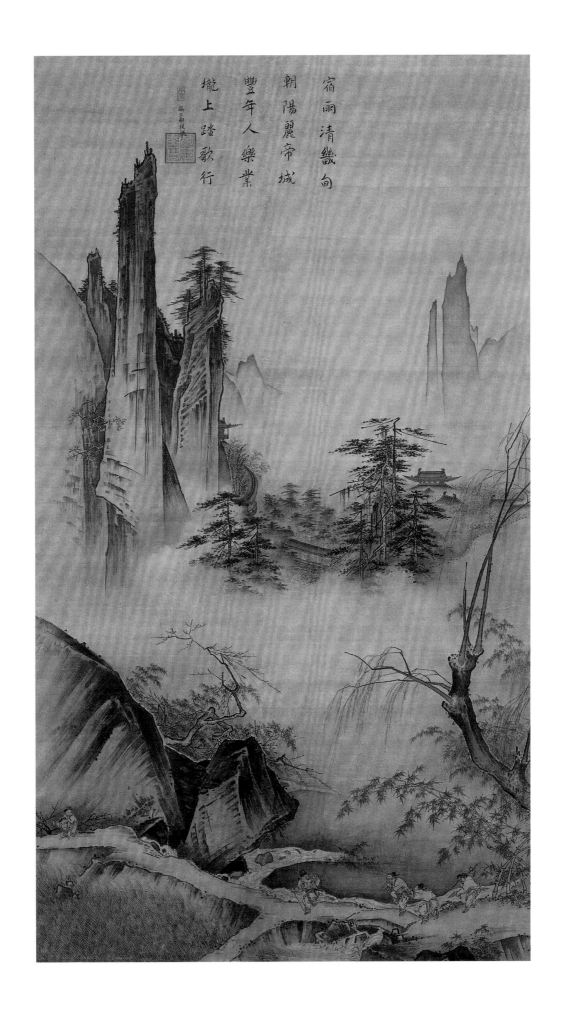

宿雨清畿甸

朝陽麗帝城

豐年人樂業

隴上踏歌行

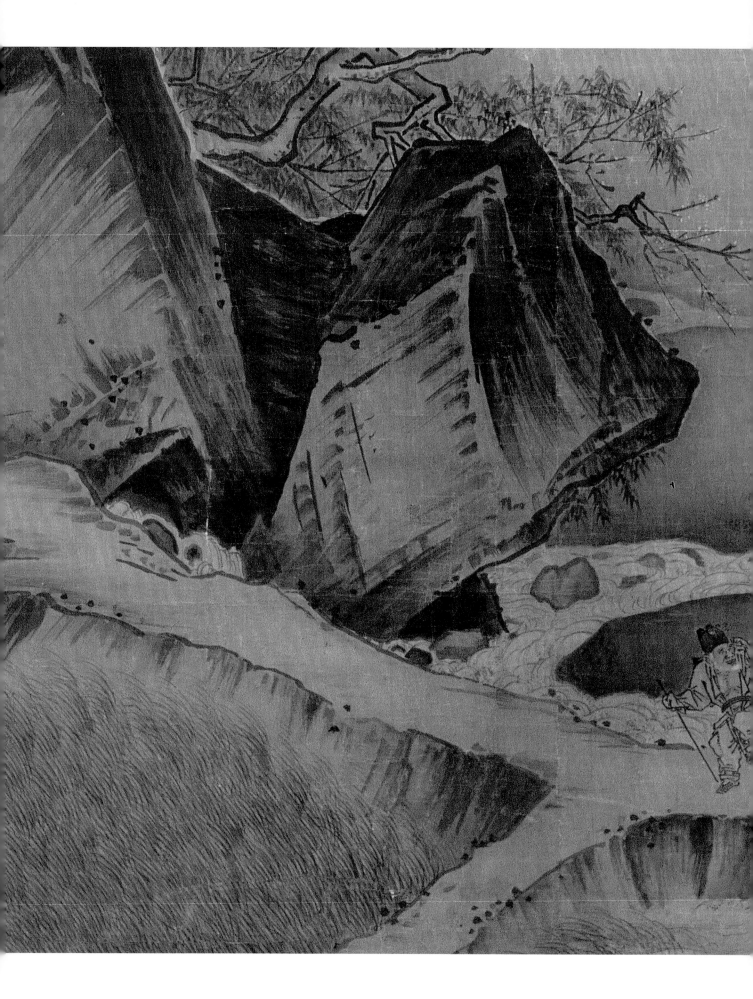

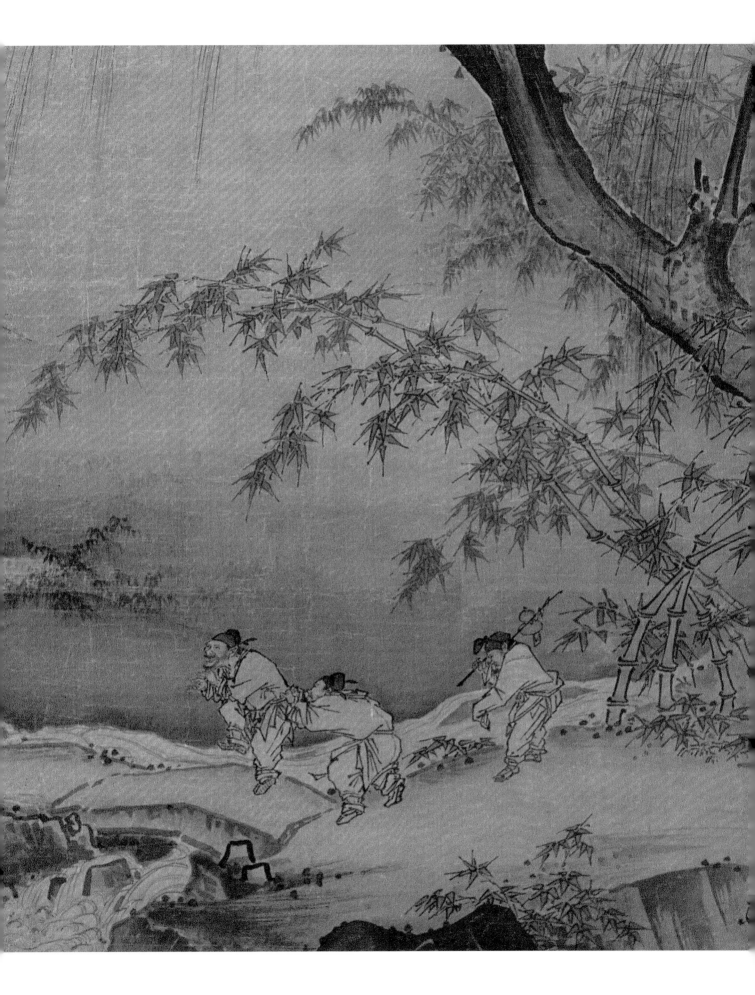

Plum Tree, Rock, Stream, and Mallards

by

Ma Yuan

of

Southern Song

Album

Ink and colour on silk

Height 26.7 cm Width 28.6 cm

This is a short sketch and a gem in waterfowl painting that emphasizes happiness in the Song Dynasty. The painting depicts a cliff towering slantingly, with plum branches hanging upside down. In the stream, shrouded in misty clouds, there are a number of wild ducks swimming, in an extremely lively way. The mountain rock is painted with the method of axe-cut wrinkles, giving it a square, hard, and towering appearance, which contrasts sharply with the fluffy feathers of the wild ducks that are painted with light and swift strokes. The composition of the painting is diagonal. The rocks and plum trees are pushed into a corner, while the flowing water and wild ducks, on the lower side, play the role of balancing the composition. They are also what brings the work to life. The scene of "The ducks are the first to know that water in the river in spring is getting warm" is represented vividly on the silk.

This work bears the painter's signature, which reads: "Ma Yuan." There are four collector seals on the painting, which are "Treasure of Lu Wang," "Appreciated by Mao Lin," "A Meng," and "Private Seal of Yuteng."

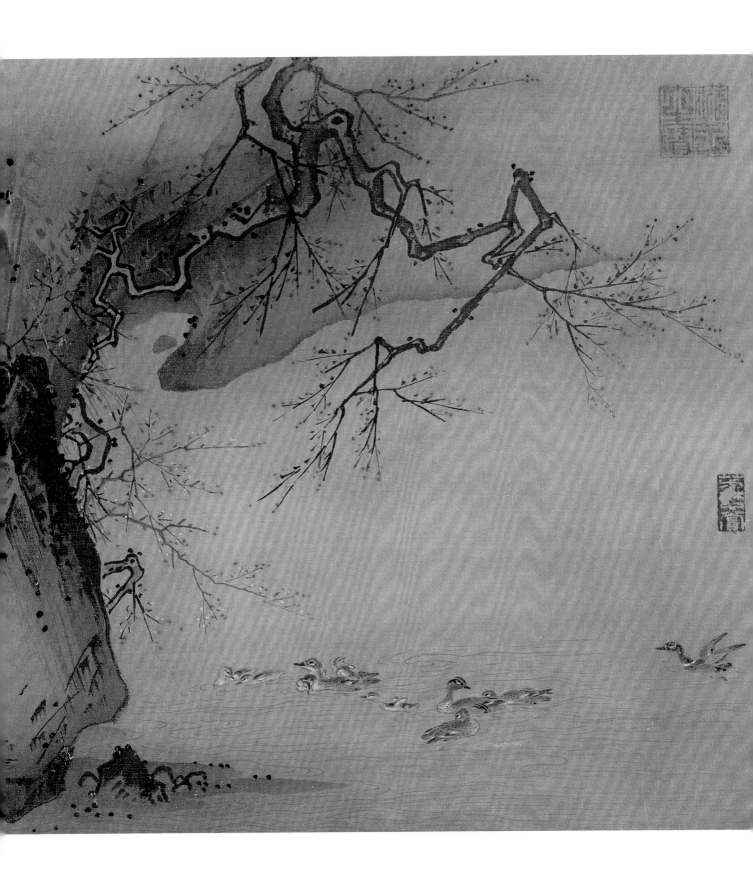

40

Layered Icy Silk

— by —

Ma Lin

— of —

Southern Song

Hanging Scroll

Ink and colour on silk

Height 101.7 cm Width 49.6 cm

This piece of art is a representative flower painting of Ma Lin whose composition, brushstrokes, and ink are impeccable. Ma Lin, son of Ma Yuan and native of Qiantang (present-day Hangzhou in Zhejiang), served as Usher in the Painting Academy from 1195 to 1264, in the period of the emperors Ningzong and Lizong of Southern Song. When he was young, he started to learn painting from his father, and soon became skilled in depicting landscapes, figures, and flowers. His flower-and-bird paintings were beautiful and free, and often included inscriptions by Emperor Ningzong and Empress Yang, since his works were given as gifts to ministers and members of the imperial family.

This work portrays three branches of palatial plums that are neatly arranged. The branches are like iron wires and clusters of white plum trees are in full blossom in an extremely concise composition. The plum branches are drawn with fine brushstrokes, heavy ink, and double outlines, and coloured with light ink. The petals of the plum flowers are circled with light ink, and coloured and covered with white powder, providing them with a feeling of transparency and transmitting their real fragrance, chill, and beauty.

This work bears the painter's signature, which reads: "Official Ma Lin." Empress Yang (a.k.a. Empress Gongsheng) of the Song Emperor Ningzong inscribed the title of the painting: "Layered Icy Silk," together with a poem. The seals read: "Yang's Seal" and "Painted at the Palace of Earthly Tranquility in the Year of Bingzi." The lower margin of the mounting has inscriptions by Gu Congde and Xiang Zijing, made in the years of Jiajing of Ming, which mentioned that this painting was bought at the price of "forty-five taels of gold." There are more than ten collector seals on the painting, including "Rare Treasures of Xiang Yuanbian," and "Rare Family Collection of Xiang Zijing" of Ming, and "Works Verified by Song Luo of Shangqiu as Authentic."

渾如冷蝶宿花房
擁抱檀心憶舊香
開到寒梢尤可愛
此般必是漢宮粧

層疊冰綃

41

Remote Mountains in the Mist and Clouds

by

Xia Gui

of

Southern Song

Album

Water and ink on silk

Height 23.5 cm Width 24.2 cm

This painting is a paradigmatic work in freehand style of small landscape sketches by Xia Gui. Xia Gui, whose years of birth and death are unknown and styled Yuyu, was a native of Qiantang (present-day Hangzhou in Zhejiang). He served as Expectant Official of the Painting Academy from 1195 to 1224, during the reign of Emperor Ningzong of Song. He started drawing figures and later became proficient in landscape painting, with a style that he inherited from Li Tang. In composition, he was fond of creating a partial scene in one of the corners of his paintings, a fact that made him labelled as "Half-side Painter Xia." He was equally famous as Ma Yuan, and these two painters were usually mentioned together as the "Ma and Xia."

This painting has a wide perspective. The foreground takes up only a very tiny part of the lower side. In the distance, vast mountain ranges are shrouded by the boundless and indistinct mist, now visible now invisible, leading one's sight to deeper and more distant places. The ink on this album is wet and moist with the addition of a large amount of water so that the brushstrokes melt fully into it, showing in full the elegance and moisture of the mountains and rivers in Jiangnan.

No signature or seal of the painter is found in this piece, but the margin of the mounting has an old inscription, which reads: "Remote Mountains in the Mist and Clouds by Xia Gui." There are two collector seals on the painting, namely, "Painting Verified by Bian Huizhi" and "Rare Collection of Authentic Paintings of Song and Yuan Periods by Pang Laichen." This painting is recorded in *Records of Famous Paintings from the Private Collection of Xuzhai*.

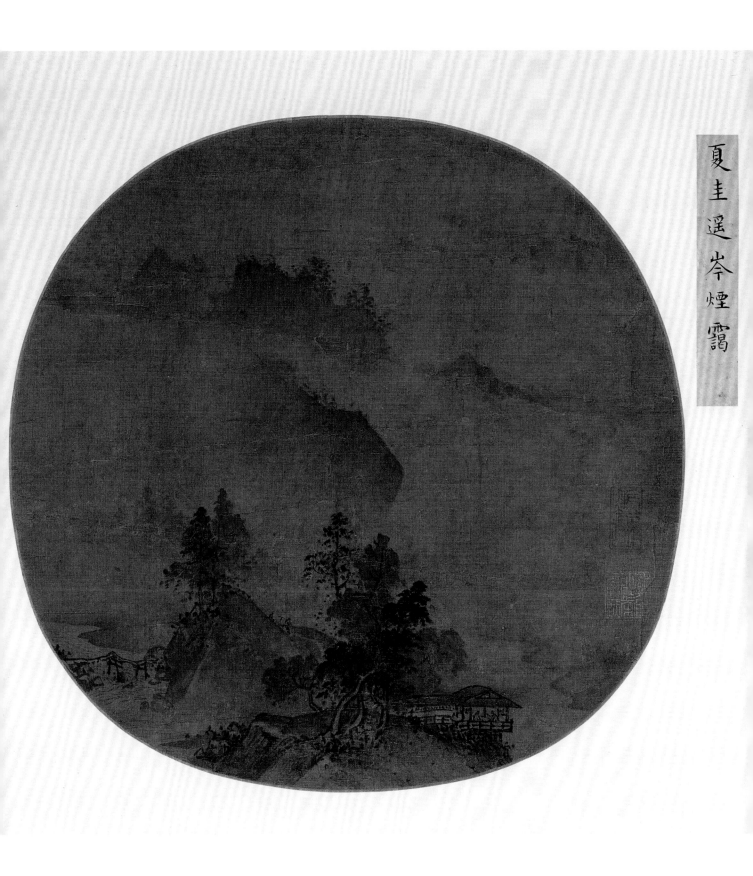

夏圭 遙岑煙靄

Friends Chatting in a Snowy Weather

by
Xia Gui
of
Southern Song

Album

Ink and colour on silk

Height 28.2 cm Width 29.5 cm

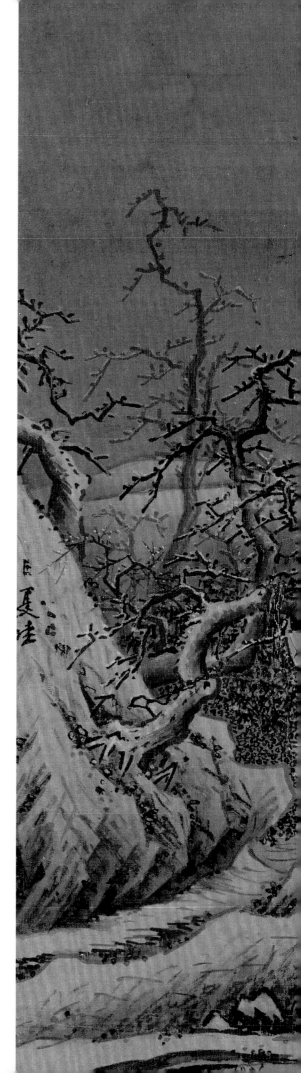

This painting is a typical landscape painting of a snowy scene and was painstakingly drawn by Xia Gui for its presentation to the royal family of the Song Dynasty. The painting depicts a scene in which the sky is beginning to clear up after a great snow in Jiangnan. The sky is still gloomy, the accumulated snow on the sloping shore and the hills is white, and an old fisherman wearing a straw hat is boating alone in the chilly river. In a waterside pavilion, there are two friends discussing their principles. The painter uses the method of colouring and leaving blank spaces to form a black and white contrastive effect, and to show the colour of the snow. He applies white powder to the treetops, eaves, and rock facets to highlight the dazzling light of the snow. The use of strokes on the houses and huts is even, and there are traces of boundary drawing.

The painter signed this work as: "Official Xia Gui."

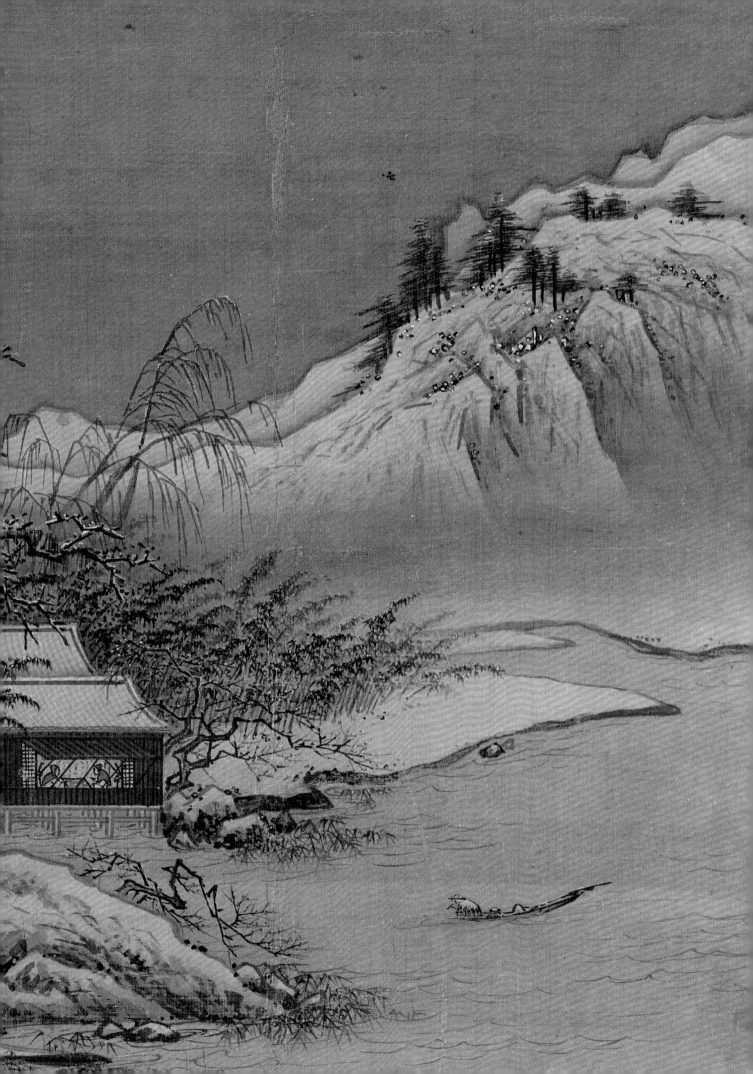

43

Bathing Horses in the Willow Pond

by

Chen Juzhong

of

Southern Song

Album

Ink and colour on silk

Height 23.7 cm Width 26 cm

This is a man-and-horse painting exquisitely drawn by Chen Juzhong. Chen Juzhong, whose years of birth and death are unknown, served as Expectant Official of the Painting Academy from 1201 to 1204, during the reign of Jiatai of Emperor Ningzong in Southern Song. He specialized in the painting of figures, foreign horses, and running beasts. The shapes are accurate and real, the use of the brush is delicate and neat, and the colour is rich and elegant.

This painting is based on the high summer season. The mountains in the distance are green and lush. On the side of the pond, there are green drooping willows. A leader of the shepherds sits cross-legged under a tree, watching the shepherds driving hordes of horses from the grassland and the woodland into the water. The men and the horses are small as beans, but the expressions of the figures, the different colours of the hair, and the postures of the horses are accurate and lively. The brushstrokes are serious, and the description is refined.

This work bears no signature or seal of the painter. The margin of the mounting has an old inscription, which reads: "Chen Juzhong." The facing couplet has an annotation by Geng Zhaozhong of Qing. There are nine collector seals on the painting, including, among others, "Appreciated by Geng Zhaozhong," "Collection of Geng Zhaozhong," by Geng Zhaozhong of Qing, and "Rare Collection of Authentic Paintings of Song and Yuan Periods by Pang Laichen" by Pang Laichen of the modern period.

陳居中

44

Knick-knack Pedlar

— by —

Li Song

— of —

Southern Song

Hand Scroll

Ink and colour on silk

Height 25.5 cm Width 70.4 cm
Qing court collection

This is a painting that faithfully reflects the village life of the Song Dynasty. Several copies of the *Knick-knack Pedlar* remain, yet this copy is the best. Li Song, whose years of birth and death are unknown, was active in the thirteenth century, and was a native of Qiantang (present-day Hangzhou). He was born into a poor family and in his youth, he worked as a carpenter. He grew fond of painting and later, he was adopted by Li Congxun, a famous painter in the Xuanhe Academy of Northern Song, who took him as his son and taught him the art of painting. Li Song served as Expectant Official of the Painting Academy from 1190 to 1233, from the reign of Shaoxi to the reign of Shaoding, going through the three reigns of the emperors Guangzong, Ningzong, and Lizong. He was therefore addressed respectfully by his contemporaries as "a veteran painter of three reigns." His artworks usually depict the villagers' customs and mores as main motifs.

This particular work depicts a fine autumn day. The old willow trees are sparse and the grass on the slope is yellowish. The knick-knack pedlar who goes from village to village puts down his load and is immediately surrounded by women and children. The scene is boisterous, filled with a rustic atmosphere. The happiness of the children and the loving hearts of the mothers are vividly shown. The mind of the pedlar, who has to serve the children while fearing that his goods would be damaged, is portrayed in a most lively manner. The pedlar's load is also drawn clearly and meticulously. His collection of goods is dazzling to the eyes, including farming utensils, food, and general merchandise. The goods are labelled with words such as "Shandong yellow rice," "vinegar," "know the geomancy," "guardian god," and "miscellaneous agreements." This reflects the solid life foundation and the serious painting style of the painter.

This work includes the signature of the artist, which reads: "Li Song, adopted son of Li Congxun, painted this work in the year of Xinwei during the reign of Jiading." It also has an inscription of a poem by Qing Emperor Qianlong. The rear separate piece has a title slate written by Liang Qingbiao of the Qing Dynasty. There are more than thirty collector seals on the painting, including "The Shiqu Imperial Catalogue of Paintings and Calligraphy," "Treasure of the Imperial Study," "Appreciated by Emperor Qianlong," and "Blessings to Children and Grandchildren" of the Qing Palace Treasury, "Layman Jiaolin" by Liang Qingbiao, and "Seal of Sun Chengze" by Sun Chengze of Qing. The painting is recorded in *The Shiqu Imperial Catalogue of Paintings and Calligraphy, Volume 1*.

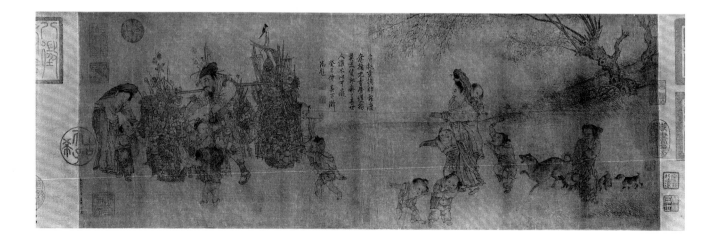

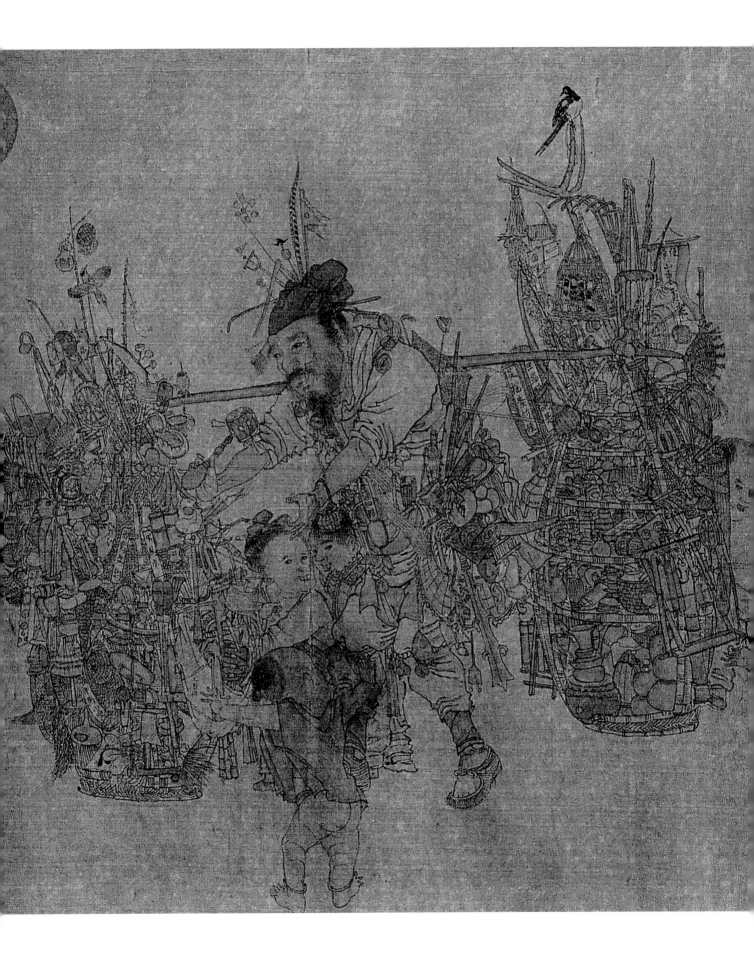

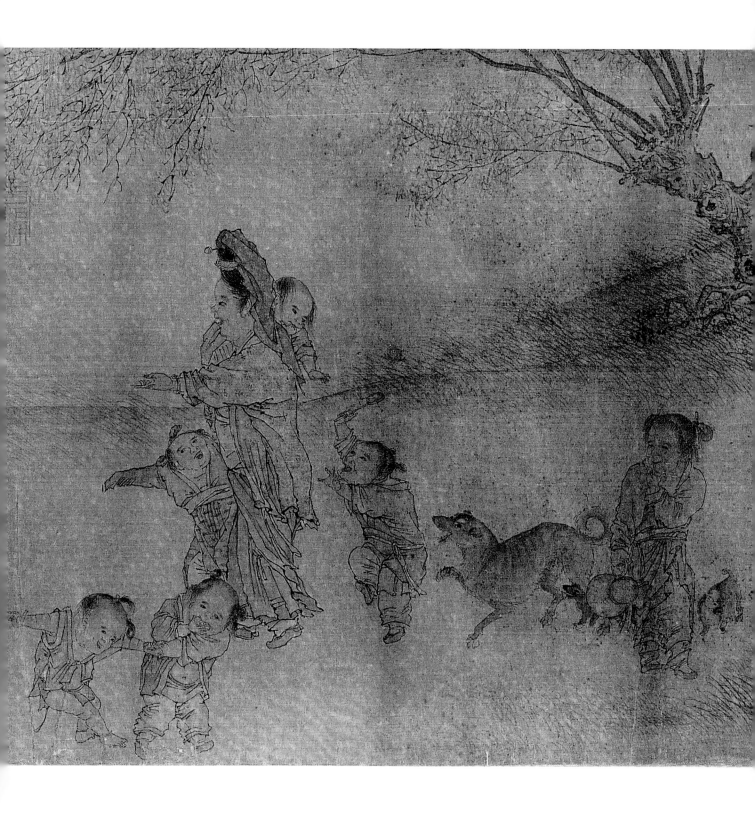

45

Lotus Flower Breaking the Surface

by

an Anonymous Painter

of

Southern Song

Album

Ink and colour on silk

Height 23.8 cm Width 25 cm

This piece is a typical flower painting that exhibits the fine brushwork and strong colouring of the Song Dynasty. Painted in the picture is a lotus flower in full bloom, which is foiled by its green lotus leaves, illustrating to the full the character of the lotus: "Lotus rises from the mud yet it is not contaminated by it, and it is bathed in clean waves yet it is not enchanting." The technique for sketching lotus petals is similar to the boneless method that emerged on later ages. Not a trace of the sketching of the brush is seen, and it brings out the feeling of a substance that is light and moist. The red threads on the petals and the powder on the tips of the pistils are detailed, making the shape light, and the colour of every petal impeccable. This has been praised as superlative craftsmanship.

The title slate on the margin of the mounting reads: "Lotus Flower Breaking the Surface by Wu Bing," yet it was proven to be a fake by later generations. This work has a damaged seal whose characters are not distinguishable. This painting is collected in *Records of Famous Paintings from the Private Collection of Xuzhai.*

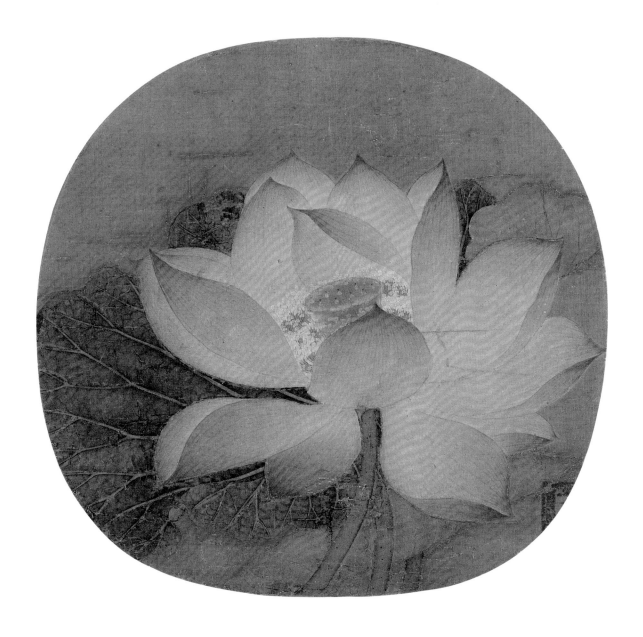

46

Autumn Willow and Double Crows

by

Liang Kai

of

Southern Song

Album

Ink and colour on silk

Height 24.7 cm Width 25.7 cm
Qing court collection

This painting is a typical example of "abbreviated brush" by Liang Kai. Liang Kai, whose years of birth and death are unknown, was active in the thirteenth century. He was a native of Dongping (belonging to the present-day Shandong Province), but he resided in Qiantang (present-day Hangzhou in Zhejiang) for a long time. He had a wild and free disposition and was not confined by rites and rules, thus he was called by his contemporaries the "Madman Liang." He was skilled in painting figures, landscapes, flowers, and birds. His style was inspired by those of Li Gonglin of Northern Song and Jia Shigu of Southern Song, and he also learned the bold-stroke figure painting from Shi Ke of the State of Western Shu in the Five Dynasties. His extant works are based either on the "fine brush" or on the "abbreviated brush" style, which is simple and free, and had a huge impact on later artists.

This painting is mounted in the form of a round silk fan. The willow trunk in the painting thrusts itself upward from the bottom in a slanted way, dividing the surface in two, which is novel and special in its composition. On each of the two sides is a flying crow chirping with each other, breaking the silence of the autumn night. The entire painting is full of dry brush and dark ink, and the blank spaces are coloured with thin ink to bring out the thin clouds and light mist. With just a few strokes, the painter sketches out in a lively way the postures of the willows and the crows. This method of "abbreviated brush" by Liang Kai and its form of composition are rarely seen in the flower-and-bird painting of the Northern and Southern Song dynasties.

This work bears the signature of the painter, which reads: "Liang Kai." There are three collector seals as well, but the characters on these seals are so blurred that they are indistinguishable.

47

Ink Sketch of Realism
— ascribed to —
Fachang
— of —
Southern Song
Hand Scroll

Ink and brush on paper

Height 47.3 cm　Width 814.1 cm

This painting is a typical example of the freehand style of painting in ink by Fachang. Fachang, whose years of birth and death are unknown, was active in the thirteenth century. He was styled Muxi, a monk of the last period of the Southern Song Dynasty. He excelled in the painting of landscape, figures, and animals, with a style that is close to that of Liang Kai but developed in a different way. People of the Yuan Dynasty recorded that Fachang attempted to use bagasse and grass knots to make his paintings, and he dotted ink according to the flow of his brush. The messages are simple and appropriate and they do not need adornments. Some of his works spread to Japan.

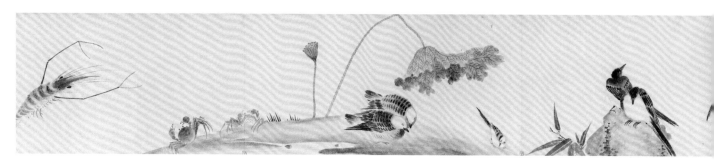

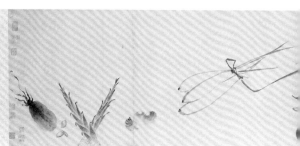

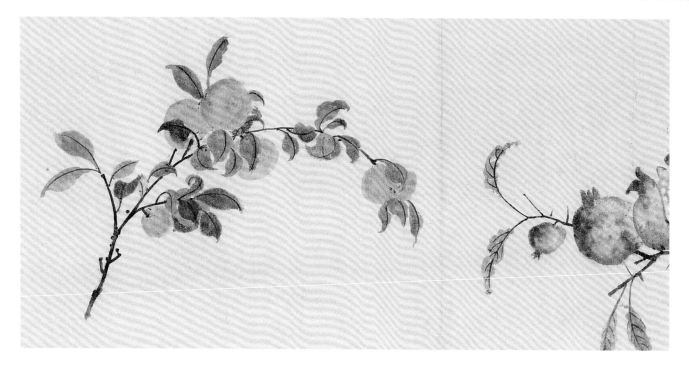

In the work, the artist paints more than twenty types of fruit, vegetable, flowers, fowls, birds, fish, and shrimps, such as pomegranates, peaches, pears, loquats, sparrows, magpies, wagtails, ruddy shelducks, lotus flowers, crabs, shrimps, water chestnuts, turnips, eggplants, wild rice stems, and bamboo shoots. They are sketched merely in ink, without any colours, an extremely creative technique in the painting circles of Southern Song. This method opened the door to the development of the freehand style of flower painting. It is true that this scroll is a free stroke live sketch, but the objects and images are very accurate and regulated, differing from the literati freehand painting that came in later ages and was based on "forsaking the appearance to get the spirit."

This work bears no signature or seal of the painter. The end paper has an annotation by Shen Zhou of Ming. Dozens of collector seals can be observed, including "Seal of Ye Gongchuo," "Seal of Wu Zixiao," "Yu Fu," "Seal of Wu Chunshu," "Yanling Zhongzi," "Seal of the Paintings and Calligraphy Collection by Ye Gongchuo from Fanyu," "Examining Painting by Wu Hufan," and "Appreciating Paintings by Liang Zhangju."

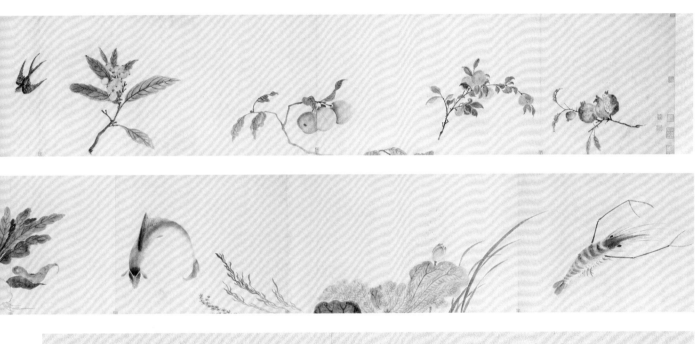

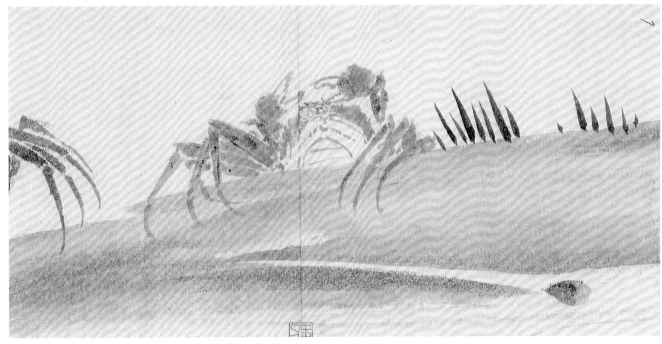

48

Orchids in Ink
by
Zhao Mengjian
of
Southern Song
Hand Scroll

Water and ink on paper

Height 34.5 cm Width 90.2 cm

This painting is a typical orchid in ink painting by Zhao Mengjian using the freehand style. Zhao Mengjian (1199–1264), also known as Zigu and Yizhai, was a member of the imperial clan of Song. When Song moved to the south, he relocated to Guangchen Town in Haiyan, Jiaxing (present-day Haiyan in Zhejiang). In 1226, the second year of the reign of Baoqing of the Southern Song Dynasty, he obtained the *jinshi* degree (metropolitan graduate), and served as Left Treasury Controller (another version is that he served as Governor of Yanzhou). He was learned, elegant, and talented. He was skilled in literature and poetry. He also excelled in calligraphy and painting. His collection of paintings was rich, comparable to that of Mi Fu, his contemporary. He was fond of drawing and sketching plums, orchids, narcissi, bamboo, and rocks, to show that he considered himself morally superior and that his breadth of mind was different from that of vulgar intellectuals.

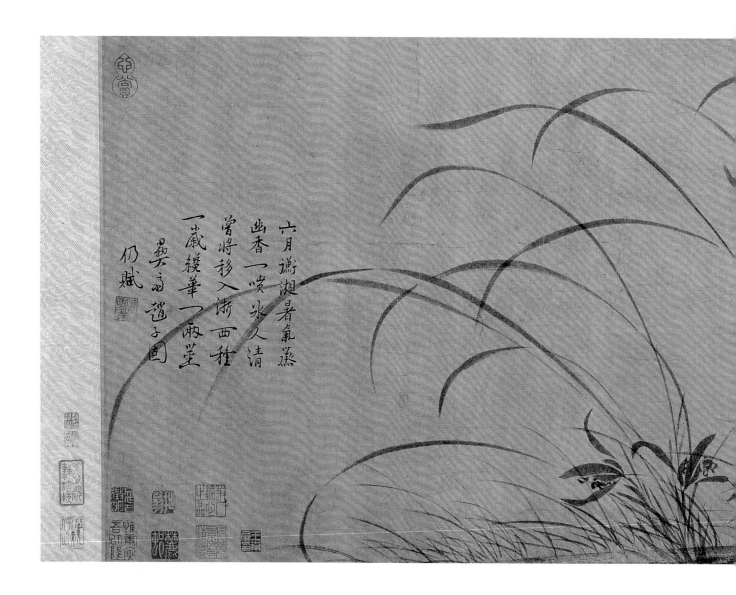

The painting depicts two orchids with their thin leaves spreading out in all directions. These are brushed with light ink from the bottom. This has the effect of making the orchid swaying lightly in the spring breeze. The brushstrokes are smooth and free. The artist raises and presses the brush and combines dryness and wetness to transmit subtly the *yin* and *yang*, the front and back, of the orchid leaves. The ink that is applied in this painting is sparse but every stroke proves necessary. This heralds a successful way of painting orchids in ink for subsequent artists. Lu Shidao realized that "calligraphy and painting are of the same origin," which was a new insight at the time. The characters of the inscription on this scroll are thin and weak, reflecting the calligraphy of the painter in his early years.

This work has a seven-character poem inscribed by the painter himself. The seal reads: "Live Sketch by Zigu" (white relief). There is also another seven-character poem inscribed by Weng Gujing of Guanyuan. The front separate piece has a title slate, which reads: "Spring Orchid by Zhao Mengjian of Song, An Qi's Collection." The end paper has eight annotations by Wen Zhengming, Wang Guxiang, Mi Yuefan, Zhou Tianqiu, Peng Nian, Yuan Jiong, Lu Shidao, and Ye Gongchuo. There are dozens of collector seals on the painting, including "Seal of Wen Zhengming" by Wen Zhengming of Ming, "Rare Family Collection of An Yizhou" and "Appreciated by Zhuo An" by An Qi of Qing, and "Seal of Wang Nanping" by Wang Nanping. This painting is recorded in *Classified Records of Calligraphy and Paintings in the Shigu Hall*, *Dream Journey in the Record of Wonderful Sights*, *Random Notes on Works in Ink*, and *Hundred Poems Appreciating Hundred Paintings in the Qingxia Studio*.

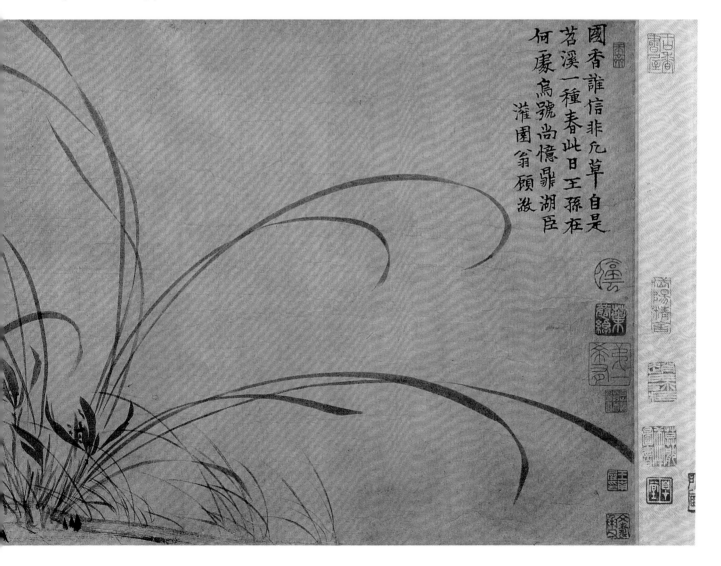

49

The Ladies' Classic of Filial Piety

———— by ————

an Anonymous Painter

———— of ————

Southern Song

Hand Scroll (partial)

Ink and colour on silk

Height (each painting) 43.8 cm
Width (each painting) 68.7 om
Qing court collection

This scroll is currently the earliest and best preserved work that reflects the content of *The Ladies' Classic of Filial Piety*. It bears no signature or seal of the painter but it is previously ascribed to a painter of the Tang Dynasty.

The Ladies' Classic of Filial Piety was edited by the wife of Houmochen Miao, who served as Gentleman for Closing Court in the Tang Dynasty. His wife, surnamed Deng (or Zheng), edited this book to regulate the behaviour of her niece, who was offered the title of Imperial Concubine of Yongwang. This classic has eighteen chapters, with a table of contents that follows the Confucian classic *The Classic of Filial Piety*. The painter uses pictorial explanations to illustrate the first nine chapters of *The Ladies' Classic of Filial Piety* in nine different sections. These sections are as follows: (1) The Starting Point and Basic Principles; (2) Empress and Imperial Consorts; (3) The Three Powers; (4) Elucidating Wisdom; (5) Serving the Parents-in-law; (6) Wives of the Federal Lords; (7) Noble Ladies; (8) Government by Filiality; and (9) Common People. Behind the painting of each section we can find the inscription of the original text of the corresponding part in *The Ladies' Classic of Filial Piety* in ink, with a style of calligraphy that is close to that of Zhao Gou, Emperor Gaozong of Song. The painting method involves neat strokes and heavy colours. The use of the brush is meticulous, fine, and strong. The demeanour of the figures is graceful and elegant, and their behaviour is regulated, which vividly illustrates a mother's composure, virtue, and ability, and the benevolence and wisdom in the speech and behaviour of women that must be observed in the feudal society. The wrinkles in the clothes are sketched with iron lines, the houses are painted by boundary drawing, and the trees and rocks are wrinkled and rubbed in a refined way.

The collector seals of this painting include the imperial seals that read "Treasure Perused by Emperor Qianlong," "Treasure Perused by Emperor Jiaqing," "Treasure Perused by Emperor Xuantong" of the Qing Palace Treasury, and also "Rare Treasure of Cao Rong." This painting is recorded in *The Shiqu Imperial Catalogue of Paintings and Calligraphy, Volume 1*.

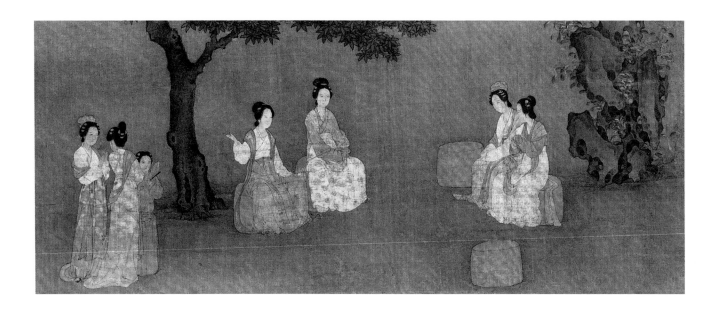

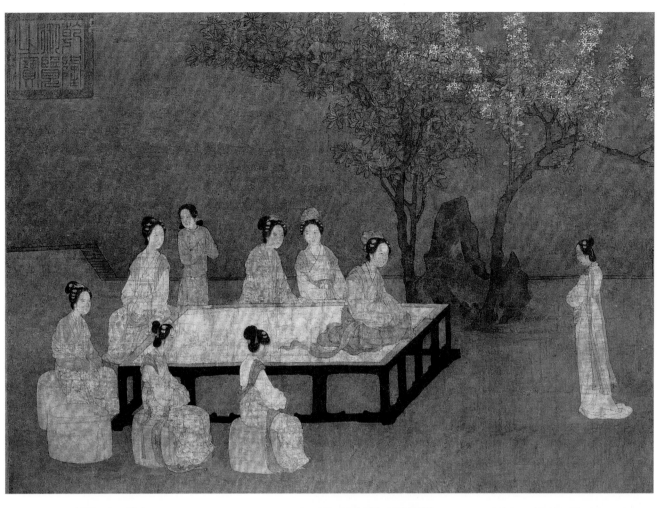

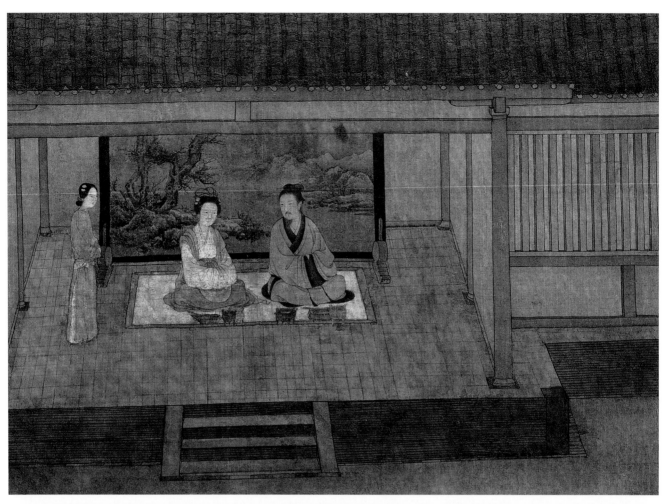

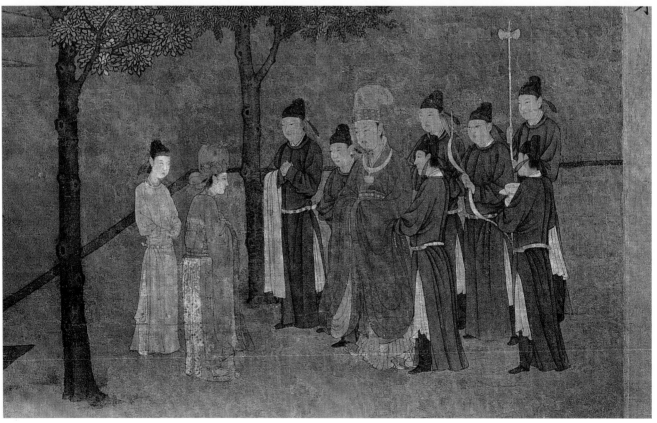

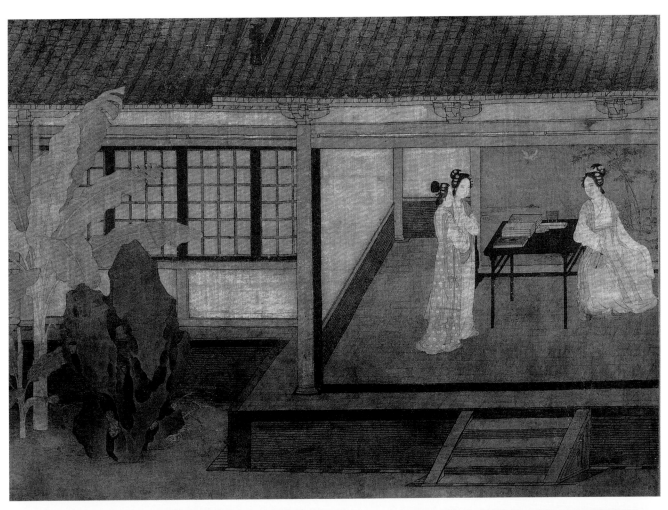

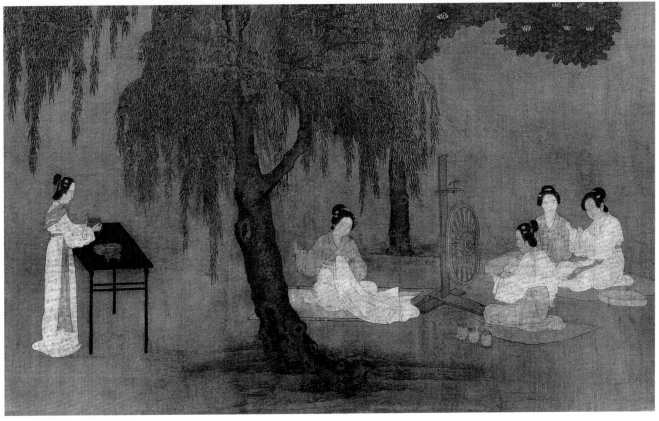

50

Confucius' Disciples

— by —

an Anonymous Painter

— of —

Southern Song

Hand Scroll

Ink and colour on silk

Height 30.6 cm Width 46.4 cm

This painting scroll shows the mature stage that figure painting reached in the Song Dynasty. It consists of portraits of Confucius and his thirty-six disciples. From right to left we can see Confucius, Yan Yuan, Min Ziqian, Ran Geng, Qu Boyu, Zhonggong, Ran Feng, Zilu, Zigao, Ziwo, Fan Xu, Zixia, Zigong, Yan Yan, Gongxi Ai, Zizhang, Zeng Shen, Tantai, Mieming, Yuan Xian, Zijian, Gongye Chang, Nangong Tao, Zeng Xi, Shang Qu, Qidiao Kai, Ren Buqi, Gongbo Liao, Yan Zu, Ziniu, Ziyou, Gongxi Chi, Wuma Shi, Liang Shan, Qiao Shan, Yan Xing, Ran Ru, and Gongsun Long. They all have different postures, lively and solemn. Some hold books and meditating, others clasp

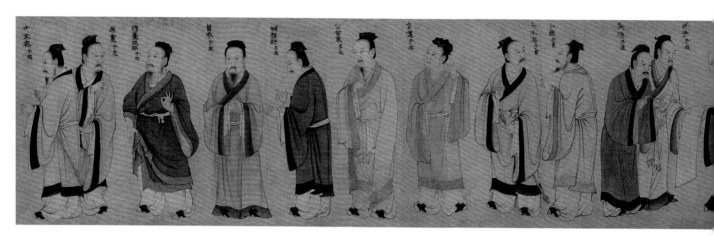

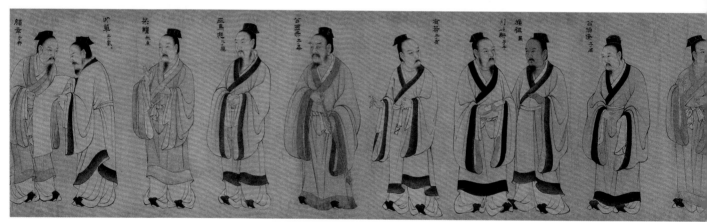

their hands to greet, still others stretch their hands debating, and yet others open their books to read. The composition is set out as a horizontal scroll. It has inscriptions but no background, and belongs to figure portrait in silk.

This work bears a signature, which reads: "Official Gonglin painted this work for presentation to the emperor on the third day of the third year of the reign of Yuanyou," but the title is fake. The end paper has annotations by Xie Jin and Wang Zhideng of the Ming Dynasty, and Guan Tong and Mei Zengliang of the Qing Dynasty. There are five collector seals on the painting, including "Family Collection of Wang Jiyu," "Wu Ting," and "Jiangcun."

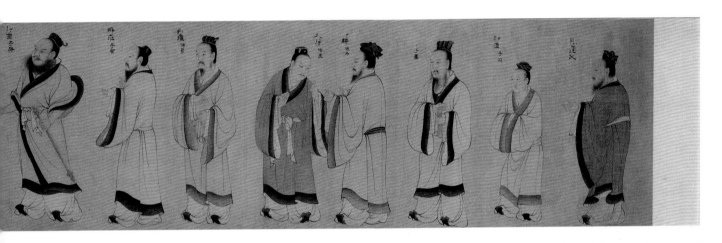

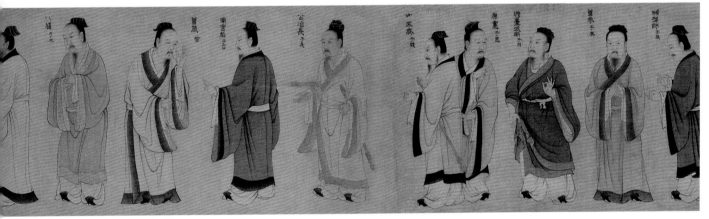

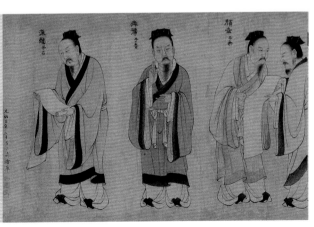

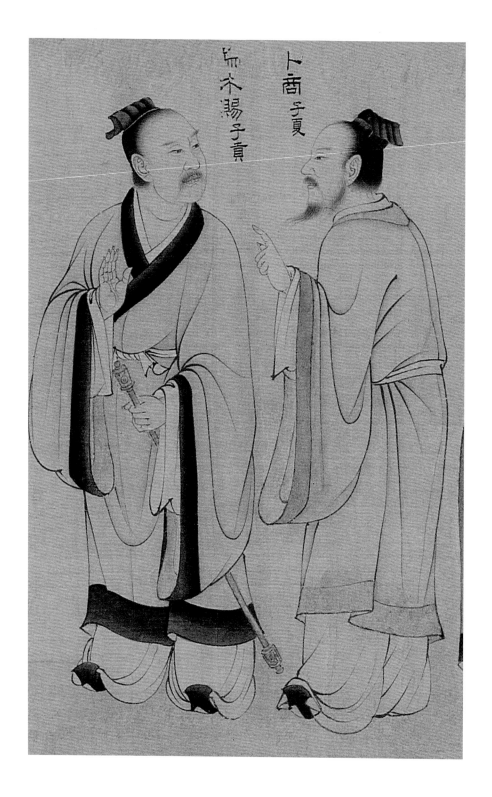

端木賜子貢　卜商子夏

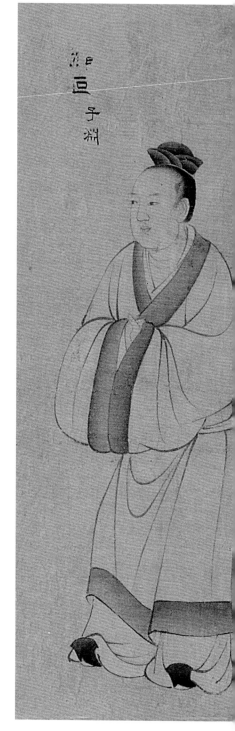

顏回子淵

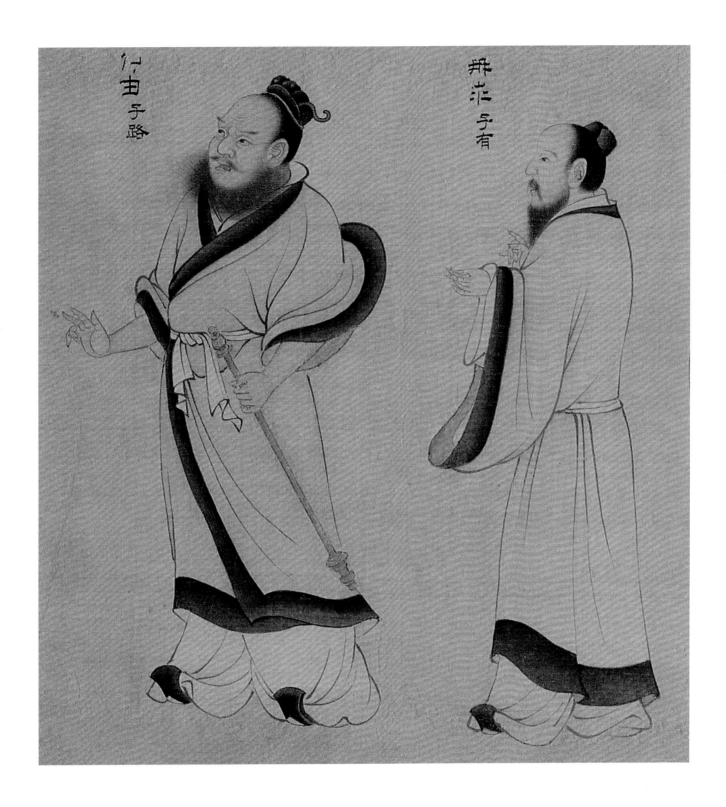

51

A Mass of the Blind under the Willow Shade

—— by ——

an Anonymous Painter

—— of ——

Southern Song

Hanging Scroll

Ink and colour on silk

Height 82 cm Width 78.5 cm

This painting is the earliest and most realistic genre painting that shows the lifestyle of the blind. Under the willow trees, three blind people are shouting and fighting. Their clothes are torn, their headscarves and hats fall to the ground and there are some people trying their best to mediate between them. The fortuneteller prays to heaven at a table in a tent, an elderly person leans to his stick and laughs loudly, and a child stands there leading a donkey. Inside the wooden door, there are old people and young children peeping out. Coetaneous observers would associate it with the Southern Song court which ignored the dangers of confronting the common people and the internal fighting of the nobles. The willow trees, wooden door, small bridge, and the figures are sketched with ink, the wrinkles in the clothes are drawn with nail-head strokes, and a pale colour is applied to the willow tree. The brushstrokes are strong and forceful, which is characteristic of that period.

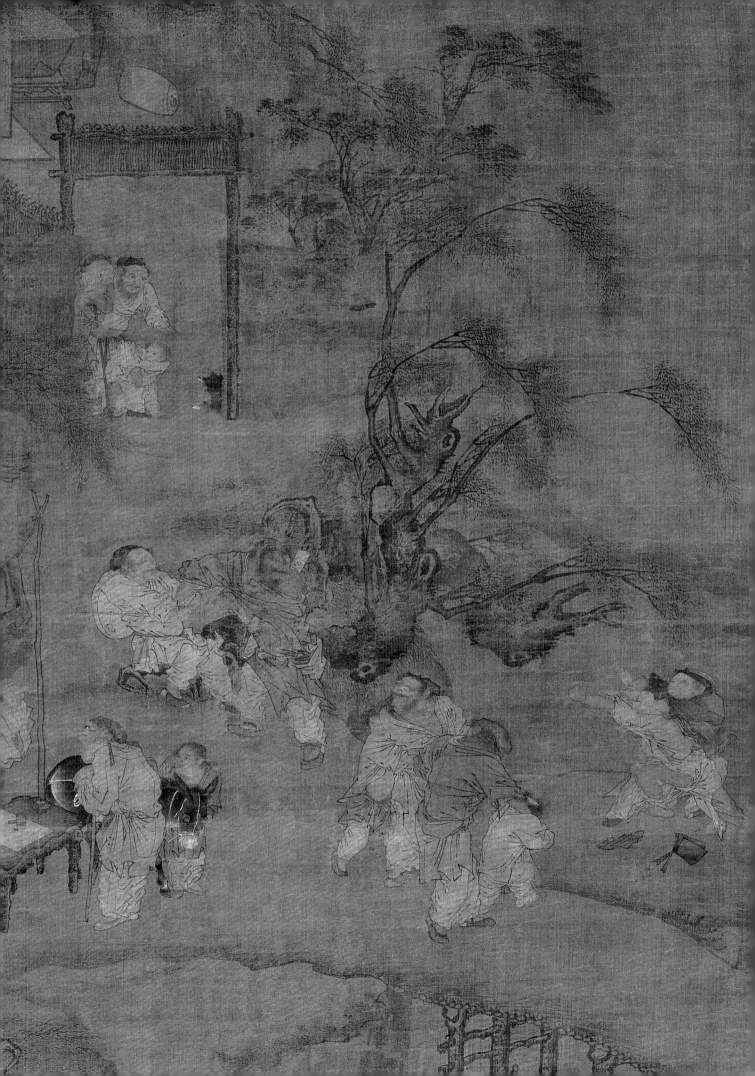

52

Returning Late from a Spring Outing

by
an Anonymous Painter
of
Southern Song
Album

Ink and colour on silk

Height 24.2 cm Width 25.3 cm
Qing court Collection

This work is a genre painting that reflects the outdoor activities of people during the Song Dynasty with realistic brushstrokes. It depicts an elderly person riding on horseback with his servants after returning from a spring outing. They pass through an avenue shadowed by willow trees and head towards the town gate. He is wearing official attire, and his hair is white at the temples. Some servants are leading the way, others are leading the horses, and still others are carrying a folding chair, a square table, and an umbrella cover respectively. On the poles are braziers, drinking utensils, and food boxes. The roads have abattis. The military equipment and the leisurely life form a stark contrast. The portrayal of the figures is done with a simple and concise brushwork, and the utensils are detailed and minute. The figures and the trees in the foreground are painted with thick ink as their outlines are clear. The scene in the far distance is gradually made vague, giving the feeling that the evening is descending.

There are two collector seals on the painting, namely "Seal for the Paintings and Calligraphy of the Qianning Office" by Mu Lin of the Ming Dynasty, and "Rare Collection of Yizhou" by An Qi of the Qing Dynasty.

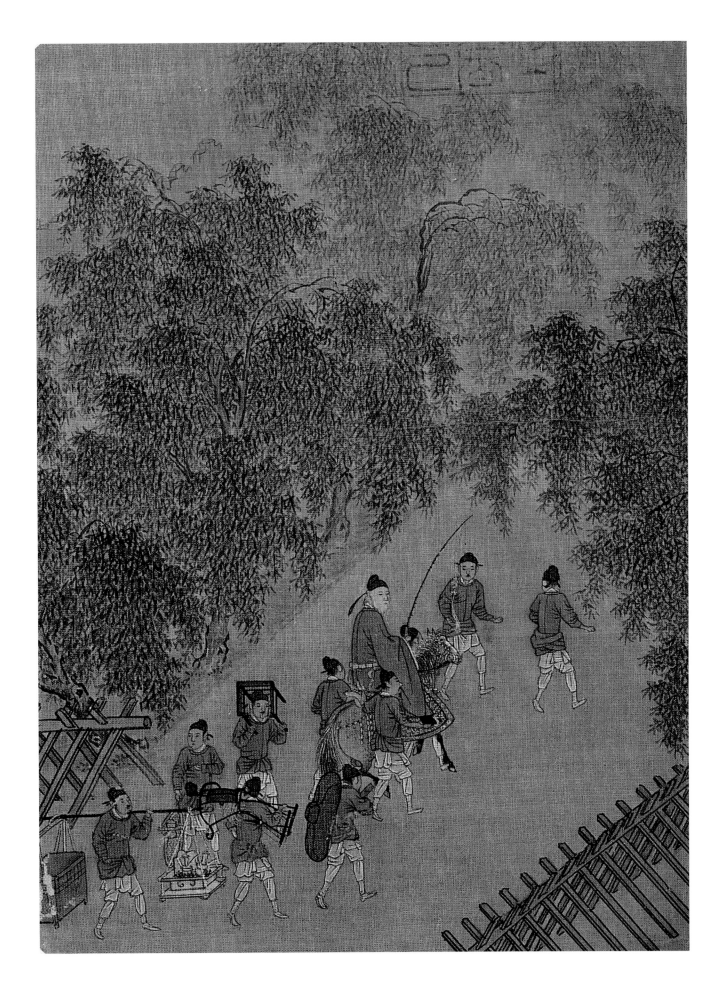

PAINTINGS OF THE LIAO, JIN, AND YUAN DYNASTIES

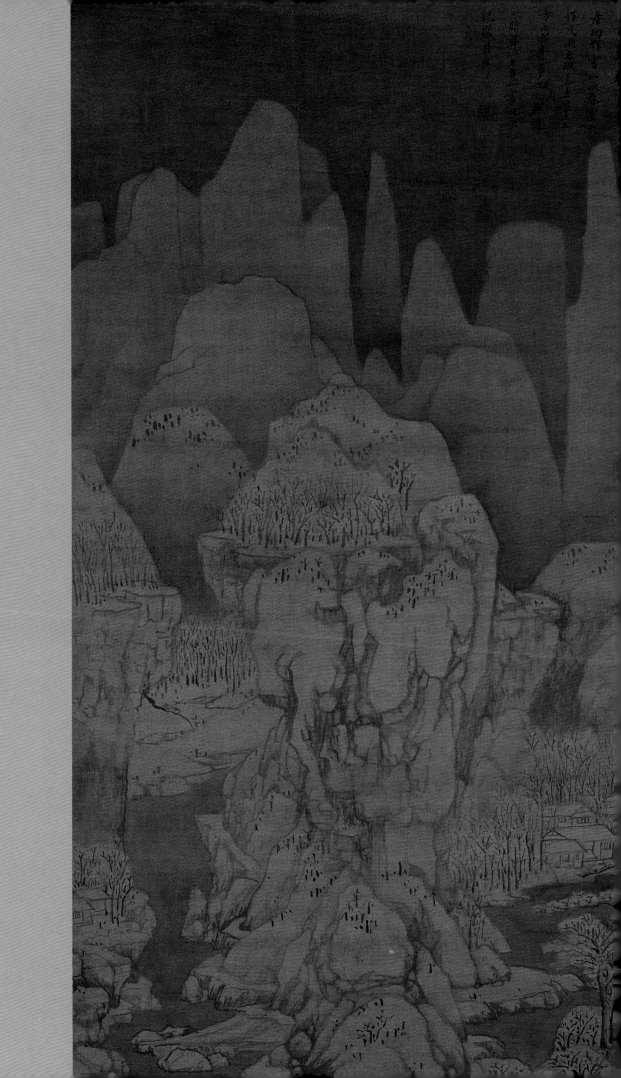

53

Rest Stop for the Khan

— ascribed to —

Hu Gui

— of —

the Liao Dynasty

Hand Scroll

Ink and colour on silk

Height 33 cm Width 256 cm
Qing court collection

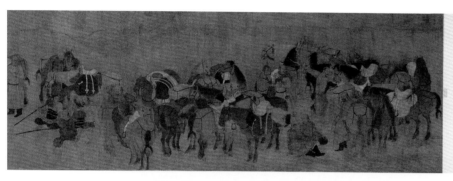

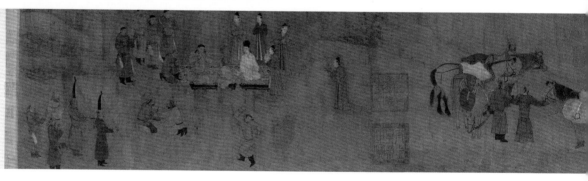

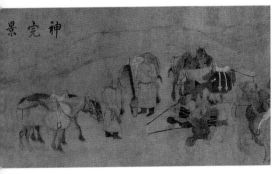

This painting is a scroll that vividly reflects the hunting life of the Jurchen people with a realistic brushwork, which is hard to find in the paintings in early China. Hu Gui, whose years of birth and death are unknown, was active in the tenth century and was a Khitan. He excelled in depicting foreign horses and figures. The main characteristics of his paintings are that the skin and hair can be drawn in detail without losing their spirit and that the vast areas can also be depicted to exhaust the scenery of the deserted places in the northern frontiers. The painting was previously ascribed to Hu Gui of the Five Dynasties. But the figures in the painting are mostly Jurchens of the Jin Dynasty with their heads shaved. The hair decorations, on the other hand, have khan characteristics. Han clothes are patterned after the twelfth century fashion. Based on this, it can be determined that this painting was drawn in the twelfth and thirteenth centuries during the Jin and Yuan Dynasties.

The painting describes a group of Jurchens having a rest on their way to hunting, and provides a strong flavour of pastoral life. The people and the horses turn from a boisterous hunting atmosphere to a peaceful rest, immersing themselves in the joy of music and dance. Sitting cross-legged on the ground is the head of the Jurchens, and the person dressed in white is an envoy of Southern Song. The composition is full of rhythm. People and horses look back and forth, echoing each other. The sketches are both fine and coarse. The brush maintains its force even at the most minute places, and the free strokes are within rules. This shows that the painter has good realistic techniques and the artistic ability to control huge scenes.

This work bears no signature or seal of the painter. It has an inscription by Qing Emperor Qianlong, which reads: "Perfect in Spirit and Close Resemblance in Scenery." The frontispiece has the calligraphy of Zhang Zhao of the Qing Dynasty that reads: "Rest stop for the Khan in a Foreign Country." The front separate piece has an inscription of Emperor Qianlong: "Song of Rest Stop for the Khan," which states that textual research discovered that the Chinese title of this work means "stand and have a rest." The end paper has the annotations inscribed by Wang Shi of the Yuan Dynasty and Gao Shiqi of the Qing Dynasty, and the inscription of Zhang Zhao of the Qing Dynasty. There are dozens of collector seals on the painting, including the "Treasure of the Seventy-year-old Emperor with Five Types of Fortune and Five Generations Living Together," "Seventy-year-old Emperor," and "Treasure Perused by Emperor Qianlong" of the Qing Palace Treasury, "Seal for the Paintings and Calligraphy of Gao Shiqi," "Rare and Valuable Collection of Jiangcun," and "Simple and Tranquil Study" of Gao Shiqi of the Qing Dynasty. This painting is recorded in *Painting and Calligraphy Catalogue of Gao Shiqi*, *Sequel to the Shiqu Imperial Catalogue of Paintings and Calligraphy*, and *Notes on the Shiqu Imperial Catalogue of Paintings and Calligraphy*.

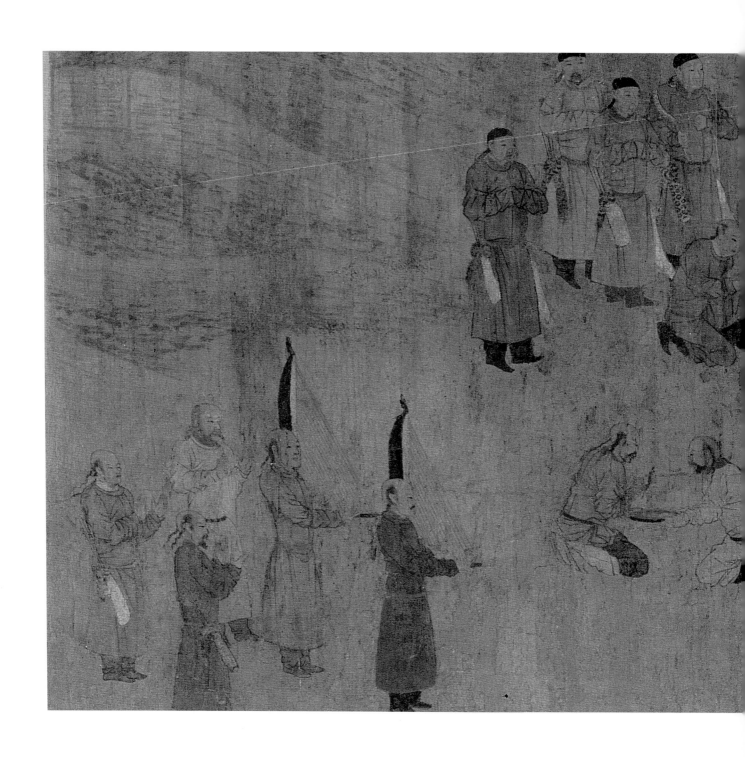

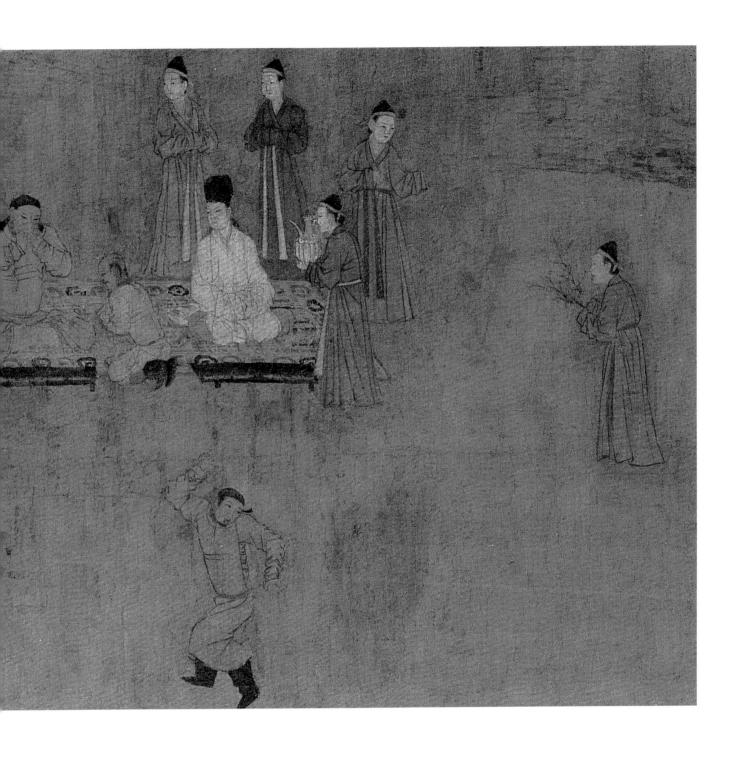

54

Six Steeds of Zhaoling Mausoleum

by

Zhao Lin

of

the Jin Dynasty (Jurchen)

Hand Scroll

Ink and colour on silk

Height 27.4 cm Width 444.2 cm

Qing court collection

This scroll painting is the only extant work of Zhao Lin. It is an excellent example of man-and-horse painting in elaborate strokes of the Jin Dynasty. Zhao Lin, whose years of birth and death are unknown, was active in the twelfth century and a native of Luoyang in Henan. He served as Palace Editorial Assistant during the reigns of the emperors Xizong (1136–1149) and Shizong (1161–1189) of the Jin Dynasty. He excelled in painting figures and horses. His style is simple, crude, bold, and vigorous.

This painting is based on the inscription on the tablet erected at the Zhaoling Mausoleum of Emperor Taizong of Tang. It depicts six steeds that follow the emperor in his expeditions. The names of the steeds are Saluzi, Quanmaogua, Baitiwu, Telebiao, Qingzhui, and Shifachi. The six of them are strong, huge, swift, and fierce. The pain brings them to stand upright, dash, or gallop. The first section shows Qiu Xinggong, who serves as a bodyguard of the Tang emperor Li Shimin, in the battle against Wang Shichong. He pulls out an arrow from a wounded horse to soothe its pain. This painting shows the shape of sturdiness of the six steeds in the original tablet and exemplifies the brush and ink techniques in depicting the minute hairs on the steeds.

In the front of each of the sections of this painting, there is an inscription by Zhao Bingwen of the Jin Dynasty (Jurchen) in running script about the "Six Horses of Emperor Taizong of the Tang Dynasty," and there are two poems written by Qing Emperor Qianlong. The frontispiece has an inscription of Qing Emperor Qianlong: "Ode to the Stone Horses of Zhaoling Mausoleum." The end paper has an annotation by Zhao Bingwen. There are dozens of collector seals on the painting, including "Treasure Perused by Emperor Qianlong," "Appreciated by Emperor Qianlong," and "Appreciated by Emperor Xuantong" of the Qing Palace Treasury, and "Wu Jian," "Seal of Tan Jing," and "Seal of a Study." This painting is recorded in *Sequel to the Shiqu Imperial Collection of Paintings and Calligraphy*.

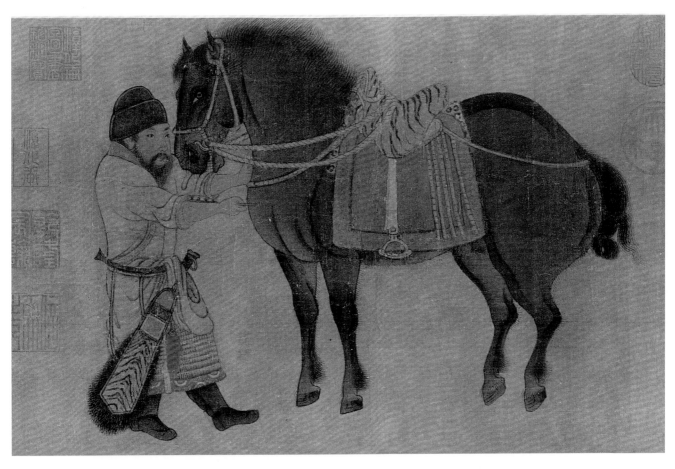

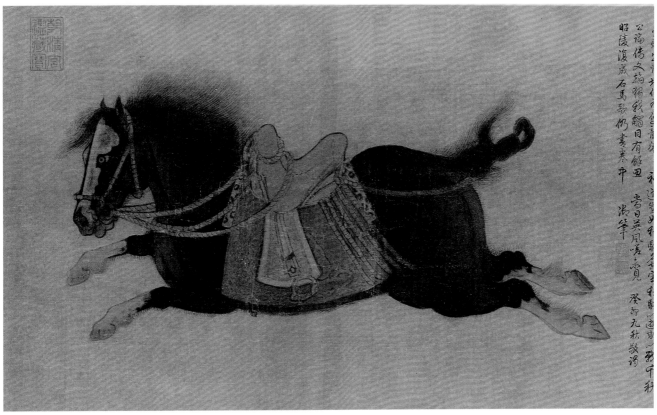

昭陵傳文稱鞘我鞴日有餘田

公論傳文稱鞘我鞴日有餘田

雪日英風嗟千載

癸丑九秋敬調

沐筆

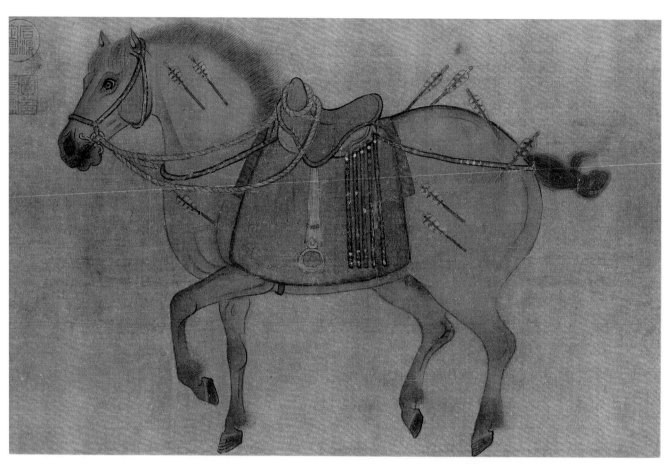

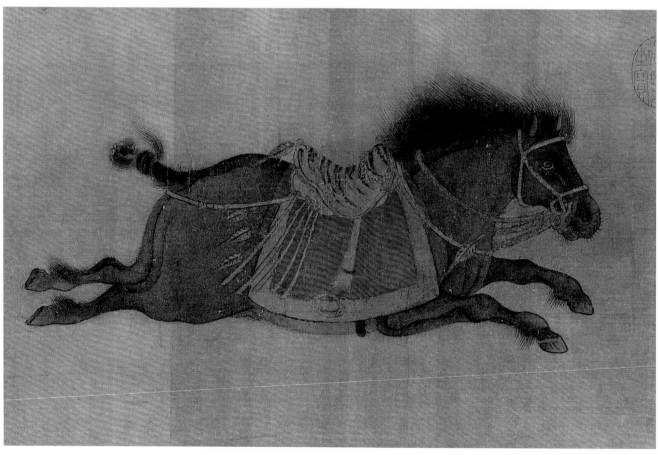

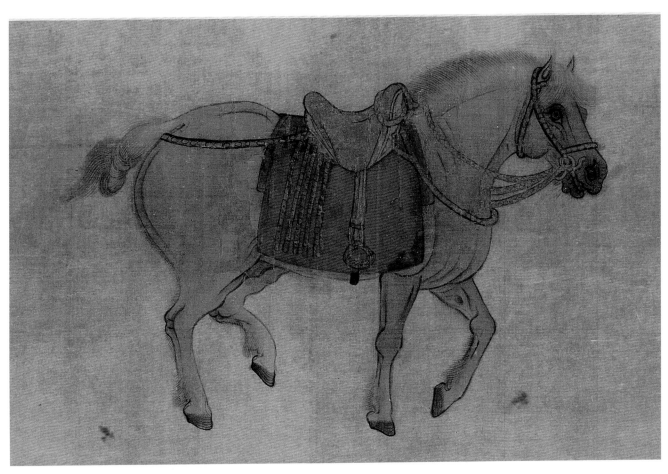

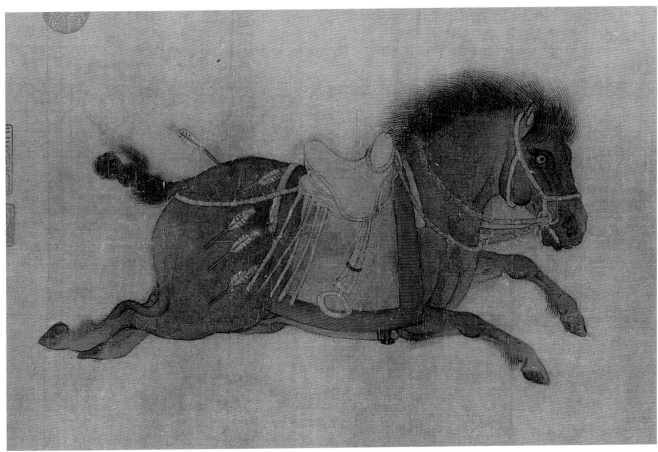

唐太宗六馬圖

太宗功德邁貫頼印次二馬六駢
陵墓引庵唐六馬而可致賞昔恭
昭陵石馬歌後二十年榮乘馬姶得
跋宗畫其爲唐太宗六馬卷長
昭陵顧顧石馬偶怵愴唐六馬車印
有愴敍作歌詞畧後展阅實玄及今而作
而歌書诸卷音名藏其梗楠如
右　戊戌金冬上湖海筆

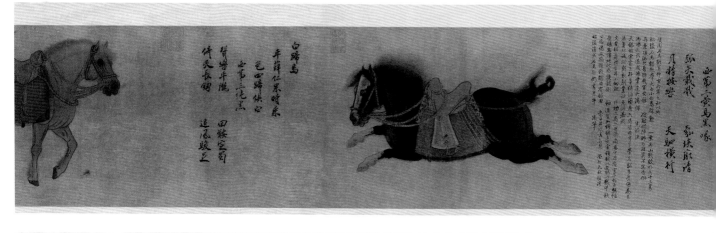

白蹄烏
平辈仁果時来
色四蹄俱白
此第三花烏

竇樂平隴
倚天長劍
回鞍定蜀
追風駿足

西第六叧馬宗咏
孤矢載戢
氣疎耶清
月精按聲　天駟横行

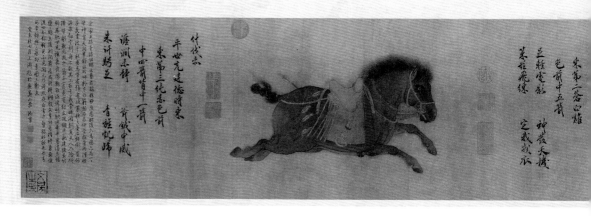

什伐赤
平世充建德時来
中四蹄首中一箭
前臀中一箭
瀍涧未靜
朱汗騁足
香惟机踤

宋第一咏囗雄
足前十五箭
三經電淡　神發天機
朱橙飛徒　定武哉乘

昭陵石馬歌

太宗文皇帝昭陵前列石馬六同雕戎
昭陵之石皆唐太宗間
陵前列石馬六同雕戎
太宗昭陵石馬二相傳名大白小白
昔年末能躬視溯太息
我

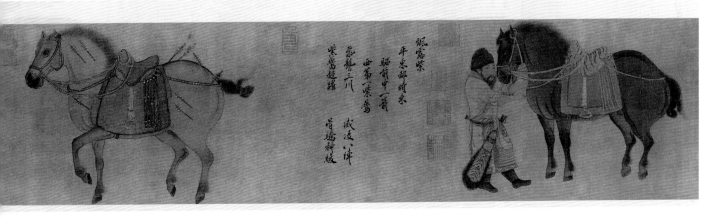

颯露紫
平東都時采
騧前中一箭
西面第一紫鷰
飛龍渡川
紫鷰超躍
咸陵沛
骨騰神駁

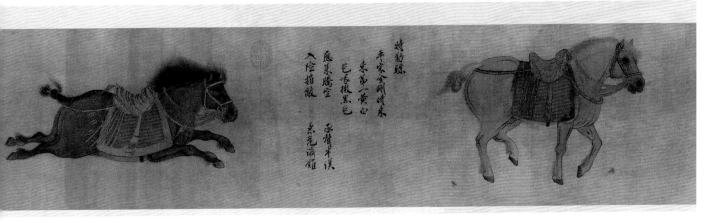

特勒驃
平宋金剛時采
束第一黃身
毛鬃微黑色
應紫騰空
人陰推颰
承肯平漢
東元諭雄

雒陽趙霖所畫
天閑六馬圖觀
其筆瀘圓熟
清勁度越儔
侶向時車於梵
林精舍覽一
貴家寶藏韓
幹畫明皇騎
廄并試馬二
圖乃知少陵丹
青引著實錄
也用筆神妙
凜凜然有生氣
俟手人間神

55

Divine Turtle

by

Zhang Gui

of

the Jin Dynasty (Jurchen)

Hand Scroll

Ink and colour on silk

Height 34.5 cm Width 55.3 cm
Qing court collection

This scroll is the only extant work of Zhang Gui and the earliest silk painting with a turtle as its motif. Zhang Gui, whose years of birth and death are unknown, was active in the twelfth century. It is said in the painting history that he excelled in painting figures, and his sketches surpassed those of his predecessors. It is therefore to be regretted that all his figure paintings are lost.

The painting depicts a turtle lying on the beach. It raises its head to the sky and exhales and inhales the cloudy air from the mountains and valleys, transmitting the essence of heaven and earth, which is a typical motif in *Auspicious Images*. The painting of the turtle is neat, detailed, realistic, and also lively. The background is vast, misty, mysterious, and unpredictable. The ancient people regarded the intelligent turtle as auspicious. The painter signed his name "Suijia" (Accompanies the Emperor). This painting may have been for the use of the emperor.

This work bears the signature of the painter, which reads: "Zhang Gui Accompanies the Emperor." Below, there is a seal with the character "Hua" (painting) (red relief). The same area under the signature is a seal with illegible characters. The end paper has an annotation bearing no signature. In addition, there is a poem inscribed by Qian Shisheng. There are more than ten collector seals on the painting, including "Hall of Literature" and "Tianli" of the Yuan Palace Treasury, "Treasure Perused by Emperor Qianlong," "The Shiqu Imperial Catalogue of Paintings and Calligraphy," and "Treasure of the Imperial Study" of the Qing Palace Treasury, "Seal of the Grand Academician," "Hermit in Guishan," "Shunju," and "Rare Family Collection of Xiang Zijing." This painting is recorded in *The Shiqu Imperial Catalogue of Paintings and Calligraphy, Volume 1.*

56

Dwelling in the Mountains

— by —

Qian Xuan

— of —

the Yuan Dynasty

Hand Scroll

Ink and colour on paper

Height 26.5 cm Width 111.6 cm

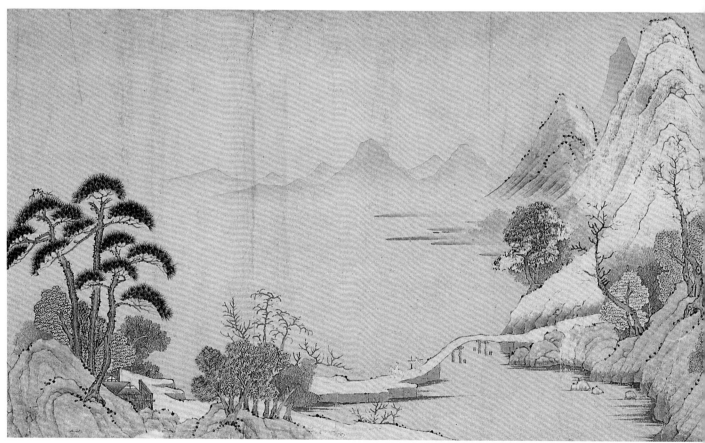

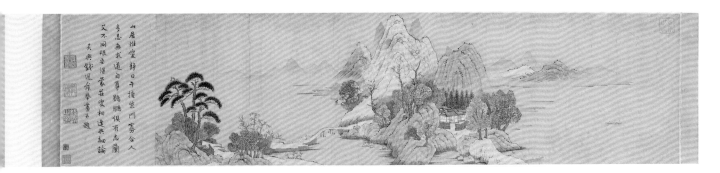

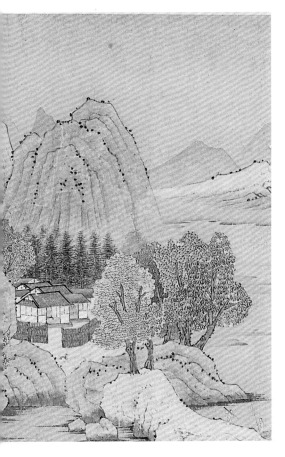

This painting heralds the realism of literati painting in the Yuan Dynasty. Qian Xuan (1239□1299), otherwise known as Shunju, Yutan, Xunfeng, Zhachuanweng, Qingqulaoren, or Xilanweng (from the name of his studio Xilanzhai), was a native of Wuxing (present-day Huzhou in Zhejiang). He devoted his life to poetry and painting, and together with others like Zhao Mengfu, was considered one of the "Eight Masters of Wuxing." He advocated showing the true character of the intellectuals in their painting. He was an influential figure who shifted from the trend of neatness and beauty to purity and lightness.

This painting has the life in seclusion as its theme, showing the kind of ideal life for intellectuals. It is light and serene, and expresses the painter's determination to live in seclusion. The brushstrokes are fine and strong, the colour is classic and elegant, and the spirit is simple and deep. The painting inherits the gold-and-green landscape painting method of the Tang and Song Dynasties but it has its own novelty.

This work has a five-character poem inscribed by the painter, whose signature reads: "Painted and Inscribed by Qian Xuan of Wuxing," and his seals: "Seal of Shunju" (white relief), "Shunju," (red relief), and "Seal of Qian Xuan" (white relief). The frontispiece has the writing of Teng Yongheng: "Dwelling in the Mountains." The end paper has *Notes on Dwelling in the Mountains* written by Yu Zhenmu of the Ming Dynasty, and the inscriptions of twenty-five calligraphers, including Liu Min, Zhou Fu, Xu Fan, Zhi Ansheng, Zhou Qifeng, Qian Shen, Xie Jin, Zhang Shou, Zhu Fengji, Dong Qichang, and Gu Wenbin. There are dozens of collector seals on the painting, including "Authenticated by Xili," "Authentic Works of Prominent Painters Verified by Wu Yun of Gui'an," and "Rarely Found in the World." This painting is recorded in *Records of Paintings and Calligraphy in the Summer of the Year of Gengzi.*

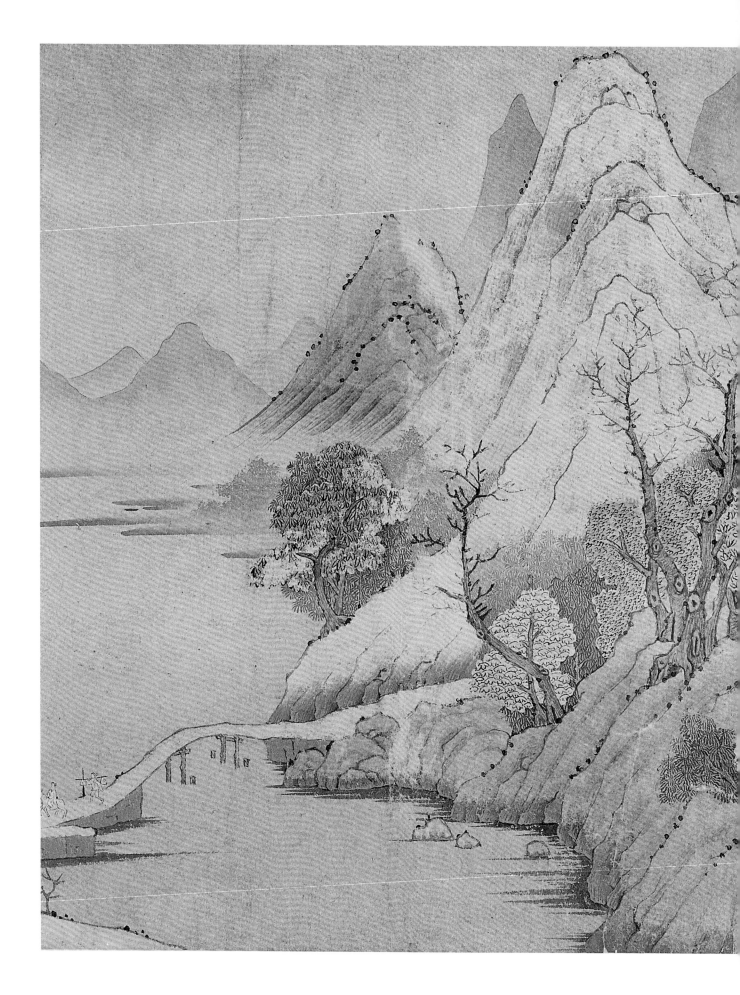

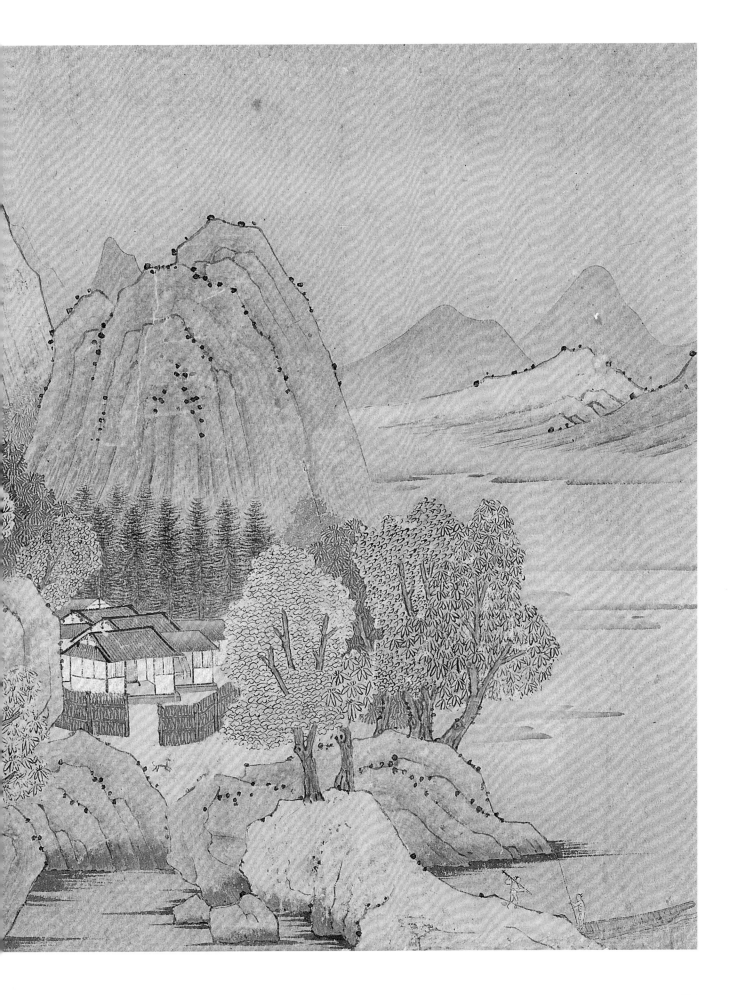

57

Eight Flowers

by

Qian Xuan

of

the Yuan Dynasty

Hand Scroll

Ink and colour on paper

Height 29.4 cm Width 333.9 cm

This painting is the only extant work on flower painting by Qian Xuan. It shows eight broken twigs of flowers, including crabapples, pear flowers, peach blossoms, osmanthus, gardenia, monthly roses, and narcissi. The painting method has inherited the academy style of the Song Dynasty. The sketching is neat and fine and the colour is light and elegant, creating a feeling of serenity and transcendence.

This work bears no signature or name of the painter. The seal reads: "Shunju" (red relief). At the end of this scroll, however, there is an inscription by Zhao Mengfu stating that it is the authentic work of Qian Xuan and that, in his later years, Qian's hands shook due to his addiction to drinking, and he was unable to paint anymore. The colophon reads: "On the fourth day in the ninth month of the twenty-sixth year of the reign of Zhiyuan (1289) by Zhao Mengfu of the same prefecture," with his "Seal of Zhao Shi Zi'ang" (red relief).

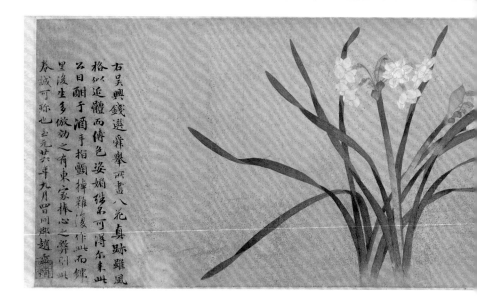

58

Narcissi

by

Wang Dijian

of

the Yuan Dynasty

Hand Scroll (two sections)

Ink and brush on paper

Height 31.4 cm Width 80.2 cm and 146 cm
Qing court collection

This painting, originally titled *Dashing Waves* by Wang Tingji of Yuan, is the only extant work of flowers by Wang Dijian. Later, it was broken into two sections. This painting is, therefore, an incomplete version. Wang Dijian, styled Tingji and Jiyin, was a native of Xinchang (present-day Zhejiang). His years of birth and death are uncertain but it is known that he was active in the thirteenth century. He excelled in painting narcissi and landscapes.

The painting depicts a springtime scene with narcissi in full blossom. The flowers and leaves intermingle with each other, and are dense, full, and lively. The front, back, turning, and bending of the leaves, and the rise, fall, opening, and closing of the flowers are painted meticulously and vividly. It carries the message of "fairies in dashing waves."

According to some documents, this painting originally had two seals of the artist: "Wang Tingji" and "Ji Yin," but now it only has traces of them. The end paper originally had annotations inscribed by Han Xing, Hu Zhu, Zhang Qing, Seng Yue, and Zhao Xin. At present, however, only the annotation in verse by Seng Yue and a poem by Zhao Xin remain. The collector seals on the painting include: "Tangcun" and "Cangyanzi" of Liang Qingbiao of Qing, and "Appreciated by Lianke." This painting is recorded in *The Shiqu Imperial Catalogue of Paintings and Calligraphy*.

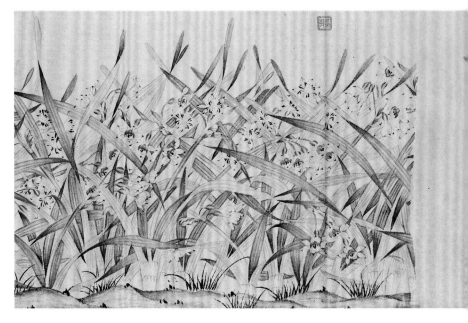

59

Bathing Horses

——— by ———

Zhao Mengfu

——— of ———

the Yuan Dynasty

Hand Scroll

Ink and colour on silk

Height 28.5 cm Width 154 cm
Qing court collection

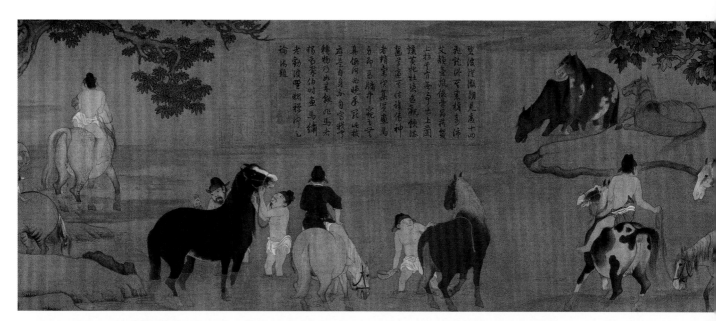

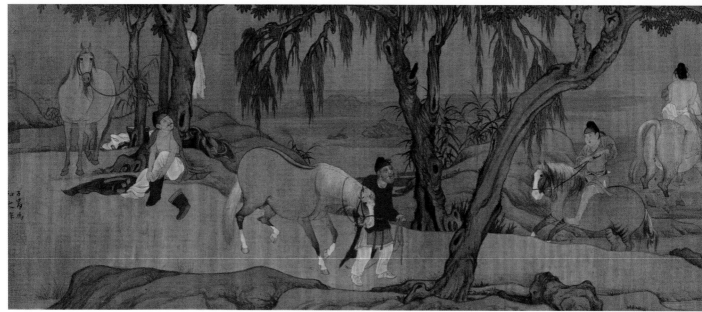

This painting shows the unique style and achievement of Zhao Mengfu in painting horses. It is a masterpiece of saddled horses. Zhao Mengfu (1254–1322), styled Zi'ang, Songxue, Oubo, and Shuijinggongdaoren, was a native of Huzhou (present-day Zhejiang). He was a member of the imperial clan of Southern Song and, during the Yuan Dynasty, he served as Recipient of Edicts in the Hanlin Academy and Grand Master for Glorious Happiness. He was learned and talented, and displayed great skill in painting landscapes, figures, saddled horses, flowers, trees, bamboos, and rocks. He promoted the idea that "calligraphy and painting are of the same origin."

This work paints menial officers washing and cooling horses beside a pool in a sparse forest on a summer day. The figures are either washing or brushing the horses that, in turn, are inclined to one side or crouching. All of them are lively and natural, holding different postures, echoing to each other, and creating a light-hearted atmosphere. The wrinkles in the clothes of the figures are smooth while the trees and rocks on the slope are sketched in a simple and concise way. The colour does not cover up the ink, and blue and green are both used in combination with light red. The colours are delicate, beautiful, and elegant.

This work bears the signature of the painter, which reads: "Painted by Zhao Zi'ang for Hezhi" along with a poem inscribed by Qing Emperor Qianlong. The frontispiece has the inscription of Qing Emperor Qianlong: "Clear Stream and Leaping Dragon." The end paper has annotations inscribed by Wang Zhideng and Song Xian of Ming. There are around two hundred collector seals on the painting, including the "Treasure Perused by Emperor Qianlong," "The Shiqu Imperial Catalogue of Paintings and Calligraphy," and "Treasure of the Imperial Study" of the Qing Palace Treasury, the "Tianlai Studio" of Xiang Yuanbian of Ming, and "Seal of the Rare Collection of Calligraphy and Painting in the Thatched Cottage of Gao Jiangcun" of Gao Shiqi of Qing. This painting is recorded in *The Shiqu Imperial Catalogue of Paintings and Calligraphy, Volume 2* and *Record of Rangli Hall, Volume 2*.

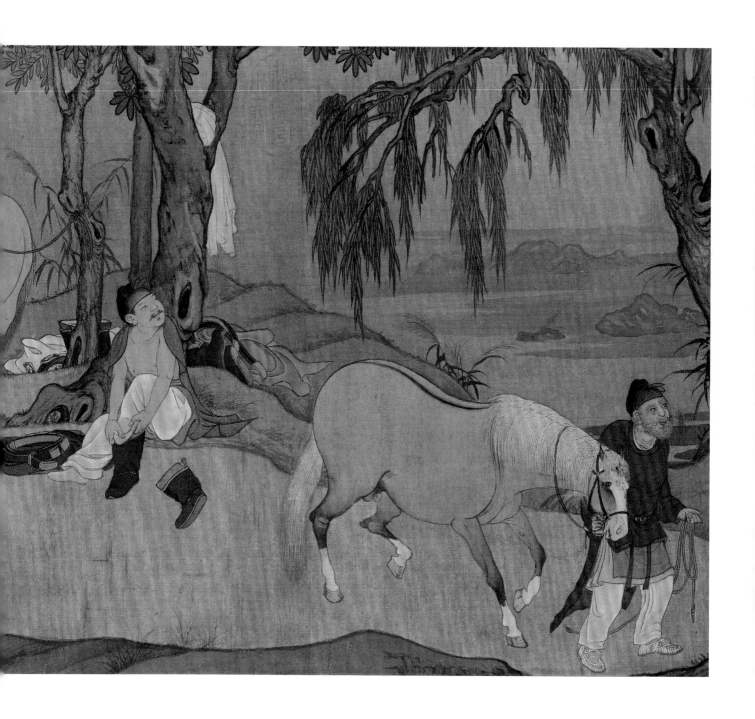

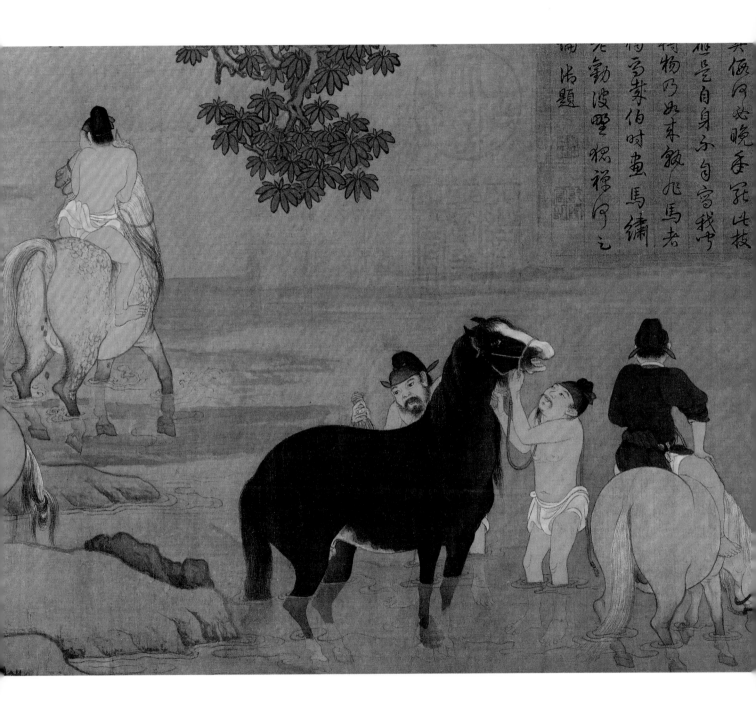

其佩何欤晚年託此技
紙是自身分自寫我乎
稍物乃如未敢托馬者
稍寫葦伯時畫馬繡
先勤波墨翅禪河之
稱迷題

60

Water Village

— by —

Zhao Mengfu

— of —

the Yuan Dynasty

Hand Scroll

Water and ink on paper

Height 24.9 cm Width 120.5 cm

Qing court collection

This painting was drawn by Zhao Mengfu at the age of forty-nine and it was the last piece of his work that could be reliably dated. In the painting, water and ink are used to depict the scene of a water village in Jiangnan. The use of the brushstrokes and the composition are clearly influenced by Dong Yuan. The scene is depicted in a level distance perspective, which shows the serene mentality of the painter and his pursuit of "ordinariness and naturalness." His brushstrokes are soft, elegant, and restrained. He uses hemp wrinkles to paint the mountains with dry brushstrokes, showing the influence of calligraphy. This painting has had a great influence on the formation of dry brush landscape in Yuan, and it also played the role of promoting the development of literati painting in the Ming and Qing dynasties.

This work has the signature of the painter, which reads: "Painted for Qian Dejun on the fifteenth day in the eleventh month of the sixth year of the reign of the Dade by Zhao Shi Zi'ang." His seal reads: "Seal of Zhao Shi Zi'ang" (red relief). In addition, the end paper has an inscription by himself with his "Seal of Zhao Shi Zi'ang" (red relief), and "Pine-snow Studio" (red relief). This work has two poems inscribed by Qing Emperor Qianlong, and the character "Qinghua" (Graceful) written in the frontispiece. The end paper has a total of fifty-six inscriptions made by Deng Ju, Gu Tianxiang, Guo Linsun, Lu Zhu, and Tang Michang, among others. There are dozens of collector seals on the painting, including "Treasure Perused by Emperor Qianlong," "The Shiqu Imperial Catalogue of Paintings and Calligraphy," and "Treasure in the Collection of the Hall of Mental Cultivation" of the Qing Palace Treasury, together with the seals of Nalan Xingde of Qing: "Appreciated by Lengqie," "Chengde Rongruo," and "Calligraphy and Paintings of Rongruo." This painting is recorded in *Critical and Descriptive Notes on Paintings and Calligraphy*, *Qinghe Collection of Calligraphy and Painting*, *Classified Records of Calligraphy and Paintings in the Shigu Hall*, and *The Shiqu Imperial Catalogue of Paintings and Calligraphy, Volume 1*.

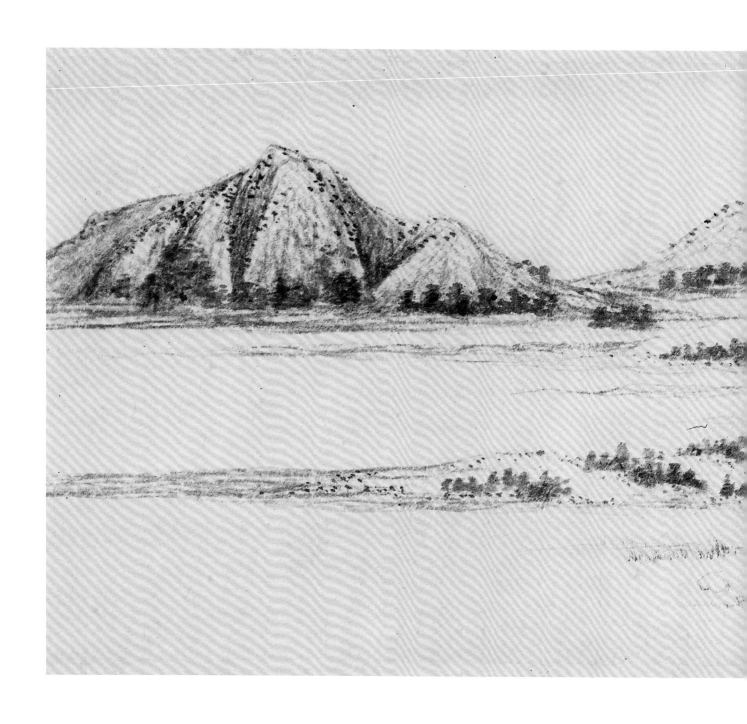

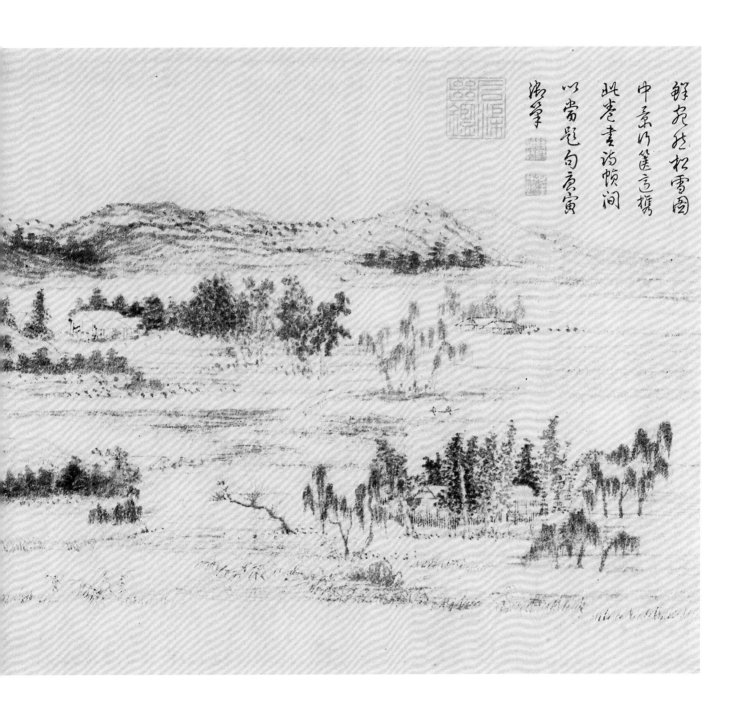

鮮花逐往松雪圖
中景竹籬遠携
此卷畫詩頻間
以當覓句庚寅
湘筆

221

61

Elegant Rocks and Sparse Trees

by

Zhao Mengfu

of

the Yuan Dynasty

Hand Scroll

Water and ink on paper

Height 27.5 cm Width 62.8 cm

This is a typical work of tree-and-rock painting by Zhao Mengfu. Zhao was known for one line in his poetry, which runs: "only now do I know that calligraphy and painting are of the same origin." This clearly shows Zhao's creative conception of incorporating calligraphy into painting, and his belief that these two art forms are interconnected.

This painting depicts old trees and young bamboos. He applied the leave-blank method in calligraphy to paint the rocks, the outlines and the wrinkles on the surfaces of the rocks, and the seal script in outlining the trunks and branches of the trees. The above features fully realized the theory of "calligraphy and painting are of the same origin" and thus totally differ from the style of the Painting Academy of Southern Song.

The painter signed this work as: "Zi'ang" with his "Seal of Zhao Shi Zi'ang" (red relief). The end paper has a seven-character poem inscribed by the artist himself, and once again his seal reads: "Zhao Zi'ang" (red relief). In addition, there are annotations inscribed by Ke Jiusi, Wei Su, Wang Xing, Lu Chongyun, and others. There are dozens of collector seals on the painting, including "Treasure in the Collection of the Crane-Dream Studio of the Li Family of Zuili," "Seal of the Paintings and Calligraphy of Liang Shi Jiaolin," "Authenticated by Li Junshi," and "Authenticated by Xuzhai." This painting is recorded in *Records of Famous Paintings from the Collection of Xuzhai, Second Series*.

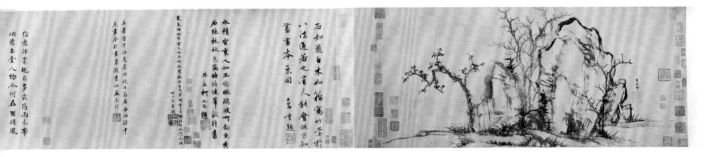

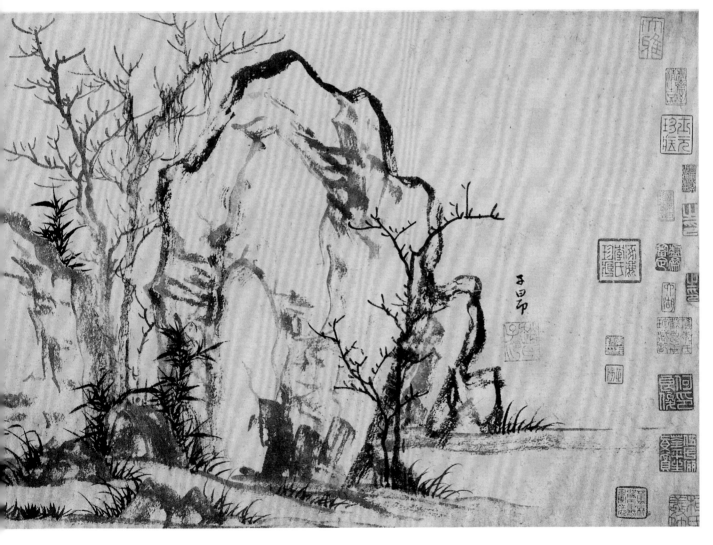

223

62

Three Bamboo Paintings of the Zhao Family

------ by ------

the Zhao Family

------ of ------

the Yuan Dynasty

Hand Scroll

Ink and brush on paper

Height 34 cm Width 108 cm

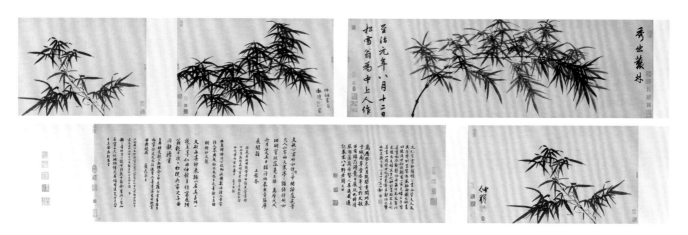

This work is formed by mounting together three paintings of bamboo by members of the Zhao family: Zhao Mengfu, Guan Daosheng, and Zhao Yong. This is the only scroll done in this manner in Chinese painting history and is therefore an extremely valuable piece of art. Guan Daosheng (1262–1319), styled Zhongji, was a native of Huzhou in Zhejiang. She was the wife of Zhao Mengfu and was given the title of Lady of the State of Wei. She excelled in calligraphy and skilled in the art of painting bamboo in ink, plums, and orchids. Zhao Yong (1291–1361), styled Zhongmu, was the son of Zhao Mengfu and Guan Daosheng. He entered officialdom due to his father's influence and the highest positions he held included Edict Attendant of the Scholarly Worthies and Associate Administrator of the Route Command of Huzhou. He learned calligraphy and painting from his family and was skilled in landscapes, in particular, figures and saddled horses. He also painted boundary drawing. In calligraphy, he excelled in regular, running, and cursive scripts, and was also good at seal script. He specialized in art appreciation.

The first part of the scroll features an ink bamboo drawn by Zhao Mengfu, who, as aforementioned, incorporated calligraphy into his painting. Every brushstroke is powerful, round, moist, thick, and heavy. This part bears the signature of the painter, which reads: "Elegance comes out of bushes, Zhao Mengfu painted this work for people of the middle and upper class on the twelfth day of the eighth month of the first year of the reign of Zhizhi" with his "Seal of Zhao Shi Zi'ang" (red relief) and "Seal of the Paintings and Calligraphy of the Tianshui Prefecture" (red relief).

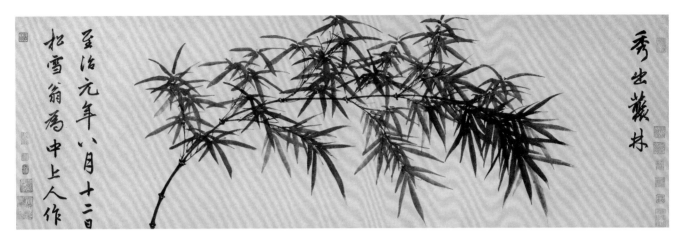

The second part is the ink bamboo drawn by Guan Daosheng who applied the brush powerfully. The bamboo leaves are dense and the joints are strong, unlike the weak brushstrokes of other ladies. This part has the signature of the painter, which reads: "Zhongji paints this work for Shuqiong." And the seal reads: "Guan Zhongji" (white relief).

The third part is the bamboo painted by Zhao Yong. His use of the brush is plain and steady. It has the charm of calligraphy and his brushstrokes are deeply influenced by what he had learned from his family members. This part bears the signature of the painter, which reads: "Zhongmu." The seal also reads: "Zhongmu" (red relief).

The date that Zhao Mengfu put down on his painting is the first year of the reign of Zhizhi (1321), three years after the death of Guan Daosheng. This means that this work was compiled by people of later generations, not painted by the artists of his time. The end paper has annotations inscribed by Du Mu, Zhou Tianqiu, Wang Zhideng, Zhao Ziyong, and Xu Zonghao. There are dozens of collector seals on the painting, including "Seal of An Qi" and "Seal of the Calligraphy and Paintings of An Yizhou" by An Qi, and "Authenticated by Xuzhai" and "Appreciated by the Heart of Laichen" by Pang Laichen, both of Qing.

63

Hunting on a Horse

— by —

Zhao Yong

— of —

the Yuan Dynasty

Hanging Scroll

Ink and colour on paper

Height 109 cm Width 46.3 cm
Qing court collection

This is a gem of Zhao Yong's man-and-horse painting inherited from the style of the Tang Dynasty. Painted in the picture is a horseback rider who wears a red round neck robe, straddles a fat horse, presses a catapult with his hand, and turns back to gaze at the trees. The person and the horse are both painted in the Tang way with a fat body and thin legs. The sketches and lines are fine, strong, and smooth, and the picture is painted delicately.

This work bears the signature of the painter, which reads: "Painted by Zhongmu on the fifteenth day of the fourth month of the seventh year of the reign of Zhizheng. The seals read: "Zhongmu" (red relief) and "Seal of Tianshui Prefecture" (red relief). There is also a seven-character poem inscribed by Nai Xian. There are nine collector seals on the painting, including "Treasure Perused by Emperor Jiaqing," "The Shiqu Imperial Catalogue of Paintings and Calligraphy," and "Appreciated by Emperor Xuantong" of the Qing Palace Treasury. This painting is recorded in *The Shiqu Imperial Catalogue of Paintings and Calligraphy, Volume 3*.

227

64

Boating around Spring Mountains

———— by ————
Hu Tinghui

———— of ————
the Yuan Dynasty

Hanging Scroll

Ink and colour on silk

Height 143 cm Width 55.5 cm

This painting is the only surviving work of Hu Tinghui. It keeps many of the traditional methods of the blue-and-green landscape of the Tang Dynasty, thanks to which we can distinguish the landscapes of the early period. Hu Tinghui, whose years of birth and death are unknown, was active in the thirteenth century He was a native of Huzhou in Zhejiang, living in the same lane as Zhao Mengfu. He was invited by Zhao Mengfu to his home to replicate *Picking Melons* by Li Zhaodao, and Hu reproduced in part from memory, resulting in a copy that looked like the original.

The present painting exhibits green mountains towering into the clouds. The pine trees are luxuriant. The houses and pavilions on the mountains are joined by winding verandas, and intellectuals are enjoying themselves in the mountains. At the foot of the mountains we can see bridges over the streams and water in the pools. The glistening light of the waves shines like the scales of a fish, and travellers sail boats to enjoy the scenery. The scene is full of the warmth and clarity of spring. The whole painting uses iron lines to sketch the outlines. Colour is then added in, following the method of blue-and-green landscape of the Tang Dynasty.

This work does not include the signature or name of the painter. One half of the seal reads: "Tinghui" (white relief). The collector seals on the painting include "Examined and Verified by Wang Jiqian as Authentic Works."

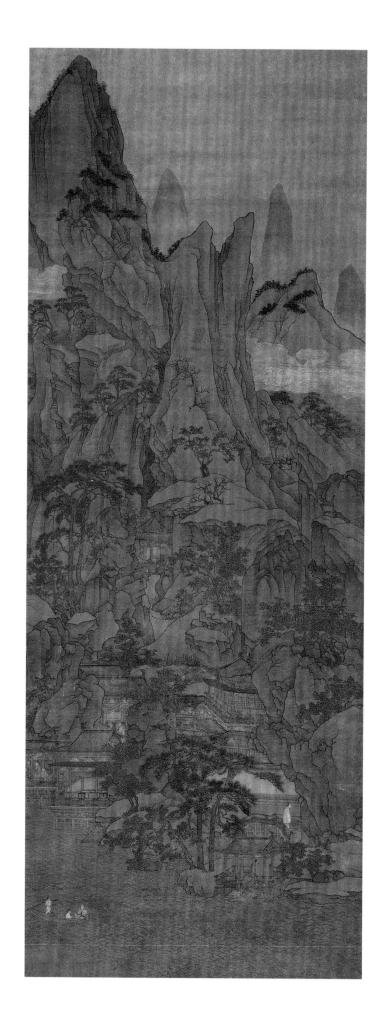

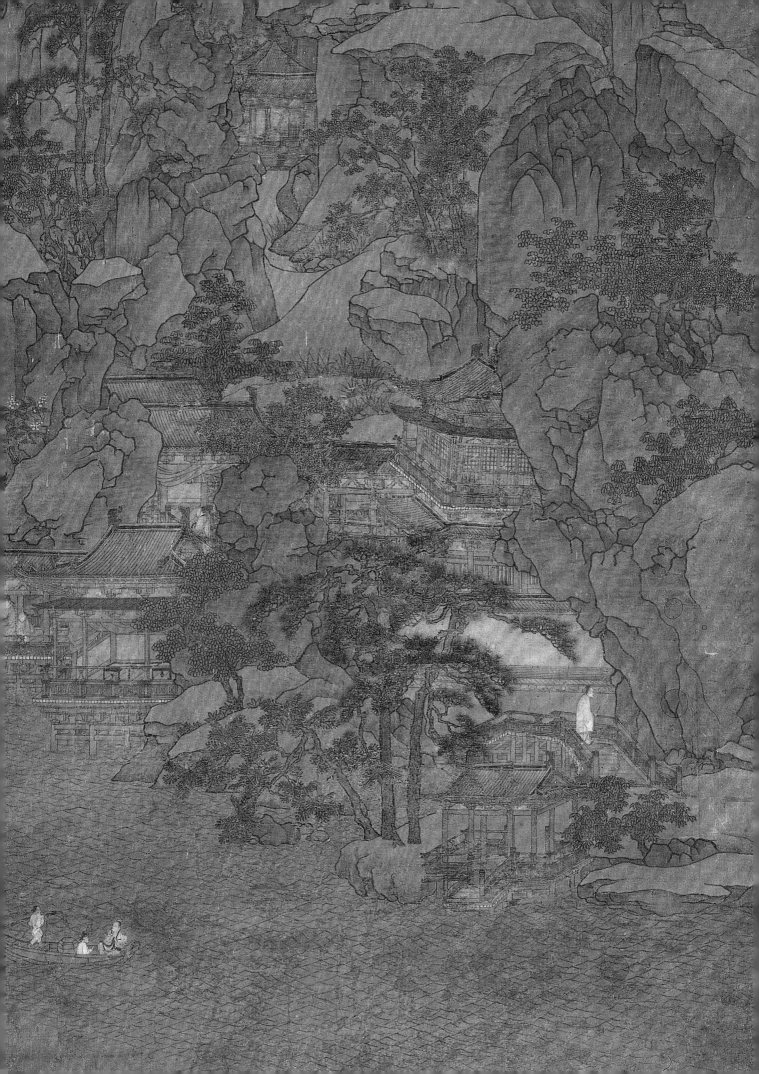

65

Two Horses

by

Ren Renfa

of

the Yuan Dynasty

Hand Scroll

Ink and colour on silk

Height 28.8 cm Width 142.7 cm

Qing court collection

This painting is the earliest extant work that carries the intention of admonishing officials. Ren Renfa (1254–1327), styled Ziming and Yueshandaoren, was a native of Songjiang (now belonging to Shanghai). The highest position he held was Vice Commissioner of the Waterways and Paddy Fields. He was an irrigation specialist and took part in the river regulation work of places such as Jiangzhe and Hebei. He was skilled in calligraphy and painting, especially figures, flowers and birds, and horses.

The painting features two good horses of the Western Regions, one is fat, and the other, thin. The fat horse raises its head, kicks its hoofs, and the thin horse trots slowly with its head down. The shapes of the horses are inspired by the painting method of the Tang Dynasty. The drawing is fine and the use of lines and colour is extremely meticulous.

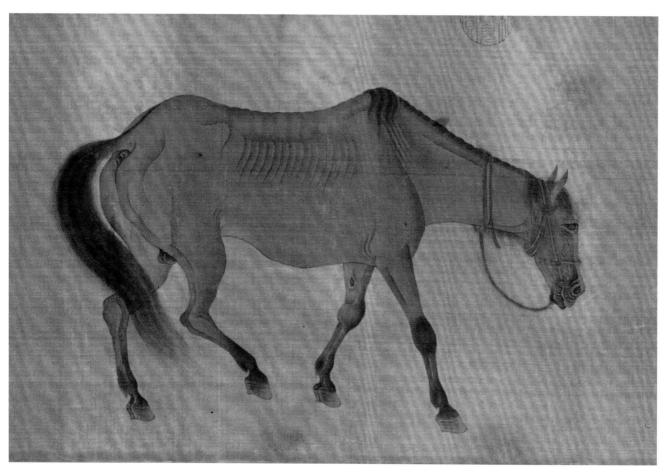

The work bears an inscription of the painter, in which he clearly states that he is using the fat and lean horses as a metaphor for officials who are corrupt and those who are clean. "Officials in the world differ in honesty and corruption and this is related to whether they are lean or fat. Those who impoverish themselves to fatten a country are clean; those who fatten themselves to impoverish the people, shouldn't they be ashamed of their dirty behavior? Shouldn't they be ashamed of their scheming? I therefore inscribe this subject at the end of this scroll for people to know. Written by Daoist Yueshan." The seals read: "Ren Ziming" (white relief) and "Daoist Yueshan" (red relief). The end paper has two annotations, one by Ke Jiusi and the other by Yu Lianke. There are dozens of collector seals on the painting, including "Treasure of the Chonghua Palace," "Shiqu Imperial Authentications," and "Treasure Perused by Emperor Xuantong" of the Qing Palace Treasury, "Appreciated by Lianke," and "Scroll of Lian Layman." This painting is recorded in *Sequel to the Shiqu Imperial Catalogue of Paintings and Calligraphy*.

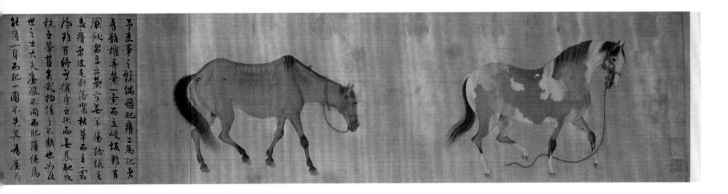

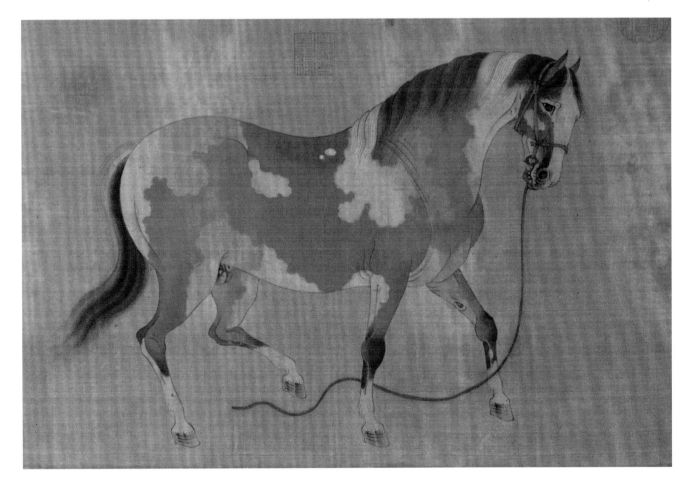

66

Man and Horse

by

Ren Xianzuo

of

the Yuan Dynasty

Hanging Scroll

Ink and colour on silk

Height 50.3 cm Width 36 cm
Qing court collection

This artwork is a typical painting of a man and a horse by Ren Xianzuo, classified as delicate-stroke painting. Ren Xianzuo, whose years of birth and death are uncertain, was active in the thirteenth century. Styled Ziliang, he was a native of Songjiang (now belonging to Shanghai). He was the son of Ren Renfa and for some time served as county magistrate, Decree-follower, and Judge of Taizhou. He was skilled in painting horses and grooms, a skill he inherited from his family.

The painting shows a man leading a horse, walking slowly. The figure has a strong build, wears a red robe, and has a noble status. The piebald horse has a strong body and long legs, a treasured horse of the Western Regions. The composition of this painting inherited the style of painting from the Tang Dynasty, yet it incorporated the sketching method of the Song people.

This work displays the signature of the painter, which reads: "Painted by Ziliang at the Keshi Hall." The seal reads: "Ren Ziliang" (white relief). There are ten collector seals on the painting, including "Treasure Perused by Emperor Qianlong," "The Shiqu Imperial Catalogue of Paintings and Calligraphy," and "Imperial Seal of the Hall of Three Treasures" of the Qing Palace Treasury, "Zhang Zezhi," "Ciben," and others.

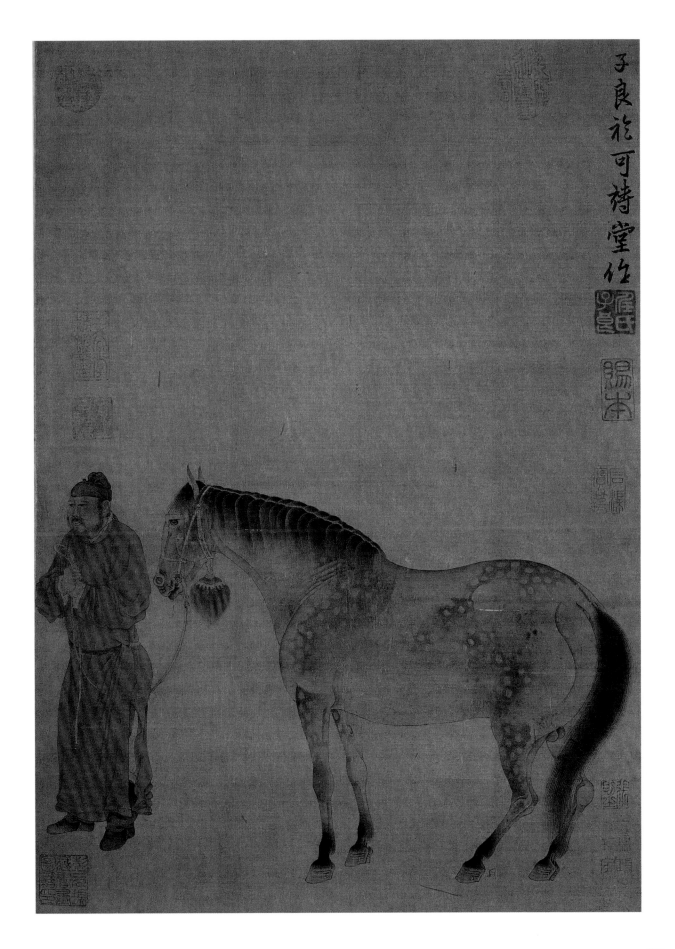

233

67

Tribute Bearers

— by —

an Anonymous Painter

— of —

the Yuan Dynasty

Hand Scroll

Ink and colour on silk

Height 26.8 cm Width 163 cm
Qing court collection

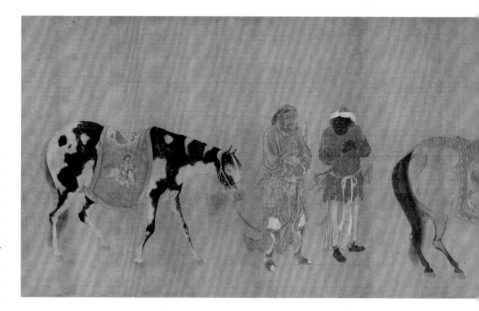

This painting depicts a scene in which the states in the Western Regions are paying tributes to the court with good horses. Those who pay tributes wear the dress of the extraterritorial people. At the front are two pilot black slaves, one of them embracing a treasured sword and the other holding a flag of tribute. At the rear are three messengers dressed in red leading their horses with their hands and walking respectfully, followed by another black slave guarding with a sabre. The colour is soft and fine, the lines are strong and forceful, and the painting has the beautiful and simple freestyle of folk water-and-land painting. This artwork is a copy of the *Three Steeds* by Ren Xianzuo, which is part of the collection of the Palace Museum.

There are close to ten collector seals on the painting, including the special seals of the Yuan Palace Treasury that were checked and received by the Ming Palace Treasury, "Seal of the Directorate of Ceremonial," "Paintings and Calligraphy of the Bogu Hall," and others.

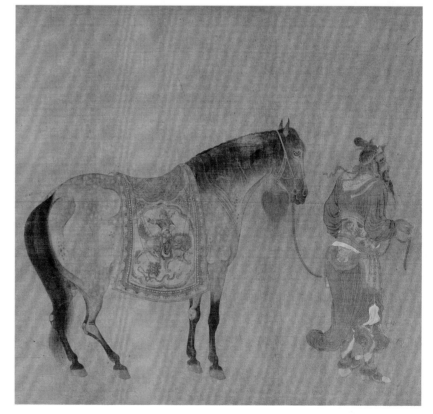

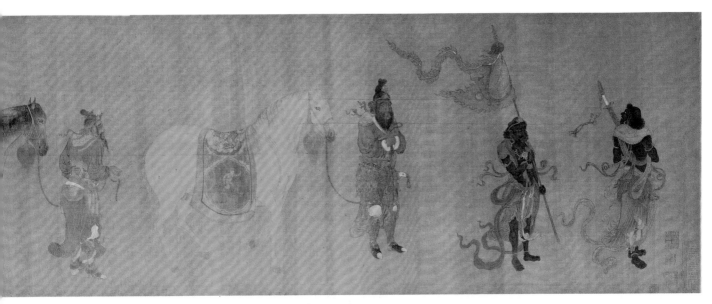

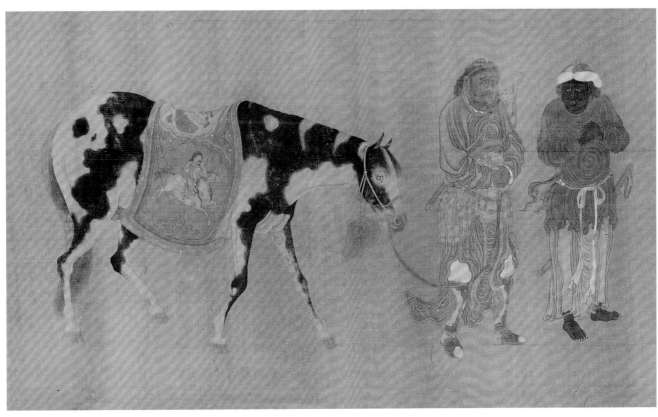

68

Stone Cliffs and Heavenly Lake

by

Huang Gongwang

of

the Yuan Dynasty

Hanging Scroll

Ink and colour on silk

Height 139.4 cm Width 57.3 cm

This is Huang's masterpiece painted in his old age. Huang Gongwang (1269–1354), originally surnamed Lu, was a native of Changshu in Jiangsu. Later, he was adopted by a family surnamed Huang at Yongjia in Zhejiang, and he styled himself Zijiu, Yifeng, and Dachidaoren. He served as a minor official, but he was put into prison as a result of a criminal case. When he was released from prison, he lived in seclusion and did not take up any other official position. Finally, he converted to Daoism. He was skilled in calligraphy and musical composition. He started to do landscape painting after the age of fifty. He became a master of painting in his old age, and together with Wu Zhen, Ni Zan, and Wang Meng, he was considered one of "the Four Masters of Yuan." In fact, he was regarded "the First of the Four Masters of the Yuan Dynasty."

According to his own inscription on the painting, this painting was drawn for the poet Gong Xingzhi, and the scene is about Mount Tianchi in the west of the Suzhou Town. On the peak of Mount Tianchi is a huge rock. Half way up the mountain is a permanent pool of clear water, hence it is named "Tianchi" (Heavenly Lake). The mountains in the painting are majestic and of different shapes. The mists and clouds are smooth and moist. The stone walls on the two sides of the Heavenly Lake face each other, and there are several pavilions in the lake. At the foot of the mountains are valleys and streams, with tall pine trees and meandering mountain lanes. The methods of high distance and deep distance are used in the composition of the painting. The mountain rocks are painted with hemp-fibre wrinkles, and there are variations in the use of the brush. This painting is a paradigm of his "light purple red landscapes." In this work, the painter uses faint umber as the major tone. This shade is used to colour the mountain rocks whereas dark green is used to colour the vegetation so as to show the greenness of the mountains and the

warmth of the sun.

This work has an inscription by the painter and his own signature, which reads: "In the tenth month of the first year of the reign of Zhizheng, Dachidaoren painted Stone Cliffs and Heavenly Lake for Xingzhi, at the age of seventy-three." The seals read: "Seal of Huang Gongwang" (red relief), "Huang Shi Zijiu" (white relief), and "Yifengdaoren" (red relief). This work has an inscription by Liu Guanchang of Yuan, in which Liu claimed that Huang Gongwang was "the best disciple of Wu Xing." It shows that Huang Gongwang studied under Zhao Mengfu, and this is important information in the study of the history of Chinese painting. There are five collector seals on the painting, including the "Seal of Zou Diguang," "Seal of Li Wei," and a seal with a half part. This painting is recorded in *Dream Journey in the Records of Wonderful Sights* and *Du Mu's Allegorical Meaning*.

Nine Peaks after Snow

Ink and brush on silk

Height 117 cm Width 55.5 cm

This painting is the painstaking work of Huang Gongwang who made it for Yan Gong (i.e. Ban Weizhi, a literary figure in Yuan) at the age of eighty-one. It shows a scene of coldness and desolation with the peaks covered by the snow. The "Nine Peaks" refers to the nine hills scattered on the north-west of the Songjiang County in Shanghai, and they are known as the "Nine Peaks of Song Prefecture," well-known for their significance in Daoism. The painting depicts the main towering peak surrounded by other hilltops. The main and the subsidiary peaks are clearly distinguishable and the ranges are connected. Under the main peak are trees in the snow and some deserted villages. The stream that goes round the mountains is coloured with light ink, which echoes the gloomy sky. The trees are drawn with the method of representing bamboo roots and pistils, which is apparently broken but actually linked. The mountain rocks, on the other hand, are drawn with seal script calligraphy and outlined without filling in colour. "He borrows the ground as snow," and does colouring with ink so as to strengthen the appearance of layers and three-dimensionality of the mountain rocks.

This work bears the signature of the painter, which reads: "In the first month of the ninth year of the reign of Zhizheng, I worked on a painting for Yan Gong and went to the snowy mountain several times. The spring snow fell two or three times, and stopped only when I completed my painting. This is really strange. Written by Dachidaoren at the age of eighty-one to mark the passage of time." The seals read: "Dachi" (red relief), "Huang Shi Zijiu" (white relief), and "Yifengdaoren" (red relief). There are twelve collector seals on this painting that include "Treasure of the King of Yi" by Yun Xiang, "Appraised and Appreciated by Yizhou" by An Qi, "Jiaolin" by Liang Qingbiao, and "Huang Shi Zhongming" by Huang Zhongming, all of them from Qing. This painting is recorded in *The Boat of Calligraphy and Paintings on the Qing River*, *Classified Records of Calligraphy and Paintings in the Shigu Hall*, *Dream Journey in the Records of Wonderful Sights*, and *Random Notes on Works in Ink*.

70

Seclusion amid Mountains and Streams

by

Wu Zhen

of

the Yuan Dynasty

Hanging Scroll

Ink and brush on silk

Height 160 cm Width 73.5 cm
Qing court collection

This painting is a typical landscape of Wu Zhen who modelled his work after that of Ju Ran. Wu Zhen (1280–1354), styled Zhonggui and Meihuadaoren, was a native of Jiaxing in Zhejiang. He lived in seclusion and did not serve as an official. He was skilled in poetry, literature, and calligraphy, and well versed in the painting of landscapes, old trees, bamboo, and rocks.

The painting depicts the luxuriant growth of the grass and the trees in the mountains, surrounded by meandering narrow footpaths. There is a stream below the mountains. Waterside pavilions are barely visible, and everything seems to indicate that it is a summer day on the green and remote mountains. The painting method comes basically from that of Ju Ran. His hemp wrinkles are more scattered and clear, the ink colour is softer, wetter, and more moisten, which makes the packed composition less congested.

This work bears the signature of the painter, which reads: "Painted by Meihuadaoren." The seal reads: "Meihua Hut" (red relief), and "Seal of the Calligraphy and Paintings of Wu Zhen of Jiaxing." The collector seals include "Cangyan" and "Layman Jiaolin" of Liang Qingbiao of Qing, to name but a few.

71

Withered Wood, Bamboo, and Rock

by

Wu Zhen

of

the Yuan Dynasty

Hanging Scroll

Ink and brush on silk

Height 53 cm Width 69.8 cm

This painting is a small sketch for entertainment that the artist drew in a leisurely way in his later years, but it is, nonetheless, the work of a master. The painting features a rock on a slope with a boneset, a piece of withered wood, and bamboos in ink. The ink is moist, thick, and heavy, and the brushstrokes are free. After outlining the rock on the slope, the artist uses a brushstroke that is close to axe-cut wrinkles to paint the texture of the rock. The wrinkles of the withered wood are also drawn with straight brushstrokes within the outline. The brushstrokes are fast, and even the clump of boneset beside the rock has acquired some kind of delicacy.

This work has a five-character poem inscribed by the painter, and the signature reads: "A Play of Ink by Meihuadaoren." Unfortunately, the seal is corrupted and illegible.

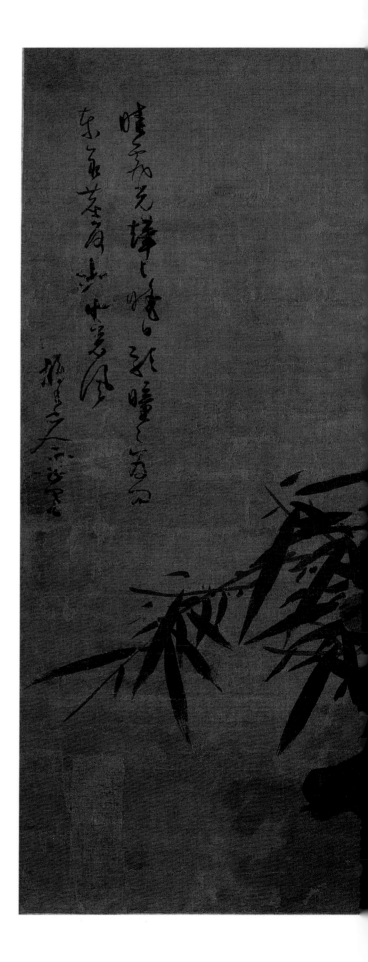

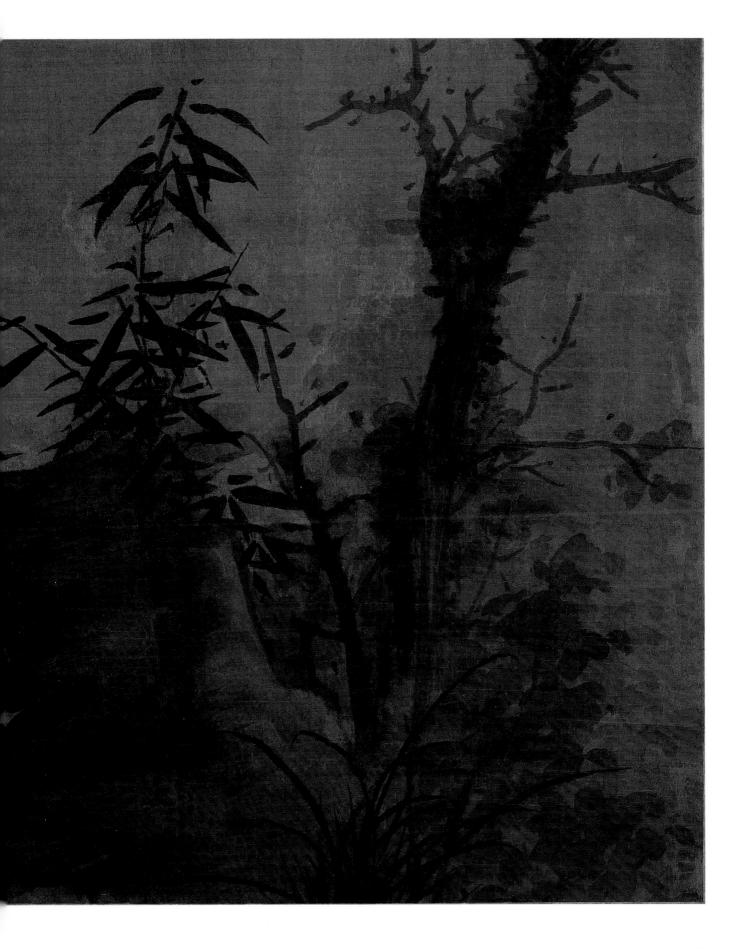

243

72

Parasol Tree, Bamboo, and Elegant Rocks

by

Ni Zan

of

the Yuan Dynasty

Hanging Scroll

Ink and brush on paper

Height 96 cm　Width 36.5 cm
Qing court collection

This is a masterpiece showing the versatility of Ni Zan's paintings. Ni Zan (1301–1374), originally named Ni Ting, was styled Yuanzhen, Yunlin, and Youxia. He was a native of Wuxi in Jiangsu. He was part of a rich local family, but he dissipated all his family fortune in the late Yuan Dynasty, and led a wandering and vagabond life in the length and breadth of the country, for which he was known as Ni Yu. He was skilled in landscape painting and created the folding-ribbon wrinkle method. His paintings are mostly about scenes of Lake Tai.

This painting has a tall barren rock on the bank of a lake, with a tall parasol tree and bamboos with scattered leaves on its sides. The trunks of the trees and the elegant rock are brushed in a sketchy way, and the leaves of the parasol tree are painted with broad brushstrokes and wet ink. Though this is a work that is "hastily drawn with a free brush and does not seek to achieve formal resemblance," it has a kind of charm of the ink that is green, moist, free, and novel.

This work has an inscription by the painter, which mentions that he gave this piece to his friend Zhong Su through another friend. He also wrote a poem for him. There is also one poem inscribed by Zhang Yu of Yuan, and another by Qing Emperor Qianlong. There are more than ten collector seals on the painting, including "Treasure Perused by Emperor Qianlong," "The Shiqu Imperial Catalogue of Paintings and Calligraphy," and "Appreciated by Emperor Qianlong" of the Qing Palace Treasury, "Layman Jiaolin" by Liang Qingbiao, "Rare Family Collection of An Yizhou" by An Qi, and "Rare Collection of Authentic Paintings of Song and Yuan Periods by Pang Laichen" by Pang Laichen of the modern period. This painting is recorded in *Random Notes on Works in Ink*, *Dream Journey in the Records of Wonderful Sights*, and *Classified Records of Calligraphy and Paintings in the Shigu Hall*.

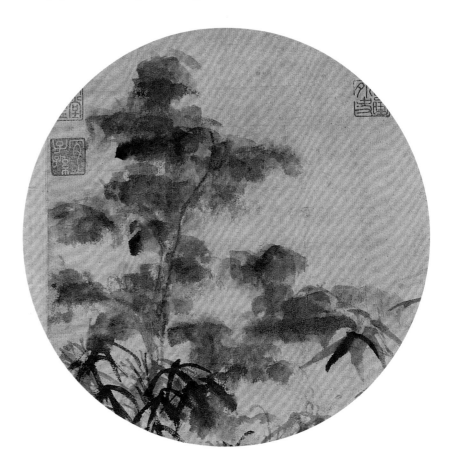

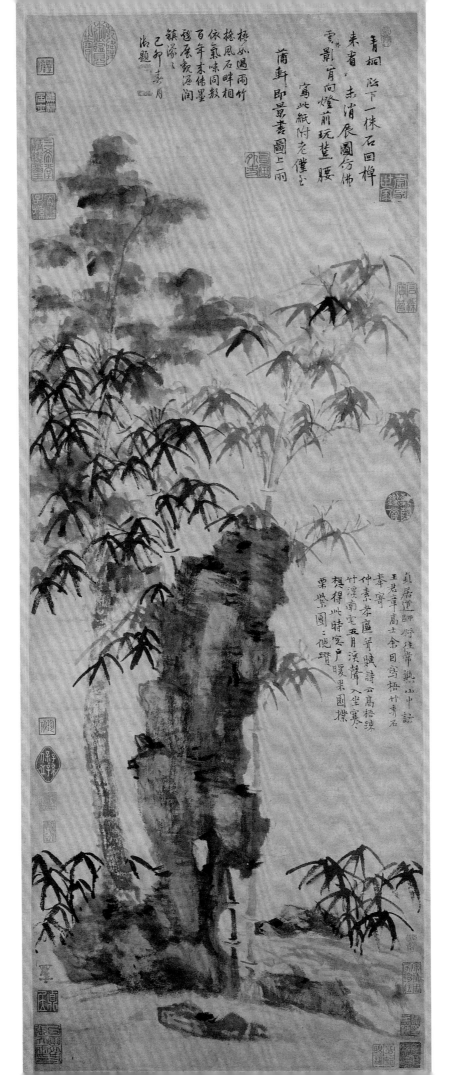

245

73

Secluded Stream and Cold Pines

by

Ni Zan

of

the Yuan Dynasty

Hanging Scroll

Ink and brush on paper

Height 59.7 cm Width 50.4 cm
Qing court collection

As the self-inscription on the painting reveals, this is a work given to Zhou Xunxue. The chilly pine tree is a metaphor for the integrity of an official, which carries the meaning of admonition. The picture has a flat slope and a low hill, with cold pines near a stream. There are no trees in the distant mountains, no grass on the rocks of the slope, and there are only cold pines standing straight beside the stream. It creates a scene of emptiness and desolation. The brush and ink are simple and light. The mountain rocks are outlined with dry and light brushwork with some wrinkling and rubbing skills. The pine branches are double-outlined with two strokes without any wrinkling or colouring. Only a few joints are circled and dotted, and the pine needles are scattered.

This work has a five-character poem written and inscribed by the painter, and it bears his signature, which reads: "My close friend Xunxue left his family in the hot autumn for military service. I painted Secluded Stream and Cold Pines and inscribed a poem on it to present to him, carrying with it the implication of inviting him to be a hermit, written by Ni Zan on the eighteenth day of the seventh month." There are four collector seals on the painting, including "Works Verified by Song Luo of Shangqiu as Authentic," and "Works Verified by He Shi Yuanlang," both of Qing. There is also a seal, half of which remains. This painting is recorded in *The Boat of Calligraphy and Paintings on the Qing River*, *Daily Records of Genuine Works, Third Series*, *Paintings and Calligraphy Seen by Zhang Chou*, *Classified Records of Calligraphy and Paintings in the Shigu Hall*, and *Records of Paintings and Calligraphy in the Qing Dynasty*.

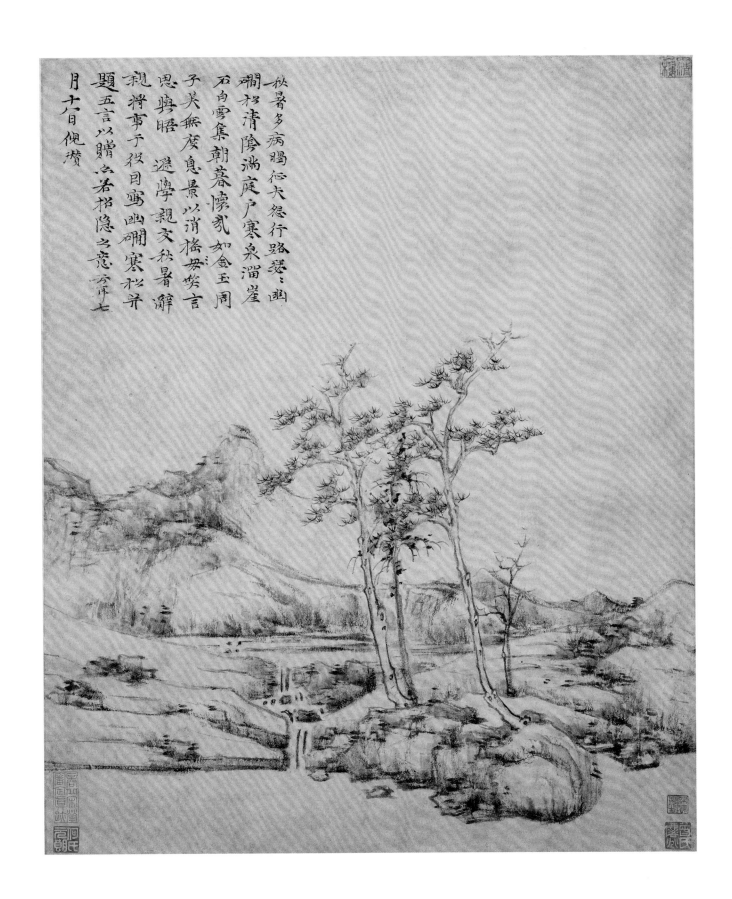

一秋暑多病暍征夫怨行路瑟瑟幽
珊松清陰滿庭戶寒泉溜崖
石自雲集朝暮懷我如金玉周
子芙無度息景以消搖毋勞言
思與晤避暑親交秋暑辭
親將事于役日事幽珊寒松芽
題五言以贈石若招隱之意雲平七
月十八日倪瓚

247

74

Lofty and Secluded Mountains in Summer

by

Wang Meng

of

the Yuan Dynasty

Hanging Scroll

Ink and colour on silk

Height 149 cm Width 63.5 cm

This painting conveys a luxuriant and smooth feeling and it represents Wang Meng's highest artistic level. Wang Meng (1308–1385), styled Shuming and Huangheshanqiao, was a native of Wuxing (present-day Huzhou in Zhejiang) and a maternal grandchild of Zhao Mengfu. He served at a time as a minor official of no significance, but forsook officialdom to retire and live in seclusion in the latter years of the Yuan Dynasty. During the Ming Dynasty, he served as the Subprefectural Magistrate of Tai'an. He later died in prison due to a criminal punishment. He was skilled in poetry, literature, and calligraphy, and especially landscape painting.

The painting shows a waterfall in isolation amidst mountain ranges. In the valley, the stream meanders. Village families and temples appear among the trees. The environment is one of serenity and seclusion. The brush and the ink are wet, moist, simple, and thick, showing the charm of greenness and humidity that is characteristic of the mountains and rivers in summertime in the south. The composition is dense, and yet it still gives the impression of space and depth.

This work bears the signature of the painter, which reads: "Lofty and Secluded Mountains in Summer, painted on the seventeenth day of the fourth month in the twenty-fifth year of the reign of Zhizheng. Wang Meng, styled Huanghe Shanren, painted this piece for Hermit Yanming at his residence at Wumen." The seal reads: "Shuming" (red relief), and the characters on another seal are not legible. There are five collector seals on the painting, including "Collection of Shendi," to give an example. This painting is recorded in *Classified Records of Calligraphy and Paintings in the Shigu Hall*, *Dream Journey in the Records of Wonderful Sights*, *Record of Paintings and Calligraphy Seen by Gao Shiqi*, and *Reflections on Paintings and Calligraphy*.

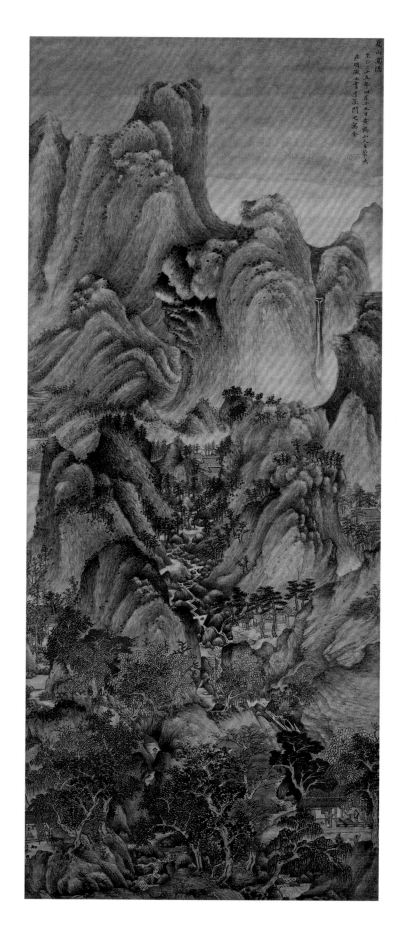

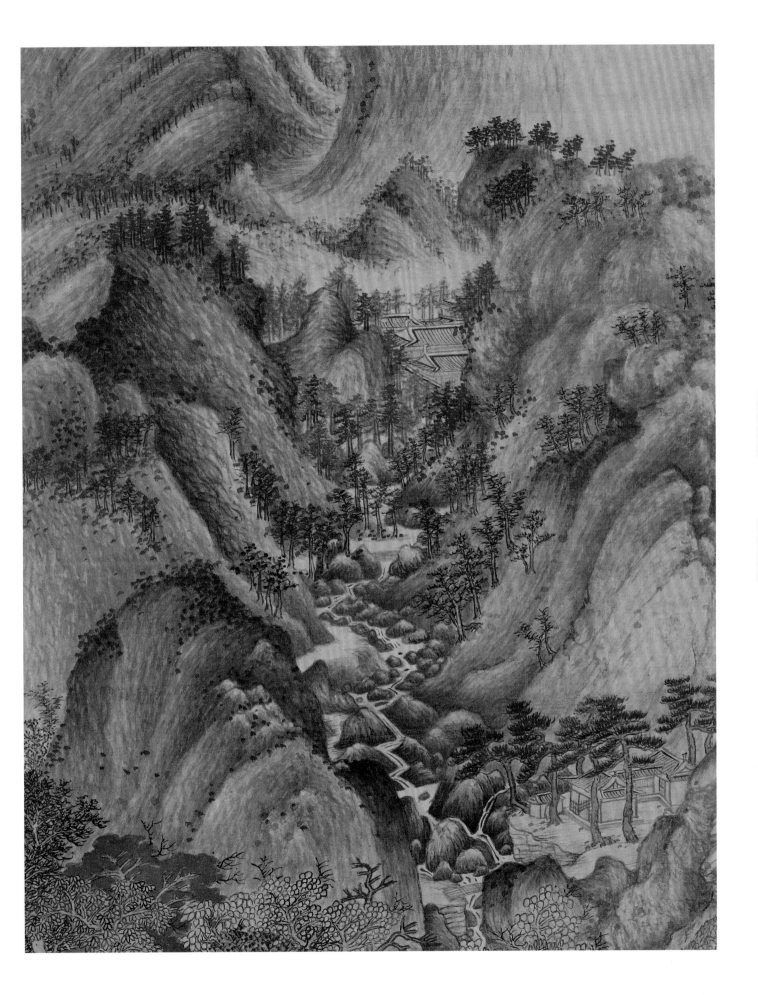

75

Ge Zhichuan Relocating

by

Wang Meng

of

the Yuan Dynasty

Hanging Scroll

Ink and colour on paper

Height 139 cm Width 58 cm

This painting is a classic work that reflects Wang Meng's wish to retire from the world and live in seclusion. It describes the Jin Daoist Ge Hong moving with his family to reside in Mount Luofu. The brush and ink work are delicate and beautiful. The leaves of the trees are drawn with double outlines filled with colour, and the colours are classic and elegant. The mountains rocks are painted with ink, with the slight addition of garcinia but without moss dots. The colour of the ink is pale, light, and multilayered.

The painter signed this work, with the following statement: "It was several decades ago when I collaborated with Rizhang on the painting of Ge Zhichuan Relocating. Today I looked at it again, and wrote my inscription on it, by Wang Shuming." Along with this message, we can see the character "sheng" code and the signature of Xiang Yuanbian. There are more than ten collector seals on the painting, including "Seal of Appraisal and Appreciation of Xiang Molin" by Xiang Yuanbian of Ming, "Treasure of the King of Yi," by Yun Xiang, "Appraised and Appreciated by Yizhou" by An Qi, "Record of Calligraphy and Paintings in the Collection of Zhang Yi of Luhe" by Zhang Yi, "Seal and Record of Calligraphy and Paintings Authenticated by Tao Zhai" by Weng Danian, "Treasure of the Xuzhai Studio" and "Works Examined and Collected by Laichen" by Pang Laichen, "Seal of Sun Yufeng" by Sun Yufeng, and "Hongyi Studio" by Sun Yufeng of Qing. This painting is recorded in *Postscripts on Famous Calligraphy and Paintings by Wang Keyu, Yu's Record of Inscriptions and Annotations on Paintings and Calligraphy, Catalogue of Paintings and Calligraphy in the Peiwen Studio, Classified Records of Calligraphy and Paintings in the Shigu Hall, Random Notes on Works in Ink,* and *Record of Famous Paintings from the Private Collection of Xuzhai, Second Series.*

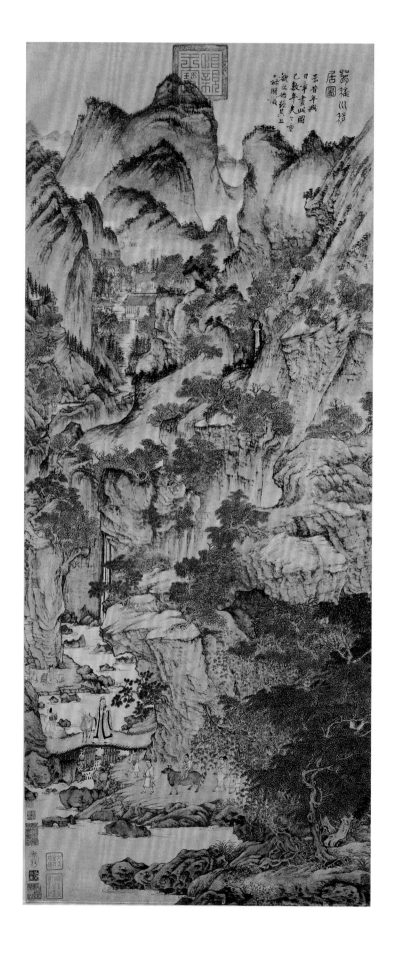

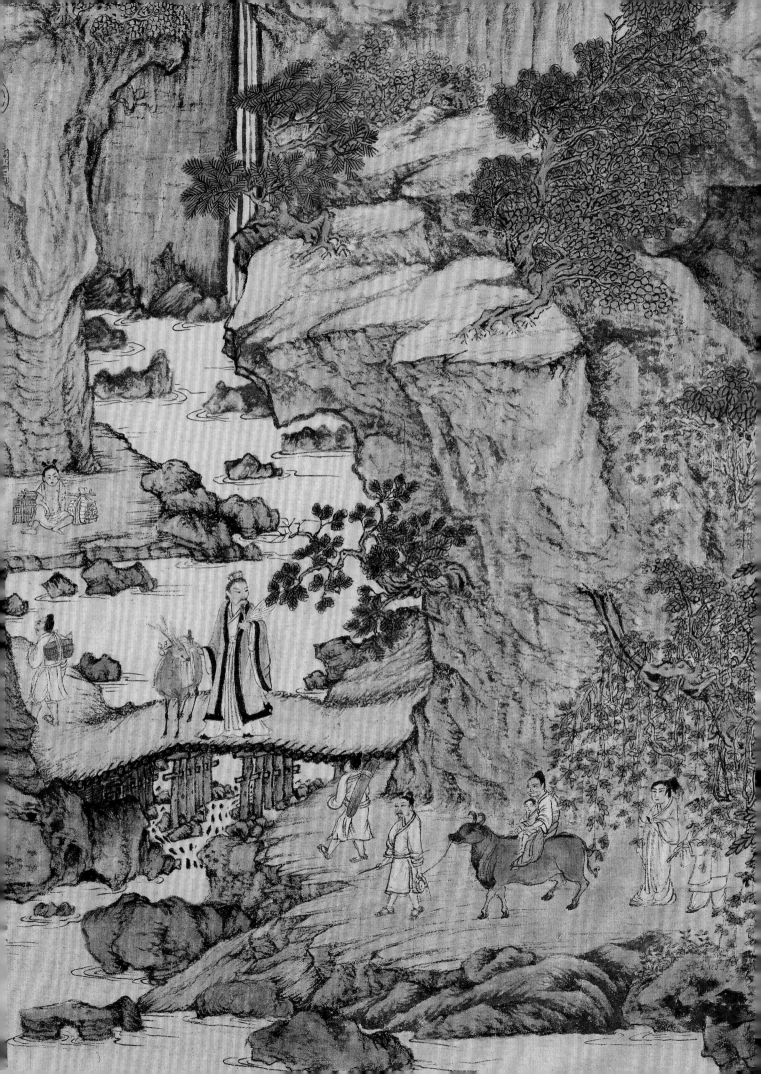

76

Crossing the Pass on the Snowy Hill

by

Ma Wan

of

the Yuan Dynasty

Hanging Scroll

Ink and brush on silk

Height 125.4 cm Width 52.7 cm

This painting is a gem of freestyle drawing that Ma Wan copied from *Nine Peaks after Snow* by Huang Gongwang. Ma Wan, whose years of birth and death are unknown, was active in the fourteenth century. He was styled Wenbi and Luchunsheng, and although he was born in Qinhuai (present-day Nanjing in Jiangsu), he resided in Songjiang (present-day Shanghai). He held the position of the Prefect of Fuzhou in early Ming. He was skilled in poetry, literature, and calligraphy, especially in landscape painting, which were considered at that time as the "three best skills."

The picture shows the towering peaks covered in snow and the waterfalls of the mountain springs. On the meandering mountain paths some travellers are walking towards the border town. The style of the painting is modelled after Huang Gongwang. The ambiance is desolate, a typical atmosphere of the Yuan people.

This work bears the signature of the painter, which reads: "Crossing the Pass on the Snowy Hill is a painting I did for Yanming." His seals read: "Seal of Ma Wan" (red relief) and "Wenbi" (white relief). There are four collector seals on the painting, including "Rare Treasure of Jiaolin" and "Taking a Grand View" by Liang Qingbiao of Qing.

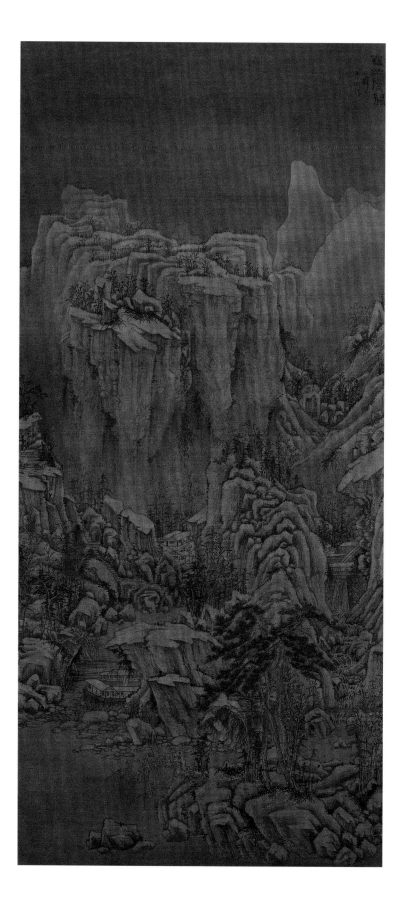

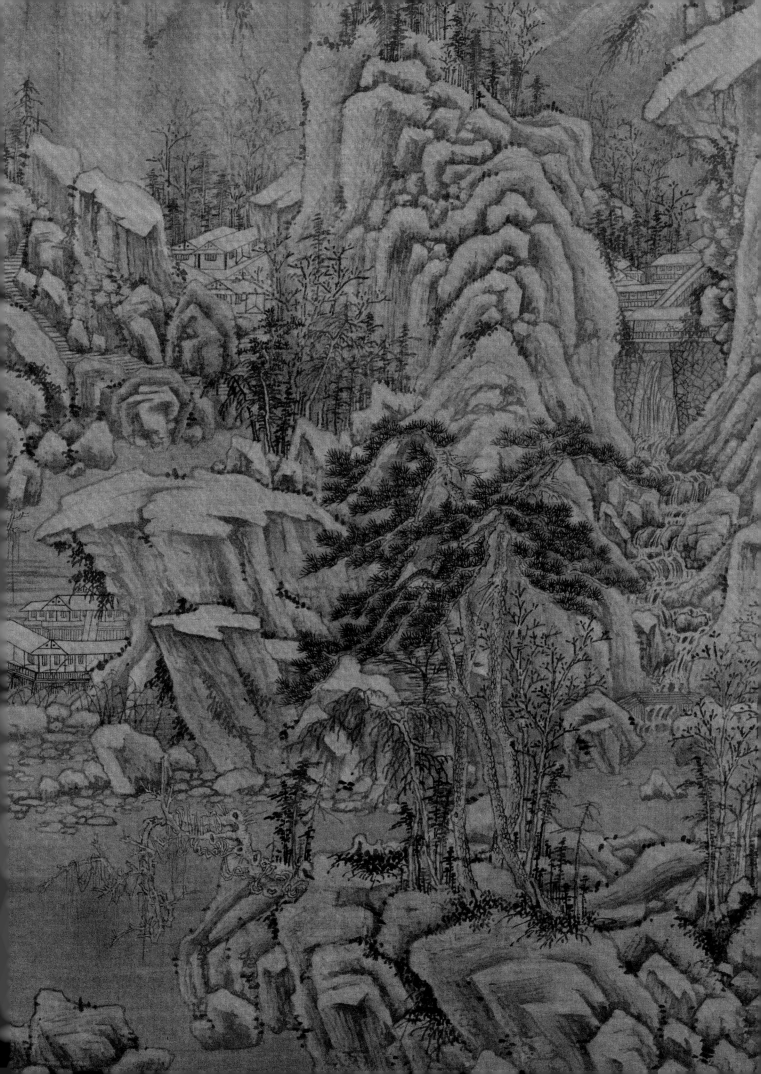

77

Trees and Rocks

———— by ————
Zhao Yuan
———— of ————
the Yuan Dynasty
Album

Ink and colour on silk

Height 25 cm Width 19.7 cm

This painting is a representative work of landscape sketch on a fan by Zhao Yuan. Zhao Yuan, styled Shanzhang and Danlin, was a native of Jucheng (present-day Jucheng in Shandong). The years of his birth and death are uncertain, but he was known to be active in the fourteenth century. He resided in Suzhou and was on good terms with Gu Ying, Ni Zan, and Wang Meng, with whom he often exchanged poems and paintings. He was skilled in painting landscapes, especially bamboo in ink, and had the esteem of his contemporaries. During the Ming Dynasty, he was summoned to the court and commanded to paint *Portraits of Officials of Merits in Various Dynasties*, but he was killed because his work did not meet the emperor's decree.

This painting depicts the rocks on the shore of a stream, surrounded by pine, willow, poplar, and scholar trees. The mountains in the distance are undulating, and their rocks are sketched out by wielding brushstrokes to one side, and thin ink and wrinkles in colour are subsequently added. The tree branches are painted with double-outlines filled with colour, and the joints are dotted mainly with pale ink. The leaves are outlined, dotted, and coloured. His artist's drawing is neat, his brush and ink, smooth and beautiful, and his style, elegant and free.

This work bears no signature or name of the painter, but the seals read: "Personal Seal of Zhao Yuan" (red relief) and "Shanzhang" (white relief).

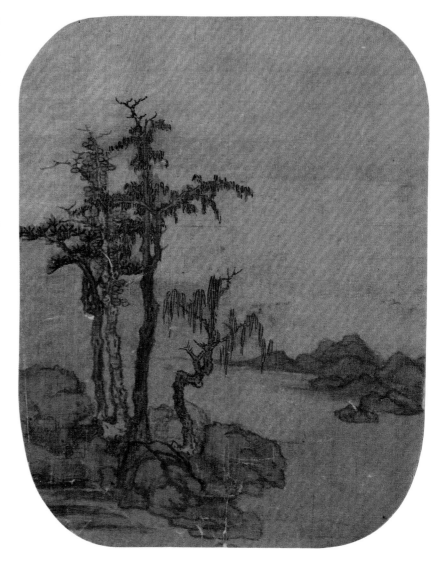

78

Spring Clouds and Morning Mist

by

Gao Kegong

of

the Yuan Dynasty

Hanging Scroll

Ink and colour on paper

Height 138.1 cm Width 58.5 cm

This is a meticulous work of Gao Kegong, who patterned this painting after the "Mi-style misty mountain." Gao Kegong (1248–1310), styled Yanjing and Fangshandaoren, was born in Datong in Shanxi but resided in Dadu (present-day Beijing), where he served as Minister of Justice. He was skilled in painting landscapes and bamboo in ink. He was a literati painter whose ancestors were Uighurs from the Western Regions. In landscape painting, he followed the style of Dong Yuan and Ju Ran of the Five Dynasties, and Mi Fu of the Song Dynasty.

This painting features high mountains and tall peaks, with floating clouds and morning mist shrouding the valleys. The mountain ridges are painted with hemp-fibre wrinkles. One can see the clear influence of Mi Fu in the painting of the misty mountains. The brush is wet and moist, with thick ink. The drawing of the temples and monasteries is neat and fine, but the village houses are drawn in a more simple way.

This work bears the signature of the painter, which reads: "This work is painted for Bo Gui on the twentieth of the ninth month of the year of Gengzi, by Daoist Fangshan." The seal reads: "Seal of Gao Yanjing" (white relief). The margin of the mounting includes inscriptions by Jiang Guobang and Li Jian of the modern period. More than ten collector seals have been placed on the painting, including "Su Shi Changling" by Su Changling, "Zhu Shi Zemin" by Zhu Zemin, "Liu Shi Shuya" by Liu Shuya, and "Gao Shiqi" by Gao Shiqi of Qing. This painting is recorded in *Dream Journey in the Records of Wonderful Sights* and *Record of Paintings and Calligraphy Seen by Gao Shiqi*.

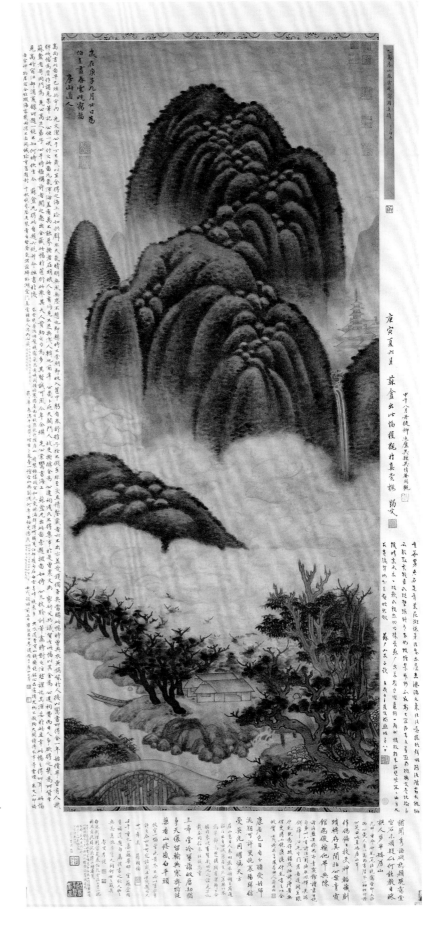

79

Pavilion of Elegant Plain

by

Zhu Derun

of

the Yuan Dynasty

Hand Scroll

Ink and colour on paper

Height 28.3 cm Width 210 cm

Qing court collection

This work constitutes an example of the extraordinary artistic skills of Zhu Derun. Zhu Derun (1294–1365), also called Zemin and Suiyangsanren, was a native of Suiyang (present-day Shangqiu in Henan), but resided in Kunshan (belonging to the present-day Jiangsu). Upon the recommendation of Zhao Mengfu, he served as Supervisor of the Confucian Schools of Zhendong Branch Secretariat. He was skilled in painting landscapes and modelled himself on Guo Xi.

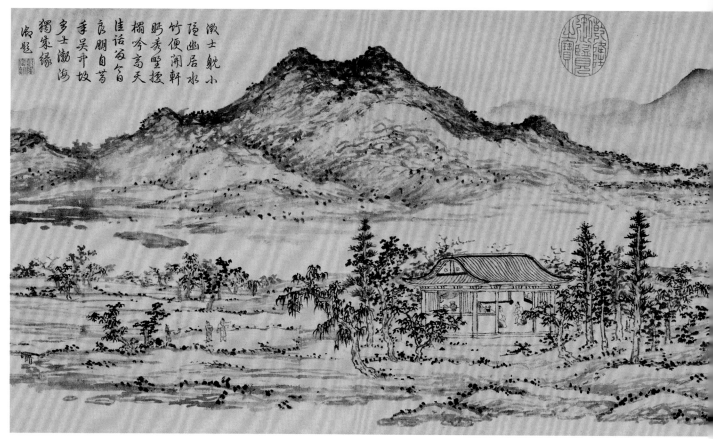

This painting depicts a real scene in the Pavilion of Elegant Plain, residence of Zhu's good friend Zhou Chi. This residence was located in the southwest of the Yuhang Mountain in Zhejiang, surrounded by the Jinfeng, Zhenshan, Yuzhe, and Tianchi mountains, with two streams dividing the south and north. Between the mountains is a flat and fertile plain grown with luxuriant grass and trees. Flower-blue ink was applied to the mountain rocks and trees, and the painting was completed mainly with moist ink, which was interspersed with both thick and thin, and dry and moist strokes. The painter uses empty outlines as a technique of colour gradation in some places, whereas hemp-fibre wrinkles or dots are employed in other areas. The brush and the ink are green, moist, clear, and free, and the colour is light and elegant.

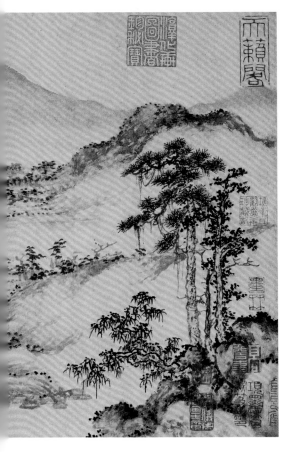

This work bears an inscription by the painter, which reads: "Record of the Pavilion of Elegant Plain," and his signature reads: "This work is painted on the tenth day of the fourth month of the year of Jiachen, the twenty-fourth year in the reign of Zhizheng, at the age of seventy-one. Painted and inscribed by Zhu Derun." The seals read: "Zhu Zemin" (red relief) and "Meiyusanren" (red relief). This work also includes a poem inscribed by Qing Emperor Qianlong. The frontispiece has an inscription by Zhou Boqi of Yuan, which reads: "Pavilion of Elegant Plain, inscribed by the aged Yu Xuepo." There are twenty-one annotations on the painting, including those by Zhang Jian, Gao Qi, Xu Ben, Wang Yi, Xu Gui, Hui Zhen, and Gao Shiqi. Dozens of collector seals are present, including "Treasure Perused by Emperor Qianlong," "Shiqu Imperial Authentications," "Rare and Precious Treasure of the Paintings and Calligraphy of the Chunhua Studio," and "Treasure Perused by Emperor Xuantong" of the Qing Palace Treasury, "Seal of Appraisal and Appreciation of Xiang Molin" by Xiang Yuanbian of Ming, "Seal of the Paintings and Calligraphy of An Yizhou" by Ai Qi, and "Seal of the Rare Collection of Calligraphy and Paintings in the Thatched Cottage of Gao Jiangcun" by Gao Shiqi, both of Qing. This painting is recorded in *Critical and Descriptive Notes on Paintings and Calligraphy*, *A Collection of Miscellaneous Notes Compiled by Ming Scholar Li Rihua, Third Series*, *Catalogue of Paintings and Calligraphy in the Peiwen Studio*, *Classified Records of Calligraphy and Paintings in the Shigu Hall*, *Dream Journey in the Record of Wonderful Sights*, *Record of Paintings and Calligraphy Seen by Gao Shiqi*, *Random Notes on Works in Ink*, *Sequel to the Shiqu Imperial Catalogue of Paintings and Calligraphy*, and *Painting and Calligraphy Catalogue of Gao Shiqi*.

Sparse Pines and Secluded Cliffs

by

Cao Zhibai

of

the Yuan Dynasty

Hanging Scroll

Ink and brush on paper

Height 74.5 cm Width 27.8 cm

This is a representative painting with a dry brush and light ink by Cao Zhibai. Cao Zhibai (1272–1355), otherwise known as Youyuan, Zhensu, and Yunxi, was born in Huating (present-day Songjiang in Shanghai) into a wealthy family. He served as Kunshan Instructor, but resigned because he found it uncongenial. From then on, he lived in retirement and devoted himself to read books and painting.

This work depicts a slope with tall pines and weed trees. We can observe winding islets and flowing water at the foot of the mountains, and the scene is one of seclusion and remoteness. The scene is balanced in its composition, the brushwork is elaborate and fine, and the brushstrokes and ink are extremely scarce. Brushstrokes are applied only to deep and caved-in places, mountain tops, and other structures to represent the rocks. All the rest is left unpainted. The dry brush and light ink applied to the wrinkles of the trees and rocks show that the painter in his late years had a style which was spacious, minimalistic, forceful, and beautiful.

This work bears the signature of the painter, which reads: "Born in the year of Renshen, at the age of eighty. This work is painted in the first month of the year of Xinmao in the reign of Zhizheng, inscribed by Yunxi." The seals read: "Yunxi" (white relief), "For self-entertainment" (white relief), and "Suxuan" (red relief). There is another self-signature, which reads: "... Shu Kuan ...," with a seal that reads: "Zhensu" (red relief). This painting has poems inscribed by Pan ... and Yuan Ben. The collector seals include "Authenticated by Xu Zhai" and "Seal of the Collection of Pang Laichen" by Pang Laichen of the modern period. This painting is recorded in *Records of Famous Paintings from the Private Collection of Xu Zhai, Second Series*.

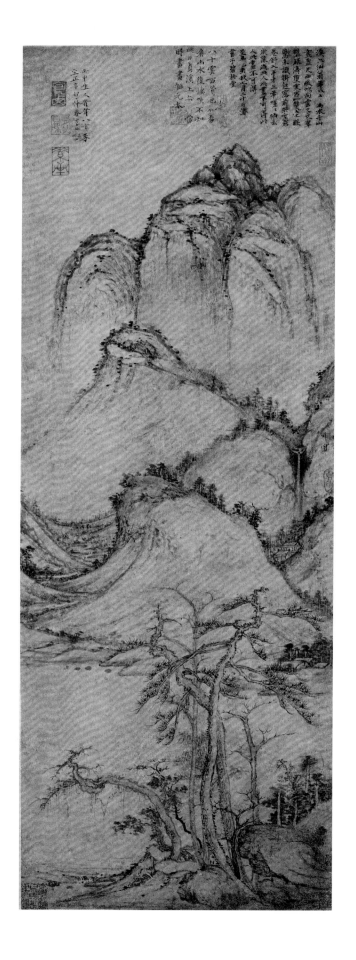

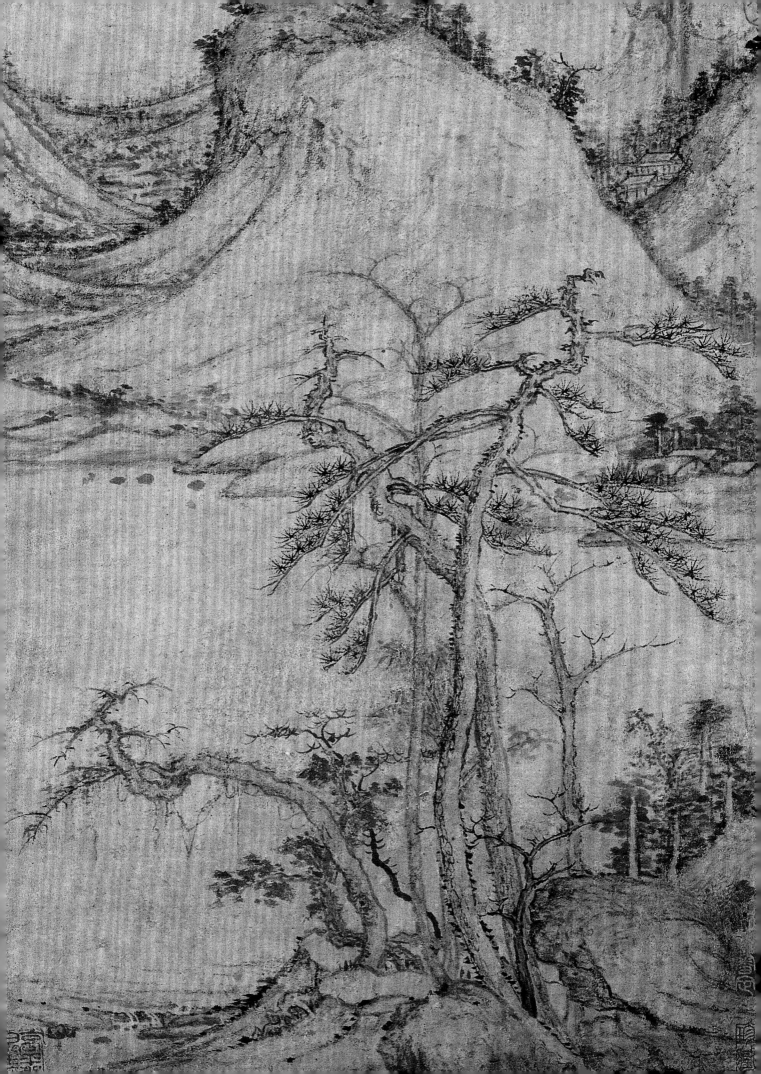

Bamboo in the Rain

by

Li Kan

of

the Yuan Dynasty

Hanging Scroll

Ink and colour on silk

Height 111.5 cm Width 55 cm

This painting is a typical example of the style of Li Kan who is known for drawing bamboo with the double-outline method. Li Kan (1245–1320), styled Zhongbin and Xizhaidaoren, was a native of Jiqiu (present-day Beijing), where he served as Minister of Personnel. He excelled in painting bamboo, so he went to a bamboo village in the south to observe and sketch this plant. He received imperial edicts to make murals for imperial palaces and temples.

This painting features four bamboos on a slope in the rain, with a few clumps of orchids underneath. The bamboo leaves are luxuriant and drooping. The painter shows the graceful movement of the bamboos in the drizzling rain in a most natural way. As aforementioned, the stems and leaves of the bamboos are drawn using the double-outline method. The brushstrokes are forceful, neat, and delicate, coloured in green ink. The tips of the leaves have a dash of umber, and their greenness is appealing. The artist also uses the method of leaving blanks to show the water drops on the leaves after the rain.

This work bears the signature of the painter, which reads: "In the rain," and the seals read: "Xizhai" (red relief) and "Li Kan, Styled Zhongbin" (white relief). The collector seals include "Appreciated by Qun Yi of Qing" and "Rare Family Collection of An Yizhou." This painting is recorded in *Classified Records of Calligraphy and Paintings in the Shigu Hall*.

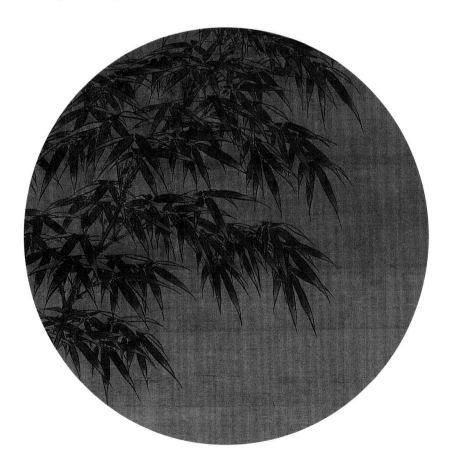

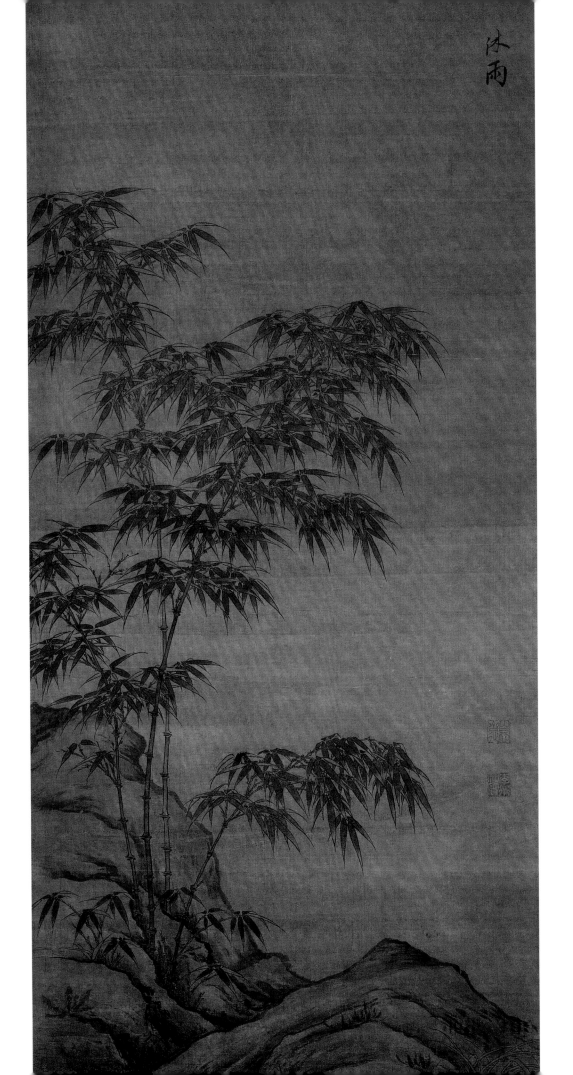

82

Bamboo Painted at Qingmi Chamber

— by —

Ke Jiusi

— of —

the Yuan Dynasty

Hanging Scroll

Ink and brush on paper

Height 132.8 cm Width 58.5 cm
Qing court collection

This painting is a representative work of Ke Jiusi, who used calligraphy to express with his brush the "freestyle painting of bamboo." Ke Jiusi (1290–1343), otherwise known as Jingzhong, Danqiusheng, and Wuyungeli, was a native of Xianju in Taizhou (which belongs to present-day Zhejiang). He was knowledgeable and well versed in letters. He served as Literary Erudite of the Hall of Literature. He was skilled in painting ink bamboos and landscapes.

In the picture there are two bamboos, sketched in ink, standing upright beside a lake rock. Decorating the sides of the rock are tender bamboo sprouts and short grass. The bamboo leaves are painted freely with the calligraphy method of brushing down to the left. The colour of the ink is clear and soft, interlacing the thick with the thin. The lake rock is in hemp-fibre wrinkles, and it seems strong and thick.

This work bears the signature of the author, which reads: "I stayed at the Qingmi Chamber where I painted this work on the thirteenth day of the twelfth month of the year of Wuyin, after the reign of Zhiyuan. Inscribed by Danqiusheng (courtesy name of Ke Jiusi)." The seals read: "Ke Jingzhong" (red relief), "Literary Erudite of the Hall of Literature" (white relief), "Home of Xunzhong" (white relief), "Seal of Ke Jingzhong's Painting" (red relief), and "Seal of the Xixun Hall" (white relief). This work has a poem inscribed by Emperor Qianlong and dozens of collector seals, including "Treasure Perused by Emperor Qianlong," "Shiqu Imperial Authentications," and "Appreciated by Emperor Qianlong" of the Qing Palace Treasury, "Seal of Ni Zan" by Ni Zan of Yuan, "Rare Family Collection of Xiang Zijing" by Xiang Yuanbian of Ming, "Calligraphy and Paintings in the Shigu Hall" by Bian Yongyu, and "Appraised and Appreciated by Yizhou" by An Qi, both of Qing. This painting is recorded in *Random Notes on Works in Ink*, *The Shiqu Imperial Catalogue of Paintings and Calligraphy, Volume 1*, *Records of Famous Paintings in the Private Collection of Xuzhai*, and *Classified Records of Calligraphy and Paintings in the Shigu Hall*.

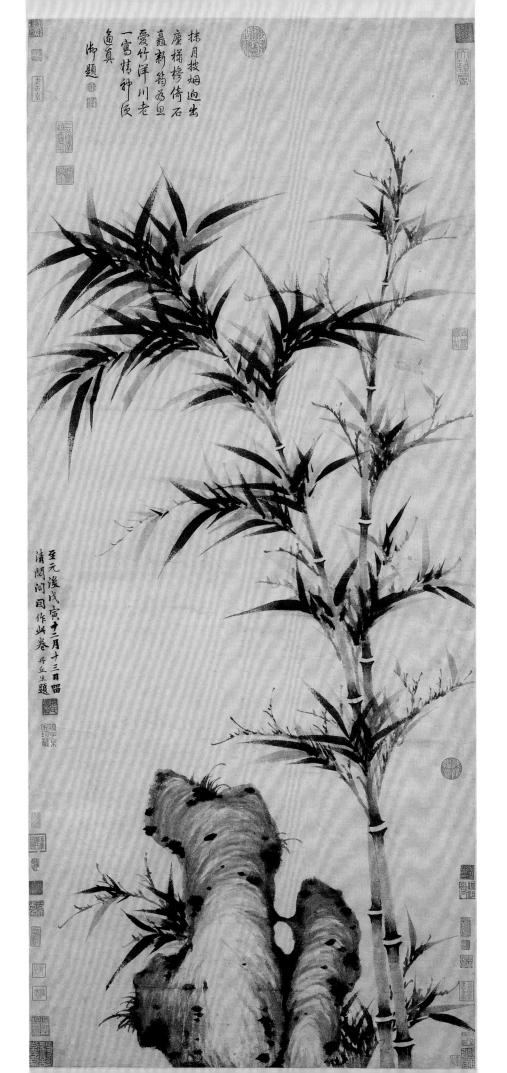

263

Tranquil Bamboo and Elegant Rock

by

Gu An

of

the Yuan Dynasty

Hanging Scroll

Ink on silk

Height 184 cm Width 102 cm

This painting is a representative work of Gu An, who learned from Li Kan and used the meticulous and refined brushwork and most realistic technique to paint bamboo in ink. Gu An (1289–1365), styled Dingzhi and also known as Yunelaoren, was born in Pingjiang (present-day Suzhou in Jiangsu), but his original native place was Huaidong (present-day Jiangsu), and that is why he claimed that he was a native of Huaidong. He served as Tong'an District Defender of Quanzhou. He was skilled in painting bamboo, especially bamboo in the wind and bamboo sprouts.

The present painting has a lake rock standing high, which is painted exquisitely. Behind the rock are bamboo groves. The bamboo stems are thin and sturdy, whereas the bamboo leaves are upturned, graceful and charming. Several new bamboo shoots intersperse the bamboo clumps, and seem full of vitality. The brushstrokes are delicate and serious. The composition seeks the extraordinary out of the ordinary, in an atmosphere of peace and serenity.

The artist signed this artwork as: "Gu An of Donghuai," and his seals read: "Seal of Gu An" (red relief) and "Cuncheng Studio" (red relief). There is a seven-character poem inscribed by Zhang Shen. The top margin of the painting has an annotation inscribed by Xu Zonghao. There are four collector seals on the painting, including, "Xu Zonghao" and "Seal of the Collection of Xu Zonghao" by Xu Zonghao of the modern period.

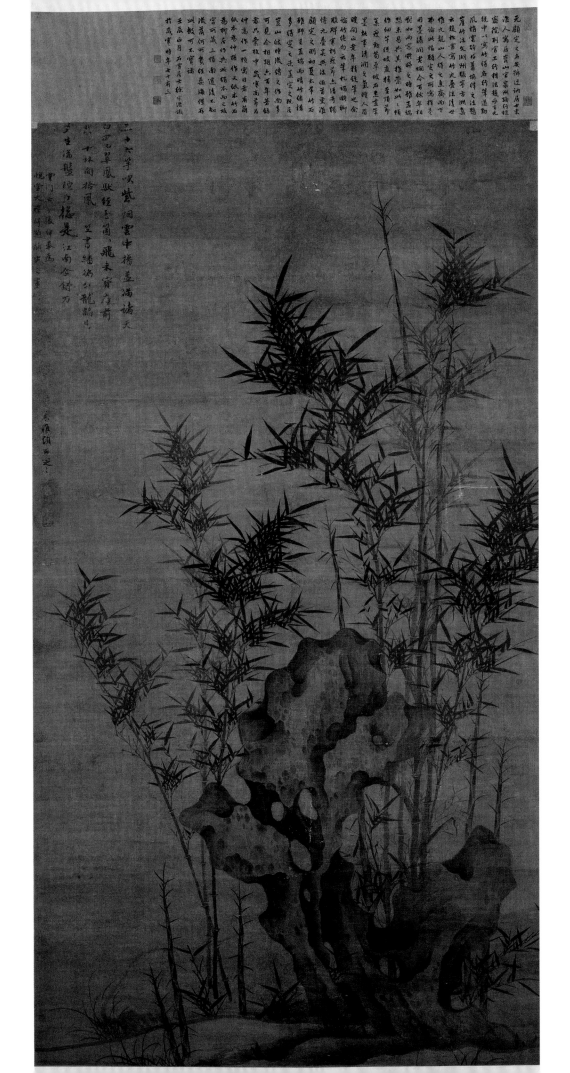

84

Plum Blossoms

— by —

Wang Mian

— of —

the Yuan Dynasty

Hand Scroll

Ink and brush on paper

Height 31.9 cm Width 50.9 cm

This is a masterpiece of plum blossoms in ink by Wang Mian. Wang Mian (1287–1359), styled Yuanzhang, Laocun, Zhutang, and Zhushishannong, was a native of Zhuji in Zhejiang. He later retired to Mount Jiuli in Huiji. He was skilled in writing poems and painting, especially the painting of plum blossoms in ink. He followed the School of Yang Wujiu of Southern Song, which has the sparse style and the dense style. He created the "rouge and boneless style" and made it all his own.

In this painting the plum blossoms are drawn in a spacious style. The ink for the plum branches ranges from thick to thin with elegance and grace. The plum blossoms are dotted with pale ink and thick ink and fine brushes are used to dot out the calyxes and pistils, which is harmonious and natural. His brushwork and the spirit of the painting have the characteristics of an intellectual, making this work a classic in ink plum blossoms of the Yuan Dynasty.

This work has an inscription by the painter in which he says that he would rather leave this work unappreciated than using bright colours to paint peach blossoms. This expresses the strong artistic character of the painter. The valediction reads: "Wang Mian, styled Yuanzhang, painted This work for Liang Zuo." The seal reads: "Yuan Zhang (white relief) and "Offsprings of King Wen" (white relief). The painting has a poem inscribed by Emperor Qianlong and a collector seal of Emperor Xuantong. There are also other collector seals on the painting, including "Appraised and Appreciated by Yi Zhou" (white relief) by An Yizhou and "Jiaolin" (red relief) by Liang Qingbiao, both of Qing.

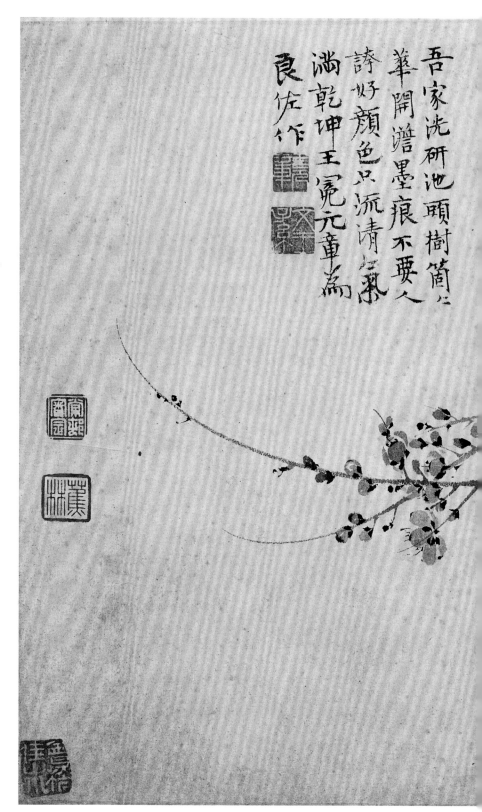

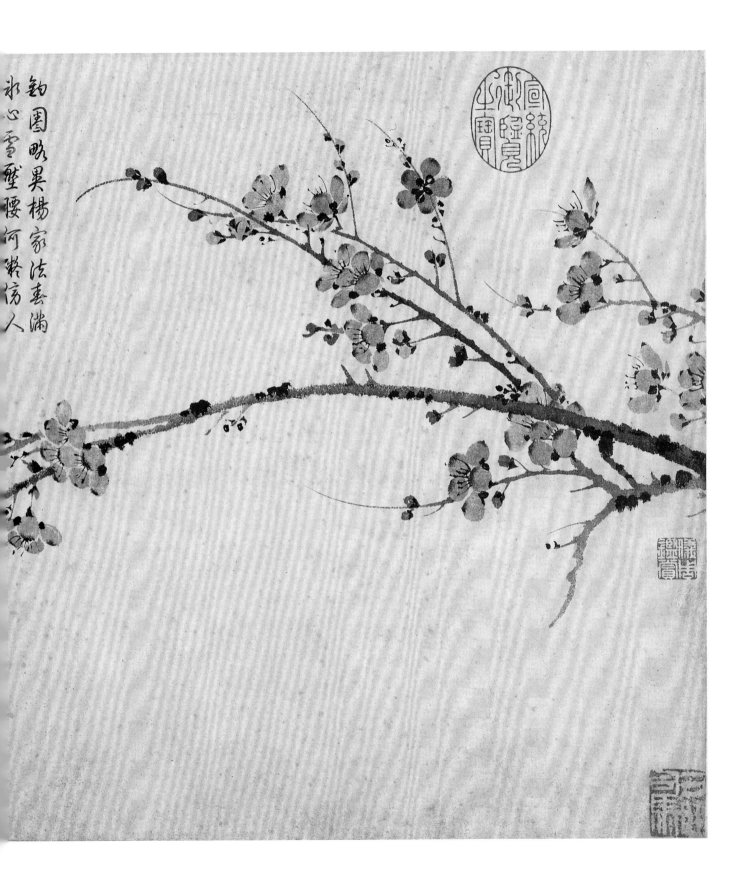

鈞圜眇果楊家法豈滿
冰心雪壓腰何舞傍人

267

85

Peach, Bamboo, and Golden Pheasants

by

Wang Yuan

of

the Yuan Dynasty

Hanging Scroll

Ink and brush on paper

Height 111.9 cm Width 55.7 cm

This painting is not only the most exquisite work of Wang Yuan, but it is also a paradigm of flower-and-bird painting transiting from colour to ink. Wang Yuan, styled Ruoshui and Danxuan, was a native of Qiantang (present-day Hangzhou in Zhejiang). The years of his birth and death have not been determined but he was active in the fourteenth century. When he was young, he received instruction from Zhao Mengfu. He was skilled in painting flowers and birds in ink and landscapes.

This painting depicts rocks on the bank of a stream. A male golden pheasant is combing its feathers on the principal rock, while a female golden pheasant hides itself among the rocks on the slope. Beside the rocks the peach blossoms are colourful. A titmouse raises its head, curls up its tail, and rests on a peach branch. The feathers of the golden pheasants are not drawn in detail, the peach flowers and leaves are drawn with the boneless method, and the ink bamboos are expressed by double outlines. This elegant and polished style sets a new trend in freestyle flower-and-bird ink painting, becoming a model for later generations.

This work bears the signature of the painter, which reads: "Wang Ruoshui painted Peach, Bamboo, and Golden Pheasants for Huiming, in the year of Jichou of the reign of Zhizheng," and the seals read: "Danxuan" (red relief) and "Seal of Wang Ruoshui" (white relief). There are also three collector seals, which include "For the permanent keeping of the children and grandchildren," "For the self-entertainment of Mi Weng," and "Cheng of Shuaibin."

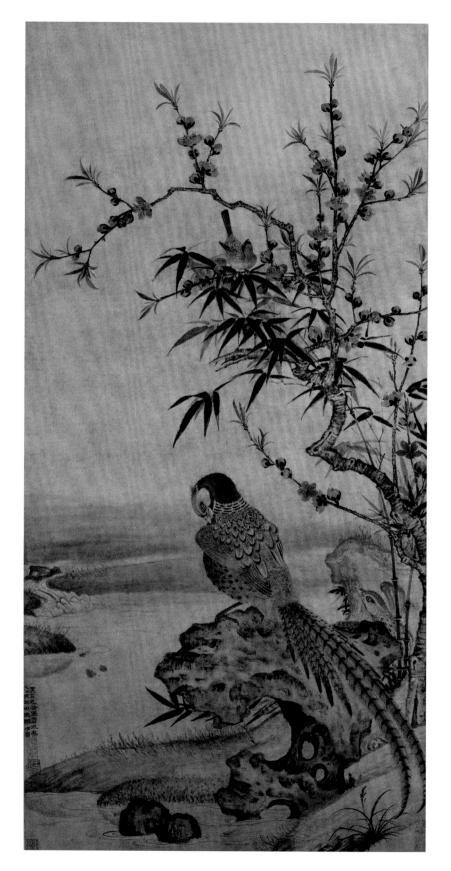

86

Rowing by Mount Wuyi

— by —

Fang Congyi

— of —

the Yuan Dynasty

Hanging Scroll

Ink and brush on paper

Height 74.4 cm Width 27.8 cm
Qing court collection

This painting is a freestyle landscape that Fang Congyi drawn with traditional brush and ink, which has a unique artistic tone. Fang Congyi, styled Wuyu and Fanghu, was a native of Guixi (in present-day Jiangxi). The years of his birth and death are uncertain, but he was active in the fourteenth century. He was a Daoist of the Shangqing Temple in Mount Longhu. He was skilled in poetry, literature, calligraphy, and painting, especially landscape painting. He was fond of travelling throughout his life. In the early years of the reign of Zhizheng, he travelled the length and breadth of the country, and arrived at the capital, where he became famous.

This painting was drawn for his fellow Daoist Zhou Jingjin when Fang Congyi was residing in Mount Wushi (Mount Min). The picture depicts Mount Wuyi standing tall. The brushstrokes are varied, and the ink is thick, moist, and smooth. Mount Wuyi lies to the southwest of Chong'an in the present-day Fujian and runs for more than a hundred miles. It is of particular importance to Daoists who address it as "the sixteenth heavenly abode."

This work bears an inscription by the painter, which reads: "Rowing by Mount Wuyi," together with his signature that reads: "This work is painted in the winter of the Year Jihai in the reign of Zhizheng, when I stayed at Mount Wushi." His seal reads: "Hermit Fanghu." The collector seals on the painting include seals of Qianlong, Jiaqing, Xuantong of the Qing Palace Treasury, "Authenticated by Bian Lingzhi," "Tan," "Jing" (red relief, linked), "Seal of the Calligraphy and Paintings of An Yizhou," and "Calligraphy and Paintings in the Shigu Hall" and others, making a total of fifteen seals. This painting is recorded in *Dream Journey in the Records of Wonderful Sights*, *Classified Records of Calligraphy and Paintings in the Shigu Hall*, and *The Record of the Paintings and Calligraphy in the Baoyu Pavilion*.

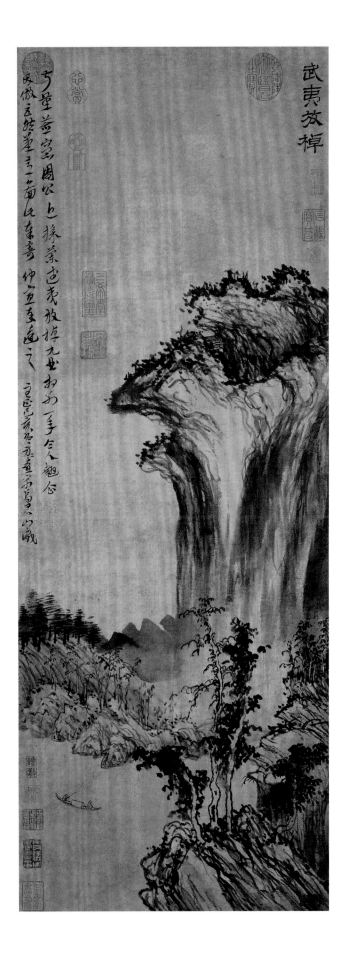

87

Boya Plays the *Qin*

by

Wang Zhenpeng

of

the Yuan Dynasty

Hand Scroll

Ink and brush on silk

Height 31.4 cm Width 92 cm
Qing court collection

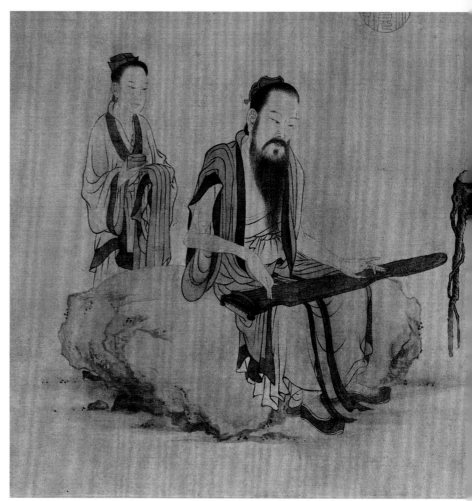

This painting displays a successful combination of spirit and form in figure painting. Wang Zhenpeng, styled Pengmei, was a native of Yongjia (present-day Wenzhou in Zhejiang). Although the dates of his birth and death are unknown, it is determined that he was active in the fourteenth century and served as Transport Battalion Commander. He was skilled in figure painting and boundary drawing of buildings and pavilions. Due to his exceptional skill in painting, he was greatly appreciated by Yuan Emperor Wenzong, who bestowed the title of "Solitary Clouds Recluse" on him.

The source of this painting is *Lü's Spring and Autumn Annals*. It is a story recording how Yu Boya, a well-known literary figure in the Spring and Autumn Period, and Zhong Ziqi, a woodman, met and became close friends thanks to music. In the painting, Boya sits straight on a huge rock, with his beard reaching his chest, and concentrates on playing the *qin*. Zhong Ziqi, who listens to the music, sits on the right-hand seat, folds his hands slightly and puts them on his knees, meditating quietly and attentively. It seems that only his upturned right foot follows the rhythm. The boys who are standing behind them are either listening quietly with concentration, absorbed in thought, or looking blank, a reflection of how people of different levels in society respond to the same piece of music. Since there are no high mountains or flowing water to serve as a background, the painting leaves plenty of room for the viewer's imagination. In terms of technique, Wang Zhenpeng uses plain sketching, with lines that resemble a silkworm producing silk in spring. The lines go on and on without break, and yet they are full of changes, which shows how tangible tools like brush and ink can be used to create an intangible musical concept.

This work bears the signature of the painter, which reads: "Wang Zhenpeng," and the seal reads: "Bestowed by the Emperor with the Title of Solitary Clouds Recluse" (red relief). The end paper has three poem inscriptions by Feng Zizhen, Zhao Yan, and Zhang Yuanshi of Yuan, respectively. There are more than ten collector seals on the painting, including "Treasure Perused by Emperor Qianlong," "Treasure in the Collection of the Hall of Mental Cultivation," "Treasure Perused by Emperor Jiaqing," and "Appreciated by Emperor Xuantong" of the Qing Palace Treasury, "Paintings and Calligraphy" by Xianggelaji of Yuan, "Rare Treasure of Liang Jiaolin," "Tangcun," and "Fisherman Fishing in a Stream" by Liang Qingbiao. This painting is recorded in *The Precious Mirror of Paintings*, *Yu Ji's Collected Works*, and *The Shiqu Imperial Catalogue of Paintings and Calligraphy, Volume 1*.

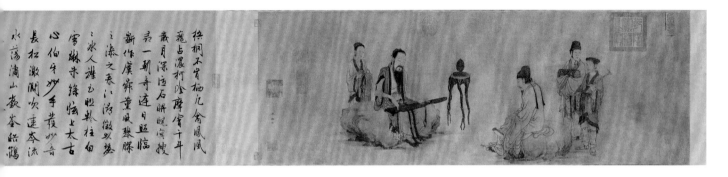

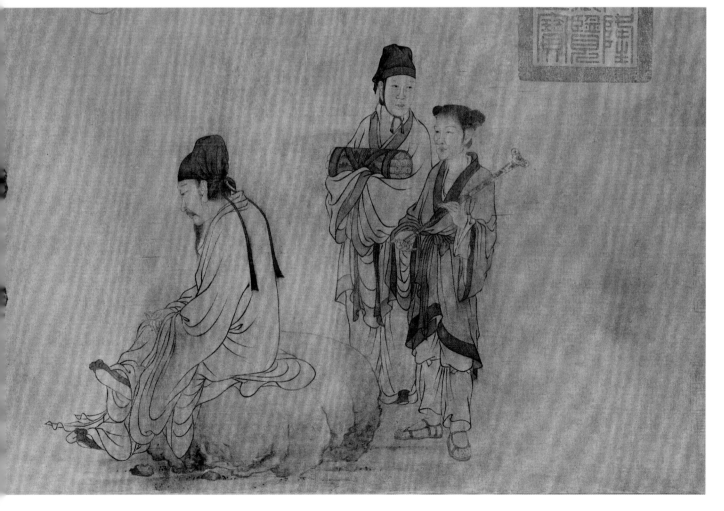

88

Dragon Boat Regatta

— by —

an Anonymous Painter

— of —

the Yuan Dynasty

Hand Scroll

Ink and brush on paper

Height 25 cm Width 114.6 cm

Qing court collection

This is a masterpiece of plain sketching for showing a bustling crowd scene. It was drawn during the Chongning years of Northern Song (1102–1106). The royal family holds the annual grand dragon boat regatta at the Jinming Pool in the Rear Hall of the imperial palace on the third day of the third month. In the painting, the palaces and pavilions are towering and lofty, the banners and flags are fluttering in the wind, the oars are moving vigorously, and the dragon boats are racing fiercely, displaying tense action and surrounded by an atmosphere that bursts excitement. The artist's brushstrokes are elegant, forceful, meticulous, and dense. With the use of plain sketching, he gives a feeling of delicacy, briskness, and elegance.

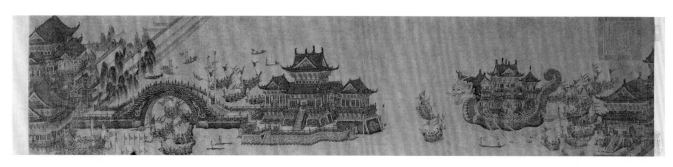

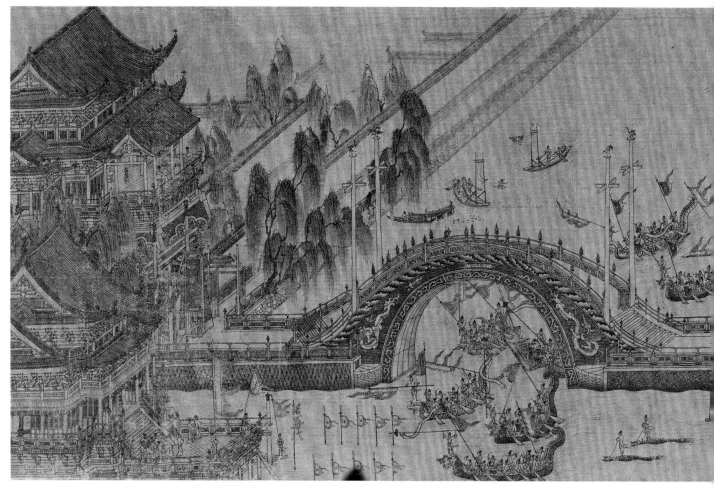

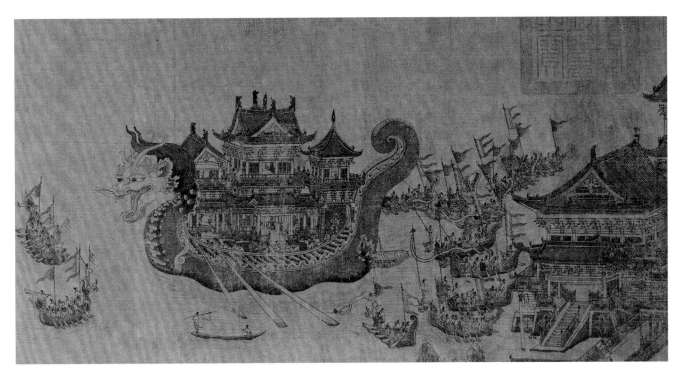

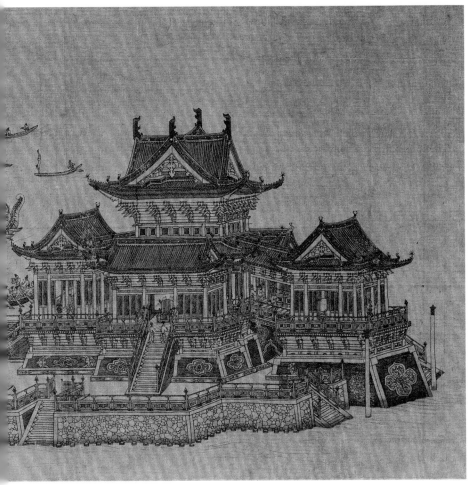

Boundary drawing was the most popular new trend in the painting of architecture in the Yuan Dynasty. The court painter Wang Zhenpeng was a typical exponent of this style, so it has been rumoured in the past that this painting was drawn by him. Wang actually did paint on this theme twice, and was greatly praised by Princess Supreme, causing many later comers to copy his style.

There are four collector seals on the painting, including "Treasure Perused by Emperor Qianlong," "Treasure of the Imperial Study," "The Shiqu Imperial Catalogue of Paintings and Calligraphy," and "Treasure Perused by Emperor Jiaqing," all of the Qing Palace Treasury.

89

Yueyang Tower

by

Xia Yong

of

the Yuan Dynasty

Album

Ink and brush on silk

Height 25.2 cm Width 25.8 cm
Qing court collection

This painting is a representative work of Xia Yong. Xia Yong, styled Mingyuan, was a native of Qiantang (present-day Hangzhou in Zhejiang). The dates of his birth and death are unknown, yet he was active in the fourteenth century. He followed the style of Wang Zhenpeng, a court painter of the Yuan Dynasty, in boundary drawing of towers and pavilions. He was skilled in using plain sketching to paint buildings, and specialized in the drawing of small strips.

Yueyang Tower, located on the shore of Lake Dongting, went down in history thanks to *On the Yueyang Tower*, an essay written by Fan Zhongyan, a literary figure of the Song Dynasty. Alongside the Pavilion of Prince Teng and the Yellow Crane Tower, it is considered one of the Three Great Towers of south China. This painting was mounted on a round silk fan, and depicts the lofty three-storey Yueyang Tower. In front of the tower is a great deserted ravine, framed by the distant mountains, forming a belt. This is taken from a poetic line in a poem by Meng Haoran, which runs: "Vaporous air rises above the Cloud-dream Marsh; the roaring waves strike Yueyang City." The brushstrokes are elegant, forceful, fine, and delicate, making clear the gradation of the Tower in different perspectives: far and near, tall and deep. The composition is exact and appropriate. The upturned eaves, the roof beams, the corbels and brackets, and the fences are all painted in delicate detail. On the upper side of the painting the full text of the essay *On the Yueyang Tower* has been copied in small hand-written characters in regular script that can be described as "(as) small as the eyes of an ant" and "(as) tiny as a marking peg."

This work bears the signature of the painter, which reads: "This work is painted and written by Xia Yong, styled Mingyuan, of Qiantang, on the twenty-second day of the fourth month in the seventh year of the reign of Zhizheng." Opposite to the signature is a poem inscribed by Qing Emperor Qianlong. Some collector seals can be found on the painting, including "Treasure of the Emperor at Eighty" and "Treasure of the Emperor's Father" of the Qing Palace Treasury, "Rare Collection of Yizhou" and "Paintings and Calligraphy of the Imperial Collection" of An Qi of Qing. This painting is collected in *Sequel to the Shiqu Imperial Catalogue of Paintings and Calligraphy*.

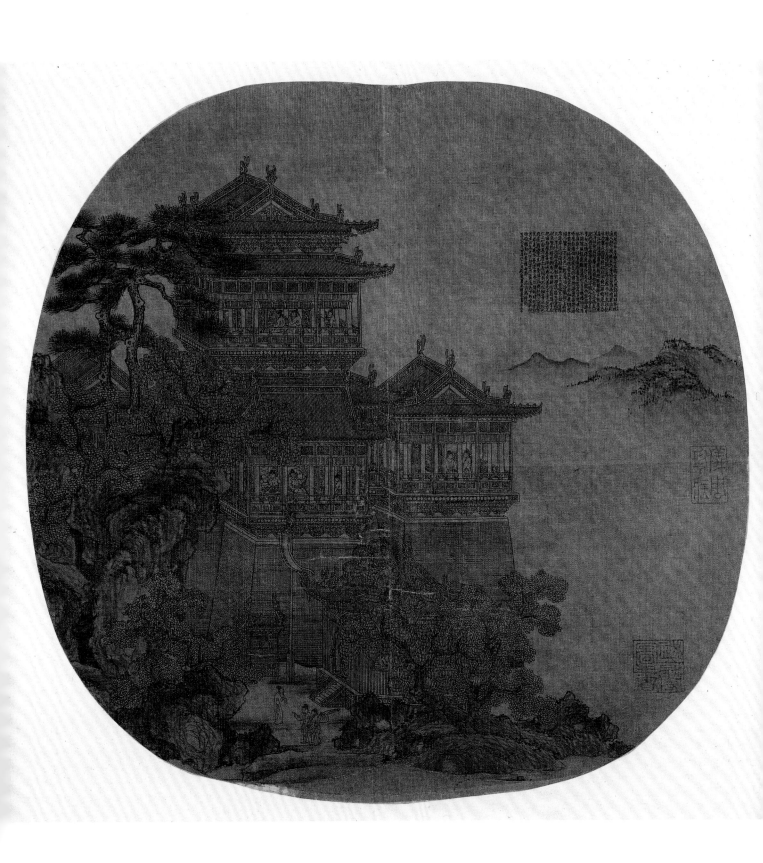

90

Spring Mountains

— by —

Shang Qi

— of —

the Yuan Dynasty

Hand Scroll

Ink and colour on silk

Height 39.6 cm Width 214.5 cm
Qing court collection

This painting is the only extant work of Shang Qi with his signature. It has the style of the academy of the Southern Song Dynasty and the features of Guo Xi, which shows the painter's absorption of different traditional painting techniques. Shang Qi (?–1324), styled Defu and Shouyan, was a native of Jiyin in Caozhou (present-day Heze in Shandong). His father Shang Ting was a well-known official in early Yuan. Shang Qi served as Auxiliary Academician of Scholarly Worthies and as Assistant in the Palace Library. He was gifted in painting blue-and-green landscapes and had made a landscape mural in the capital.

This painting depicts the landscape of northern China. The composition is arranged on a horizontal scroll, which inherits the characteristics of the landscape painting of the Jin Dynasty, and conforms to the structure of opening, development, transition, and conclusion of a literary essay. The combination of blue-and-green with water-and-ink lets out the aura of the scholars.

This work bears the signature of the painter, which reads: "Shang Qi of Caonan." There are nine collector seals on the painting, including "Treasure Perused by Emperor Qianlong," "The Shiqu Imperial Catalogue of Paintings and Calligraphy," "Treasure of the Chonghua Palace," "Treasure Perused by Emperor Jiaqing," and "Treasure Perused by Emperor Xuantong" of the Qing Palace Treasury, and "Seal of the Paintings and Calligraphy of Liang Shi Jiaolin" by Liang Qingbiao of Qing. This painting is recorded in *The Shiqu Imperial Catalogue of Paintings and Calligraphy, Volume 1.*

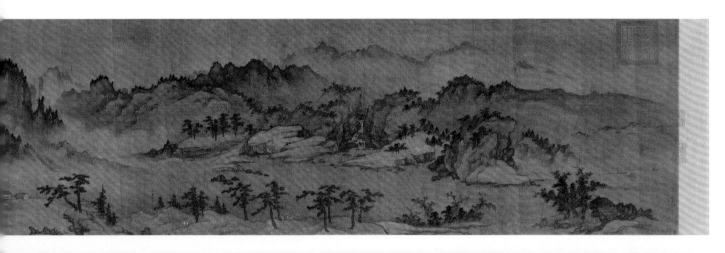

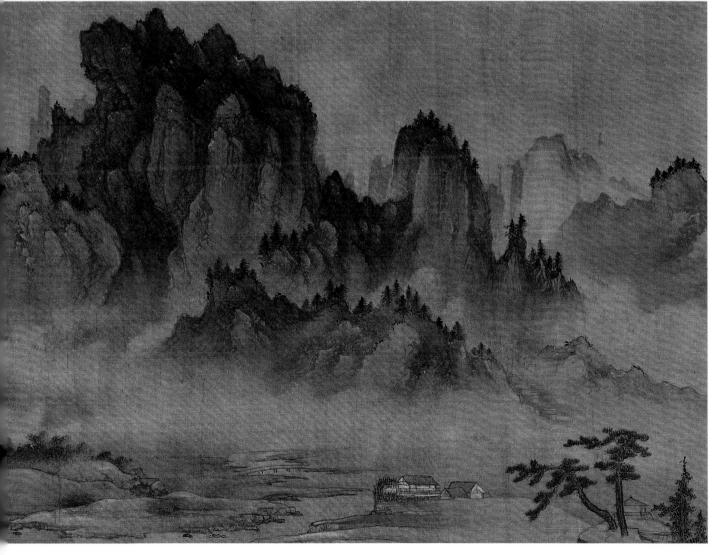

荊江水清滑生女白如脂其

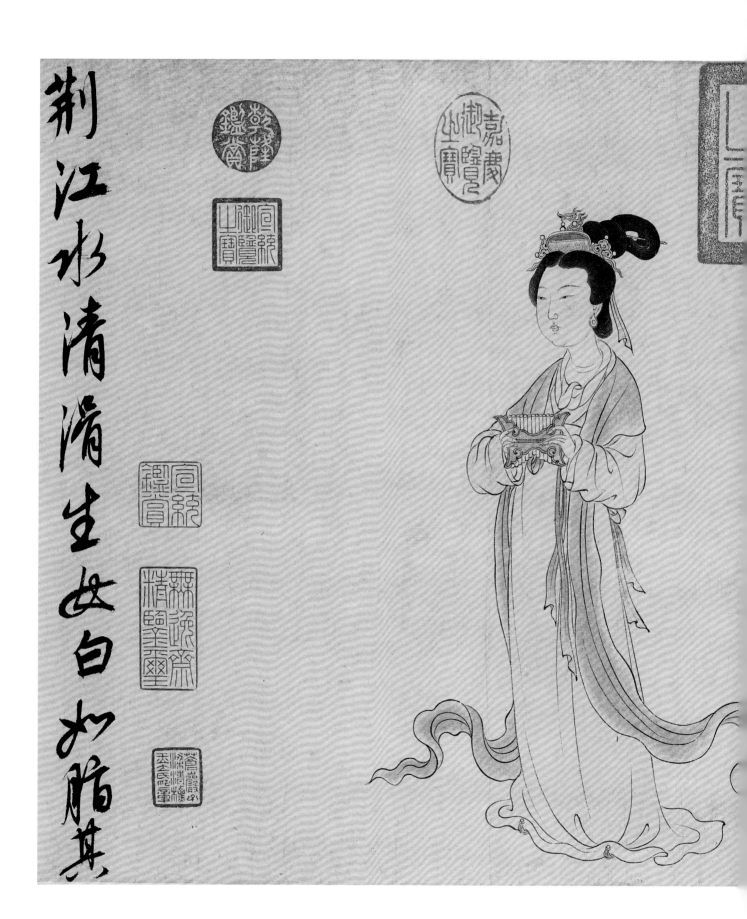

Lady Du Qiu

by

Zhou Lang

of

the Yuan Dynasty

Hand Scroll

Ink and colour on paper

Height 32.3 cm Width 285.5 cm

Qing court collection

This painting is the only extant work of Zhou Lang and a gem of beauty painting characterized by the use of light colour and outlining. Zhou Lang, also known as Langbo and Binghuhuayin, and whose years of birth and death are unknown, was active in the fourteenth century. He excelled in painting beauties and horses. His brush and ink strokes are both simple and vivid. In the second year of the reign of Zhiyuan (1336), he painted *The State of Fulang Presenting a Heavenly Steed to the Yuan Emperor*.

Du Qiu was a lady of Jinling. She was talented and had entered the imperial palace to serve as the imperial tutoress of Li Cou, King of Zhang and son of Emperor Muzong of the Tang Dynasty. Later, with the ousting of the King of Zhang, Du Qiu was also ordered to return to her home town, where she died of old age in poverty. This painting was based on a poem by the Tang poet Du Mu, *A Poem about Lady Du Qiu*, and made for Kangli Naonao. Du Qiu in the painting is a fat woman with a high tuft of hair and a long dress, whose belt dances in the wind. She holds a pan pipe in her hands and is deeply immersed in thought, with a touch of worry in her eyes. This is taken from a line in his poem. The figures are sketched in light ink and colour. The picture is filled with the beauty of serenity, which conveys the painter's sympathy for the tragic fate of Lady Du Qiu.

The work was signed with: "Zhou Lang," whose seal reads: "Binghuhuayin" (red legend). There is also a full text of the poem Lady Du Qiu by the Tang poet Du Mu, written by Kangli Naonao, and an inscription by Song Sui. There are nine collector seals on the painting, including "Treasure Perused by Emperor Qianlong," "The Shiqu Imperial Catalogue of Paintings and Calligraphy," "Treasure of the Imperial Study," "Treasure Perused by Emperor Jiaqing," and "Treasure Perused by Emperor Xuantong" of the Qing Palace Treasury, "Authenticated by Jiaolin," "Seal of the Paintings and Calligraphy of Liang Shi Jiaolin," and "Seal of Liang Qingbiao, Cangyanzi" by Liang Qingbiao of Qing. This painting is recorded in *The Shiqu Imperial Catalogue of Paintings and Calligraphy, Volume 1*.

92

A Meeting to Form an Alliance at Bianqiao

— by —

Chen Jizhi

— of —

the Yuan Dynasty

Hand Scroll (partial)

Plain sketch on paper

Height 36 cm Width 774 cm
Qing court collection

This painting depicts military affairs in a spectacular scene, which shows Chen Jizhi's design and layout ability in composition. It was rumoured in the past that this is a painting of the Liao Dynasty. However, that proved impossible because both the Jiali Khan and his servants wear Mongolian clothing of the Yuan Dynasty in the painting. Chen Jizhi, styled Zhupo, was a native of Fusha and a commoner literary figure of northern China. It is not determined neither when he was born nor when he died, but it is clear that he was active in the fourteenth century.

This painting shows a meeting to form an alliance at Bianqiao, an event from the early Tang. In 626 when Li Shimin, Emperor Taizong of the Tang Dynasty, ascended to his throne, Jiali Khan of Turk led 200,000 soldiers to the north of Bianqiao on the Wei River outside the walls of Chang'an, capital of Tang, causing a shock to the capital. Emperor Taizong of the Tang Dynasty was then forced to play the trick of deceptively deploying troops to mislead the enemy. He personally led his ministers, generals, and soldiers to the Bianqiao, and conversed with Jiali Khan over the Wei River. Once he saw the majesty of the Tang army and the gold, clothes, and money that the Tang emperor was offering, Jiali Khan signed the alliance with Tang following the ritual of killing a white horse, and retreated with his army. This excerpted part of the painting shows the life of the grassland people, including the drilling of the mounted troops, the riding performances, and the playing of polo. The spacing in the composition of the painting is orderly. Though the figures are small, their expressions are vivid and lively. The brushwork is fine and detailed and yet the painting does not lose its broadness.

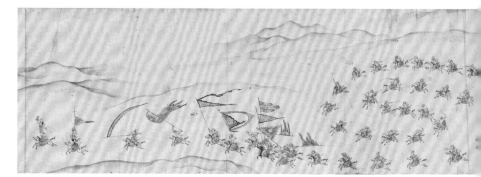

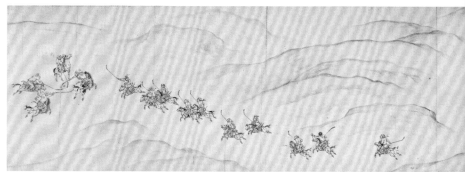

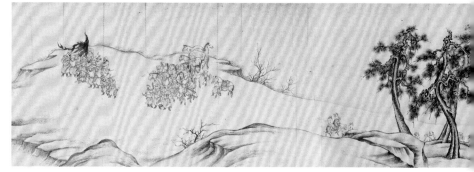

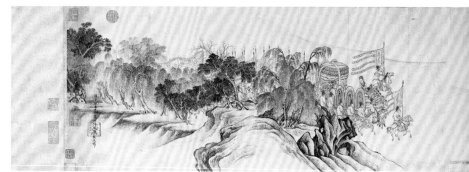

This work bears the signature of the painter, which reads: "Painted by Chen Jizhi of Fusha in Zhonghuan in the first month of the year of Youshen," and his seal that, in turn, reads: "Painted by Chen Jizhi for fun" (in red relief). The frontispiece has "A Meeting to Form an Alliance at Bianqiao Painted by Chen Jizhi," written by Liang Qingbiao. There are dozens of collector seals on the painting, including "Treasured Perused by Emperor Qianlong," "The Shiqu Imperial Catalogue of Paintings and Calligraphy," and "Treasure Perused by Emperor Jiaqing" of the Qing Palace Treasury, "Authenticated by Jiaolin," "Cangyanzi," and "Jiaolin Bookhouse" by Liang Qingbiao, and "Family Collection of Zhang Yuanzeng." This painting is recorded in *The Shiqu Imperial Catalogue of Paintings and Calligraphy, Volume 1.*

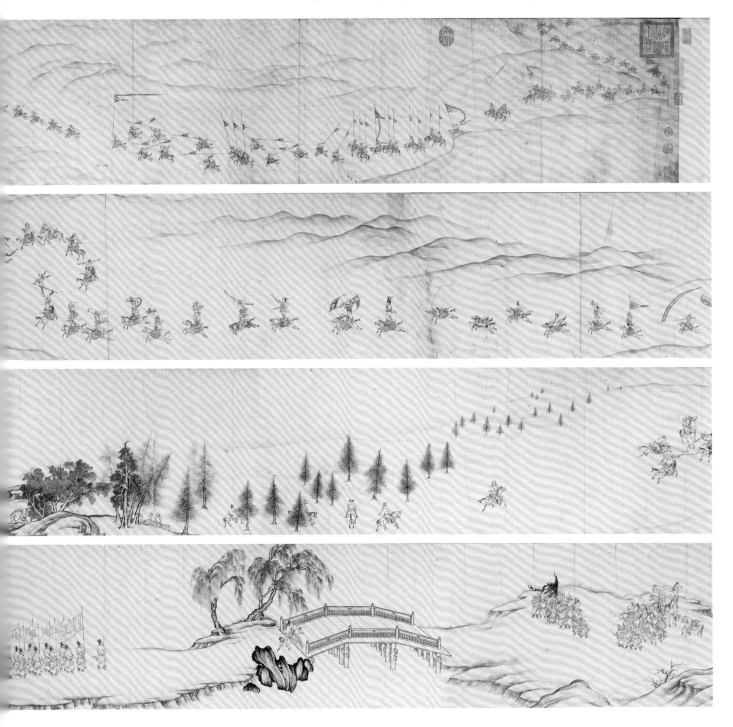

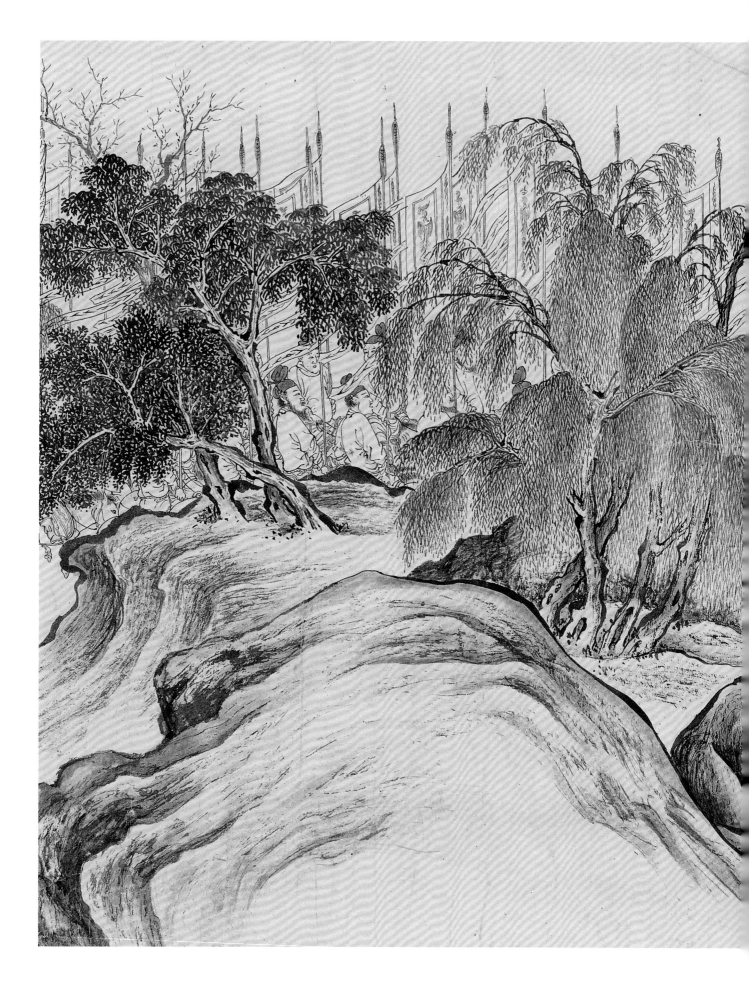

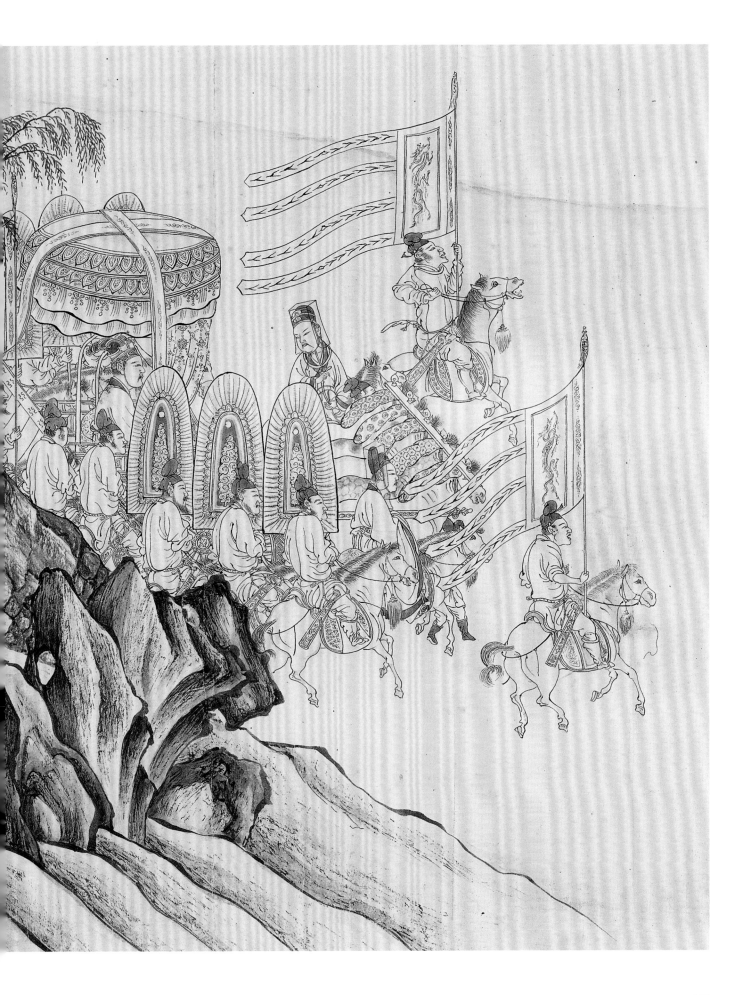

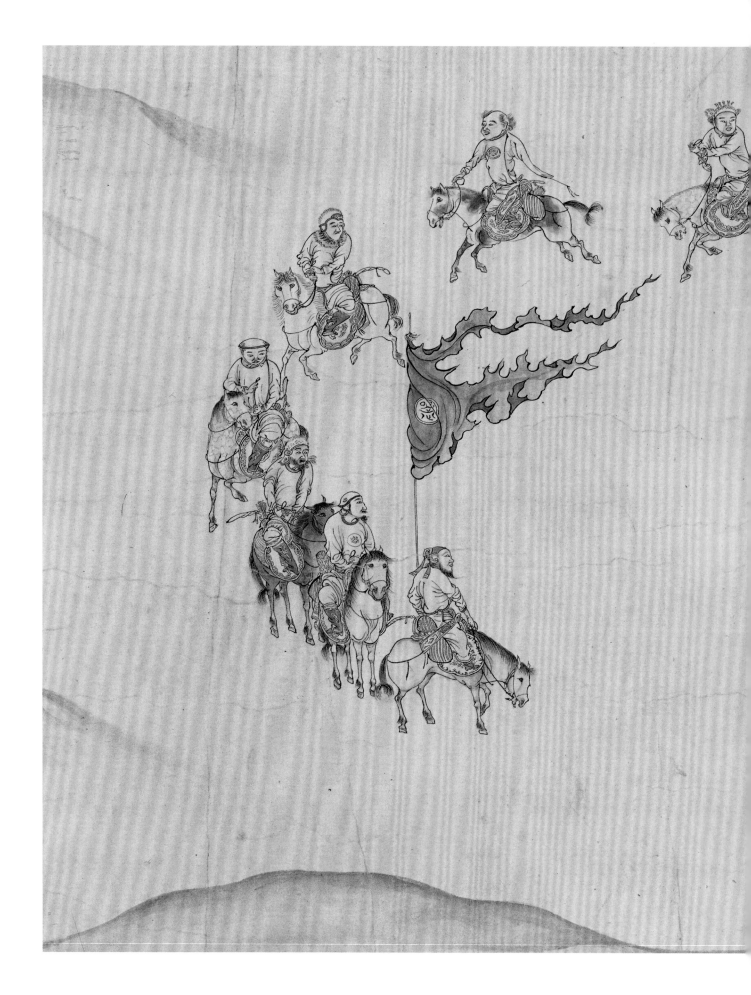

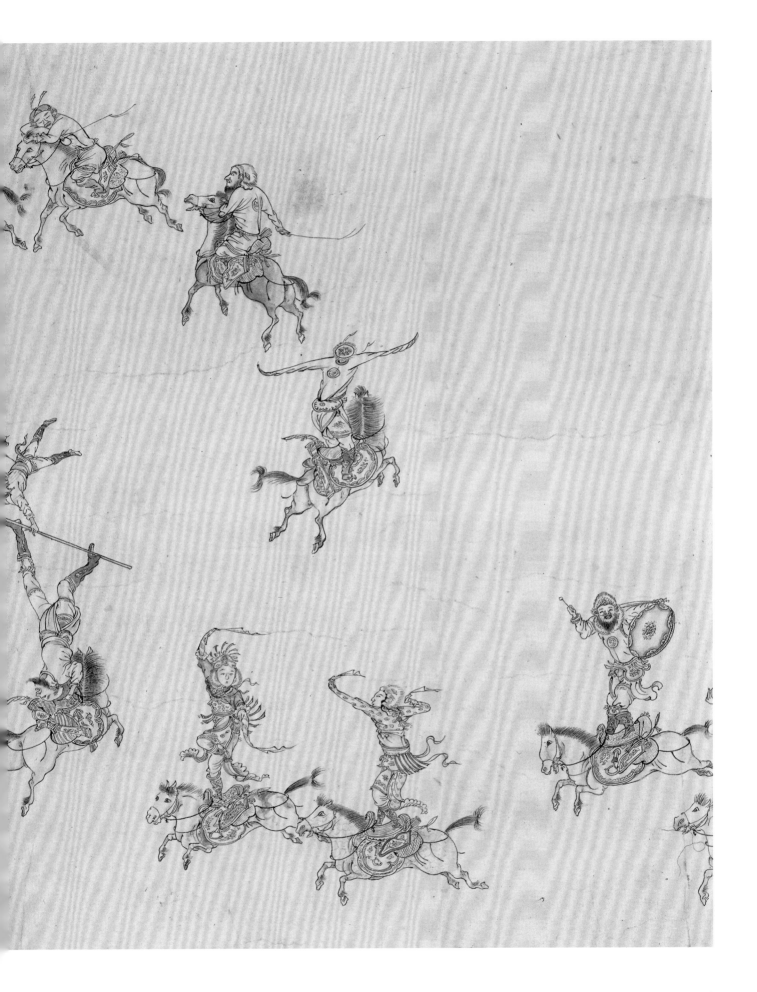

93

Portrait of Yang Zhuxi

— by —

Wang Yi and Ni Zan

— of —

the Yuan Dynasty

Hand Scroll

Painting in Ink and brush on paper

Height 27.7 cm Width 86.8 cm

This is the only remaining work that was jointly painted by Wang Yi and Ni Zan. It represents the highest level of portrait painting of the Yuan Dynasty. Wang Yi, otherwise known as Sishan and Chijuesheng, was a native of Muzhou (present-day Jiande in Zhejiang) who resided in Hangzhou. His birth and death dates are unknown but he was active in the fourteenth century. He was skilled in painting figures and portraits. When he painted, he was able to capture vividly the shape and the face of people talking and laughing. He is also the author of *Key to Portrait Painting*.

The literary figure portrayed was Yang Qian (1283–?), styled Pingshan and Zhuxi, who was a native of Songjiang (present-day Shanghai). In the painting Yang Qian has a thin face and wears a black headcloth and a loose garment. He stands with his hand holding a stick on a slope where there are a pine tree and some rocks, showing his uprightness and dignity. The figure is painted in lines with some colouring, and it is presented lively without much ink. The turquoise was later added by Ni Zan. The brushstrokes and ink are light and loose, making the picture complete in detail.

This work has an inscription by Ni Zan, which reads: "This portrait of the noble scholar Yang Zhuxi was painted by Wang Yi of Yangling and the turquoise was added by Ni Zan of Juwu. This work was painted in the second month of the year of Guimao." On the front is a section for the titles, which includes the names of the annotators, hymn writers, and painters. There is also a number with the code "Mian" written by Xiang Yuanbian in ink. The end paper has ten annotations and hymns by scholars such as Zheng Yuanyou, Yang Weizhen, and Ma Wan, to mention but a few. There are dozens of collector seals on the painting, including "Seal of Appraisal and Appreciation of Xiang Molin" by Xiang Yuanbian of Ming, "Painting Verified by Song Luo of Shangqiu as Authentic" by Song Luo, "Seal of the Pei's Family Collection of Paintings and Calligraphy" by Pei Jingfu, and "Seal of He Fengxi" by He Fengxi, all of them from Qing. This painting is recorded in *Postscripts on Famous Calligraphy and Paintings by Wang Keyu*, and *Dream Journey in the Records of Wonderful Sights*.

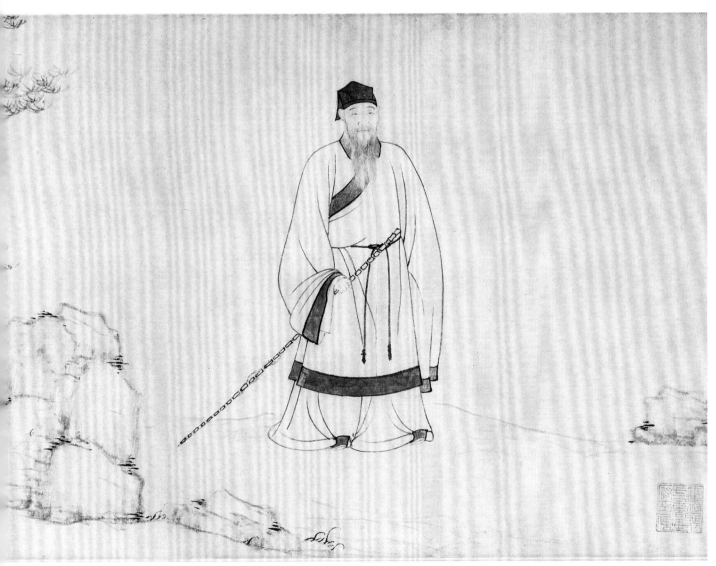

94

Hawk and Juniper

by

Xue Jieweng and Zhang Shunzi

of

the Yuan Dynasty

Hanging Scroll

Ink and colour on silk

Height 147.3 cm Width 96.8 cm

Not many paintings by Xue Jieweng and Zhang Shunzi have passed on to the present. In fact, this painting is their only extant collaborative work. Xue Jieweng has not been recorded in any history of Chinese painting whereas Zhang Shunzi, styled Shikui, is known for his painting of landscapes, trees, and rocks.

This picture features an old juniper with strong branches on a mountain rock. The withered branches contrast sharply with the new leaves. A goshawk is standing proudly on an old horizontally lying branch with a raised head, flashing eyes, and sharp claws. Its figure seems firm as a rock and fearless in the face of danger. The goshawk is depicted in detail with fine brushstrokes and rich colours, following the academy style of flower-and-bird painting inherited from the Song Dynasty. The old juniper and the rock, on the other hand, are painted in a slight freehand style. It is harmonious and unique in composition.

The artist wrote the following statement as his signature: "Xue Jieweng painted the goshawk, and Zhang Shunzi painted the old juniper. The painting was given to our friend in Tongcheng on his wedding." The characters on the seal are blurred and indistinguishable. The collector seals on the painting are "Liang" and "Collection of Huang Zhou" by Huang Zhou of the modern period.

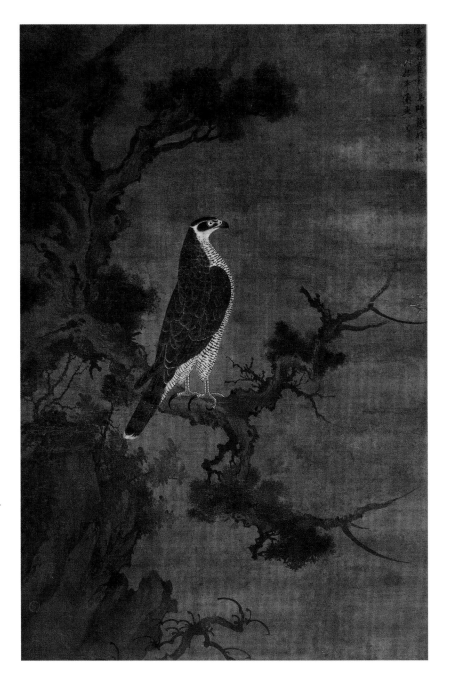

95

Waiting for the Ferry on the Autumn River

by

Sheng Mao

of

the Yuan Dynasty

Hanging Scroll

Ink and brush on paper

Height 112.5 Width 46.3 cm
Qing court collection

This is an illustrative piece of freestyle landscape painting by Sheng Mao. Sheng Mao, styled Zizhao, was a native of Lin'an (present-day Hangzhou in Zhejiang), but resided in Jiaxing (present-day Jiaxing in Zhejiang). It is not certain when he was born or when he died but he was active in the fourteenth century. He was born into a family of painters from whom he learned the skills of painting when he was young. He was particularly skilled in painting landscapes.

This scene depicts the flat but distant stream and mountains thickly wooded with tall trees. In this scene of tranquility on an autumn day, the artist uses thick ink for the foreground and light ink for the background, yet he is always meticulous in the use of brushstrokes. His brushstrokes and ink are elaborate, powerful, elegant, and smooth, displaying a style of his own.

This work bears the signature of the painter: "On the sixteenth day of the third month of the year of Xinmao in the reign of Zhizheng, Sheng Mao of Wutang painted Waiting for the Ferry on the Autumn River for You Bai." And the seals read: "Sheng Mao" (white relief) and "Zizhao" (red relief). It has six inscriptions by Lao Pu, Ying Yu'an, Yu Ying, Liu Gongxu, Zhuang Guangyi, and Qing Emperor Qianlong. The collector seals on the painting are traceable to Emperor Qianlong of the Qing Dynasty, Li Zhaoheng, and Da Zhongguang of the late Ming Dynasty, and etc. This painting is recorded in *Catalogue of Paintings and Calligraphy in Shao Songnian's Collection*.

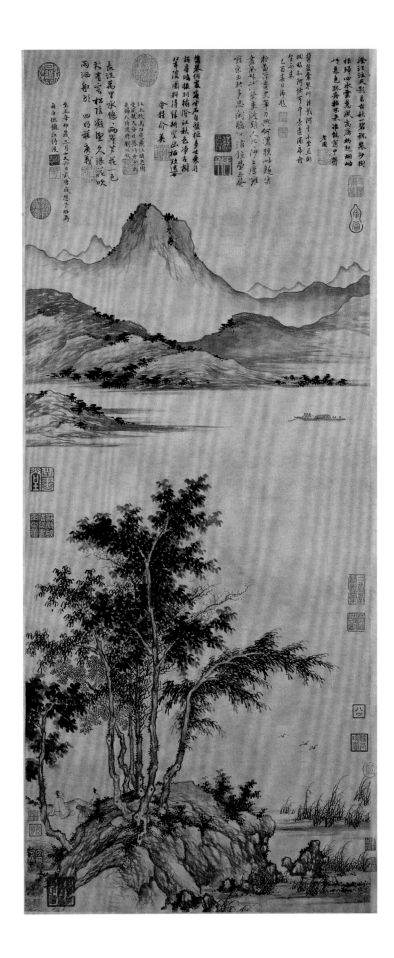

96

The Immortal Li Tieguai

by

Yan Hui

of

the Yuan Dynasty

Hanging Scroll

Ink and colour painting on silk

Height 146.5 cm Width 72.5 cm
Qing court collection

This painting is an example of the powerful style of Yan Hui and is also a pathbreaking work of Wu Wei's thick-brush figure painting of the Zhejiang School. It is not certain when Yan Hui was born or whether he was a native of Jiangshan in Zhejiang or Luling (now known as Ji'an in Jiangxi). What is clear is that he was active in the fourteenth century. He was skilled in painting Daoist and Buddhist figures, and specialized in painting ghosts. During the reign of Dade (1297–1307), he assisted in the painting of the murals of the Fushun Palace.

This painting depicts Li Tieguai, one of the Eight Immortals. His hair is dishevelled, he is barefoot, he frowns his brows, and his eyes are full of anger. He wears simple and coarse clothes and sits on a mountain rock holding a stick. Behind him are thin, floating clouds and misty air evaporating upwards, and a waterfall in the valley is pouring down. The immortal's face is depicted with fine brushstrokes and is extremely vivid, while the wrinkles in his clothes are painted with thick and simple brushstrokes, which is a characteristic of the murals.

This work bears the signature of the painter, which reads: "Yue Yanhui," and the seal reads: "Qiuyue" (red relief). The upper part of this painting was trimmed, so the signature is incomplete, with the character "Qiu" missing. There are dozens of collector seals on the painting, including "Treasure Perused by Emperor Qianlong," "Imperial Seal of the Hall of Three Treasures," "Blessings to Children and Grandchildren," and "Zhang Zezhi" of the Qing Palace Treasury. This painting is recorded in *Catalogue of Buddhist and Daoist Works in the Qianlong Imperial Collection*.

97

Guanyin with a Fish Basket

— by —

an Anonymous Painter

— of —

the Yuan Dynasty

Hanging Scroll

Ink and brush on paper

Height 70.3 cm Width 27.7 cm

The allusion of this painting comes from *Guanyin Reflective Biography*. The picture depicts Guanyin as a village woman with a fish basket, wearing two coils of hair on her head painted in pale ink. Guanyin wears a long dress, and holds a bamboo strainer in her left hand and a basket in her right hand, a basket, as a symbol of exorcism of raksasa or demons. Few brushstrokes are used to convey the message, which is full of the spirit of Chan Buddhism. The painting is certainly a masterpiece that followed the style of Chan Buddhism of the Song Dynasty.

This work bears the signature of the painter, yet his name is illegible: "The Chief Painter is …" There is also an inscription of a hymn by Master Mingben, who was awarded the title of Puying Teacher of the State by Emperor Renzong of Yuan (1312–1320). He was a close friend of Zhao Mengfu, and he named his residence Illusory Abiding Mountain Lodge. The collector seals on the painting include "Seal of the Paintings and Calligraphy of Tan's Studio," "Essay of He'an," and "Personal Seal of Tan Jing." The collector seals on the margin of the mounting include "Seal of Tan Jing, a Cantonese," and "Painting Verified as Authentic by He'an."

98

Seven Buddhas Preaching Buddhism

———— by ————

Zhu Haogu and Zhang Boyuan

———— of ————

the Yuan Dynasty

Ink and colour on mud

Height 320 cm Width 1810 cm

This painting was originally a mural on the southern wall of the middle hall of the Xinghua Temple in Jishan, Shanxi Province. It was made in 1320, or the seventh year of the reign of Yanyou of the Yuan Dynasty. A native of Xiangling (present-day Xiangfen in Shanxi), Zhu Haogu, whose years of birth and death are unknown, was active in the fourteenth century. He was a leading painter in Shanxi. He and his fellow painters Zhang Maoqing and Chang Yunrui are known as the "three best-known painters of Xiangling." However, he is the only painter in the Yuan Dynasty of whom we have documentary records. The rear hall of the original Xinghua Temple still keeps the inscriptions made by Zhu Haogu and his disciple Zhang Boyuan.

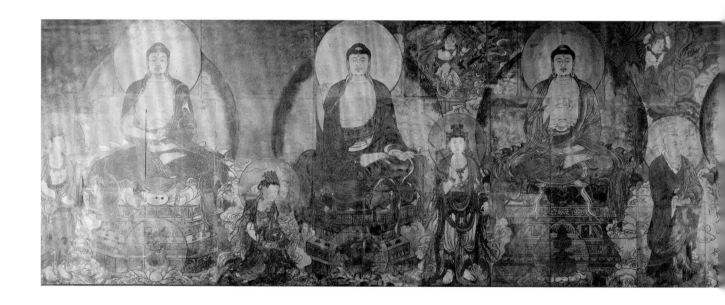

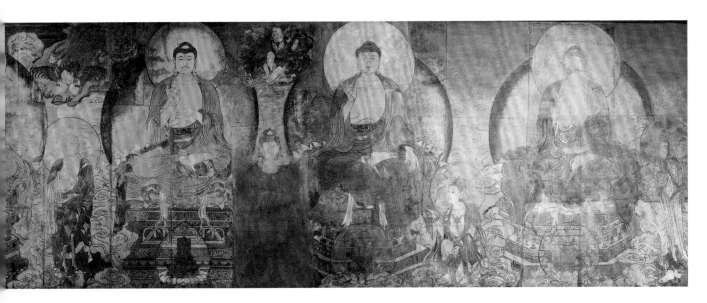

The seven Buddhas refer to Sakyamuni, the founder of Buddhism, and the six honoured Buddhas are those who gained the wisdom of Buddhism before the appearance of Sakyamuni. The seven Buddhas in the painting are sitting cross-legged. They have shell-like tufts of hair on their heads, and are bare-chested. They wear red cross-shouldered robes with a green toga inside. The one in the middle is the Vipasyin Buddha, whose hands are making the seal of expounding the law. In front of his seat is a bottle of flowers for offering. On his left side is the ascetic dhuta Kasyapa Buddha with a countenance of resolution and steadfastness, and on his right, Ananda with an intelligent and elegant appearance. On the upper side with misty air curling are the two bodies of the Kalavinka bird, with a human head, bird's wings, and the tail of a phoenix. On the left side of the Vipasyin Buddha is the Sikhin Buddha, on his right, the Visvabhu Buddha, who is turning the wheel of dharma. In front of the thrones of these two Buddhas are incensers,

each of which has a bodhisattva in charge of the offerings standing in attendance. Further to the left is the Krakucchanda Buddha, whose hands are making a dialectical seal. In front of his throne is a strange rock bowl for alms, and on the right side is a bodhisattva crouching on his seat, holding a grotesque rock in his hands. Further to the right is the Kanakamuni Buddha, and in front of his throne are flowers for offering; on the right, crouching on his seat, is a bodhisattva with flowers in his hands. On the upper side of each of these two bodhisattvas is a boy soaring into the sky. As mentioned above, the third Buddha on the left side is the Ananda Buddha. His right hand is making a fearlessness seal, and his left hand, a meditation seal. In front of his throne is coral for offering, along with a standing bodhisattva in attendance, holding lotus flowers. The third Buddha on the right side is the Sakyamuni Buddha, whose hands are making the seal of turning the wheel of the dharma. In front of his throne are the glossy ganoderma and pilose antler for offering, served by a standing bodhisattva in attendance, holding a grotesque stone in his hand. The lines are strong and powerful, and the colours are thick and heavy, with some parts decorated with gold flakes.

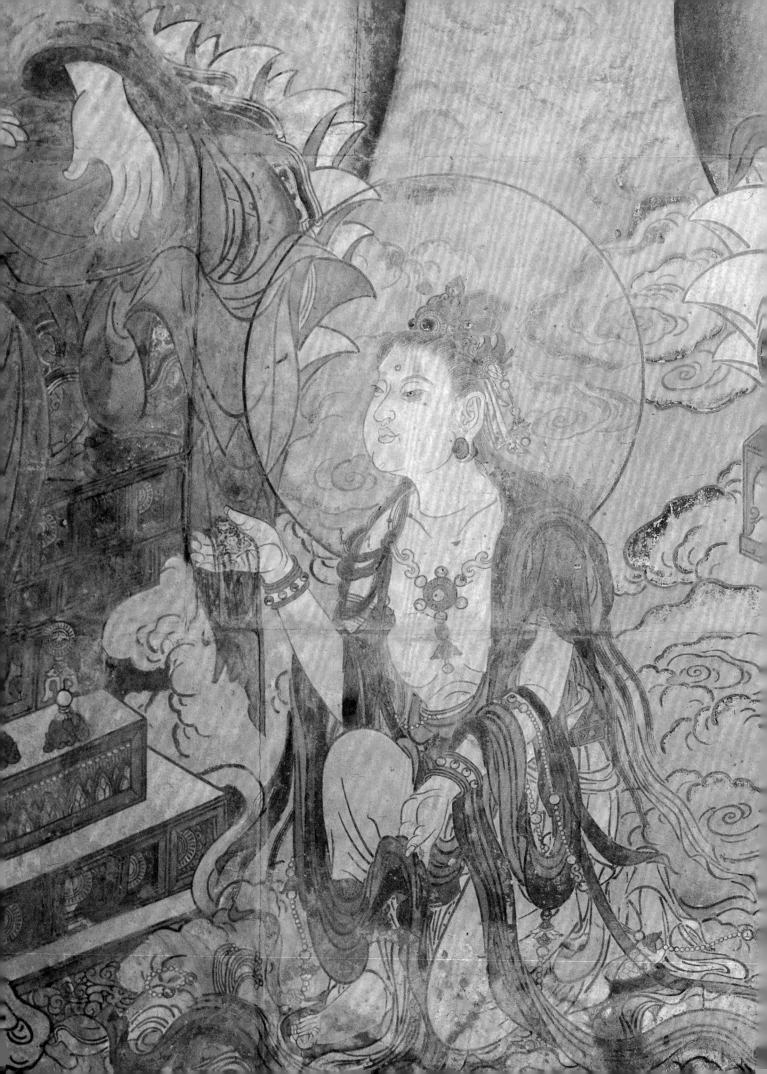

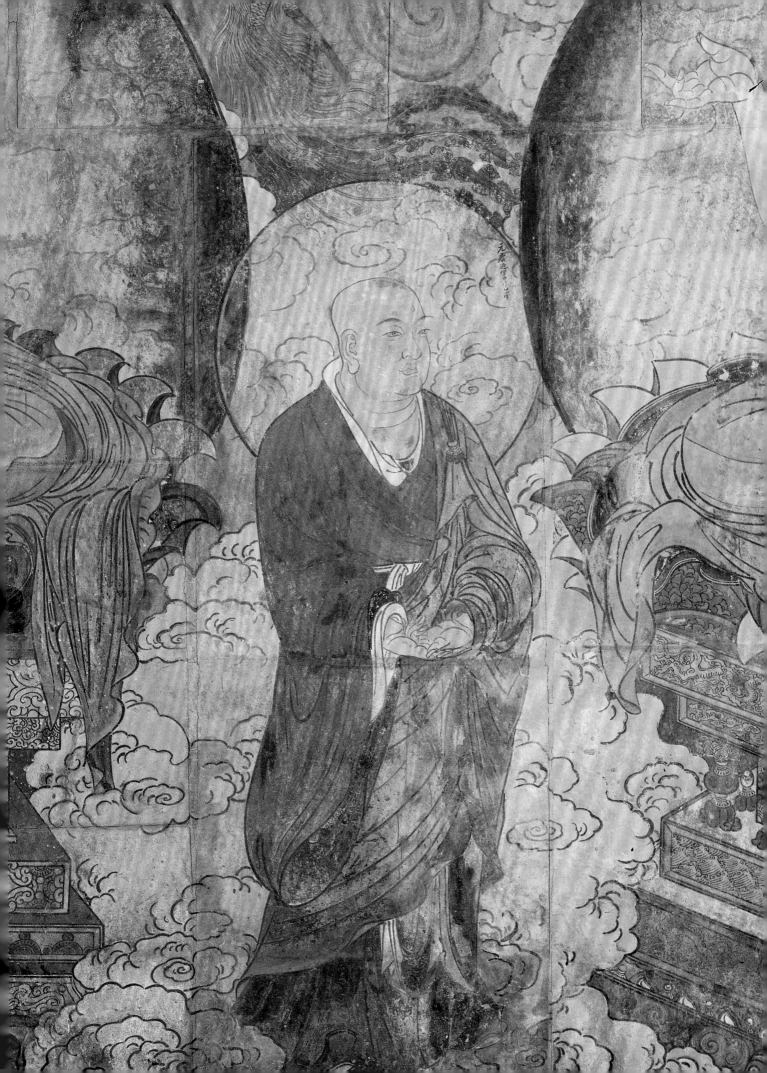

99

Lifting the Overturned Alms Bowl

by

Anonymous Painter

of

the Yuan Dynasty

Hand Scroll

Ink and colour on silk

Height 31.8 cm Width 97.6 cm

This work is a treasure of early Chinese Buddhist painting. As it has many features of Song paintings in terms of technique, composition, and figure shaping, it is possibly a copy of a Song painting indeed.

The allusion of this painting comes from the *Hariti Sutra* and *Reasons for Hariti Losing Her Son*. Hariti was originally an evil goddess but was converted and became a Buddhist goddess who protected young children. The painting shows the moment when the Buddha teaches Hariti. The Buddha sits cross-legged on a girdling lotus throne; he holds the seal of fearlessness on his right hand and the seal for subduing demons on the left. His disciples Kasyapa, Ananda, and the protector gods are standing beside him. On the right is Hariti sitting and crying for the loss of her son, with ghost girls serving on her side and a small child lying on her knee. In the middle is a transparent round

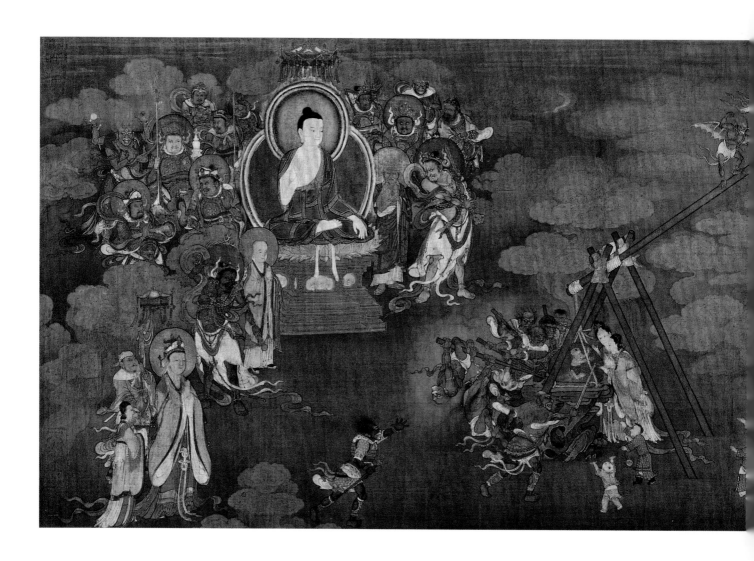

alms bowl with the small child Pingala in it. The ghost soldiers seem to find it difficult to lift the lip of the bowl.

The head of the scroll reads: "Authentic Painting of Lifting the Overturned Alms Bowl," which was written by Ni Can of Qing. The end paper has *Sutra of Accumulated Treasures* written by Ni Can, and the valediction and signature of Liu Shuxun of Qing. The collector seals include "Tianli," "Shuxun," and "Seal of Ni Can."

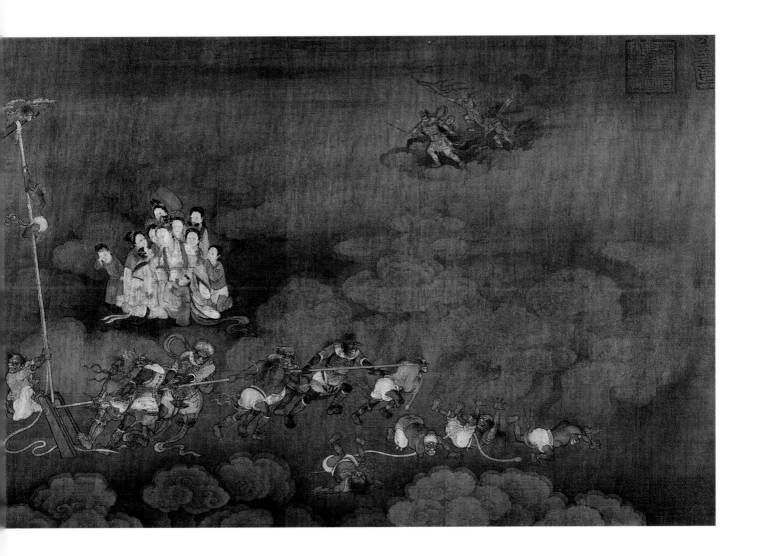

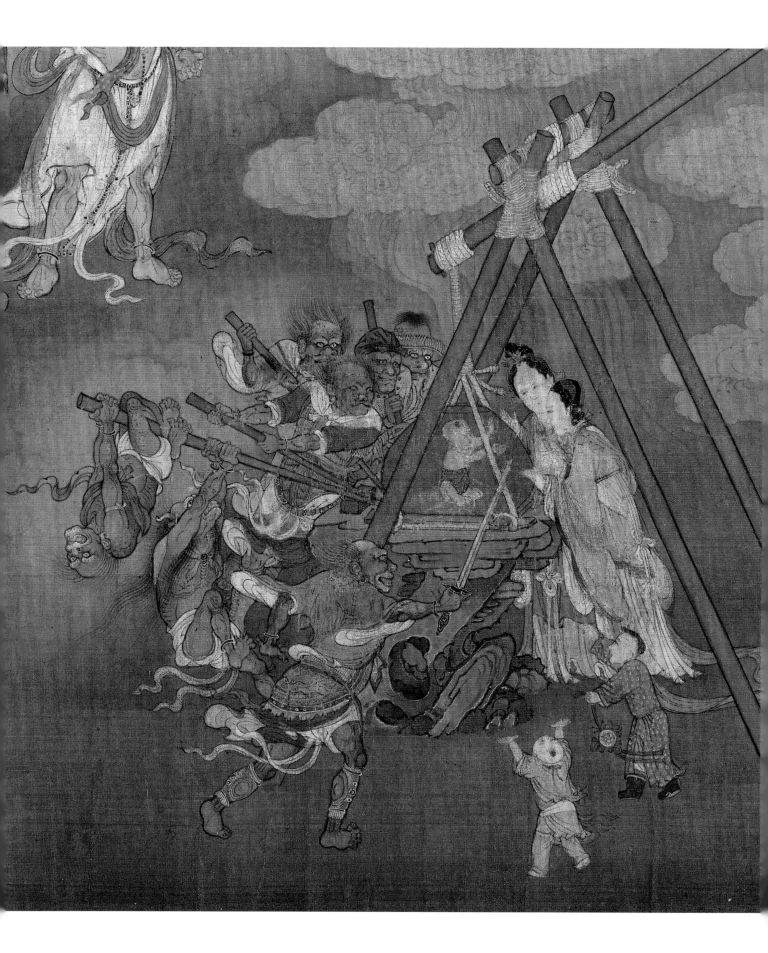

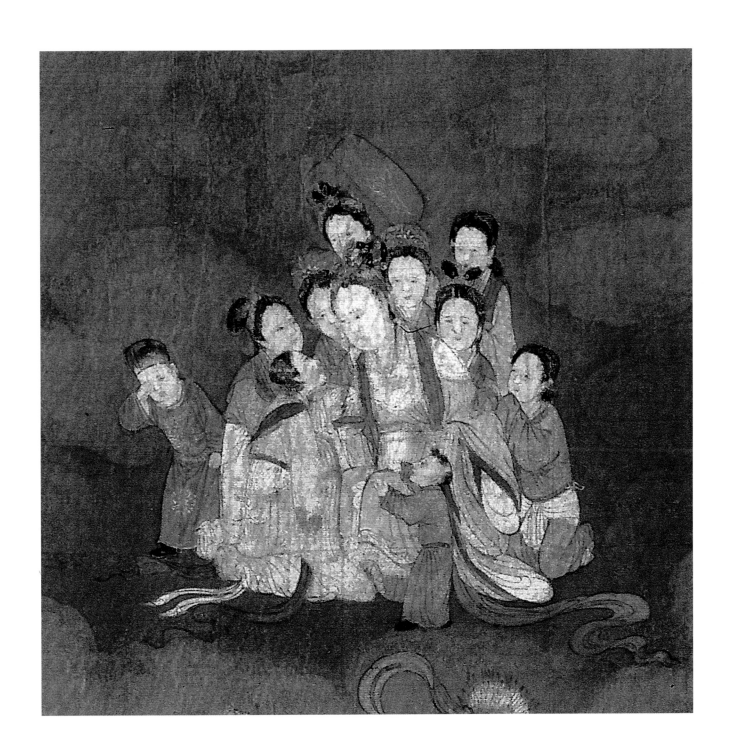

Dynastic Chronology of Chinese History

Xia Dynasty	Around 2070 B.C.—1600 B.C.
Shang Dynasty	1600 B.C.—1046 B.C.
Zhou Dynasty	
Western Zhou Dynasty	1046 B.C.—771 B.C.
Eastern Zhou Dynasty	770 B.C.—256 B.C.
Spring and Autumn Period	770—476 B.C.
Warring States Period	475 B.C.—221 B.C.
Qin Dynasty	221 B.C.—206 B.C.
Han Dynasty	
Western Han Dynasty	206 B.C.—23A.D.
Eastern Han Dynasty	25—220
Three Kingdoms	
Kingdom of Wei	220—265
Kingdom of Shu	221—263
Kingdom of Wu	222—280
Western Jin Dynasty	265—316
Eastern Jin Dynasty Sixteen States	
Eastern Jin Dynasty	317—420
Sixteen States Periods	304—439
Southern and Northern Dynasties	
Southern Dynasties	
Song Dynasty	420—479
Qi Dynasty	479—502
Liang Dynasty	502—557
Chen Dynasty	557—589
Northern Dynasties	
Northern Wei Dynasty	386—534
Eastern Wei Dynasty	534—550
Northern Qi Dynasty	550—577
Western Wei Dynasty	535—556
Northern Zhou Dynasty	557—581
Sui Dynasty	581—618
Tang Dynasty	618—907
Five Dynasties Ten States Periods	
Later Liang Dynasty	907—923
Later Tang Dynasty	923—936
Later Jin Dynasty	936—947
Later Han Dynasty	947—950
Later Zhou Dynasty	951—960
Ten States Periods	902—979
Song Dynasty	
Northern Song Dynasty	960—1127
Southern Song Dynasty	1127—1279
Liao Dynasty	907—1125
Western Xia Dynasty	1038—1227
Jin Dynasty	1115—1234
Yuan Dynasty	1206—1368
Ming Dynasty	1368—1644
Qing Dynasty	1616—1911
Republic of China	1912—1949
Founding of the People's Republic of China on October 1, 1949	